Saint Peter's University Library
Withdrawn

William Morris Hunt (1824–79) is included in all standard surveys of American art, but this is the first modern study of the influential Boston painter who played a leading role during an important watershed period in American art. Little examined, this era (1850–80) witnessed the decline of the nativist school of landscape painting and the emergence of a new aesthetic introduced by successive generations of artists trained in Europe (primarily Paris and Munich) who sought to bring more emotion and painterly expression to the art of their country. Members of this generation included John La Farge, Elihu Vedder, Frank Duveneck, George Fuller, George Inness, William Merritt Chase, and Albert Pinkham Ryder, many of whom Hunt encouraged during their early careers. Hunt himself worked in several modes – sculpture, genre, portraiture, lithography – and at the end of his life made a lasting contribution to the fields of American landscape and mural painting. His participation in this new aesthetic synthesized the painterly lessons of the French academic Thomas Couture and the humanistic subject matter of the Barbizon artist Jean François Millet. Furthermore, he introduced the poetic figure studies and landscapes of the Barbizon school to a new generation of artists and collectors.

Hunt was also the author of the well-known *Talks on Art* (1875). Conceived as a compendium of his classroom instructions, it is in fact a passionate account of his views on art and artists. Today, Hunt's ideas and influence are better known than his paintings. The many illustrations in this volume – a number of which have never before been published (including important studies for his now lost Albany murals) – deepen our understanding of this gifted teacher and highly regarded painter.

WILLIAM MORRIS
HUNT

WILLIAM MORRIS
HUNT
1824–1879

Sally Webster

The right of the
University of Cambridge
to print and sell
all manner of books
was granted by
Henry VIII in 1534.
The University has printed
and published continuously
since 1584.

CAMBRIDGE UNIVERSITY PRESS
Cambridge • New York • Port Chester • Melbourne • Sydney

Published by the Press Syndicate of the University of Cambridge
The Pitt Building, Trumpington Street, Cambridge CB2 1RP
40 West 20th Street, New York, NY 10011, USA
10 Stamford Road, Oakleigh, Melbourne 3166, Australia

© Cambridge University Press 1991

First published 1991

Printed in the United States of America

Library of Congress Cataloging-in-Publication Data
Webster, Sally.
William Morris Hunt, 1824–1879 / Sally Webster.
 p. cm. – (Cambridge monographs on American artists)
Includes bibliographical references.
ISBN 0–521–34583–9
1. Hunt, William Morris, 1824–1879. 2. Painters – United States –
Biography. I. Title. II. Series.
ND237.H9W4 1991
759.13–dc20
[B] 90–20040
 CIP

British Library Cataloguing in Publication Data
Webster, Sally
William Morris Hunt 1824–1879. – (Cambridge monographs
on American artists).
1. American paintings. Hunt, William Morris 1824–1879
I. Title II. Hunt, William Morris 1824–1879
759.13

ISBN 0–521–34583–9 hardback

ND
237
H9
W4
1991

To Nick

Contents

Illustrations

xi

Editor's Preface

THE CAMBRIDGE MONOGRAPHS ON AMERICAN ARTISTS series presents the most recent and thorough research on individual artists whose position and influence in the history of American art demands an up-to-date analysis and reinterpretation of their work and its importance. Rather than rework material on the best-known and heavily documented artists familiar to all, we publish the research of scholars who can bring us valuable information and cogent analyses of the contributions of American artists who have yet to receive the critical attention commensurate with their importance.

William Morris Hunt by Sally Webster is the first modern biography and careful assessment of the place of an American artist who has long been recognized as a tastemaker and a teacher. In this work, the author provides a larger point of view, showing an artist who incorporated the latest in contemporary French art into his own work and introduced a modern aesthetic to a new generation of artists. A leader in the Boston art community, Hunt directly encouraged younger colleagues and through his example motivated them to work independently and find their own artistic voice.

Professor Webster also examines key paintings, particularly the ill-fated Albany murals, providing insightful analysis of the ideas and context from which they spring. Hunt thus reemerges as both an important artist and an important innovator in late-nineteenth-century American painting. Through this monograph, we better understand his stature and the respect his work commanded in his own time.

DAVID M. SOKOL

Acknowledgments

THIS BOOK WOULD HAVE BEEN long delayed and incomplete without the generous loan of files and photographs from my colleague Dr. Martha Hoppin, curator of American Art at the Springfield Museum, Massachusetts. It is her 1974 dissertation, "William Morris Hunt: Aspects of His Work," with its invaluable "Handlist of Paintings," which has formed the basis of all subsequent research on Hunt. I am similarly indebted to my dissertation advisers, Professors Barbara Weinberg and William Gerdts. Also, I was greatly aided throughout the writing of this book by Dr. Gabriel P. Weisberg of the University of Minnesota.

In addition, there are numerous people at various museums, libraries, and historical associations whose help and advice have been invaluable. These include Sherry C. Birk, curator of Prints and Drawings at The Octagon Museum, Washington, D.C., who provided ongoing support of my research and assistance in securing photographs of documents in its collection; Dr. James Yarnall, director of the La Farge Catalogue Raisonné project, and Mrs. Henry A. La Farge, both of whom responded generously to my inquires; and Ruth Levin, registrar of the Bennington Museum, Bennington, Vermont. I am also indebted to the Department of Paintings, the Department of Prints and Drawings, and the photographic services at the Museum of Fine Art, Boston. My thanks also to the Brooks Memorial Library, Brattleboro, Vermont; the Essex Bar Association, Peabody, Massachusetts; Vose Galleries, Boston; the Adams National Historic Site, Quincy, Massachusetts, and the Library of the Boston Athenaeum.

I have benefited greatly from the counsel of Dr. David Sokol, editor of this series, and am grateful to him for the opportunity to write this monograph on Hunt. I am also appreciative of the encouragement and advice given to me by my colleagues of the Department of Art, Lehman College. In addition, I wish to thank the members of the George N. Shuster Fellowship Committee

at Lehman College for their generous and timely financial aid of my photographic costs.

Thanks, too, to the many private collectors who have allowed me access to their paintings. I extend my gratitude in particular to Willard G. Clark, Mr. and Mrs. Elliot Forbes, Mr. and Mrs. W. Channing Howe, Mrs. Lawrence A. Norton, Martin Peretz, and Mrs. Benjamin W. Thoron.

I also want to thank the women who have assisted me in this project including my daughter-in-law, Kristina Stierholz, and Sieglinde Talbott. Lastly, my unceasing gratitude to my husband, Nick; my children, Albert and Kate; my mother, Mrs. Robin Wright; and my beloved father-in-law, Albert N. Webster, and his late wife, Janet K. Webster.

Introduction: A Bridge
Between Two Eras

MOST COMMENTATORS on nineteenth-century American art use either 1850 or the Civil War as dates of demarcation between the provincial–nativist art of the early nineteenth century and the European-inspired, cosmopolitan art of the second half. Seldom is the divide between the two transversed in terms either of trying to relate the century's two halves or of mapping how changes came about. One problem is that European training and art are still regarded as influencing only marginally the work of the three great embattled American masters – Winslow Homer, Thomas Eakins, and Albert Pinkham Ryder. Unfortunately, the discounting of this European influence impedes a true understanding of the main ideas and currents in late-nineteenth-century American painting.

What are missing are discussions analyzing the goals and ambitions of the American artists during the second half of the nineteenth century. For instance, the 1860s and 1870s, the decades of William Morris Hunt's activity, have yet to be studied critically. No overriding construct exists to link the work of Hunt, Elihu Vedder, Eastman Johnson, Homer, George Inness, John La Farge, and James Abbott McNeill Whistler. Is there a common denominator in the careers of these artists? And how, given this midcentury chasm between the two halves of the century, were their training and interests different from those of previous generations? Well known, yet poorly understood, is that, with the exception of Homer (whose sources have been critically debated), the common link is their adoption of European precedents. Their first-hand exposure to modern and old master painting and their European training, particularly in Paris, separates them from the past. To add further weight to their experience, it should be noted that all successive generations of artists, through the 1950s sought instruction and inspiration from abroad.

It is difficult today to imagine, given the proliferation of printed images and the ease of travel, how few reliable examples were available to American artists in the first half of the nineteenth century. There were steel engravings,

copies of old master paintings, and plaster casts of famous antique sculpture, but little information on the nature of color or development of technique – the use of glazes, the mixing of pigments, the preparation of grounds. Nor were there organized schools of art. In New York, the National Academy of Design, established in 1826, offered studio space where students could work from plaster casts and later from the live model. In Boston, the most highly regarded art organization was a private library, the Athenaeum, which sponsored important exhibitions but had no facilities for the study of art. Mostly American artists learned from each other.

What was lacking, in contrast to Europe, was systematic instruction in drawing, information about the craft of painting, and first-rate examples of earlier art. We admire and exalt the efforts of John Trumbull, Thomas Sully, and Gilbert Stuart; nevertheless their work, when compared to that of their European contemporaries – David, Ingres, Delacroix, Géricault, Constable, and Corot – was not as technically competent or as conceptually ambitious.

Many persuasive cases have been made in the attempt to ignore this fact. A myth widely subscribed to is that throughout U.S. history, artists have sought to find their own independent voice in a way analogous to this nation's desire to stand as model of democratic freedom. Accordingly, the most admired artists are those whose work reflects a self-taught technique and whose subjects are unsullied new world landscapes and frank, unadorned portraits. The reality is that most American artists dreamed of, and saved for, their trips abroad to learn their craft.

The case of Washington Allston, the early-nineteenth-century painter whose career is most often linked to Hunt's, is illuminating. Allston spent his formative years in Europe studying in Rome and London at the beginning of the nineteenth century. Unlike Benjamin West and John Singleton Copley (both of whom remained in England), he decided to return to the United States following his second European trip in 1818. Given the favorable critical reception of his work in London as opposed to the relatively uninterested audience for painting in the United States, the reasons behind his decision to return have eluded scholars.

Similarly, Hunt's decision to return to Boston in 1855 is not clear. Ostensibly he came back to marry the socially prominent Louisa Dumaresq Perkins. It could be that Hunt and Allston preferred to be the proverbial "big fish in a small pond," yet evidence shows they shared a sense of obligation and responsibility to develop the visual arts in this country, and to other American artists. As proof of the esteem in which Allston was held, he was the artist most sought after for the prestigious commission to contribute paintings for the Capitol Rotunda – an invitation he declined in order to continue his work on his unfinished masterpiece, *Belshazzar's Feast* (The Detroit Institute of Arts).

Of all the artists of the first half of the nineteenth century, Allston was the most sophisticated and accomplished in terms of technique and complex subject matter. Only Samuel F. B. Morse and Thomas Cole, in his late series

paintings, in their response to old master European painting and tradition were as sophisticated as Allston. It is in this context of the drive and desire of American artists to gain training and exposure to the ideals of art, and to introduce these ideas to artists and audiences in the United States, that Hunt's career can best be understood.

Because of the diversity of the ideas Hunt investigated, which often makes his work difficult to categorize, his career is paradigmatic of the ambitions carved out by later nineteenth-century artists. Over its course he explored sculpture, genre, printmaking, portraiture, figure painting, landscape, mural painting, and, to a limited degree, still life. He was also a great teacher, and his written views on art were widely read. Mostly he encouraged students and fellow artists to pursue their own independent vision and was thus able to support artists of diverse temperaments such as La Farge (whom he taught), Vedder, Frank Duveneck, Inness, and George Fuller. Few nineteenth-century American artists had as comprehensive an involvement with the visual arts.

Hunt devoted his early student years to sculpture, his production limited to a few cameos and reliefs. In 1846, following years of study in Cambridge, Massachusetts, as well as Rome and Düsseldorf, he arrived in Paris to begin instruction with one of the most popular academic painters of the era, Thomas Couture.

An exhibition entitled *The American Pupils of Thomas Couture* was organized in 1971 by Marchal Landgren. His research, and that of Albert Boime's on Couture and the mid-nineteenth-century training of French artists, confirm the central importance of Couture in both American and French art instruction. Further, their work enables us to assess Couture's influence on Hunt, as well as on American art in general, and to see that Couture's and Hunt's combined efforts led to a new appreciation of painterly expression.

Following a few years of atelier study with Couture, Hunt devoted the next ten years, the decade of the 1850s, to genre painting. This interest generated two types of subject matter: the urban and literary genre of his realist contemporaries in Paris, and the rural genre of the Barbizon master Jean François Millet. In 1852, Hunt left Paris to live in Barbizon and to work alongside Millet. His involvement with France's peasant painter is the aspect of his career which has received the most attention. Their relationship and Millet's influence, have been well documented by Laura Meixner, who carefully delineated Hunt's years with Millet and the extraordinary impact Millet had on American painting and popular culture throughout the second half of the century.[1]

In spite of these known facts, the implication of the combined influence on Hunt of Couture, the Parisian art scene, and Millet has not been fully assimilated. Some implications for American art in the second half of the century include an abandonment of the linear definition of form to a greater reliance on and interest in the generative properties of color. Specifically, it was Couture's rediscovery and application of the chiaroscuro techniques of the Ba-

roque masters Rembrandt and Velázquez that influenced Hunt and others. In France this new interest in color went hand in hand with changes in subject as artists turned from historical and literary themes to those that reflected everyday life, changes best exemplified in the work of the French Impressionists. But even before the 1870s and the triumph of Impressionism, such shifts were evident in renderings of peasant life by Millet and the plein-air painting of Charles Daubigny and other Barbizon artists. It was this early group of French artists who most influenced Hunt, first in the 1850s and again during his second trip to Europe in the late 1860s.

Genre painting occupied Hunt during the 1850s, but once back in the United States he devoted the next ten years to portraiture. To some extent, this direction was conditioned by a need to establish himself professionally. Indeed, his full-length *Judge Lemuel Shaw* (1859) was undertaken, as he put it, as "an entering wedge into the profession." Overnight he became Boston's premier portrait painter, and several of his early portraits of women are done in a flattering Continental style, an amalgam of Couture and Franz Xavier Winterhalter. Later, however, Hunt abandoned this style as his paintings of women became excuses for figure studies. Similarly, his portraits of men lost the dryness of commission as he sought to render his sitters more intimately and sympathetically. Some of them were not always successful, especially when compared with the similarly intentioned ones by Eakins done in the 1880s and 1890s; but Hunt did introduce the idea that portraits were not simply documents but also interpretations of personality and character. Although earlier, incisive examples of this genre can be found in American art, Hunt, as a result of his exposure to European ideas, meaningfully expanded the possibilities of portraiture.

Hunt's interest in landscape came late in his career in the 1870s, during the last five years of his life. His approach to landscape reflects the quietude associated with work done by members of the Barbizon school, particularly Daubigny. In his scenes of woodland interiors and New England farmland, Hunt, with a closely hued palette of browns, grays, greens, and ochers worked to unify the picture plane. Often he began his explorations by sketching in charcoal; as did his French contemporaries, he felt these studies contained the moment of true inspiration and were thus equal to the finished work. Significantly, his restricted compositional formats and harmonious color represented a break from the contemporary work of the Hudson River painter Frederic Church and the Luminists Martin Johnson Heade, Fitz Hugh Lane, and John Kensett.

Today it is difficult to discern the radical nature of Hunt's unassuming studies of the land, which, when he exhibited them, aroused a storm of criticism in Boston because he challenged the prevailing Ruskinian interest in detailed topography. Hunt's innovations carried the day and his work, along with that of George Inness, introduced to a younger generation the emotional and evocative – as opposed to the documentary or theatrical – aspects of

landscape. His plein-air painting, and that of his followers in Boston, inspired a new generation of European-trained artists in New York. Exhibitions sponsored by this group, later known as the Society of American Artists, included works by Hunt and other Boston landscape painters, all of which effectively challenged the aesthetic hegemony of the National Academy of Design.

It was also in the 1870s that Hunt undertook some of the most important tasks of his career – teaching, the exposition of his art theories, and mural painting. More than any other, the art of mural painting was the one most closely associated with the old master, Renaissance tradition. With the exceptions of John La Farge's painted decorations for Trinity Church, Boston, and Emanuel Leutze's *Westward Ho!* for the U.S. Capitol, no professional American artist had undertaken such an effort. There were, however, examples of monumental paintings – Allston's *Belshazzar's Feast,* Thomas Cole's multipaneled *The Course of Empire,* Church's *Niagara,* and, to a lesser degree, Rembrandt Peale's *The Court of Death.* As disparate as these works are, they do provide an American context for Hunt's two murals – *The Flight of Night* and *The Discoverer.* Executed for the Assembly Chamber of the Albany state capitol, his efforts were surprisingly successful and enthusiastically received by most critics. In fact, his work inspired many writers with the expectation that there was a future for monumental mural painting in this country. Tragically, Hunt died nine months after his work was unveiled, and it was not until the 1890s that mural painting flowered in the United States in decorative projects such as those for the the Boston Public Library, Chicago's World Columbian Exposition, the Library of Congress, and the many new state- and courthouses at the turn of the century. As with changes in genre, portraiture, and landscape, so, too, in mural painting did Hunt chart a new course.

Hunt had an inquiring mind, led a peripatetic life, and undertook various artistic endeavors (the variety of which might be attributed to an irresolute nature) in order to examine their essentials, to try and discover their basic elements, to investigate their fundamental properties. This notion is confirmed in his art as well as in his teaching and writings. He saw himself not as maker of masterpieces but as an explorer of ideas. As Henry James put it, Hunt "played over questions as if they were objects and objects as if they were questions."[2]

This approach not only reflected Hunt's temperament but was also appropriate for this transitional period when Americans were becoming aware of the possibilities of art, possibilities that extended the province of art beyond the recording of fact. A study of Hunt's career can therefore serve as a way to examine the elements of change in American art at midcentury and lead to a more cohesive overview of this watershed period.

1

Early Life, Travel, and Training Abroad

PROLOGUE

WILLIAM MORRIS HUNT (1824–79) was a tall, slim, aristocratic-looking young man. At Harvard, in the early 1840s, he was very social, loved to play the guitar, and, according to his classmate Edward Wheelwright, was an extraordinary mimic.[1] Throughout his life he was beloved by his friends, whom he would often visit unexpectedly, delight with a few droll tales, then quickly depart. He never wanted to "bore" them, and in later life seldom mentioned his problems – the loss of his studio in the 1872 Boston Fire, the separation from his wife and children, and his poor health. Instead, according to Henry Angell, a Bostonian physician, collector, amateur painter, and close friend, "he seemed very merry and light hearted, and would take up his banjo or guitar and play a little, sing a French song, joke a great deal, and tell stories."[2]

Hunt was also an eccentric. If the mood struck him, while visiting a friend, he might balance an empty wine goblet or glass paperweight on his head.[3] He was also fond of bizarre stories about animals. On one occasion, he regaled friends with a sadistic tale about a French painter who teased his pet monkey by substituting a jack-in-a-box for a sugar bowl. Thinking he was opening the sugar, the monkey opened the jack-in-the-box and in shock and fear withdrew into his cage. This teasing went on for several days until the monkey dropped dead from fright and frustration.[4] A macabre story like this became hilarious when Hunt acted it out for friends.

In the 1870s, when these anecdotes were recorded, Hunt was in his early fifties; stooped over, bald, and with a long gray beard, he looked seventy. He had suffered all his life from what his brother Leavitt described as a pulmonary condition, a form of consumption that not only tired and depressed him but aged him prematurely. However, he seldom complained – except about critics – and was described by his contemporaries as generous and kind to fellow artists. He was also a celebrated personality in Boston; after his death, mag-

6

azines were filled with anecdotes describing his helpful nature, magnetic personality, and unpredictable outbursts of rage.[5]

Hunt's temperamental nature and idiosyncrasies were not often reflected in his work: subject matter was subordinated to technique. Only a handful of small paintings and sketches hint at personal demons, and none displays the mystery or literary fantasy found in the paintings of his friends William Rimmer and Elihu Vedder. Yet a strange moodiness, a melancholy, haunts most of his work. Hunt was both a high-strung noncomformist, indulged by loving friends and family, and a dedicated, single-minded artist whose intellectual grasp of modern aesthetic issues and sensitive understanding of the European old masters were communicated through his innovative painting methods and teaching.

EARLY LIFE AND EDUCATION

Hunt was born in Brattleboro, Vermont, into a prominent New England family that had made its fortune in land speculation in northern Massachusetts and southern Vermont. His father, Jonathan (1787–1832), who graduated from Dartmouth in 1807 and studied law privately in Litchfield, Connecticut, was a prominent and influential member of the city of Brattleboro; at the time of his marriage in 1820, he was president of the local bank. Hunt's mother, Jane Maria Leavitt (1801–77), born in Suffield, Connecticut, also came from a well-to-do family. Her father, a local judge, made sure she received as good an education as was available to women in the early nineteenth century: first at Miss Clarke's Boarding School in Northampton, Massachusetts, and later at Colonel Dunham's School in Windsor, Vermont. It was at the Windsor Inn, in 1819, while dining with her father, that she met her future husband.[6]

After their marriage in 1820, the Hunts settled in Brattleboro and over the next ten years had five children: Jane (1821–1904); William (1824–79); Jonathan (1826–74); Richard (1827–94); and Leavitt (1830–1907). From the beginning their family history was marked by a wanderlust and restlessness. Diaries and letters kept by the couple reveal a hunger for new sights and an enthusiasm for travel that their children later shared. During a trip in 1831 to Fayette County in West Virginia, for example, Jonathan wrote to his wife of the wild scenery of the Appalachians: "The roaring of the water and the winds through this deep and narrow channel of the winding mountains contributes not a little to the sublimity of this wild part of creation."[7] At the time of this trip, Jonathan was serving in the House of Representatives and his family was living in Washington, D.C. A year later he went west again to explore the possibility of purchasing land near Cincinnati and settling there with his family after leaving Congress. Tragically, he contracted cholera and died in 1832, shortly after his return to Washington. What dreams and ambitions he and his wife had for the children is not known, yet Mrs. Hunt's

later decision to educate them abroad had an extraordinary impact on their lives and indirectly, through the careers of her two sons William and Richard, on the future development of the visual arts in the United States.

Mrs. Hunt was well provided for by her husband's estate. After a few months spent in Brattleboro closing out her husband's affairs, she moved with the children to New Haven, Connecticut – a city midway between her parents in Suffield and New York City, which she frequently visited. Although details about her life are scarce, it is known that she maintained an important friendship with the novelist Catharine Sedgwick. Author of *Hope Leslie* (1827) and *Married and Single* (1857), Sedgwick, along with Harriet Beecher Stowe, was one of the country's most popular female novelists during the first half of the nineteenth century.[8] She had first made a name for herself in 1822 with *A New England Tale,* a novel about the emergence of Unitarianism following a schism in 1821 among New England Calvinists as well as her own conversion to Unitarianism that same year. It is not clear when she and Mrs. Hunt met: it may have been through the Unitarian church that Mrs. Hunt had joined sometime in the early 1830s.[9]

The far-ranging importance of the ethical humanitarian values of Unitarianism, which pervaded the teaching at Harvard and the intellectual life of Boston during the first half of the nineteenth century, has just begun to be documented.[10] In addition to their involvement with education, social reform, and literature, New England Unitarians supported the revolutionary movement in Italy and found housing for Italian refugees who needed asylum in the United States. Sedgwick participated in this effort, referring several refugees to Mrs. Hunt, who gave them room and board during the summer of 1837. One of her boarders was the painter Spiridione Gambardella, who gave her and the children art lessons as payment for his lodgings.[11] In addition to a passion for art, Gambardella may have also kindled in Mrs. Hunt an ambition for wider horizons and greater educational opportunities for the children. The following year, the Hunt family moved to Cambridge, Massachusetts, so that William could attend William Welles's Preparatory School in South Boston before entering Harvard.[12] Living in New Haven, Mrs. Hunt could easily have sent William to Yale, which her father had attended. Yet Cambridge and Boston were livelier communities, and Harvard, with its prestige and its new Unitarian leadership, apparently had more appeal.[13]

To judge from reunion reports written by his friend Edward Wheelwright, Hunt was hugely popular with his classmates. Yet he was an indifferent student, often in trouble with the administration, and at the end of his sophomore year he was put on probation.[14] Restless and bored with academic routine, he began to study sculpture with John Crookshanks King.[15] In the late 1830s and 1840s, Boston was a mecca for American sculptors. There were not only art patrons but also commissions for memorial sculpture for Mount Auburn, the first of America's garden cemeteries. King had arrived in Boston along

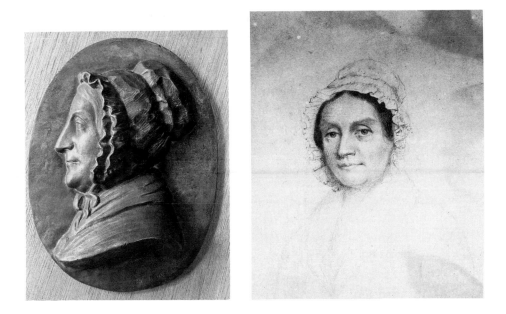

FIGURE 1. *Jemima Leavitt*, 1841. Bronze relief, 10¼″ × 7⅝″ × 1⅝″. Brooks Memorial Library, Brattleboro, Vermont.

FIGURE 2. *Jemima Leavitt*, c. 1841. Photograph of drawing. The American Architectural Foundation, Prints and Drawings Collection, The Octagon Museum, Washington, D.C.

with other sculptors who had worked earlier in Cincinnati under the patronage of Nicholas Longworth, including Shobal Vail Clevenger (Boston, 1839–40); Edward Brackett (Boston after 1841); and Henry Kirke Brown (Boston 1837–42), with whom Hunt would later study in Rome.[16]

Two works remain from Hunt's study with King, a sketch and portrait relief of his maternal grandmother, Jemima Leavitt (fig. 1), dated 1841. While the crude outline and modeling of the relief are not surprising for an early attempt at three-dimensional form, the sensitive and precisely rendered pencil sketch (fig. 2), a study for the cameo, is evidence of Hunt's emerging artistic promise.

Sick a good deal of the time, William contracted consumption, and late in the summer of 1843 his doctor advised Mrs. Hunt to take her son to a warmer and drier climate rather than risk another winter in Cambridge. Evidently, William and his mother used this as an excuse to go to Europe, presumably for his health but more probably to continue his study of sculpture. The Reverend and Mrs. Samuel Parker, friends with whom Hunt had stayed during the summer, tried to deter them.[17] But Mrs. Hunt, who later acknowledged that her decision to take all five children to Europe was impulsive and rash, was not swayed by such appeals, and the family left for Europe on October 9, 1843.[18]

PARIS, ROME, AND DÜSSELDORF

Mrs. Hunt planned to stay in Europe only a year, or until William regained his health. Yet what began as a Grand Tour turned into a twelve-year sojourn

that decisively influenced her children's future careers. It was in Rome, Düsseldorf, and, most importantly, Paris that William's artistic skills, temperament, and ambitions were molded.

The Hunts spent their first winter in Paris sightseeing and socializing, which included being presented at court to Louis Philippe.[19] Paris in those days was at relative peace. Although under increasing pressure from various factions – pressure that would culminate in the Revolution of 1848 – Louis Philippe was still popular with the newly rich bourgeoisie, and buildings were being erected everywhere to house an ever expanding governmental bureaucracy. Significantly, in view of Hunt's later mural commission at the Albany state capitol, these building programs often included wall paintings; in the 1840s, France was just at the beginning of a mural revival.[20]

The Hunts did not stay long in Paris; after four months, they left for Rome, their base for the next year and a half. In the 1840s Italy, more than France, was a mecca for American travelers, particularly for those who wanted to see at first hand the great monuments of Western civilization – classical sculpture and Renaissance painting.[21] Throughout the century American and European sculptors came to this ancient capital, whose supply of fine Italian marble and skilled stonemasons could be found nowhere else. Given Hunt's interest in sculpture, Rome was a logical choice.

On arrival Hunt took a short trip through the Apennines with a classmate and friend, Francis Parkman, future author of *The Oregon Trail* (1849). Parkman recorded their trip in his journal, and Hunt sketched many of the sights they saw together in the hill towns of Tivoli, Civitella, Palestrina, and Velletri. Two of these sketches are among a group of early pen-and-ink drawings preserved by a family descendant. One depicts a young peasant boy with a staff leading an ass saddled with a baggage frame; the other is of an old man with a domed hat who stands behind a low fence. In the background, only summarily suggested, is the high rock wall and castle turret of the town of Subiaco as described by Parkman in his journals.[22] As far as can be determined, the two men never met again. Yet this contact with Parkman is tantalizing because the historical issues that Parkman wrote about for the rest of his life were presented in allegorical form by Hunt in his mural program in Albany.

After his return from the Apennines, Hunt, along with other members of his family, explored Rome and the rest of Italy, visiting churches, palaces, and galleries, and calling on European and American sculptors including John Gibson, Bertel Thorwaldsen, and Thomas Crawford.[23] Inspired by these men's work and desiring to build on what he had learned from King, Hunt resumed his study of sculpture in the fall of 1844, with Henry Kirke Brown, whom he may have met earlier.[24] The young man worked under Brown's supervision approximately six months, and by March 1845 had completed several works including a copy of "the head of the Naples Psyche, restoring the head as he imagined it might have been."[25]

While in Brown's studio, Hunt may have also carved in shell four cameo portraits of himself and his three brothers. Mounted on a bracelet, now in the Museum of Fine Arts, Boston, these undated carvings are more technically refined than his earlier relief of Jemima Leavitt. There is only one other known work from this period, a cameo of Brown that William carved for Mrs. Brown as a gift (unlocated).[26] The most important outcome of Hunt's training with Brown, according to his sister, was his decision "to devote himself to the study and profession of art" instead of returning to Harvard.[27]

Hunt's ambition to become a professional artist may have been reenforced by his friendship with Emanuel Leutze – who would later produce one of America's best-known paintings, *Washington Crossing the Delaware* (1851, Metropolitan Museum of Art).[28] The two met sometime in late 1844 or early 1845. A carefully delineated pencil sketch of Hunt by Leutze, inscribed "Rome/Italy/ 1845" (Museum of Fine Arts, Boston) confirms their meeting. This sketch, a good example of Leutze's highly refined realistic portrait style, impressed Hunt and influenced his decision to attend the Düsseldorf Academy, where Leutze had received his training – although Hunt may have also felt he had had insufficient exposure to the practice of sculpture in Brown's studio and needed the discipline of an academic course of study.

Düsseldorf was then an important center for art and art training, and in the 1850s its academy was more open to Americans than the Ecole des Beaux-Arts in Paris. Although the French capital would soon eclipse Düsseldorf, at midcentury American art students were impressed with Leutze's success and the popularity of contemporary German painting then being shown at the Düsseldorf Gallery in New York.[29] By the 1870s, however, French academic painting and works by the Barbizon school began to lure artists and collectors. Study in Paris became desirable and was made easier by the 1863 curriculum reforms at the Ecole des Beaux-Arts and the establishment of independent ateliers, such as the Académie Julian and the Académie Suisse.

In September 1845, Hunt enrolled at the Düsseldorf Academy as a student of sculpture.[30] Although the academy was not an important center for sculpture, the basic training in drawing and anatomy it offered was good preparation for any artistic field Hunt might chose. Yet he balked at the routine academic instruction, as he had earlier at Harvard, and left after his first year.[31] One important aspect of Hunt's stay in Düsseldorf was that Leutze, who had returned from Rome at the same time, was occupied during the 1840s with a painting cycle based on the life of Christopher Columbus. By 1845 he had completed three works: *Columbus Before the High Council of Salamanca* (1842, unlocated); *The Return of Columbus in Chains to Cadiz* (1843, private collection); and *Columbus Before the Queen* (1843, Brooklyn Museum). Not only did this series introduce Hunt to modern monumental painting, but Columbus, who through his discovery of America connected the Old World with the New, would become the principal figure in Hunt's mural *The Dis-*

coverer. In fact, there is an early sketch for *The Discoverer* (see fig. 137) dated "1850 or 1860," which Hunt may have done in response to Leutze's cycle.

PARIS AND THE STUDIO OF THOMAS COUTURE

Hunt's Albany commission, however, lay in the future; in 1846 he was still determined to be a sculptor, and Paris was his next stop. His choice of cities was in part influenced by a desire to be with his family.[32] In the fall he applied for admission to the Ecole des Beaux-Arts as a student of James Pradier, professor at the Ecole and a favorite sculptor of Louis Philippe's.[33] Although Hunt arrived too late to enroll, it may be that he failed to pass his entrance examination as his brother Richard had a year earlier. Richard persevered and after being accepted into the studio of the architect Hector Martin Lefuel in 1845, passed his exams the following year and was admitted to the Ecole des Beaux-Arts in December 1846, becoming the first American to be trained at what was then Europe's premier school of architecture.

Unlike Richard, William had other options. Inspired by the academic painter Thomas Couture's *The Falconer* (fig. 3), he abandoned sculpture to study painting under Couture, who had recently opened his own school independent of the Ecole. Hunt's choice may seem surprising given his impatience with the academic routine in Düsseldorf; Couture, however, was more interested in teaching his students how to paint and use color than how to excel as draftsmen. Hunt had seen *The Falconer* in the window of Deforge's art store, and legend has it that he stopped before it and exclaimed: "If that is painting, I am a painter!"[34] This painting is, in fact, a good example of Couture's technique, which with its emphasis on the spontaneous rendering of form through the almost intuitive application of light and dark values, would have been a revelation to Hunt following his training at Düsseldorf. Hunt entered Couture's atelier – or, as Couture called it, a new " 'school of national painting' " – as his first American student sometime in 1847, following the success of Couture's best-known work, *The Romans of the Decadence* (1847, Louvre) at the spring Salon.[35] In this monumental painting, sometimes regarded as an indictment of Louis-Philippe's July Monarchy, Roman aristocrats in various states of inebriation recline dissolutely around a banquet table set in the center of a large marble hall open to the sky, surrounded on three sides by classical columns and larger-than-life-size statues. Hugely popular and greatly admired as this work was at the Salon, Couture never achieved the same success with any other painting.[36]

For nearly a century, Couture has been regarded as a reactionary academic painter, and his career has been largely ignored. Recent scholarship, primarily by Albert Boime, has revealed, however, that Couture's teaching, painting technique, and subject matter influenced a new generation of innovative French and American artists, including Edouard Manet and Puvis de Chavannes.[37]

FIGURE 3. Thomas Couture, *The Falconer*, c. 1846. Oil on canvas, 51″ × 28½″. The Toledo Museum of Art, Ohio. (Gift of Edward Drummond Libbey)

Couture began his own career in an orthodox manner as a pupil of Baron Antoine Jean Gros, who in turn had been a pupil of Jacques Louis David. This was a distinguished pedigree for a nineteenth-century French painter, yet, in his announcement for his school, Couture rejected neoclassicism as a " 'spurious classical school which reproduces the works of bygone times in a banal and imperfect fashion.' " He had even less use for the Romantic school, unofficially led by Delacroix, and declared he was " 'even more hostile to that abominable school, known under the rubric of "Romantic" and views with disfavor the tendencies towards petty artistic commercialism.' "[38] What Couture advocated was a return to the direct study of antique sculpture and the old masters instead of relying on their reinterpretation by either the Classicists or the Romantics. He also believed that subject matter should be drawn from a broad range of sources, which would help link tradition to the demands of a new age. Couture's "eclectic vision" (a mysterious amalgam of sources that often defies traditional art historical interpretation) can be found in the work of Puvis de Chavannes, whose murals, with their classical figures placed in dreamlike arcadian settings, never illustrate a specific Greek myth. Instead, their curious combinations of ancient and modern sources together evoke the roots of French culture and history.[39] Later, Hunt in his Albany murals paired the obscure Persian goddess Anahita with an image of the heroic discoverer Christopher Columbus to create a not easily recognizable dualistic interpretation of America's history and destiny.

It was, in fact, in Couture's studio that Hunt began to articulate his first ideas for *The Flight of Night*. Interestingly, one of his first, known as *Flight of*

FIGURE 4. *Thomas Couture,* 1848. Bronze medallion, 9¼" × 7½". Brooks Memorial Library, Brattleboro, Vermont.

Night – Horses of Anahita, was done as a relief sculpture. When Hunt entered Couture's studio, at the age of twenty-three, he had been studying sculpture, albeit sporadically, for seven years, and his total output of it was small. That he had become a competent carver can be seen in a comparison of his earliest relief of his grandmother (see fig. 1) with a signed and dated bronze relief of Couture (fig. 4) – done, significantly, in 1848, at the beginning of his study with the master. In the Couture head, Hunt's modeling is surer and more expressive. More importantly, as can be seen in *Flight of Night – Horses of Anahita* (fig. 5), probably done at the same time, he was beginning to move away from the restrictive plane of the cameo.[40] This relief, which served as an important motif in his painting *The Flight of Night,* and all of his subsequent work on this theme, were derived from a Persian poem titled "Anahita," translated into English by his brother Leavitt (who was studying in Heidelberg, an important center for the study of Persian language and literature). Leavitt sent him the poem sometime between 1847 and 1848, with the suggestion that Hunt use it as the basis for a new interpretation of Guido Reni's *Aurora* (see fig. 150) (Rospigliosi Palace, Rome).[41]

In Leavitt's translation, Anahita – who is woman, moon, and night – is described as "circling down the lofty heights of Heaven" riding in a car of light pulled by "well-trained coursers [that] wedge the blindest depths with fearful plunge, yet heed the steady hand that guides their lonely way." These particular lines are the ones illustrated by Hunt in *Flight of Night – Horses of Anahita.*

Yet Hunt found that sculpture limited his ability to represent fully the poetic narrative, a frustration that led him to investigate the storytelling potential of painting. His decision to use two-dimensional expression for this

purpose, is confirmed by a small pencil sketch (fig. 6) that incorporates most of the relief and elements of the poem, and also contains many of the motifs of the 1879 mural.[42] It is clear from this small, chaotic composition, however, that Hunt was not yet well versed in painterly design. This same crude rendering of form also characterized three small paintings (all containing images of horses) probably done at the same time as the plaque and the sketch: *White Horse; Three Horses in a Stable* (both Bennington Museum, Bennington, Vt.); and an oval painting of two horses and rider (private collection). From the evidence of these paintings and the pencil sketch, Hunt's study of sculpture and a year of academic training in Düsseldorf had not prepared him for the complex demands of large-scale painting. Thus, Hunt's choice of Couture was likely based on his wanting to study with the painter of the famous monumental *Romans of the Decadence* as well as on the inspiration of the more intimate and painterly *The Falconer.*

Hunt began, like all of Couture's students, by drawing. In the Print Collection of the Museum of Fine Arts, Boston, are six academic studies probably done when he first began to study with Couture.[43] They were all done in charcoal, some heightened with white, on gray crayon paper: four male heads (one of which, #84.286, is called a self-portrait) and two female heads (fig. 7). These studies are traditional academic exercises, but it was not long before Couture's particular method of painting appeared in Hunt's work. In a small oval *Self-Portrait* (fig. 8), Hunt pictures himself in a *chapeau montagnard*, a black top-hat worn by the supporters of the Revolution of 1848. It is a bust portrait done in russet browns, blacks, and whites. The white also becomes light that illuminates and models the right-hand side of his face.

Hunt continued his early lessons in this oval format (also favored by Couture) in three later works – *Head of a Girl* (Museum of Fine Arts, Boston); *Woman in Profile* (Vose Galleries, Boston); and *The Jewess* (fig. 9). The best known of these is *The Jewess*, in which we can sense Hunt's more confident grasp of Couture's method. The form is fuller, his paint handling is surer, and color values are better understood.

Following this series of oval portraits, Hunt took on a larger project: a three-quarter-length figure study, *Mother* (Portrait of Jane Maria Leavitt Hunt) (fig. 10). Although it is known that Hunt depended on his mother for financial and, one assumes, emotional support, little is known of their relationship or Hunt's feelings about her. Such information would be relevant given the evidence of this dark, unflattering portrait. In her plain black dress she dominates this somber painting, a mood reinforced by the dark blue background unrelieved by the warm golden tonalities found in Hunt's smaller works. The only attractive part of the painting is her hands, which were painted with a vitality and grace. At this early stage in his career, Hunt seemingly focused his energies on technical problems rather than the sympathetic representation of personality or character.

These early years with Couture provided an important base of instruction

for Hunt, and he continually acknowledged his indebtedness to the master. For someone of Hunt's temperament and enthusiasms, Couture was a perfect choice: "With Couture himself he was in perfect sympathy; and under his guidance, certain qualities in Hunt's mind and work unfolded as they scarcely would have done under any other auspices."[44] Indeed, the training Hunt received in Couture's atelier formed the basis of his own painting technique and teaching methods. Yet Hunt soon asserted his independence in a series of genre paintings done in the early 1850s.

FIGURE 5. *Flight of Night – Horses of Anahita*, 1860. Tinted plaster panel in high relief, 18½″ × 28½″. The Metropolitan Museum of Art, New York. (Gift of Richard Morris Hunt)

GENRE PAINTING

As noted, Hunt did two types of genre painting: the city and ethnic types he painted in Paris; and the peasant subjects done later in Barbizon with Millet. The Parisian paintings, which he exhibited more often than those undertaken in Barbizon, reveal an extraordinary amalgam of sources reflective of the changing nature of French painting. Moreover, this city type – for example *The Hurdy-Gurdy Boy* – can be connected to contemporaneous changes in American genre painting.

While still in Paris, between 1850 and 1852, Hunt painted no fewer than seven genre paintings, five of which he exhibited in 1852 – *La Marguerite* I and *The Fortune Teller* at the Paris Salon; *The Hurdy-Gurdy Boy, Bohemian Girl* (unlocated), and *The Prodigal Son* at the Boston Athenaeum. (The last, which is usually thought of as a religious subject, illustrates a moment in the parable

16

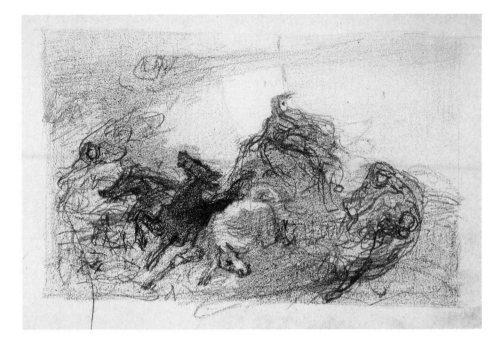

FIGURE 6. Study for *Flight of Night*, c. 1848. Sketchbook page, pencil on paper, 4³⁄₄″ × 7¹⁄₄″. The American Architectural Foundation, Prints and Drawings Collection, The Octagon Museum, Washington, D.C.

in which the universal human qualities of the story are stressed, and can therefore be classified as literary genre.) The two other paintings done these same years were *The Greek Girl* (Graham Gallery, N.Y.) which was never widely exhibited; and *The Violet Girl*, or *La Bouquetèrie*, which he exhibited in 1855 at the Paris Universal Exposition.[45]

These early genre paintings, often characterized by sentimentality and, in some cases, melodrama, are nonetheless surprisingly complex. Seen in the larger context of contemporary political and artistic events, they illuminate Hunt's response, in both style and subject matter, to the revolutionary developments then beginning in French painting. These developments – sparked by the political and social events culminating in the Revolution of 1848 – were, in part, a reaction against dominant academic taste, a style of painting considered inappropriate for documenting modern life.[46]

Genre painting, with its working-class images and depictions of the urban poor, reflected the mood of the times; and in the "Realist" Salon of 1850–1, there were significantly more paintings of this type, and the category itself was expanded and elevated. Artists as diverse as Gustave Courbet, Théodule Ribot, Narcisse Diaz de la Peña, Honoré Daumier, and Millet introduced subject matter that better reflected modern-day circumstances – stone diggers, savoyards, street urchins, bootblacks, organ-grinders, and regional types. Paintings with these themes were conspicuous at the Salons at the beginning of Hunt's professional career.

In addition, most of Hunt's genre subjects, like those by his French contemporaries, drew on traditional sources. Not surprisingly, his approach to

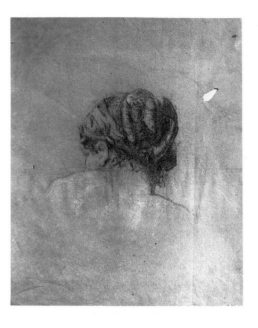

FIGURE 7. *Female Head*, c. 1848. Charcoal on paper, 22″ × 28″. Courtesy, Museum of Fine Arts, Boston. (Gift of Miss Helen M. Knowlton)

FIGURE 8. *Self-Portrait*, c. 1848–9. Oil on canvas, painted oval, 11″ × 8¾″. Courtesy, Museum of Fine Arts, Boston. (Gift of William P. Babcock)

FIGURE 9. *The Jewess*, c. 1850. Oil on canvas, 22″ × 18½″. Private collection. Photo: Courtesy of Vose Galleries, Boston.

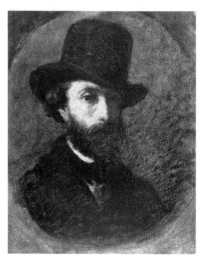

genre painting is similar to that of Manet, who studied with Couture at the same time as Hunt (1850–6). As noted by many writers, Manet, in such early works as *Boy With Dog* (1860–1, private collection, Paris), *The Absinthe Drinker* (1858–9, Ny Carlsberg Glyptothek, Copenhagen), *The Spanish Singer* (1860, Metropolitan Museum of Art), and *The Old Musician* (1862, National Gallery of Art, Washington, D.C.) combined modern subjects with compositional ideas and themes borrowed from earlier artists.[47]

The painting by Hunt that comes the closest in subject and concept to those early works of Manet is *The Hurdy-Gurdy Boy* (fig. 11). Although Hunt's sources are not identical with Manet's, he gained inspiration from the old masters and illustrated albums consulted by many French artists of the period.

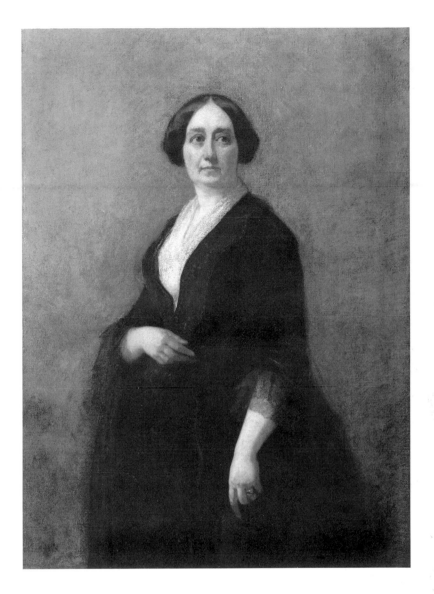

FIGURE 10. *Mother* (Portrait of Jane Maria Leavitt Hunt), 1850. Oil on canvas, 49¼″ × 36″. James S. Murphy. Photo: Courtesy of Vose Galleries, Boston.

The theme of the young musician has a long history dating back to the seventeenth century in Holland – where images of such types were used as allegories for the sense of hearing.[48] In the eighteenth century, the itinerant musician became a standard figure in the *fêtes galantes* by such artists as Antoine Watteau, who, in his *Music Party* (c. 1719, Wallace Collection, London), used the image of a mandolin player as the central character. There is even a painting by a contemporary of Watteau's, Jean François de Troy, entitled *The Hurdy-Gurdy Player* (c. 1710, location unknown), which is surprisingly similar to Hunt's.[49] It cannot be claimed that this painting was the source of Hunt's work, but it is characteristic of a "city type" reproduced in albums of engravings such as Edmé Bouchardon's *Cris de Paris*, published in the mid-eighteenth

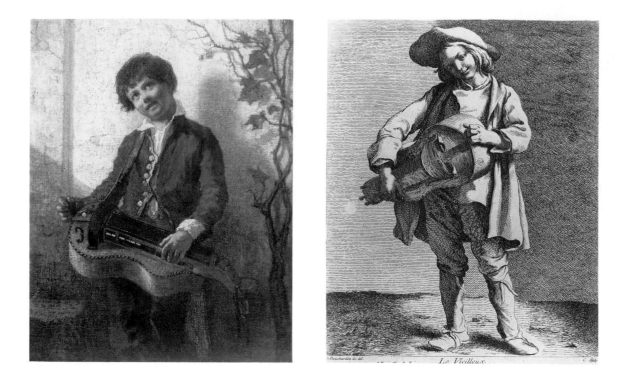

century. These albums, common in the ateliers of French artists, were particularly popular after 1850 and may thus have been known to Hunt.[50]

An engraving entitled *Le Vieilleux* ("Hurdy-Gurdy Player") (fig. 12), included in one of Bouchardon's volumes, seems to be the direct source for Hunt's painting. In both works, the single figure of a young boy is placed in a shallow space in front of a blank wall. The smiling expression and tilt of the head are startlingly similar. Both figures hold the hurdy-gurdy, or barrel organ, in their arms, each with a hand on the crank. While the light in Hunt's painting is more realistically observed, and the ivy growing on the wall enlivens the background, the happy mood and innocent pose of the Bouchardon engraving is retained.

Hunt's painting can also be linked to two very similar works by the American artists Richard Caton Woodville (*Boy with Hurdy-Gurdy*) and Eastman Johnson (*The Savoyard Boy*). Like Hunt, both had studied in Düsseldorf and were friends of Leutze's. Woodville, who followed Hunt to Paris, began his study with Couture in 1851; the next year he painted his *Boy with Hurdy-Gurdy* (fig. 13) in a fashion very similar to Hunt's version of the year before. Woodville's boy – with his direct, almost insolent gaze and languorous pose – is more realistic and less sentimental than Hunt's. Johnson's painting *The Savoyard Boy* (fig. 14) is also of a youngster, this time without the hurdy-gurdy, who, in well-worn clothes, stands in a shallow space in front of a blank wall. Johnson's is a more highly finished and detailed work than either Hunt's or

FIGURE 11. *The Hurdy-Gurdy Boy*, 1851. Oil on canvas, 42½″ × 32¾″. Courtesy, Museum of Fine Arts, Boston. (Bequest of Edmund Dwight)

FIGURE 12. Edmé Bouchardon, *Le Vieilleux*, from *Etudes prises dans le bas peuple; ou, les cris de Paris*, quatreme suite, pl. 8 (1742). Print Collection, Miriam & Ira D. Wallach Division of Art, Prints and Photographs, New York Public Library, Astor, Lenox and Tilden Foundations.

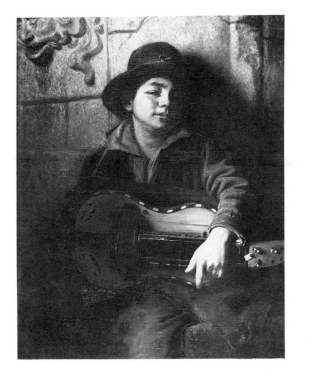 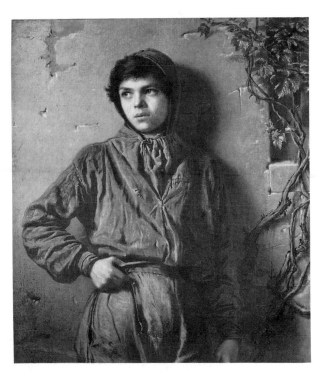

FIGURE 13. Richard Caton Woodville. *Boy with Hurdy-Gurdy*, 1852. Oil on canvas, 36″ × 27¾″. Walters Art Gallery, Baltimore, Maryland.

FIGURE 14. Eastman Johnson. *The Savoyard Boy*, 1853. Oil on canvas, 37⅜″ × 32¼″. The Brooklyn Museum. (Bequest of Henry P. Martin)

Woodville's—reflecting his years of study at Düsseldorf and later at the academy in The Hague. In 1854, Johnson moved to Paris to study with Couture, which suggests he had visited that city earlier and had perhaps met Hunt and been inspired by his painting.

These artists' interest in urban genre subjects may have also been sparked by their awareness of an American market for such imagery. For reasons which are still not clear, at midcentury in America there was a shift in subject matter from group narratives illustrating an anecdote or moral to the lone figure or "city type," such as the hurdy-gurdy boy.[51] In part, an audience for genre painting was stimulated by the American Art-Union. Modeled after the art unions of Europe, it promoted the work of contemporary artists by buying works and distributing them through a lottery system. The paintings were also engraved, and purchasers of lottery tickets received an engraving as a premium. Leutze had made a name for himself through his participation in the American Art-Union, as had Woodville even before he went to Europe. It seems likely that Woodville would have furthered Hunt's knowledge of the American Art-Union's success, particularly in the area of genre painting. Unfortunately, the Union was put out of business by the New York State Supreme Court in 1852, so Hunt's involvement with it remains moot.[52]

Another painting by Hunt, *The Violet Girl* (fig. 15), while not technically a companion piece to the *The Hurdy-Gurdy Boy*, is very similar.[53] Both are almost identical in size; and the *The Violet Girl*, like the *The Hurdy-Gurdy Boy*, is also

21

SAINT PETER'S COLLEGE LIBRARY
JERSEY CITY, NEW JERSEY 07306

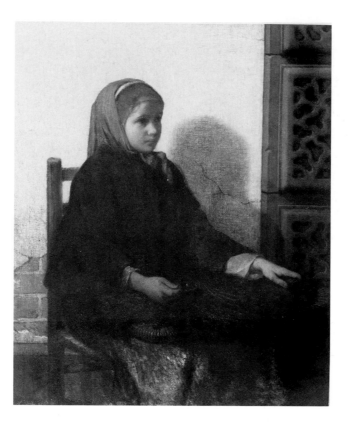

based on an illustration from the Bouchardon volume. Yet the mood is different. The illustration, *La Savoyarde* (fig. 16), is of a young girl wearing a head scarf, peasant style, sitting in a chair similar to the one in *The Violet Girl*. She, too, is placed in a shallow space in front of a cracked wall. However, she holds not a large, flat basket of flowers, but a cradle. A pathetic mood pervades both the engraving and Hunt's painting, a mood heightened by the cracks and exposed bricks in the masonry wall that in *The Violet Girl*, also symbolizes a life of poverty. It is Hunt's most realistic and sympathetic painting of the plight of these vagabond children, and reflects Hunt's heightened awareness of their real-life circumstances.[54]

Hunt's other genre paintings do not deal with contemporary urban subjects in the same direct manner, but they are fascinating demonstrations of how Hunt reinterpreted different currents in contemporary French painting. Three of them – *The Prodigal Son* (fig. 17), *The Fortune Teller* (see fig. 18), and *La Marguerite I* (see fig. 20) – still have the strong impress of Couture's method, chiaroscuro lighting particularly enhancing the melodrama of the first two works. In fact, Couture also did a version of *The Prodigal Son* (c. 1841, New Museum of Fine Arts, Le Havre) in which the prodigal, seated dejectedly in the foreground, is depicted as a social outcast. Hunt, however, chose another episode illustrating the moment of reconciliation between father and son at the end of the parable in Luke 15: 11–32: "And he arose, and came to his

FIGURE 15. *The Violet Girl* (La Bouquetière), 1856. Oil on canvas, 39⅝″ × 32¼″. Museum of Art, Rhode Island School of Design, Providence. (Gift of Mrs. S. Foster Damon)

22

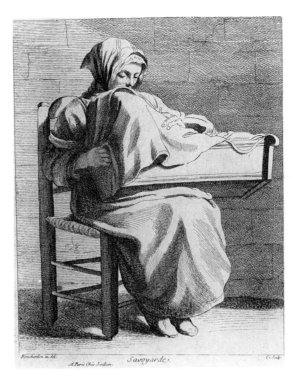

FIGURE 16. Edmé Bouchardon, *La Savoyarde*, from *Etudes prises dans le bas peuple; ou, les cris de Paris*, quatreme suite, pl. 12 (1742). Print Collection, Miriam & Ira D. Wallach Division of Art, Prints and Photographs, New York Public Library, Astor, Lenox and Tilden Foundations.

father. But when he was yet a great way off, his father saw him, and had compassion, and ran and fell on his neck, and kissed him." On the right-hand side of this large, arched-shaped composition the father, a bearded patriarch, gazes upward while supporting the son in his arms. The son, his head concealed, leans forward – his legs, back, and arms forming a strong diagonal from the left-hand corner to his father's shoulders. Strong lighting, which reinforces the diagonal of the body, also illuminates the father's face.

Like many other nineteenth-century themes the prodigal son had been interpreted by earlier masters – Jacques Callot, Guercino, and Bartolomé Murillo – who typically did a series of works incorporating various episodes from the parable. However, the best-known source for Hunt's painting was Rembrandt's late work *The Return of the Prodigal Son* in the Hermitage, Leningrad. Both artists focus on the intensely private moment of reconciliation between the elderly father and the repentant son. Hunt and Couture were great admirers of Rembrandt, regarding him as a supreme artist. Couture's palette and painting method in fact closely imitated Rembrandt's, which in the nineteenth century was a welcome antidote to neoclassicism.

Hunt's contemporaries, the French Théodore Chassériau and Charles Gleyre, and the American Robert Loftin Newman, also did versions of the prodigal son, a theme that may have had particular significance for nineteenth-century artists, who often saw themselves at odds with society. Even Couture, Chassériau, and Gleyre, all of whom painted in an accepted academic style, were outsiders, challenging in various ways the hegemony of the

FIGURE 17. *The Prodigal Son*, 1851. Oil on canvas, 60″ × 48″. Brooks Memorial Library, Brattleboro, Vermont.

French art establishment. In the United States, too, given the general mistrust of artists by the public, a similar defiant attitude was maintained. The prodigal son theme, in Hunt's case, in view of the loss of his father when he was eight years old, may also signify his unconscious longing to receive his father's acceptance and approval.

Of the several subjects Hunt explored in the early 1850s, none has as distinguished an art historical pedigree as the theme of the fortune-teller (*la bonne aventure*) (fig. 18). Among early treatments were several versions by Caravaggio, including one entitled *The Fortune Teller* (c. 1594, Louvre), which had been in France since 1665.[55] The Baroque versions of the theme by Caravaggio and the French painter Georges de la Tour focus on the relationship between the fortune-teller, or prostitute, and the cavalier as innocent who is distracted, by the woman's good looks and advice, from the theft of his purse. In the eighteenth century a young woman replaced the young cavalier, and her fortune was usually told by an old crone. The appearance of the crone (or a witch) – women whose predictions were feared – is the aspect of this theme that was further explored in the nineteenth century.

Couture himself did a variant of this called *The Love of Gold* (1844, Musée des Augustins, Toulouse). In this tableau a man dressed in a hooded robe sits behind a tapestry-covered table; his crossed hands stretched out like claws. He gazes aggressively at the petitioners who surround him. Two women with open bodices offer him their bodies, a man, nude to the waist, offers his signature – all in exchange for gold. Hunt, however, chose a different model for his interpretation of this ancient theme, basing his version instead on one of several paintings by Diaz de la Peña, who was associated with the Barbizon school. In the 1840s, Diaz painted and exhibited several works with the fortune-teller as subject – *Le maléfice* ("The Evil Spell") (Salon of 1844); *Bohémiens écoutant la prédiction d'une jeune fille* (Salon of 1845), and a second version of *Le maléfice* (1851) (fig. 19). This may be the painting now called *The Sorceress* in which two women – one young, one old – stand together in a moonlit landscape. A great admirer of Diaz, Hunt referred to him in his *Talks on Art* and in the 1860s helped introduce his paintings in the United States through exhibitions at the Allston Club. Hunt, in *The Fortune Teller*, one of his most dramatic paintings, creates a complicitous bond between the fortune-teller and a young mother, loosely following Diaz's version. Hunt, however, adds a third person – a child – who sits on the lap of the young mother. All three are grouped closely together and form a broad pyramid in the middle of the painting. The fortune-teller or witch is on the right with a long stick in her left hand. She bends forward, about to touch the young child's small open palm with a bony crooked finger. The child recoils. Yet the pose of the mother, as she leans in the direction of the old crone, suggests an alliance between the two. This connection is reinforced by illumination in the background that links the heads of the mother and the fortune-teller.

Hunt was not the only American to paint fortune-tellers. Newman, who also studied with Couture and Millet, did a series of paintings based on this theme, probably in the 1880s.[56] Because his expressive brushwork heightens the emotional content of his paintings, Newman is often linked to other late Romantic American painters such as George Fuller, Ralph Albert Blakelock, and Albert Pinkham Ryder. One Newman version of *The Fortune Teller* (Brooklyn Museum), in which a crone with a walking stick leans forward in conversation with a young woman and her baby, closely reproduces Hunt's scheme. Newman's figures, however, are very sketchily painted and merge with their surroundings, thus emphasizing the mysterious and evocative aspects of the scene rather than narrative detail.[57]

The reappearance of the fortune-telling theme at midcentury in Europe reflected a certain universal fatalism that, with revolutionary political changes, caused many to feel their lives were subject to forces outside their control. In addition, new scientific investigations, such as Charles Darwin's theories of evolution, challenged traditional Christian beliefs in God and salvation. In the United States, the view of the national destiny was clouded by the divisiveness and irrationality of the Civil War. Pessimism, introspection, and a

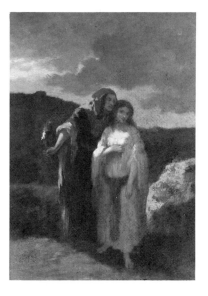

FIGURE 18. *The Fortune Teller*, 1852. Oil on canvas, 54¾" × 51". Courtesy, Museum of Fine Arts, Boston. (Bequest of Elizabeth Howes)

FIGURE 19. Narcisse Virgile Diaz de la Peña. *The Sorceress*, c. 1851. Oil on canvas, 12⅞" × 9¼". Montreal Museum of Fine Arts. (Bequest of Mrs. William Forrest Angus) *"This photograph is being used with the permission of the owners. The painting has been stolen and is presently being sought by the police."*

moral paralysis replaced an earlier confidence in the viability of the country as a participatory democracy. Hunt later explored the theme of fatalism in his mural *The Discoverer,* in which a personification of fortune directs the rudder of Columbus's small barque. In this context it is fortune, along with faith, hope, and science (the other allegorical figures who accompany Columbus), who control the discoverer's journey and, by extension, the fate of the New World.

Two other paintings by Hunt – *La Marguerite I* and *Girl at the Fountain* (1852, Metropolitan Museum of Art), both of which date from the early 1850s – are the same general figure type, yet reflect other literary and artistic currents. In fact, a painting entitled *Marguerite at the Fountain* (1859, Wallace Collection, London) by the French academician Ary Scheffer, based on an episode from Goethe's *Faust,* combines both themes. Hunt's *La Marguerite I* does not refer overtly to the Marguerite of the Faust legend (a popular subject in the Salon of 1850–1), but more specifically to the flower – a marguerite or daisy – whose petals are pulled by a young girl dreaming of love. This common wild flower humanizes the saintly aspect of Marguerite, and the legend of Marguerite elevates an everyday image of a young girl lost in reverie. What is unexpected about this relatively simple painting is that Hunt was prompted to create a second version after he had met Millet and moved to Barbizon. Although almost identical to the first, the second was done deliberately to represent his shift from the atelier training of Couture, to the broader humanitarian values stressed by Millet.

MILLET AND BARBIZON

Hunt's first introduction to Millet's work was *The Sower* (1850, Museum of Fine Arts, Boston), which he saw at the Salon of 1850. Two years later, in the company of his companion William Babcock, the first American artist to befriend Millet, Hunt visited Barbizon and purchased this painting.[58] At this time, Millet's international reputation was not yet established. In fact, he had only sold a few works and was desperately poor. Hunt, who became one of his earliest champions and collectors, recalled his shock at finding Millet, whom he came to regard as "the greatest man in Europe," living in such impoverished circumstances. "I found him working in a cellar, three feet under ground, his pictures mildewing with the dampness, as there was no floor. That stuck in my crop, I tell you!"[59] In addition to *The Sower,* Hunt purchased (and encouraged other influential Bostonians to do the same) a number of important paintings from this critical early phase of Millet's Barbizon career.[60]

Historically, there are several Millets. One is the Millet of *The Angelus* and *The Gleaners* – a sentimental picturemaker best known to an older generation of Americans. Then there is the Millet who for many decades was dismissed by art critics for the very reasons he was beloved by the public.[61] Today, he

is rightfully regarded, along with Daumier and Courbet, as one of the leading Realist painters of the mid-nineteenth century. *The Sower*, which brought Millet his first serious critical attention, has been reevaluated and is now acknowledged as a seminal Realist work with political significance comparable to Courbet's *Burial at Ornans* and *The Stone Breakers*, which were also shown at the Salon of 1850–1.[62]

Over the past fifteen years important research has been done on Hunt's relationship with Millet and his role in bringing the Barbizon tradition to the United States. In a 1975 exhibition entitled *American Art in the Barbizon Mood*, Peter Bermingham was the first to survey the impact of the Barbizon school on American painting. The artist's influence was further explored by Laura Meixner in her dissertation "Jean-François Millet: His American Students and Influence," and later in her essay for the exhibition catalogue *An International Episode: Millet, Monet and Their North American Counterparts*. Meixner, in particular, established the far-ranging impact of Millet's noble rendering of the French peasant on American art and culture in the late nineteenth century.[63] For many Americans, Millet's paintings, with their direct, uncluttered representations of rural labor, embodied sentiments – religious piety, hard work, virtuous enterprise, endurance, and a respect for the land – thought to be instrumental to our success as a nation.

What is missing from these earlier discussions is a systematic review of the paintings Hunt did in Barbizon (a difficult task given the lack of a working chronology), as opposed to those done in Paris, and the thematic relationship of these paintings to the ones Millet was developing at the same time.

During the two years Hunt was in Barbizon he worked on five themes, some of which he continued to enlarge upon after his return to the United States: young women in interiors; peasants tending animals at the edge of a forest; young women knitting and tending cows; gleaners; and young peasant women with a baby lamb or "belated" kid. These are also themes that Millet worked on throughout the 1850s, often completing finished versions for the Salon after Hunt had left France. In this light it is astonishing to realize what intimate access Hunt had to Millet's ideas and how free he was to adopt them even as the older artist was in the process of working them out for himself. Theirs was not the typical student–master relationship, but one in which a less experienced artist worked alongside a highly creative and generous colleague.

Discussions of the relationship between Hunt and Millet have usually begun with an analysis of the two paintings mentioned above: *La Marguerite I* (fig. 20), done in Paris and *La Marguerite II* (fig. 21), painted in Barbizon.[64] However, between the two, Hunt painted a small panel painting, *Sheep Shearing at Barbizon* (fig. 22), that was a direct copy – in size, support, and subject – of Millet's *Three Men Shearing Sheep in a Barn* (fig. 23), which Hunt bought from the artist. In its geometric simplicity and surface crudeness *Sheep Shearing at Barbizon* is a far cry from the presence and finish Hunt had achieved in *The*

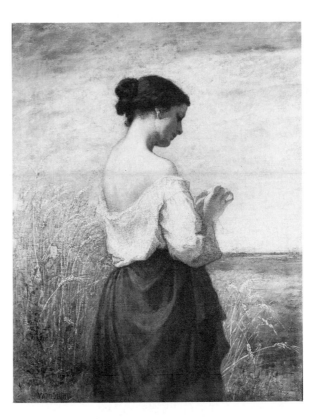

FIGURE 20. *La Marguerite I*, 1851. Oil on canvas, 46″ × 35″. Louvre, Paris.

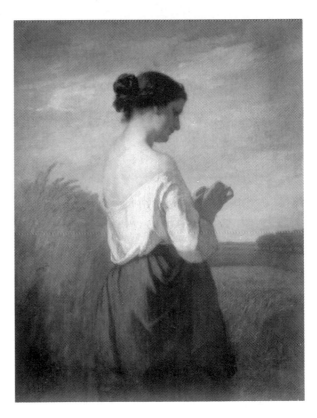

FIGURE 21. *La Marguerite II*, 1853. Oil on canvas, 46″ × 35½″. Courtesy, Museum of Fine Arts, Boston. (Bequest of Mrs. Martin Brimmer)

29

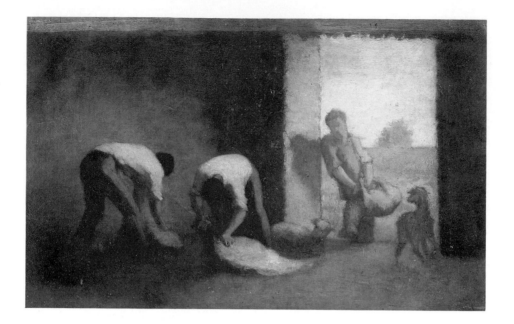

FIGURE 22. *Sheep Shearing at Barbizon*, c. 1852. Oil on panel, 10″ × 15½″. Courtesy, Museum of Fine Arts, Boston. (Bequest of Mrs. Edward Wheelwright)

Hurdy-Gurdy Boy and *The Fortune Teller.* In this exercise, Hunt became the student once more as he abandoned studio conventions and adopted Millet's direct engagement with the subject.

Hunt's later version of *La Marguerite* is essentially the same composition as *La Marguerite I* – a beautiful young woman, with dark hair caught up in a bun, stands in right profile in a wheatfield with her back partly turned to the viewer. She wears a dark skirt and a white blouse that falls off her shoulders exposing her back in a manner reminiscent of Hunt's oval bust-portraits *The Jewess* and *Woman in Profile;* both versions of *La Marguerite* are the city sisters of Millet's peasant women. The difference between the two is that in the earlier version, the landscape setting is a studio invention. The integration of figure and landscape, in emulation of Couture's method, takes place on the surface and is achieved through attention to decorative detail. In the later version, done after Hunt moved to Barbizon, he more effectively unites figure and landscape through closer observation of light and atmosphere. As Hunt recalled in his *Talks on Art,* Millet took him outside and taught him how to look at nature.[65]

Both *La Marguerite II* and *Sheep Shearing* are important because they contain ideas and motives that Hunt reworked and transformed through Millet's example over the next ten years in France and later in the United States. From *La Marguerite II,* Hunt went on to explore the introspective pose and image of a young woman in a rural landscape; and from *Sheep Shearing at Barbizon* he developed other contemporary rural images that broke with the literary and urban genre paintings of his Paris years.

An early example of Hunt's work following *La Marguerite II* is the dark, quiet painting *Girl Reading* (fig. 24), one of the few works from this Barbizon period that Hunt both signed and dated. A young woman in a studious

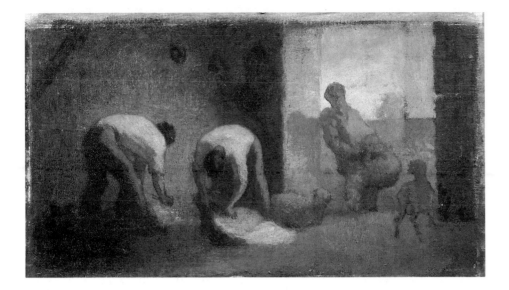

FIGURE 23. Jean François
Millet. *Three Men Shearing
Sheep in a Barn* c. 1852. Oil
on canvas mounted on
panel, 9⅝″ × 15½″. Photo:
Courtesy, Museum of Fine
Arts, Boston. (Lent by Mrs.
Enid Hunt Slater)

posture, similar in mood to *La Marguerite II*, sits in a dark interior reading a book. In a painting by Millet, *Women Sewing by Lamplight* (fig. 25), which may have inspired Hunt, two women with hair tucked modestly underneath tight scarves, sit diagonally across from each other intently sewing by lamplight. Illumination from an oil lamp on a wall bracket highlights the women's task and creates a circle of light enclosing both their figures. This painting was done as a companion to *Seated Spinner* (1854, Museum of Fine Arts, Boston), in which a young peasant girl in a winged cap, also in a darkened interior, is seated in profile in front of a low spinning wheel. Hunt also did a version of this theme, *Girl Spinning* (fig. 26) – which served as a companion to his *Girl Reading*. However, neither of Hunt's models are peasants but seem to be young middle-class women found more commonly in an American parlor than a Barbizon farmhouse.

As far as is known, these are the only paintings of interiors by Hunt from his years with Millet. More typical are his paintings of outdoor rural subjects, in which *La Marguerite* is transformed from a studio model plucking daisy petals into a young peasant woman engrossed in her knitting as she tends her cow. This transformation begins with three paintings – *French Peasant Woman with Pig* (fig. 27); *Gathering Shadows* (fig. 28); and *On the Edge of the Forest* (fig. 29). The first two, in the same vertical format, may have been planned as a pair. In both, peasant women, dwarfed by trees, graze their animals in a no-man's land between the ancient forest of Fontainebleau and the farmlands on the Plain of Chailly.[66] *On the Edge of the Forest* also depicts a girl with a cow, but Hunt has minimized the presence of the Fontainebleau forest as he focuses on the young girl's absorption in her task and the natural integration of her figure with its surroundings. She seems to move slowly forward, absorbed in her knitting, seemingly oblivious to the cow loosely tethered to her right arm.

The subject of a girl knitting while tending her cow was one that Millet

31

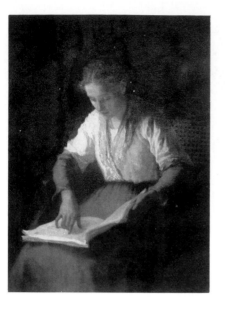

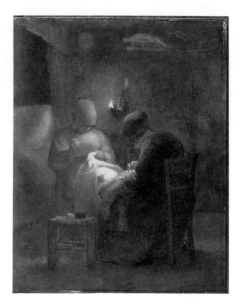

FIGURE 24. *Girl Reading*, 1853. Oil on canvas, 21½" × 16". Museum of Fine Arts, Boston. (Gift of Mrs. Charles W. Dabney)

FIGURE 25. Jean François Millet. *Women Sewing by Lamplight (La Veillée)*, 1853–4. Oil on panel, 13¾" × 10½". Courtesy, Museum of Fine Arts, Boston. (Gift of Quincy Adams Shaw through Quincy A. Shaw, Jr., and Mrs. Marian Shaw Haughton)

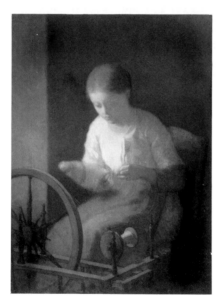

FIGURE 26. *Girl Spinning*, c. 1853. Oil on canvas, 21¼" × 16". Photo: Courtesy, Museum of Fine Arts, Boston. (Lent by William Morris Hunt II)

began work on in 1852; his final Salon version, *Woman Grazing Her Cow* (1858, Musée de l'Ain, Bourg-en-Bresse), was completed three years after Hunt had left France.[67] Millet also did countless variations on this particular theme that, according to Alexandra Murphy in her Millet catalogue for the Museum of Fine Arts, Boston, was in reality an image of "the landless peasant forced to accompany her cow as it grazed, to prevent it from straying into the fields or pastures of another." Murphy made other important observations on Millet's

paintings noting the contemporary political context of his themes: "[These] young girls from struggling families, for whom the cow represented their only stake in the farming community, spent endless, mindless hours, lashed to the large, wandering bovines, prodding or pushing them to keep them along the free highways or uncultivated wastes and out of the furrows of more prosperous neighbors."[68]

This subject was developed further by Hunt in an oil sketch entitled *Woman Knitting and Cow, Fontainebleau* (1860, Vose Galleries, Boston), which was a study for a large work, *Girl with Cows* (fig. 30). Both are dated 1860, but like several other works done by Hunt, they were probably begun in Barbizon and finished later in the United States. In both, the landscape settings are intimate, while the images of the young peasant girls are enlarged. In the final version of *Girl with Cows*, a second cow is added and the young girl is placed companionably between them. All three figures are bound together and seem to move slowly forward in a timeless ritual. This element of ritual gives strength to Millet's peasant themes and is what critics found lacking in Hunt's renderings. However, in this work he comes closest to Millet's humane naturalism. Hunt's peasant girl concentrates intensely on her knitting, her hands held together above a pouch that contains her yarn. Over both arms are looped ropes attached to each cow. So close are the ropes to her knitting, they look about to be incorporated into it. The ropes and the cows thus literally become part of the fabric of the girl's life.

Hunt undertook two other subjects involving a young peasant girl – *The Little Gleaner* and *The Belated Kid* – which are closely related compositionally. Signed and dated 1854, *The Little Gleaner* (fig. 31) is a young, innocent-looking child, staring soulfully at the viewer as she carries a bundle of grain down a gentle incline. Sketches by Millet of this subject as early as 1850–1 were later reworked for a painting called *Gleaners*, or *Summer* (1852–3, private collection, New York), done for a cycle of the four seasons.[69] His most famous version of this subject – a painting entitled simply *The Gleaners* – was completed in 1857 and shown at the Salon of the same year. In the Hunt version, none of the backbreaking labor immortalized in Millet's 1857 painting is evident; instead, Hunt's gleaner epitomizes the most saccharine aspects of his peasant genre painting, with no hint of the controversy that then surrounded gleaners' rights to gather wheat and hay after the harvest:

> The practice of gleaning dated back to the origins of the country, but the controversy concerning the gleaners had recurred with growing frequency since the eighteenth century. On the one hand, landowners objected to gleaning as an infringement of their own personal property, feeling that the practice encouraged the poor to steal as much as they could under the protection and pretext of fulfilling "inalienable rights." On the

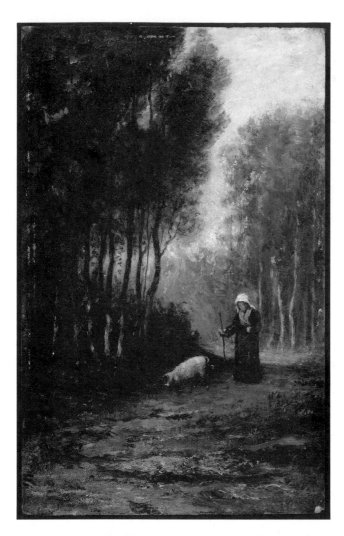

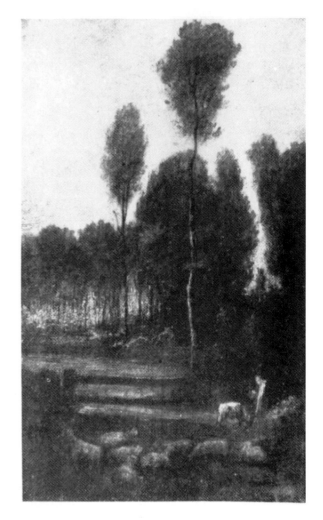

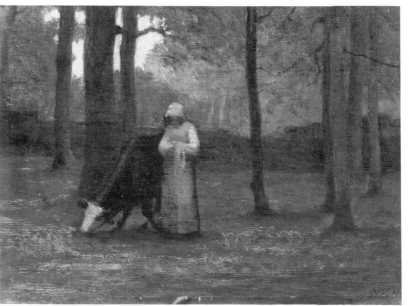

FIGURE 27. *French Peasant Woman with Pig*, c. 1853. Oil on panel, 17¼″ × 11″. Courtesy, Museum of Fine Arts, Boston. (Gift from the Isaac Fenno Collection)

FIGURE 28. *Gathering Shadows*, c. 1853. Oil on canvas, 17½″ × 11″. Location unknown.

FIGURE 29. *On the Edge of the Forest*, c. 1853. Oil on panel, 7½″ × 11″. Courtesy, Museum of Fine Arts, Boston. (Bequest of Mrs. Edward Wheelwright)

FIGURE 30. *Girl with Cows*,
1860. Oil on canvas, 3 15/8″
× 25½″. The Los Angeles
County Museum of Art.
(Purchased with Funds Pro-
vided by Joseph T. Hendel-
son and Mrs. and Mrs. Allan
C. Balch Fund.)

other side, traditionalists recognized the benefits of gleaning,
feeling that outlawing the custom would undermine the op-
pressed and deny a "basic patrimony of the poor."[70]

Hunt may have also been influenced by two other contemporary artists who
were, like Millet, later beloved by American audiences: Pierre Edouard Frère,
painter of intimate childhood scenes, and Jules Breton, painter of more ro-
manticized, monumental versions of peasant subjects such as *The Gleaners*
(1854, National Gallery of Ireland, Dublin) and *Blessing of the Wheat in the
Artois* (Salon of 1857, Musée d'Orsay, Paris).[71] An intriguing connection be-
tween Hunt and Breton is found in a second version of the gleaner subject
made by Hunt in 1865. Called *The Gleaner* (fig. 32), it is a close-up bust portrait
of a young peasant woman, painted in three-quarter view, balancing a large
bundle of wheat on her head. Her expression is somber and introspective,
like the expression of his young peasant women of the 1850s; yet the source
for this figure seems much closer to the central figure of one of Breton's most
famous paintings, *The Recall of the Gleaners* (figs. 33a, 33b), than to Millet.

35

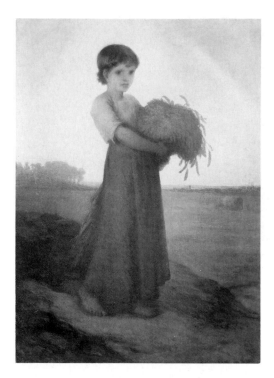

The last of the rural subjects Hunt painted in France is that of the belated kid, of which there are three versions. Hunt did the earliest one, now in the Museum of Fine Arts, Boston (fig. 34), between 1854 and 1857, finishing it in Newport.[72] Millet also painted this subject, but, with the exception of a highly romanticized version called *Newborn* (1846, location unknown) in his early *manière fleurie* style, all were completed after Hunt left France.[73] In all three versions of *The Belated Kid,* Hunt has reworked the format he developed for *The Little Gleaner.* A young peasant girl, accompanied by a goat, walks slowly down a gentle incline holding a newborn kid. The girl, lost in thought, is oblivious to her task and her surroundings.

This was the last of the Barbizon subjects Hunt explored before returning to the United States in 1855. Before leaving France he exhibited three paintings at the Universal Exposition in Paris: *Girl at the Fountain; A Study Head* (unknown version); and *The Violet Girl.* It is not clear why he chose these works done earlier in Paris, instead of the works painted during the time he was with Millet. One cannot even speculate that he considered these works to be more finished, since he continued to work on *Girl at the Fountain* and *The Violet Girl* after his return. There is no question that he continued to be indebted to Millet throughout his life. Yet Millet's influence on Hunt's paintings done later in the United States, with the exception of subjects begun in France, was limited to a very few works. It could be that Hunt was temperamentally uneasy with these peasant subjects – as some commentators have noted, a peasant

FIGURE 31. *The Little Gleaner,* 1854. Oil on canvas, 54″ × 38″. The Toledo Museum of Art, Toledo, Ohio. (Gift of Arthur J. Secor)

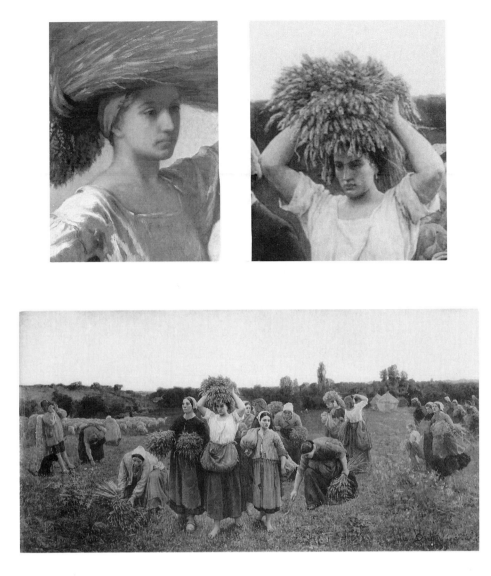

FIGURE 32. *The Gleaner*, 1865. Oil on canvas, 21¼″ × 15¼″. Courtesy, Museum of Fine Arts, Boston. (Gift of George R. White)

FIGURE 33a. Jules Breton. *The Recall of the Gleaners* (detail).

FIGURE 33b. Jules Breton. *The Recall of the Gleaners*, 1859. Oil on canvas, 35⅞″ × 69⅞″. Musée d'Orsay, Paris.

class did not exist in the United States. He did continue to emulate Millet's generosity to other artists, encouraged friends to purchase Millet's works, and, in his subsequent years in Newport, tried to establish an American Barbizon.

Hunt had first gone to Europe to study art and later decided to become an artist. These are two different enterprises, and after making his decision, he observed firsthand a number of models – Henry Kirke Brown, Leutze, Couture, and, finally, Millet. As is evident from many references in Hunt's *Talks on Art*, Millet was his most important and enduring exemplar. Hunt admired him as a painter and as a human being. It was not, however, the rural life-style or peasant subject matter that Hunt adopted, but Millet's independence, ideals, and convictions about art. It was this devotion to the

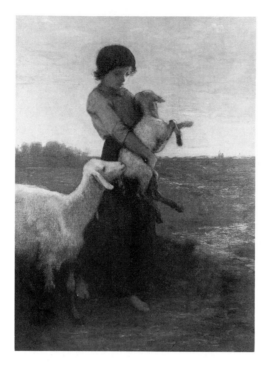

particular demands, sacrifices, and rigors of the artistic life that Hunt brought back to America and that is reflected in the pages of his *Talks on Art*. Through Millet, Hunt learned that artistic expression is more than subject matter and technique, it is also a commitment to the life of the mind.

FIGURE 34. *The Belated Kid*, c. 1854–7. Oil on canvas, 54″ × 38½″. Courtesy, Museum of Fine Arts, Boston. (Bequest of Elizabeth Howes).

2

Newport and Boston

THERE IS NO EVIDENCE that William intended to remain in Europe, and in 1855 he and the rest of the Hunt family came home. He had plans to marry, and he and Richard had decided to open a joint atelier, based on the French system, where William would give instruction in painting and Richard would teach the fundamentals of architecture he had learned at the Ecole des Beaux-Arts.[1] Such a course of study, which offered training in both painting and architecture, would have been unique in the United States. Unfortunately, this venture never materialized, yet each became an influential teacher on his own – William, in Newport and Boston; Richard, in New York.

From the start Hunt was active professionally. He exhibited regularly in Boston and New York, published a series of lithographs of his French-inspired paintings, and established an informal atelier in Newport, Rhode Island. In the 1860s he moved to Boston permanently, and reawakened that city's moribund artistic community. Under his leadership Boston again became a lively and important center for the visual arts, for he influenced equally fellow artists and collectors. Yet, despite his considerable success in New England, Hunt was not without his detractors, for he had received most of his training in Europe and had had little contact with current developments in American art. In New York his painterly technique and French genre subjects caused immediate controversy.

In the fall of 1855, Hunt married Louisa Dumaresq Perkins (1831–97) of the wealthy and socially prominent Perkins family. Louisa's grandfather Thomas Handasyd Perkins was one of Boston's most celebrated citizens and patrons of the arts. Since the early 1800s, he had been a leader of Boston's art community as a collector and as a member of the Boston Athenaeum. His donation of eight thousand dollars in 1827 made possible the creation of the Athenaeum's Art Gallery, which remained the most important exhibition facility in Boston until the opening of the Museum of Fine Arts in 1876.[2] Perkins had also been a close friend and patron of Washington Allston's and, in 1826,

was one of twelve subscribers who supported the completion of Allston's *Belshazzar's Feast*. Perkins had met Allston aboard the *Galen*, when they were returning from Europe in 1818. Allston, like Hunt, had come back to America to transplant the seeds of European art and culture.[3]

William and Louisa had met in Europe in 1852 when she was traveling abroad.[4] At midcentury the Perkinses were a large, well-to-do Boston family, whose cosmopolitan members traveled frequently. Richard Hunt and Louisa's brother, Gus Perkins, traveled in England together in 1855, and the future art historian and educator Charles Callahan Perkins, who was Louisa's cousin, had been in Rome at the same time as William.[5] What contact Hunt and Charles Perkins may have had is not documented. Yet Perkins lived in Boston most of his life and shared Hunt's interest in art education, serving with him in the late 1870s on the Museum Art School committee. He also wrote some of the earliest books on art history in America: *Tuscan Sculptors* (1864); *Italian Sculptors* (1868); *Raphael and Michaelangelo* (1878); *Historical Handbook of Italian Sculpture* (1883); and *Ghiberti et son Ecole* (1886).[6]

Because Hunt was not native to Boston, it is often noted that he benefited from his wife's social position and contacts. To trace the genealogy of the Perkins family at midcentury is to trace the history of Boston society – for several generations they were related through marriage to the Forbeses, the Abbotts, the Cabots, the Elliotts, and the Carys. Of these, only the Forbeses actively supported Hunt's career, yet over the years individual members of the various Boston families came to Hunt for portraits and bought his paintings. Like the elder Perkins, John Murray Forbes, a cousin of Louisa's, was one of Boston's merchant princes. He hired Hunt shortly after his return to Boston to paint his two daughters, Mary and Sarah, and later asked Hunt to paint a Civil War portrait of his son Colonel William Hathaway Forbes. In the mid-1870s Hunt stayed on two occasions at the Forbes home in Florida, and when John Murray Forbes retired as president of the Chicago, Burlington, Quincy Railroad, he was presented with one of Hunt's large-scale Niagaras.[7]

As a tribute to his success in Europe and the approval of his work exhibited at the Boston Athenaeum, Hunt was accepted shortly after his arrival for membership in the new Boston Art Club, one of several organizations formed during the second quarter of the nineteenth century to promote work by local artists.[8] Boston was ready to welcome a new artist; the Boston Athenaeum, the city's most important institution for the promotion of fine arts following its move into new quarters on Beacon Street, sponsored several important exhibitions of European and American painting. These included an 1852 exhibition of works by Düsseldorf artists; in 1854, an exhibition of Thomas Cole's five-part work *The Course of Empire* (1836, New-York Historical Society), which remained on view for two years; and in 1855, Frederic Church's *Andes of the Ecuador* (1855, Reynolda House, Museum of American Art, Winston-Salem, N.C.). Also in 1855, the Athenaeum joined with the Boston Art Club

FIGURE 35. *Girl with Cat*,
1856. Oil on canvas, 42″ ×
33½″. Courtesy, Museum of
Fine Arts, Boston. (Bequest
of Edmund Dwight)

to sponsor a major exhibition of work by Boston painters as well as by leading members of the Hudson River school (Joseph Ames, Benjamin Champney, Church, Samuel Colman, Jasper Cropsey, Asher B. Durand, Walter Allen Gay, Sanford R. Gifford, Thomas Hicks, John F. Kensett, Fitz Hugh Lane, Aaron Draper Shattuck, and Jerome Thompson). Given this new activity and interest in contemporary art, Boston appeared ready to support artists who could restore its former prestige. Even so, it would be seven years before Hunt settled in Boston permanently. Not ready to make the city his home, shortly after his marriage he moved with his wife to Brattleboro, where he set up a studio in the town hall and resumed work on several paintings he had brought back from France – including *Girl at the Fountain* (c. 1852, Metropolitan Museum of Art, N.Y.) and *The Violet Girl*.[9]

Yet these were not the works he chose to exhibit the following spring (1856) at the National Academy of Design in New York. Instead he sent a more representative sample: *The Fortune Teller* done while studying with Couture and exhibited at the annual salon in Paris in 1852; *La Marguerite II*, painted in 1853 while with Millet in Barbizon; and *Girl with Rabbit*, a new painting done after his return to the United States. Unfortunately, *Girl with Rabbit*, which was owned by Martin Brimmer (who also bought *La Marguerite II*), is known only from a photograph. It is related, however, in terms of the model's pose and costume, to another work done at the same time, *Girl with Cat* (fig. 35) a work commissioned by Edmund Dwight as a companion work to Hunt's *The Hurdy-Gurdy Boy* (see fig. 11), which he had bought earlier in Paris.[10] Although identical in size to *The Hurdy-Gurdy Boy*, the quiet and somber

mood of *Girl with Cat* is much different from the jaunty air and anecdotal quality of the former. Sisters to two works done in Barbizon, *Girl Reading* and *Girl Spinning*, both *Girl with Rabbit* and *Girl with Cat* reflect Hunt's interest in grafting the direct realism of Millet onto an American subject.

These works, however, were greeted with scorn and incomprehension by New York critics, who at the time favored the more finely detailed and anecdotal style of Lily Martin Spencer's *The Young Husband* (1854, private collection, New York) or the reassuring familiarity of such Hudson River paintings as Asher B. Durand's *In the Woods* (1855, Metropolitan Museum of Art) or John F. Kensett's *Bish-Bash Falls* (1855, National Academy of Design, New York). For instance, *The Fortune Teller* was ridiculed by a writer for the *New York Tribune* as having "the look and complexion of dried mushrooms with a vehicle of soapsuds." Yet he went on to praise Hunt's drawing and expression noting that the child "who is admirably posed...expresses the disgust and terror it feels at the haggard look of the old crone." And he concluded by stating that "it is, in short, a very good picture, without any particular meaning – well done in a very bad style."[11] This paradoxical statement summarized the difficulties American critics had in comprehending Hunt's work. What informed this writer's discussion of Hunt's work was John Ruskin's moralizing, quasi-religious, newly published critique of modern painting. In his several volumes of *Modern Painters* written between 1843 and 1856, Ruskin advanced his conviction that it was the artist's first obligation to be truthful, that is, to record faithfully the factual appearance of nature. Those American artists who subscribed to Ruskin's admonitions created, in turn, extraordinarily detailed transcriptions of nature, rendering with great faithfulness each leaf, stone, and ripple of water. In the late 1850s, even before the full flowering of Ruskin's influence in America, Hunt's work, in the eyes of several New York writers and artists, failed to be true to nature and to God: "For ourselves, we have always felt that the artist was great and true in proportion to the extent of his development of the beauties which exist for him in the creation of God, and not to his contrivance of new qualities and impossible combinations."[12] These latter sentiments were expressed in the new art periodical *The Crayon*, founded in 1855 by William Stillman and John Durand (son of the Hudson River painter Asher B. Durand). Although short-lived, it was the first American periodical devoted to art criticism, and the movements and ideas it promoted remained influential throughout the 1860s. Understandably, because it supported the Hudson River school, work by the new English Pre-Raphaelite painters, and the teachings of John Ruskin, writers such as Stillman were unsympathetic to Hunt's work.

Simply put, Hunt's unelaborated paintings, in which forms were defined by color values and light, were unfavorably compared to the linearity and high finish of an older generation of American painters whose work was still largely inspired by the English school, be it portraiture or landscape painting. During the late 1850s, the New York critics dismissed Hunt's work as a "de-

parture from the truth" (i.e., nature), "idiosyncratic," and "destitute in meaning and sentiment." All these failings indicated that Hunt deviated from the loving and factual representation of God's creations.

NEWPORT: PRINTMAKING AND EARLY PORTRAITURE

Hunt's reaction to these reviews has not been recorded but during his first year back he was preoccupied with his new role as head of a family. In the fall of 1856 his first child, a son named Morris, was born and the family moved to Newport, Rhode Island, which had not yet become the summer outpost for New York society. Artists, however, had long been attracted to the region's distinctive topography – a craggy coastline, flat marshes, boulder-strewn fields, and uninterrupted views of the sea.[13] Hunt, too, would record this terrain, but it was more Newport's rural atmosphere, like that of the village of Barbizon in France, that attracted him. During the six years he spent in Newport he was highly productive, exploring the medium of lithography, beginning his successful foray into the field of portraiture, and opening, albeit briefly, an informal school for art students.

Once his family was settled, Hunt, undaunted by the negative reviews of the previous year, in the spring submitted to the National Academy of Design five paintings and a lithograph, none of which had been exhibited before in New York: *The Hurdy-Gurdy Boy, La Bouquetière (The Violet Girl*, painted and lithographed versions), *The Fountain (Girl at the Fountain), The Belated Kid*, and *Sheep Pastures (Twin Lambs)*. To underscore his commitment to French painting, this selection was more comprehensive than the previous year's and contained a good sampling of his Parisian training. It included work done under Couture and exhibited at the Salon, as well as his newer, Millet-inspired paintings – *The Belated Kid* and *Sheep Pastures*. In the latter, known today as *Twin Lambs* (fig. 36), two lambs are shown resting in a sloping depression of a rocky meadow characteristic of the Newport area. Lambs grazed freely along the Rhode Island coast, and their presence no doubt reminded Hunt of similar views in Barbizon.

This time the writers for the *Tribune* and *The Crayon* liked his paintings. They may have been different writers, since neither referred to Hunt's work from the previous year. Instead they were mildly approving: The *Tribune* reviewer found *La Bouquetière* "most impressive," while the writer for *The Crayon* was full of praise for *The Fountain:* "The subject derives its interest from the naturalness of the attitude, and a very agreeable tone of color and breadth of light, make us conscious of a feeling of harmony and repose."[14]

It is difficult to explain this new enthusiasm for Hunt's Paris-inspired paintings in the pages of *The Crayon*. It may be that the powerful hand of Richard was already at work on his brother's behalf in New York art circles. By 1857, Richard had established his studio at the University Building, which before the construction of his Tenth Street Studio Building, was the most

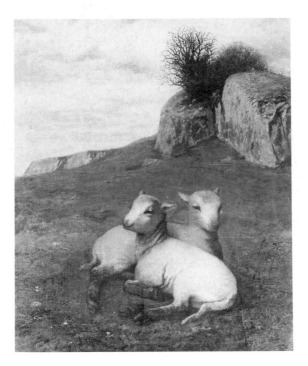

FIGURE 36. *Twin Lambs*, c. 1857. Oil on canvas, 38½" × 32". Courtesy, Museum of Fine Arts, Boston. (Gift by subscription)

important gathering place for artists in the city. Furthermore, Richard, in his capacity as secretary of the newly formed American Institute of Architects (AIA), was a correspondent to *The Crayon*. Yet it would take twenty years before Hunt's work would be fully accepted in New York.

Although unremarked in these reviews, the lithograph Hunt exhibited, *The Violet Girl* (one of a suite of six he published in 1857), introduced the superiority of lithography as a medium for the reproduction of paintings. This graphic medium, in which form is built from tone and texture rather than line, could more faithfully re-create the nuances of painterly expression than did the tight linearity of etching or engraving. In Paris, several of the artists Hunt most admired – Millet, Barye, and Delacroix – made lithographs of their paintings and sculpture in order to make their work available inexpensively.[15] Millet did his first lithographic series in the early 1850s, reproducing images on the stone himself. He introduced this process to Hunt, who in 1853 did a freely composed lithograph of his painting *La Marguerite* (Museum of Fine Arts, Boston).[16] Back in the United States, in order to appeal to a new audience, and following Millet's example, Hunt lithographed six of his French-style paintings: *Boy with Goose, Fortune Teller, Girl at the Fountain, The Hurdy-Gurdy Boy, The Violet Girl*, and *Stag in Moonlight*. These drawings, executed by Hunt himself, were then printed by S. S. Frizzel and published by Phillips and Samson.[17]

Four of the prints duplicated paintings of the same title almost precisely (and were, in fact, paintings he had publicly exhibited and that had received

44

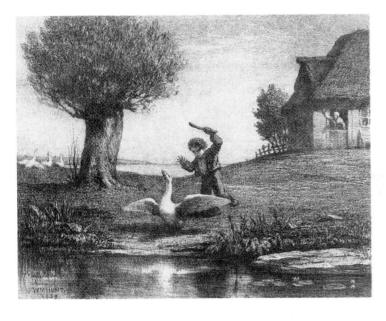

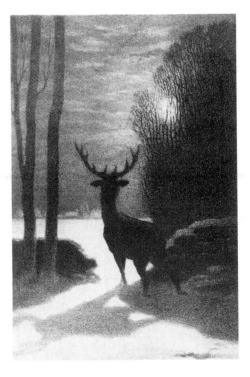

FIGURE 37. *Boy with Goose*, 1857. Lithograph. Boston Athenaeum.

FIGURE 38. *Stag in Moonlight*, 1857. Lithograph. Boston Athenaeum.

critical notice). The others were *Boy with Goose* (fig. 37) and *Stag in Moonlight* (fig. 38). The former was the reworking of a small panel painting entitled *Boy Chasing a Goose* (Vose Gallery, Boston) done in 1850, the latter, *Stag in Moonlight*, was a reproduction of a now lost painting called *Stag in Fontainebleau.* This painting was also one of a pair (the other, also lost, known as *Deer*) done by Hunt about 1850.[18] These two images are among the few animal paintings done by Hunt. Their source is not known, but they may have been inspired by his (and Richard's) friend the French sculptor Antoine Louis Barye – with whom, Knowlton claims, Hunt studied briefly.[19] The image of the stag, in particular, was a favorite of Barye's. But Hunt's image, although placed in a dramatic setting, contains none of the attention to the stag's majestic anatomy or exaggerated pose characteristic of Barye's interpretations. Another potential source is the British artist Sir Edwin Landseer, whose paintings of stags – such as *The Sanctuary* (1842, Her Majesty Queen Elizabeth II) and his most famous work, *Monarch of the Glen* (1851, John Dewar & Sons Ltd., London) – became known internationally through engravings, and according to one scholar, Richard Ormond, "in the late 1840s and 1850s it was the deer pictures above all that earned him his legendary reputation."[20] Perhaps the popularity of Landseer's animal prints prompted Hunt to include his own haunting image of the stag as part of his lithograph series.

Unfortunately, the sales of this series were few, yet Hunt's efforts did not go unnoticed by critics.[21] The series received a favorable notice in *The Crayon*,

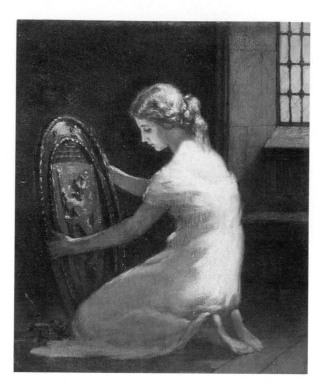

FIGURE 39. *Elaine with Her Shield*, 1860. Lihograph, 9½" × 8½". Alexander Slater. Photo: Courtesy of Vose Galleries, Boston.

and Henry Tuckerman writing in 1867 stated that the lithographs were "well known" and "widely circulated."[22] But it was enough to discourage Hunt who, with one exception, abandoned printmaking until 1863, when he was back in Boston during the Civil War.

The one exception is a lithograph, *Elaine with Her Shield* (fig. 39), which was designed not for sale as a single print but as an experiment in illustration. It was commissioned by the art dealers Doll & Richards, who in 1860 invited Hunt to create a series of works to accompany Alfred Lord Tennyson's *Idylls of the King*, which had been published in England the year before. Under pressure to complete the series quickly, Hunt rebelled, and *Elaine with Her Shield* was the only image he completed. Tennyson's narrative epics lent themselves to illustration; during the 1850s his poems often served as subjects for the British Pre-Raphaelites. His nostalgic poetry with its memorable verses was also very popular in Victorian America, and artist friends of Hunt's, La Farge and Vedder, contributed to one of the first artist-illustrated books published in the United States, Tennyson's *Enoch Arden* (1864).[23]

As an illustration, Hunt's representation of a kneeling, barefooted girl in an empty room furthers the poignancy of the reader's knowledge that Elaine's love is unrequited and that she will soon die tragically. Elaine, like Ophelia (another ill-fated heroine Hunt painted), was to become one the most often represented female fictional characters in late-nineteenth-century academic painting. These later artists, however, preferred to represent Elaine's death

46

by drowning rather than the more intimate and less dramatic moment chosen by Hunt.

Earlier, a more personal tragedy, the death of his infant son, Morris, in September 1857, had interrupted Hunt's first year in Newport. Because no letters or diaries of Hunt or his wife exist from this period, it is difficult to assess their response to this loss. They would go on to have four other children, but the gradual deterioration of their marriage may have dated from this tragic event.[24] At the time, in order to recover from their misfortune, Hunt and his wife traveled to Fayal, the Azores, where they spent six months (November 1857 to April 1858) as the guests of his Harvard classmate Charles W. Dabney, whose family had made its fortune as whale-oil merchants and had served for three generations as American consuls to the Azores.[25] Though little is known about that visit, the break in both his routine and his living arrangements allowed Hunt to explore more fully painting outdoors and formal portraiture. Of the five landscapes known to have been done in Fayal, two have been located – *Doorway with Rabbits, Fayal* (Kennedy Galleries, New York), and *Gate in Fayal (Azores)* (fig. 40).[26] Different from Hunt's Newport *Twin Lambs*, neither are true landscapes; rather, they are outdoor scenes in which Hunt used the architecture of this semitropical island community to focus and stabilize his compositions. However, the best-known work he executed in Fayal is the posthumous portrait of *Francisca Paim da Terra Brum da*

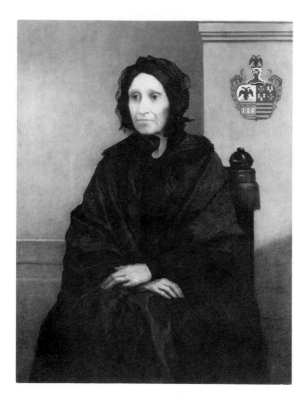

FIGURE 41. *Francisca Paim da Terra Brum da Silveira*, 1858. Oil on canvas, 40¾" × 30". The Toledo Museum of Art, Ohio. (Museum Purchase Fund)

Silveira (fig. 41), a member of a prominent Fayal family. This portrait (painted from a photograph), although large, is not impressive; the paint application is thin, the colors are dully gray-toned; and the subject represented as hollow-cheeked and ghostlike.[27] Perhaps her photograph was uninspiring.

Though disappointing, the painting of Señora Terra prompted Hunt to seek more portrait work after his return to the United States. In the winter of 1858, Hunt actively pursued and won a commission to paint the Chief Justice of the Massachusetts Supreme Judicial Court, Lemuel Shaw (fig. 42).

The Shaw portrait remains today one of Hunt's most impressive works. It also demonstrates the progress Hunt had made from the Terra portrait, and from the full-length portrait of his mother done nine years earlier while he was a student of Couture. In contrast with these works, the figure here is fully defined; the handling of color is sure, and serves as a strong complement to the linear definition of the subject's features; and the space, although shallow, is treated convincingly. Most striking is the silhouetting of the darkly clothed figure of Shaw against an almost bare light background.

The first sitting took place in a small cramped room Hunt rented in Boston's Mercantile Building, where the space was so limited that he had to kneel in order to paint "the lower half of the standing figure."[28] Other sittings followed, some in Boston and some in Newport; and, as Hunt would often do, he may have consulted an earlier photograph of Shaw by the famous Boston daguerreotypists Southworth & Hawes.[29] In all, Hunt spent nearly a

year completing the portrait (an unusually long time for him), which accounts for its assuredness and attests to his determination to, in Knowlton's words, use it as "an entering wedge to his profession in Boston."[30]

Historically, Boston had been the leading center for American portraiture, but when Hunt returned to New England, there were no artists with the stature of John Singleton Copley, Gilbert Stuart, or Allston.[31] Patronage was lacking, and by midcentury the daguerreotype had become an accepted medium of portraiture for the middle class. The leading practitioners – Joseph Ames and Chester Harding – were not innovators but instead carried on the earlier traditions. Hunt, although trained in Europe, was not unaware of these traditions and, in fact, for his portrait of Shaw imitated the standard statesmanlike pose of Harding's *Chief Justice John Marshall* (fig. 43), which in turn was derived from the Lansdowne version of Stuart's *George Washington* (1796, National Portrait Gallery, Washington, D.C.). Yet the honest realism of Hunt's presentation is different from Harding's genial, grand-manner portrait. The patterned carpet, baize-covered table, heavy red draperies, and monumental scale of the interior confer on Marshall an almost aristocratic status. In contrast, Shaw, with few formal trappings, his bulky upright figure strikingly set apart from the background, is the forthright image of New England justice.

When the Shaw portrait was exhibited at the galleries of Williams & Everett in 1859, Hunt's fellow artists derided it. Its bright color and bold new style was unlike anything they had seen before, and they may have felt threatened by the favorable reviews it received both in Boston and Salem (where the painting now hangs in the county courthouse).[32] It also immediately established Hunt's reputation as a portraitist and he soon received a number of important commissions, including invitations to paint *James Walker* (1860, University Hall, Harvard University), the retiring president of Harvard, and four memorable portraits of women, which rank among his finest work. Done between 1860 and 1861, these four portraits signal his maturity as an artist – *Mrs. Samuel Gray Ward* (fig. 44); *Mrs. Joseph Randolph Coolidge* (fig. 45); *Mrs. Robert C. Winthrop, Jr.* (fig. 46); and *Mrs. Robert Shaw Sturgis* (fig. 47).

In all of these portraits – Walker's as well as the portraits of women – Hunt paints with much more assurance than he had previously. Greater attention is paid to the rendering of details of clothing, facial features, and hands. He also effectively uses light to define form and harmonize compositions, and takes care to individualize expressions. In his portraits of women, in particular, shallow space, gently rendered contours of the face and hands, ambient lighting, and detailed rendering of fabric and lace suggest the influence of Couture's naturalistic portrait style. Also, the manner in which Hunt highlights the texture of lace and the sheen of fabric is reminiscent of the work of Ingres or Franz Xavier Winterhalter, portrait painter to the court of Napoleon III. Most important, these early portraits were much more technically refined than works by his contemporaries such as Ames, Harding, and even George P. A. Healy, who, after his return from Europe in 1855, lived in Chicago but

49

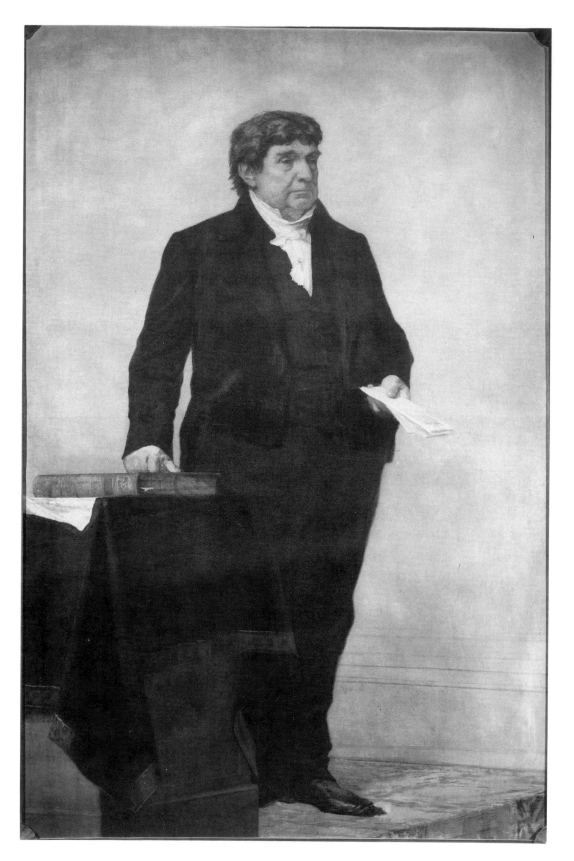

50

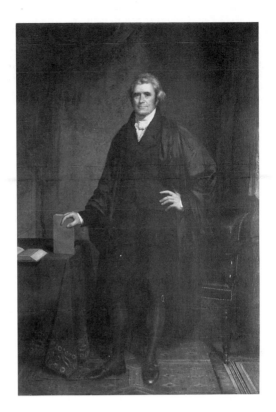

FIGURE 43. Chester Harding. *Chief Justice John Marshall*, 1830. Oil on canvas, 94″ × 58″. Boston Athenaeum.

occasionally accepted Boston commissions. Healy had also studied with Couture and at midcentury was Hunt's only true rival in Boston.

Unfortunately, almost no biographical information exists on the women who sat for their portraits, nor is it known how Hunt obtained these commissions. Presumably he met the women through his wife's social connections. Mrs. Ward (Anna Hazard Barker), originally from Rhode Island, lived in Boston, where her husband was head of the Boston branch of the British banking firm Baring Brothers. (In 1867 he helped finance the purchase of Alaska from Russia by the United States.) She had been a friend of Margaret Fuller's, and both she and her husband were close acquaintances of Emerson's.[33] Anna Ward was known as a great beauty, and Hunt's portrait is an appealing and flattering image of her at forty-eight. Standing behind a low fabric-covered table, Mrs. Ward holds a collapsed fan in her beautifully drawn hands. Directly behind her in the shallow space of the painting is a wall covered in richly embossed paper, whose rounded filigreed forms frame her beauty and echo the lacy pattern of her bow. A faintly bemused expression plays at her lips and eyes. Placed in a three-quarter pose, she does not look directly at the viewer but leans forward slightly as if to engage the attention of an unseen observer. Hers is the most elegant and engaging of these early portraits of women, and it is not surprising that Hunt selected this work to show in Paris at the 1867 Universal Exposition.

FIGURE 42. (*opposite*) *Judge Lemuel Shaw*, 1859. Oil on canvas, 78″ × 50″. Essex County Bar Association, Salem, Massachusetts. Photo by Mark Sexton.

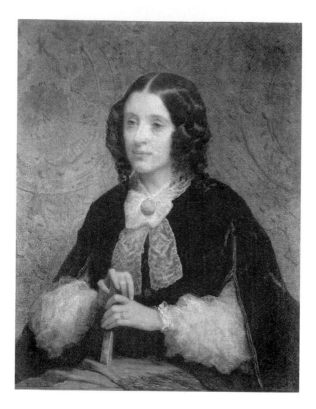

The portrait of Mrs. Coolidge, born Julia Gardner, was probably painted in December 1860 at the time of her marriage. Her husband was a lawyer and son of Joseph Coolidge, an associate of John Murray Forbes and Augustine Heard in the China-trading firm of Russell and Company. In this almost full-length portrait, Mrs. Coolidge, dressed in a beautiful sky-blue taffeta gown with lace insets at the low neckline and a small bouquet of roses tied at her breast, is the picture of New England refinement. Her brown hair is braided and drawn around her head. She wears very little jewelry – simple gold earrings and a three-strand pearl bracelet. Like Mrs. Ward, she stands in a shallow space. Behind her are faintly drawn light-brown wood panels, with a raised fleur-de-lis pattern visible in one corner. Much plainer than the backdrop for Mrs. Ward, this setting suits her modestly reserved expression.

Finery of dress also dominates the posthumous portrait, painted from a photograph, of Mrs. Winthrop (Frances Pickering Adams) who died of tuberculosis in 1860. She wears a lavender dress highlighted by contrasting wide bands of lace and black velvet. Hunt used a flicker of forest green in the skirt as a visual complement to the lavender. Green is also the color of the chair's upholstery and the background wallpaper, and serves as a tonal harmony for the painting. A small spray of white flowers on the table provides a highlight that is captured in the gold of an earring and the white texture of the lace.

FIGURE 44. *Mrs. Samuel Gray Ward* (Anna Hazard Barker), 1861. Oil on canvas, 31⅛″ × 25¼″. Mrs. Benjamin Warder Thoron. Photo: Courtesy, Museum of Fine Arts, Boston.

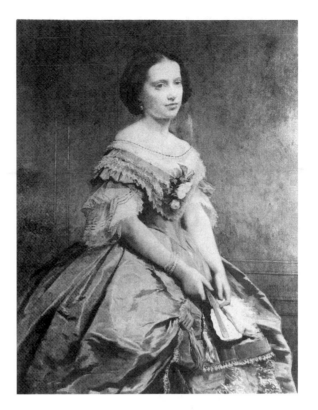

FIGURE 45. *Mrs. Joseph Randolph Coolidge* (Julia Gardner), 1861. Oil on canvas, 46½″ × 35⅜″. Location unknown.

Characteristic of many of Hunt's portraits done from photographs is the hazy definition of Mrs. Winthrop's face. Instead of copying the precision of features that a photograph would afford, Hunt's veils them, as if to remind us that the portrait was not painted from life.

The last portrait of this group was done in 1862 and its sobriety reflects the darkened mood of the early years of the Civil War. Mrs. Sturgis (Susan Brimmer Inches), pictured against a light, shallow background, is modestly dressed in sedate black taffeta. Only a three-tiered swirl of lace above her wrist betrays any concession to luxury. At the same time, the portrait is forthright and naturalistic, a more "modern" type of portraiture than the "aristocratic" or continental-style representations of the other three women. Hunt would later favor this naturalistic style, particularly in his portraits of men.

Given this new interest in portraiture, it is not surprising that when Hunt next exhibited at the National Academy of Design, in 1861, he sent two portraits instead of the genre paintings he had submitted four years earlier. Yet his portrait of *William Sydney Thayer* (fig. 48), and a painting known as *The Lost Profile* (fig. 49), were not as impressive as his other portraits. The Thayer piece, done at the same time as the four showpieces of female portraiture, is, in contrast, a modest-sized, rather plain bust-portrait, and the other, *The Lost Profile*, is unconventional.[34] In this work the model, sometimes

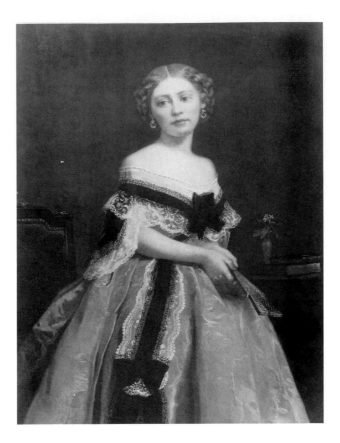

identified as Hunt's wife, is pictured from the back, and her profile is almost obscured or "lost."[35] Although this focus on the neck and back created an image at once mysterious and seductive, it is not a pose that would appeal to many sitters. Yet both portraits were prominently hung in the First Gallery, where they attracted the favorable attention of *The Crayon* and *New York Daily Tribune* reviewers. The Thayer was called "a fine likeness" and an "admirable piece of color." The *Tribune* reviewer wrote enthusiastically about *The Lost Profile:* "The artist has seized and transferred it at the exact moment of its finest pose." Most gratifying, from Hunt's point of view, in terms of the acceptance of his new French style, were the writer's closing remarks: "But even were the portrait less excellent, one could hardly fail to admire the boldness that has broken away from tradition and ventures to believe that there may be a portrait without the face."[36]

TEACHING AT NEWPORT

In addition to his forays into printmaking and portraiture, Hunt also began an art school in his spacious studio behind his Newport home, Hill Top, which became a place to paint, to teach, and to socialize.[37] There, between 1859 and

FIGURE 46. *Mrs. Robert C. Winthrop, Jr.* (Frances Pickering Adams), 1861. Oil on canvas, 47″ × 36¼″. Courtesy, Museum of Fine Arts, Boston. (Gift through Miss Clara Bowdoin Winthrop)

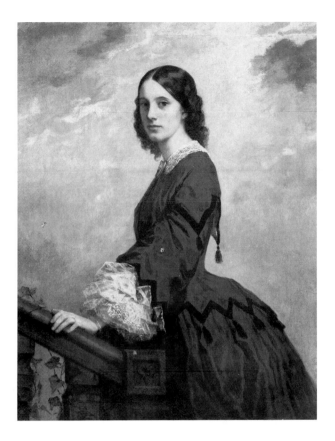

FIGURE 47. *Mrs. Robert Shaw Sturgis* (Susan Brimmer Inches), c. 1862. Oil on canvas, 43¼″ × 33¼″. Courtesy of The Carnegie Museum of Art, Pittsburgh, Pennsylvania. Lent by the family of Mr. and Mrs. Theodore Lyle Hazlett.

1860, Hunt gave instruction to at least twelve students, including John La Farge, William and Henry James, and the architect Frank Furness.[38] From the beginning of his teaching career, Hunt had two important lessons to impart to his students: the universal, humanistic significance of Millet's treatment of rural subjects, and Couture's innovative painting methods. Whereas Millet's attitude toward art and art-making was the philosophical underpinning of Hunt's method, Couture's system of drawing and paint application provided the technique for communicating the simplicity, dignity, and universality of Millet's compositions.

It is generally believed that Hunt's first pupil was Edward Wheelwright, a friend from Harvard who had studied earlier with Millet. Wheelwright had remained a close friend of Hunt's and, as secretary for the Harvard Class of 1844, wrote a valuable biographical sketch of the artist. Wheelwright never became a professional painter, but he was art editor of the *Atlantic Monthly* and wrote several informative articles, including one on Boston painters and another on his sojourn with Millet.[39]

Hunt's second pupil was John La Farge, son of a well-to-do French émigré family, who had already spent two years in France beginning his study of art with Couture. He came to Newport in 1859 on the recommendation of Rich-

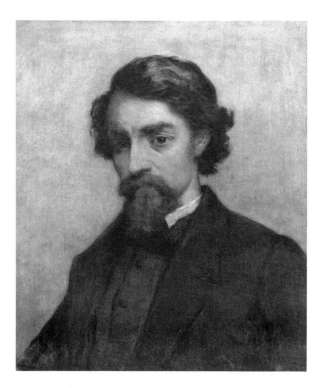

FIGURE 48. *William Sidney Thayer*, c. 1860. Oil on canvas mounted on wall board, 21⅞″ × 18″. Smith College Museum of Art, Northampton, Massachusetts (Gift of Sarah S. Thayer)

ard Hunt, whom La Farge had met in New York when both were living on West Tenth Street in the new Studio Building. One of the first buildings designed by Richard, the Tenth Street Studio was built specifically to provide studios and a gallery for artists. At the time good studio space was difficult to find and artists often had to improvise in airless, poorly lit rooms in commercial buildings. When it opened, in 1858, the Studio Building was an immediate success. At midcentury, with the proliferation of new patrons, art journals, and artists' associations, American artists were developing a new sense of professionalism and mutual responsibility, and the Studio Building, in addition to providing good working conditions and exhibition rooms, became an important center where they could exchange ideas and support one another's work.[40] Over the years the artists who lived or worked there included, in addition to Hunt and La Farge, Frederic Church, Albert Bierstadt, Leutze, William Page, Winslow Homer, Albert Pinkham Ryder, William Merritt Chase, and two men who later write on Hunt's art: Henry Tuckerman and Henry Van Brunt.

La Farge would later state that he "did not admire [Couture's] work or his views of art and he annoyed me, notwithstanding his friendliness, by his constant running down of other artists greater than himself."[41] Yet he found something of value in Couture's teaching because he sought out Hunt, wishing to continue "the practice of Couture." In this La Farge was disappointed for

56

FIGURE 49. *The Lost Profile*, c. 1860. Oil on panel, 20″ × 13¼″. Ruthmere Museum, Elkart, Indiana. Photo: Courtesy of Vose Galleries, Boston.

he found that Hunt had "abandoned" Couture's method. In Hunt's defense, he had only begun teaching and may have not been totally confident of his abilities or have fully established his own method. La Farge was particularly concerned that Hunt was always looking for a "recipe," particularly for landscape painting. La Farge, on the other hand, "wished [his] studies from nature . . . to indicate very carefully, in every part, the exact time of day and circumstances of light. . . . In a certain way Hunt recognized the value of the ideas and the value of their result, but his aim was quite the other way; and that was to find the recipe which would be sufficient for noting what he wished to do."[42]

At this time Hunt was not very interested in landscape and the few he did while in Newport do not approach La Farge's level of experimentation found in such works as *Boat House. Rocks. Newport* (1859, Art Museum, Princeton University) or *Clouds over Sea; From Paradise Rocks* (1863, private collection). Yet between 1857 and 1860 in the few landscapes he did, Hunt's rendering of light and atmosphere becomes more sensitive. These changes may be due in part to the influence of his students and in part a response to his trip to Fayal, which, with its harsh tropical sun, may have made Hunt more aware of the special nature of outdoor light. For instance, in *The Belated Kid*, begun

before his trip to Fayal, he still retains the dramatic golden light of sunset often found in the work of Millet; but in his *Twin Lambs*, this exceptional light is replaced by a more generalized daylight that is by comparison more naturalistic. In two later works, *Hillside* (fig. 50) and *Landscape Newport* (1860, Museum of Fine Arts, Boston), landscape and light were not treated very innovatively but were more carefully observed.

Nevertheless, Hunt's interest in landscape was peripheral to his dedication to figure painting and portraiture. These concerns, which formed the basis of his instruction, are also found in several works by his pupils. The first is a figure painting by La Farge called *The Choir Boy* (fig. 51), in which the robed figure of a young boy seems mysteriously out of place in his landscape setting. In pose and costume it is a reworking of Hunt's *The Singers* (see fig. 55), which Hunt was painting at the time. Unlike Hunt's work, La Farge's has no narrative content and seems to be an excuse for the study of the figure outdoors. It is as if La Farge had asked Hunt's model to step outside to be studied in full sunlight rather than the artificial light of the studio.

The pupils who next entered Hunt's atelier were the James brothers, William and Henry, both in their late teens. They arrived in Newport in 1860, having recently returned from Europe, where they, like the Hunt family, had traveled, lived, and studied for several years.[43] They had first met Hunt in Europe and had paid him a visit during an earlier stay in Newport. When

FIGURE 50. *Hillside*, c. 1860. Oil on canvas, 31½″ × 25½″. Robert Aaronson, M.D.

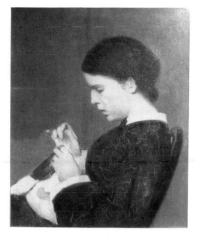

FIGURE 51. John La Farge.
The Choir Boy, 1860. Oil on
panel, 12⅛″ × 7″ inches. Lo-
cation unknown. Photo:
Courtesy, La Farge Cata-
logue Raisonné Project.

FIGURE 52. William James.
Kitty Temple, 1859. Oil on
canvas, 9½″ × 6¼″. Private
collection. Photo: Courtesy,
La Farge Catalogue Rai-
sonné Project.

William James decided he wanted to become an artist, his father, who evidently was looking for an excuse to come home, decided that the family should return so that William could study with Hunt. Henry, who had no desire to come back, thought it was ironic, given all the great teachers and academies abroad, that his father would chose an American. Yet Newport, in these few years before the Civil War, was, in Henry's words, "the one right residence," not because it was socially grand, but because it was a stimulating community of cosmopolitan people who had spent time abroad and were devoted to European culture. For Henry James and La Farge this included keeping abreast of literary and artistic developments in France through reading the *Revue des Deux Mondes* and other journals.[44]

Evidence of Hunt's training can be seen in a painting by William James, *Kitty Temple* (fig. 52). Miss Temple, who was James's cousin, is rendered in profile, seated in a chair sewing. This portrait is remarkably similar to a study of the same model by La Farge (1860, Mrs. Mott Schmidt, New York). Both in turn are very close to Hunt's *La Marguerite* I (which might have been hanging in Hunt's studio) but are perhaps closest to *The Lost Profile* (see fig. 49). Historically, this woman has been identified as Hunt's wife, Louisa, but given the similarity of hairdo and dress, it may well be a portrait of Miss Temple that Hunt painted as a demonstration piece (a practice he often followed for his classes in the 1870s) for his students in Newport.[45] The three portraits together form an interesting comparison. Both La Farge and James ably record the profiled figure in full light, although the one by James, with

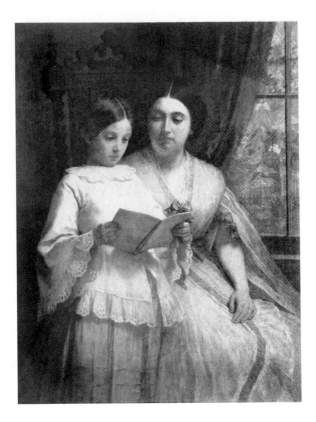

details of the young womans's task, is more engaging. Yet neither student succeeded in creating the compelling mystery of Hunt's work, in which the model, painted from a different perspective, almost from the back, her face in shadow, is transformed into a study of lights and darks.

In addition to this figure study by Hunt, a few landscapes, his lithographs and portraits, there is also a little-known body of work – primarily genre paintings – reflecting English Pre-Raphaelitism, not in their over elaboration of detail but in their genteel sentimentality. One of these is an early double portrait *Mrs. M. Woolsey Borland and Madeleine Borland* (fig. 53), mother and daughter who read together in a Victorian parlor. Here, in the attentive figure of Madeleine, Hunt repeats the pensive pose of the young girl in *Girl with Cat* and *Girl with Rabbit.* Yet in this work of quiet domesticity, Hunt sets both figures within a specific locale and includes details of furniture and costume that seem to foreshadow works done later by American Pre-Raphaelites, such as Aaron Shattuck's *The Shattuck Family, with Grandmother, Mother and Baby William* (1865, Brooklyn Museum).

There is also a pair of unique paintings, *The Listeners* (fig. 54) and *The Singers* (fig. 55), done at the same time as the Borlands.[46] In both, figures are set in darkened chapels that evoke a semireligious mood, unusual for Hunt. In *The Singers* two figures stand in the middle of the painting and sing together from an open songbook. In its companion, *The Listeners,* two women stand

FIGURE 53. *Mrs. M. Woolsey Borland and Madeleine Borland* (Julia Post and Madeleine, later Mrs. Louis McLane Tiffany), c. 1858. Oil on canvas, 45⅞″ × 35¼″. Massachusetts Historical Society, Boston.

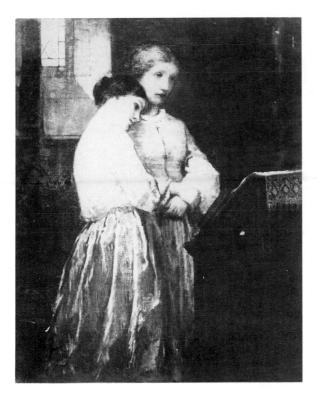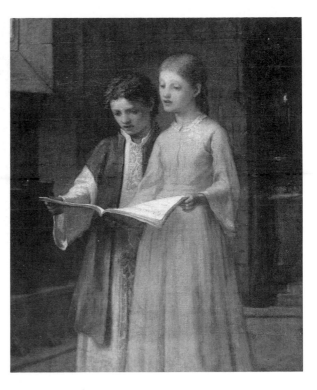

FIGURE 54. *The Listeners*, 1859. Photograph of drawing. The American Architectural Foundation, Prints and Drawings Collection, The Octagon Museum, Washington, D.C.

FIGURE 55. *The Singers*, 1859. Oil on canvas, 24″ × 20″. Mr. and Mrs. Hugh Peterson. Promised gift to the Santa Barbara Museum of Art, Santa Barbara, California.

embraced, the nearest woman's profiled stance and costume recalling *La Marguerite*. They seem to be listening to the song the others are singing, almost as if they were in the same room. The churchlike setting and medievalizing detail connect these images to British painting, particularly the quasi-religious, moralizing works by artists such as Ford Madox Brown, William Holman Hunt, and John Everett Millais, although neither painting has the highly polished surface characteristic of contemporary English painters. This influence of English art is rather surprising given Hunt's historic position as the apostle of French painting in America. It may have been the result of his seeing an important exhibition of British painting that traveled to New York, Philadelphia, and Boston (where it was housed from April 5 to June 19, 1858, in the Boston Athenaeum).[47] It afforded a firsthand introduction not only to modern British art but to the Pre-Raphaelite work that, in New York, influenced a new generation of artists. When Hunt exhibited *The Listeners* and *The Singers* at the National Academy of Design after the Civil War, he may have intended them as concessions to New York taste.

A few other works in the late 1850s and early 1860s continue this sentimental mood, but with a melodramatic or pathetic overcast, the earliest of which may reflect Hunt's feelings following the loss of his son. These are, in fact, some of the few works in which emotion is so overtly expressed. All are of winter evenings: *The Snow Storm* (fig. 56) owned by the Borlands; *Out in*

the Cold (fig. 57); and an untitled work (fig. 58) of a young boy hurrying across a desolate snowbound street. *The Snow Storm*, based on a poem by the American writer and journalist Seba Smith, is a picture of female sacrifice in which a young mother, collapsed against a snow-covered embankment, holds at her breast an infant wrapped in a purple shawl. Glued to the back of the painting is Seba Smith's poem, which Hunt's painting illustrates almost precisely:

FIGURE 56. *The Snow Storm*, 1859. Oil on chipboard, 18½″ × 12¼″. Courtesy, Museum of Fine Arts, Boston. (Bequest of Elizabeth S. Gregerson)

> The cold winds swept the mountain's height
> And pathless was the dreary wild,
> When 'mid the cheerless hours of night
> A mother wandered with her child...
> Oh God, she cried, in accents wild,
> If I must perish, save my child...
> She tore the mantle from her breast
> And bared her bosom to the storm,
> Around the child she wrapped the vest
> And smiled to think the babe was warm...
> At morn a traveller passed by –
> The babe looked up and sweetly smiled.[48]

Hunt did this picture in 1859, shortly before *Elaine with Her Shield,* and may have planned to publish it as illustration for Smith's poem – a common practice

FIGURE 57. *Out in the Cold*, 1864. Oil on canvas, 12″ × 14″. Private collection.

FIGURE 58. Untitled, c. 1864. Photograph of charcoal drawing. The American Achitectural Foundation, Prints and Drawings Collection, The Octagon Museum, Washington, D.C.

by American artists, whose paintings were often engraved as illustrations in gift books.[49]

Another maudlin subject is *Out in the Cold,* a painting done five years later, after the Civil War and after Hunt's return to Boston. The subject, a young boy dragging large branches through a winter landscape, was, like *The Snow Storm,* based on a popular literary source, a poem entitled "Out in the Cold" written by John S. Adams in 1858 and later set to music by Luther Orlando Emerson.

The last in this series, known only from a photograph, is an untitled and undated dark, mysterious charcoal drawing of a young boy hurrying down the street on a winter's evening. Aside from a tall gaslight that serves as the painting's only source of illumination, there is nothing in the work to indicate his task or destination. On the basis of stylistic evidence, Hunt's monogram, and the fact that it is a charcoal (a medium he began to use in the mid-1860s), this work is probably contemporaneous to *Out in the Cold.* And it, too, may have been undertaken to further his reputation through illustration and printmaking.

BOSTON AND THE CIVIL WAR

At the time these last two works were done, Hunt was back in Boston; the Civil War had interrupted his Newport idyll. In the spring of 1862, with

63

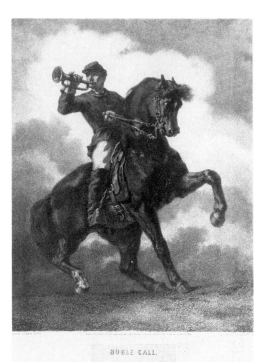

BUGLE CALL.

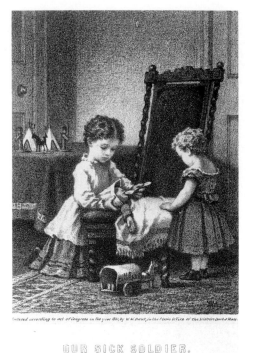

OUR SICK SOLDIER.

W.M.HUNT Pinxit et Lith. OAKLEY & TOMPSON, Imp

Louisa and two children (Eleanor, four, and Enid, two), he moved to Readville in the Blue Hills east of Milton, outside Boston. At thirty-eight he was too old for military service, but like most Bostonians he was deeply stirred by the national tragedy and in response did several patriotic paintings, two of which were lithographed in 1863: *The Bugle Call,* or *The Bugler* (fig. 59) and *Our Sick Soldier* (fig. 60).[50] He also did two other paintings, *The Wounded Drummer Boy* (c. 1864, Museum of Fine Arts, Boston) and *The Drummer Boy* (fig. 61), both of which were based on popular Civil War stories.

The Bugle Call is a conventional military image, in which a Union soldier on a rearing horse sounds a call to arms. The perspective is low, and the soldier and horse are dramatically outlined against a smoke-filled sky. In its simplicity and drama, it recalls similar paintings by the French Romantic painter Théodore Géricault. (Hunt, like Géricault, was a great horse-lover and kept many of which he was very proud. What he said of Géricault in his *Talks on Art* might have applied to him as well: "Géricault used to spend most of his time riding on horseback in the *Champs Elysées,* and nobody could imagine when he painted his pictures. When he worked, he did work. Very few people appreciated what he did, and that discouraged him.")[51]

Our Sick Soldier, in contrast to *The Bugle Call,* is an intimate genre scene of Hunt's two children playing field hospital. A far less successful work is *The*

FIGURE 59. *The Bugle Call* or *The Bugler*, 1863. Lithograph. Boston Athenaeum.

FIGURE 60. *Our Sick Soldier* or *Playing Field Hospital,* 1863. Lithograph. Boston Athenaeum.

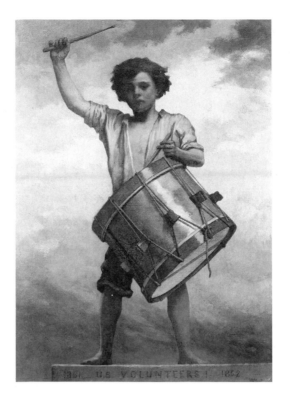

FIGURE 61. *The Drummer
Boy*, 1862. Oil on canvas, 36″
× 26″. Courtesy, Museum of
Fine Arts, Boston. (Gift of
Mrs. Samuel H. Wolcott)

Wounded Drummer Boy, which appears unfinished. In this state it is a ghastly
representation of a youth lying on the ground, more dead than alive. The
background is indistinct, and the whole has a hazy quality, very different in
mood from Eastman Johnson's spirited *Wounded Drummer Boy* (Union League
Club, New York), done in 1871.

The most famous of Hunt's Civil War images is *The Drummer Boy.* It and
The Bugle Call were cited in 1867 as "two of the most popular and significant
pictorial illustrations of the war for the Union."[52] A large painting of a barefoot
boy, his arm upraised ready to strike a large drum summoning volunteers,
The Drummer Boy is a nineteenth-century recruiting poster. Standing on a stone
plinth inscribed "1861. U.S. Volunteers! 1862." and silhouetted against a sky
full of smoke and clouds, he is the hurdy-gurdy boy off to war. Couture's
Drummer Boy (1857, Detroit Institute of Art), may have been the inspiration,
but its playful mood is in marked contrast to Hunt's stirring image.[53] The
two boys are linked by costume, however: both are dressed in rolled-up pants
and an open-necked shirt, and the drum is also similar in both. Still, it is not
certain how Hunt, who did not return to Europe until 1867, could have seen
Couture's version.

Having returned to printmaking with his Civil War lithographs, Hunt was
also inspired to create a larger, more finished reproduction of *La Marguerite,*

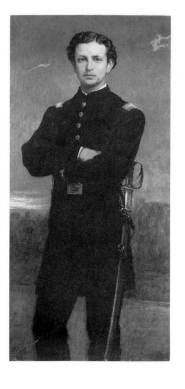 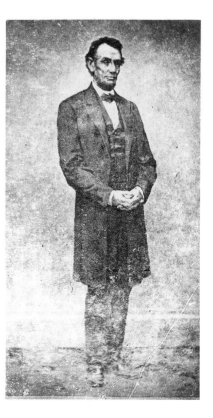

drawn on stone by the professional lithographer Dominique Fabronius. Hunt's neighbor in the Studio Building, Fabronius, was newly arrived from Belgium, where he and his family were well known for their skill as lithographers. Harry Peters, in *America on Stone*, reviewed Fabronius's work, singling out *La Marguerite* as showing "what a superb craftsman Fabronius was. Here we have artistic lithography at its best."[54] Unlike the crude, almost primitive quality of most lithographs then available in America, Fabronius's artistry is evident in the beautiful modulation of the crayon, which gave volume and texture to the figure of Marguerite.

In addition, Hunt painted portraits, some of them posthumous, of friends or sons of friends who had been in the war. These include *Portrait of Captain Edward F. Jones* (1863, Mead Art Gallery, Amherst College, Amherst, Mass.); *Theodore Wheaton King* (c. 1865, private collection); *Colonel William H. Forbes* (c. 1863, private collection); and *Lt. Huntington Frothingham Wolcott* (fig. 62). Probably all were painted from photographs for even when full-length these portraits are no more than mementos. Like the Señora Terra portrait, they have a lifeless, ghostlike quality. The best of them is the portrait of Wolcott, who was killed in 1865. Working from a photograph, Hunt finished the portrait in Paris in 1867. Unfortunately, the only area of interest is the face; the body has little form or substance, and the background is artificial.

FIGURE 62. *Lt. Huntington Frothingham Wolcott*, c. 1864. Oil on canvas, 60″ × 30″. Museum of Fine Arts, Boston. (Gift of Samuel Wolcott, Jr.)

FIGURE 63. *Abraham Lincoln*, c. 1865. Photograph of lost painting. The American Architectural Foundation, Prints and Drawings Collection, Octagon Museum, Washington, D.C.

Of all Hunt's Civil War painting, however, the most important was his posthumous standing portrait of Abraham Lincoln. Painted shortly after Lincoln's assassination in April 1865, it was commissioned by the art dealers Doll & Richards. Unfortunately destroyed in the Boston Fire of 1872, the painting is known today only from a poor photograph (fig. 63).[55] For reasons unknown the commission was withdrawn, but Hunt completed the portrait as a private tribute to someone he deeply admired. He also took it with him to Paris and exhibited it in the 1867 Universal Exposition.

Hunt's portrait of Lincoln was just one of a number done by countless painters and sculptors following the assassination, but evidently, Hunt had the co-operation of Mrs. Lincoln, who sent him some items of clothing and suggested a model who was close to the president's height and physique.[56] Yet Hunt had not met Lincoln and may have consulted Matthew Brady's standing portrait (without his beard) taken in New York prior to Lincoln's Cooper Union speech in 1860. For his face, however, Hunt seems to have referred to the most famous of Brady's Lincoln photographs, a seated version taken a few months before his death, the face of which was later used for the five-dollar bill. Brady's photograph represented the beleagured president with remarkable clarity, focusing on his deep-set eyes, which gave the work an intense, memorable quality. Hunt may have chosen this image because it was an admirable likeness and one that came to represent, for many, Lincoln's true appearance. Similarly, Hunt's *Lincoln*, without trappings of office nor rhetorical gestures, is a sober, respectful portrait.

Hunt's reliance on photographs was not limited to posthumous portraits, since he probably consulted them for his portrait of Lemuel Shaw and for at least two others: *John A. Andrews* (c. 1866, City of Boston, on exhibit in Faneuil Hall, Boston), and *Charles Summer* (1875, Metropolitan Museum of Art).[57] Yet, when one of his students asked Hunt, he tried to deny that he used photographs: "You don't believe in working from photographs, do you?" he replied unequivocally: "No, indeed! and don't make portraits of people who have died, either."[58] (When these statements were recorded in the early 1870s, perhaps he should have added "at least, not anymore.") In any case, Hunt's remarks reflect a prejudice that still exists: paintings that bear the human touch possess more emotive and aesthetic qualities than the mechanical, factual representations taken by a camera. Yet in the second half of the nineteenth century, daguerreotypes (or photographs) were invaluable tools used by many artists, particularly portraitists, and this was certainly true for Hunt, whose subjects were not always available for extensive sittings. The challenge was to go beyond the superficial appearance afforded by the camera, which was often very seductive: many examples in American painting indicate the artist has reproduced the photograph with such fidelity, almost as if in competition, that the result is a stiff, paper-doll mockery of both media. Artists of the caliber of Hunt and, later, Eakins, did not allow the camera's seemingly mag-

ical powers of reproduction to distract them from their knowledge of the sitter and the singular image they sought to create.

BOSTON IN THE 1860S

When Hunt moved to Boston in 1862, his first studio was in the Highland Hall Building in Roxbury. The following year, 1863, he moved into the new Studio Building on Tremont Street, near Beacon Hill and the Boston Common. Like his brother's Studio Building in New York, the Studio Building in Boston provided working space and fellowship for local artists. When Hunt moved in, twenty-six artists and eleven architects worked there, including La Farge, Albion Bicknell, Joseph Ames, William Furness, and William Rimmer, whose sculpture *The Dying Centaur* (1869, Metropolitan Museum of Art) and painting *Flight and Pursuit* (1872, Museum of Fine Arts, Boston) are among the most enigmatic American works of the nineteenth century. Rimmer was also a teacher and, at the time Hunt settled in Boston, was just beginning his classes in anatomical drawing. Hunt wanted to open a school in Boston to continue the work he had begun in Newport and suggested to Rimmer that they open one together. Such a partnership would have been fascinating. Rimmer was virtually self-taught and had never been to Europe. His strengths were many: he was an excellent draftsman; he had a sound understanding of anatomy, based in part on his training as a physician; he was a renowned lecturer; and he had an uninhibited imagination. Hunt would have valued these qualities; although he himself had never enjoyed the discipline of academic drawing, he knew its benefits. Hunt's strengths were his firsthand knowledge of European painting and sculpture, his wide experience as a practicing artist, the critical success of his work, and his strong social ties in Boston. No one knows why Hunt's original suggestion did not materialize or why Rimmer again declined Hunt's invitation a second time in 1870, when he returned to Boston from a year's teaching at Cooper Union in New York.[59] Yet the two remained friends and Rimmer was one the few artists Hunt later consulted on his Albany murals.

Always restless, Hunt left the Studio Building in 1864 and set up a new, larger studio in the nearby Mercantile Building on Summer Street. Here he established himself as a cultural force in Boston, decorating his studio with his own and Millet's paintings. He also entertained guests, some of them visiting actors who would be invited to perform in impromptu tableaux.

It has been said that Hunt's return marked "the beginning of a new era in the history of Boston art."[60] His presence was felt immediately: through the direct influence of his work, his knowledgeable and enthusiastic championing of modern French painting, and his active encouragement and support of fellow artists – who over a twenty-year period included not only La Farge and Rimmer but Vedder, George Fuller, Frank Duveneck, and the Boston artists Richard Henry Fuller, J. Foxcroft Cole, John B. Johnston, and Thomas

68

Robinson. In addition, Hunt's many female students – Helen Knowlton, Sarah Wyman Whitman, Elizabeth Howard Bartol, Caroline Cranch, Sarah Johnston, and Elizabeth Boott Duveneck – established successful professional careers in Boston.[61]

Vedder, after his critical success in New York at the National Academy of Design, was the first of several artists whom Hunt encouraged to come to Boston. Two works in particular, *The Questioner of the Sphinx*, shown in 1863, and *The Lair of the Sea Serpent*, in 1864, brought him to the attention of Hunt and other Bostonians. In fact, Hunt's friends Martin Brimmer and Thomas Gold Appleton, respectively, bought the two works, which are now in the Museum of Fine Arts, Boston. These two men, along with Quincy Adams Shaw, were also members of a new generation of cosmopolitan Boston patrons who provided leadership and financing for the Museum of Fine Arts, which was incorporated in 1870. (It opened officially July 4, 1876.) Not surprisingly, they shared Hunt's enthusiasm for modern French painting and turned to him for advice for their collections.

Given the favorable reception of his work, patronage for new painting, and the genial community of artists working in Boston, Vedder decided to make it his home for a year, working between 1864 and 1865 in room number five of the Studio Building. Here the newest art and literature were debated – Barbizon painting, Tennyson's poetry, and Japanese prints. Despite his being unimpressed by Millet's work, Vedder was persuaded by La Farge to go to Newport and paint landscapes. He also shared with the other artist an interest in the bizarre and exotic – an interest evident in paintings done by Vedder even before his arrival in Boston, and one that reappeared in his and La Farge's separate illustrations for Tennyson's *Enoch Arden*, published by Ticknor and Fields in 1864.

At about this time La Farge's interest in Japanese art, particularly the prints of the *ukiyo-e* school, became evident; their influence is found in several of his *Enoch Arden* images such as *Shipwrecked* and *The Solitary*. La Farge's first introduction to *ukiyo-e* was Hokusai's *Mangwa*, which he purchased while on a trip to Paris in 1856. Interestingly, his fascination with Japanese woodcuts and his adaptation of their design and composition for his own, preceded the fever of *japonisme* that swept Paris in the late 1860s and 1870s.[62] What influence Japanese art had on Vedder's work still awaits documentation, but given the flat, decorative nature of much of his graphic work, one assumes he admired similar qualities in the Japanese prints.

There are, however, a few works by Hunt done at this time that reflect his direct knowledge of Japanese art. He kept "choice specimens of Japanese art" that he had bought in New York in his studio, and urged his pupils to " 'Study the Japanese!' "[63] Like La Farge, Hunt used a Japanese tea tray as a support for an early sketch of *The Flight of Night* (1864, Museum of Fine Arts, Boston) and also included Japanese-style objects in one of his charcoal drawings. One, known as *Girl in Costume* (fig. 64), is of a young model dressed in a kimono.

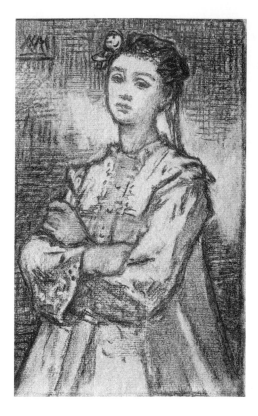

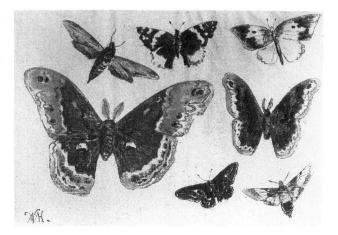

With a melancholy expression and a round flower in her hair, she appears incongruously as a Boston geisha. Further, the background plane is suggested by right-angled hatch marks similar to the woven surface of a bamboo screen. In two other works, *Butterflies* (fig. 65) and *A Bird on a Cherry Bough* or *Bay's Thrush* (1868, private collection), both charcoal still lifes, the influence of the Japanese print is clearly evident. In *Butterflies*, the winged insects are placed flat on the page in a manner highly imitative of Hokusai's arrangement of animal species in his *Mangwa*. Similarly, *A Bird on a Cherry Bough* has been linked to a woodblock print by Hokusai called *Bullfinch and Drooping Cherry*.[64]

In addition to these rather unconventional still lifes, Hunt did at least two others, *Azalea* (fig. 66) and *Flower Study* (fig. 67), also both in charcoal, that are more traditional. La Farge, too, had done a number of floral still lifes in poetic harmonies of muted color that were haunting; one example, *Flowers in a Japanese Vase* (1864, Museum of Fine Arts, Boston), may have inspired Hunt's charcoal drawing *Azalea*. Although Hunt's work contains none of the mystery of La Farge's oil, it does exemplify Hunt's exceptional ability to create with the charcoal crayon a variety of textures and tones that vary from the deepest black to the softest gray. In *Flower Study*, Hunt introduces an interesting element not often found in his work: the use of symbolism. Here, a vase of dying flowers, whose petals are spread across the bottom of the table,

FIGURE 64. *Girl in Costume*, c. 1865. Charcoal on paper, 8″ × 5″. Vose Galleries, Boston.

FIGURE 65. *Butterflies*, c. 1866. Charcoal on paper, 7¾″ × 11¼″. Courtesy, Museum of Fine Arts, Boston. (Gift of the subscribers through Miss Ellen Day Hale and Miss Adelaide E. Wadsworth)

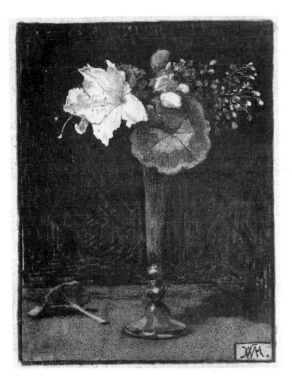

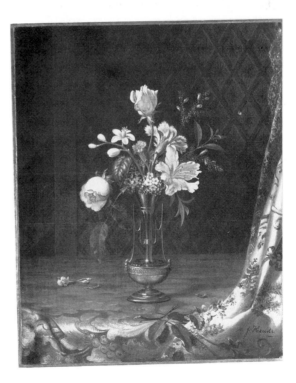

FIGURE 66. *Azalea*, c. 1867. Charcoal on paper, 8⅞″ × 9⅝″. Courtesy, Museum of Fine Arts, Boston. (Bequest of Mrs. James T. Fields. Received on the death of Mr. and Mrs. William Ralph Emerson)

FIGURE 67. *Flower Study*, c. 1864. Chacoal on paper, 22⅜″ × 16¼″. Museum of Fine Arts, Boston. (Gift of Miss Mary C. Wheelwright)

FIGURE 68. Martin Johnson Heade. *Vase of Mixed Flowers*, c. 1865–75. Oil on canvas, 17¼″ × 13¾″. Courtesy, Museum of Fine Arts, Boston. (Bequest of Martha C. Karolik for the Karolik Collection of American Paintings, 1815–1865)

FIGURE 69. *Horace Gray*, 1865. Charcoal on paper, 36″ × 29″. Location unknown.

are flanked by an hourglass. Together these elements refer to the passage of time and the transiency of nature. Interestingly, this work is similar to the early Victorian still lifes of Martin Johnson Heade, for instance, *Vase of Mixed Flowers* (fig. 68), in which stems and blossoms also fall from a dying bouquet. Heade was a New York-based artist who maintained a studio in the Tenth Street building but had earlier lived and worked in the Boston area. Best known for his Luminist landscapes of the shores and marshes of the New England coast, Heade was also an important painter of still lifes.

It is also said that Heade may have been introduced to charcoal by Hunt, who was one of the first Americans to use it as a medium of artistic expression.[65] Over the years, charcoal became a means of expression Hunt favored for his portrait and landscape sketches. Hunt enjoyed its great flexibility, which enabled him to express quickly form, values, and mood. So taken was he with his new discoveries, he even chose to exhibit his charcoal portraits at the National Academy of Design in 1866. One may have been his portrait of *Horace Gray* (fig. 69), probably the first he did in charcoal. A comparison of this likeness with the oil painting of *William Thayer* (see fig. 48), done five years earlier, shows the advances Hunt had made as well as how important the use of charcoal was in strengthening his realization. In the Thayer portrait, the subject's character and personality seem veiled behind the glaze, whereas in the Gray charcoal the crispness of outline, the detailing of features, the texture and pliancy of fabric, all brought harmoniously together through Hunt's rapid and sure draftsmanship, give it a directness and vitality.

As a way to bring these new ideas to a larger public, in 1866 Hunt and several of his Boston friends organized the Allston Club. Like earlier Boston artists' organizations, it was established to promote the art of its members. In

FIGURE 70. *Mrs. Samuel Hammond*, 1865. Oil on canvas, 46½″ × 35½″. Mrs. Lawrence A. Norton.

addition, its exhibitions introduced Bostonians to modern French paintings by the Barbizon masters (Millet, Corot, Daubigny, Troyon, Rousseau, Diaz, and Jacques); the earlier nineteenth-century French Romantic painters De-lacroix and Ary Scheffer; and the realist painter Gustave Courbet, whose painting, *The Quarry* (1857, Museum of Fine Arts, Boston) was purchased by the Allston Club in 1866 for five thousand dollars. Most important, these exhibitions introduced a new style of landscape painting to a Boston audience. In contrast to the more detailed and precise rendering of nature found in Hudson River school paintings, these modern French landscapes focused on the elusive effects of natural light, atmosphere, and weather. Hunt, whose late landscapes were greatly influenced by this new aesthetic, was thought of as Allston's spiritual and artistic heir and was fittingly elected the club's first president.

While persuing his numerous activities and interests, Hunt also did a number of portraits. Among them are a seated portrait of *Mrs. Samuel Hammond* (Mary Crowninshield Endicott); paired portraits of *Mr. and Mrs. George Warren Long;* a double portrait of his sister-in-law, Mrs. Richard Hunt, and her son Dickie; and an important figure piece, a standing image of Hamlet. In *Mrs. Samuel Hammond,* (fig. 70), Hunt continued his earlier patrician por-trait style, but it was the last one he did in a flattering, quasi-aristocratic mode.

Hunt would continue to accept portrait commissions but was no longer interested in being Boston society's official portrait painter. He preferred instead to paint family and friends, or people he admired. From this time on, he was committed to a more "modern," or naturalistic, approach, a change seen in the paired portraits of *Mr. and Mrs. George W. Long* (figs. 71, 72). Both are dark paintings, and the figures are dressed in black – softened in Mrs. Long's case by a cascading white silk headpiece. The sobriety of these portraits is undercut, however, by the informal poses of the sitters. Leaning against a waist-high pedestal, with the thumb of his left hand hooked into his waistband, Mr. Long appears quite relaxed. Mrs. Long, too, is rendered unconventionally. She is shown in profile, and the beautiful flowing silk of her headpiece frames her figure in an almost seductive way.

Hunt used much the same pose (without the headpiece) for Catharine Howland Hunt in the double portrait known as *Mother and Child*. According to Catharine, the first oil sketch (private collection, New York) was completed in 1863.[66] The second phase of work, a full-size oil sketch, was begun in 1865 (Museum of Fine Arts, Boston) but was interrupted by Hunt's work on Lin-

FIGURE 71. *Mr. George Warren Long*, c. 1865. Oil on canvas, 42″ × 21″. Mr. and Mrs. W. Channing Howe. On loan to Wheaton College in Norton, Massachusetts.

FIGURE 72. *Mrs. George Warren Long* (Mary Elizabeth), c. 1865. Oil on canvas, 42″ × 21″. Mr. and Mrs. W. Channing Howe. On loan to Wheaton College in Norton, Massachusetts.

FIGURE 73. (*opposite*) *Mother and Child* (Mrs. Richard Morris Hunt [Catharine Howland] and Richard Howland Hunt), 1865–6. Oil on canvas, 56″ × 35″. Private collection.

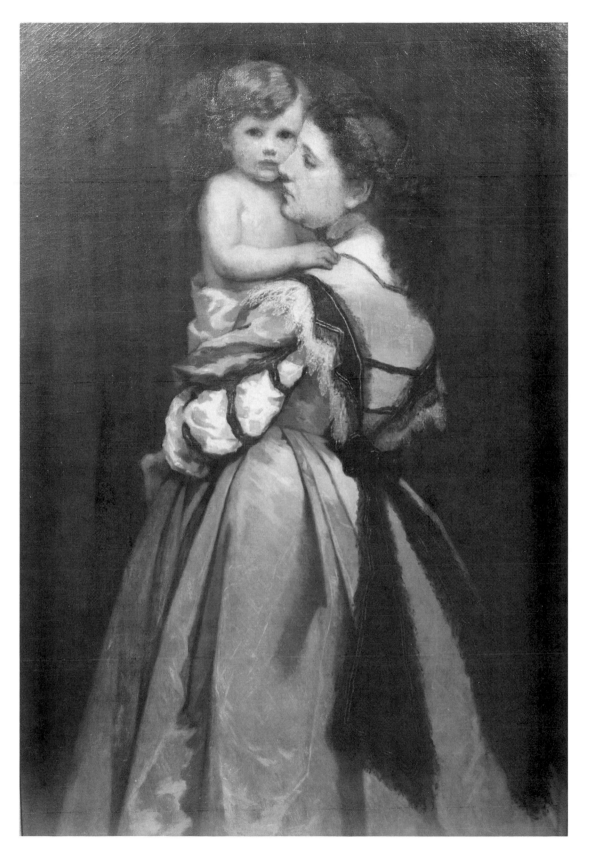

coln's portrait after the assassination. The third and final phase was done a year later, when both the oil sketch and the finished painting (fig. 73) were completed. Compared to Hunt's earlier portraits and the work of his contemporaries, the representation of an elegantly dressed mother, seen from the back and holding the nude figure of her little son, is highly unusual. It is obvious from Hunt's several sketches that he was intrigued with the variety of textures this double portrait presented. He wanted not only to unite the figures of the mother and child but to harmonize the different surfaces of fabric and flesh. This harmony evaded him in the second oil sketch, where the high finish of Catharine's dress, hair, and face, which Hunt captures with great sensitivity, contrasts too sharply with the bland skin tones chosen for Dicky's figure. The finished version is more successful. The sharp highlights are toned down, and the relationship between the two figures is better integrated through color harmonies. Here the physical intimacy is more natural and sensuous.

One of the most intriguing of Hunt's mid-1860s works is his full-length Hamlet (fig. 74), begun in 1864 to commemorate the tricentennial of Shakespeare's birth and first shown at the Saturday Club. The membership of this dining and social club (founded in 1855 by Ralph Waldo Emerson and others) comprised the cultural elite of Boston, and its early members formed a virtual Who's Who of New England literature: James Russell Lowell, Henry Wadsworth Longfellow, Richard Henry Dana, Jr., Oliver Wendell Holmes, John Greenleaf Whittier, and Nathaniel Hawthorne. Over the years, Hunt (who became a member in 1869) painted a number of them.[67] The Club had planned its own celebration of the Shakespeare tricentennial, to which Hunt was invited; he was unable to attend the gala on April 23, and sent, as a surrogate, his painting of *Hamlet*.[68] Emerson noted in his journal that he was disappointed William himself had not been there but that the artist had "graced our hall by sending us his full-length picture of Hamlet, a noble sketch."[69]

Hunt retained the painting and continued to work on it for a number of years.[70] It had particular importance for him, as Hamlet and Shakespeare were among his personal heroes. In a passage from his *Talks on Art* in which he speaks of Millet, he also alludes to Shakespeare, Lincoln, and Hamlet: "He [Millet] was immense, tremendous, — so great that very few ever could get near him. He read only such things as would help him. Knew Shakespeare and Homer by heart. He was like Abraham Lincoln in caring for only a few books. He loved Hamlet."[71]

Like the Romantics of an earlier generation, Hunt believed Shakespeare was a genius who followed his own convictions.

> Shakespeare never sat down and said, "Now I'm going to be *original!*" No. When he opened his eyes in the morning he

76

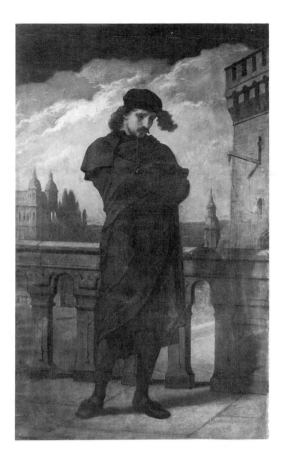

FIGURE 74. *Hamlet*, c. 1864–
70. Oil on canvas, 93¾″ ×
57½″. Courtesy, Museum of
Fine Arts, Boston. (Lent by
the Estate of Louisa D.
Hunt)

didn't think of looking as Tommy Tinker did. He wrote his
plays as I would smoke a cigar or read a book.

But you had better believe that he was a worker! The fel-
lows who have succeeded have sweated more than others. It's
a case of open pores. Most people, in their eternal grasping
for gain, keep their pores tightly closed.[72]

In Hunt's final version of Hamlet, the prince stands with his arms wrapped
tightly around his body, his head bowed, his stance and gaze indecisive. Poised
on a parapet in front of a rendering of a medieval town square, he seems
about to intone the opening lines of his famous soliloquy, "To be or not to
be. . . . " Hunt enhanced this dramatic moment by setting Hamlet's head and
torso against a clouded moonlit sky. It is interesting to note that even for this
highly theatrical scene, Hunt attempted to make the lighting as realistic as
possible. A fellow artist, Albion Bicknell, recalled: " 'What tramps we had
over hills, fields, and meadows! In our evening walks the effects of moonlight
were chiefly in his thoughts, for at this time he was painting *Hamlet*. He would
slip off his coat for me to see what relation existed between his white shirt-

sleeves and the sky and landscape. Then I would do likewise that he might make some notes.' "[73]

Hunt enjoyed the theater and liked to entertain visiting theatrical companies, and was himself an amateur actor – often performing in tableaux for friends in his studio.[74] He also did portraits of actors, including two versions of the French caricaturist Felix Regamey.[75] Reputedly, the actor Daniel Bandmann was one of the models for his portrait of Hamlet.[76] The other models Hunt used were also men he admired – his brother Richard, whose idealized portrait is said to be Hamlet's face; and William Rimmer, who posed for Hamlet's hands. Hunt later reused the dramatic introspective pose of Hamlet for the Columbus or Discoverer figure in the Albany mural, and in a modified way for his *Self-Portrait* (fig. 75).

This *Self Portrait* is one of Hunt's most notable works and arguably one of the best done in the nineteenth century by an American artist. It is a work that is light in appearance but dark in mood; there are no distracting details. Dressed in a plain black suit, the artist is set against a rich cream background. Like Hamlet's, his arms are crossed tightly across his chest. His gaze is not meditative but almost defiant as he looks directly out at the viewer. Yet his closed, protective pose seems to form a physical barrier between himself and the world. For Hunt, this pose signified the private isolation in which he and his heroes lived. Hamlet, Columbus, and, for Hunt, Lincoln were tragic figures who sacrificed personal happiness to important ideals. They were models for Hunt. Although it may be presumptuous to equate his misfortunes with those

FIGURE 75. *Self Portrait*, 1866. Oil on canvas, 30″ × 25″. Courtesy, Museum of Fine Arts, Boston. (William Wilkins Warren Fund)

78

suffered by Lincoln, at the time when Hunt's thoughts on these men were recorded, in the 1870s, he was risking social ostracism, his physical and mental health, and ultimately his life in his struggle for artistic autonomy. Such thoughts are reflected in a conversation one night with a friend, the publisher James Fields, when Hunt talked about "his own life as a painter; of his lonely position here without any one to look up to in his art; his idea being misunderstood; of his determination not to paint cloth and cheeks, but the glory of age and the light of truth."[77]

CRITICAL RECEPTION

During the Civil War years, Hunt exhibited sporadically and only in Boston. In 1865, he sent three paintings to the National Academy of Design: *The Listeners, The Singers,* and *The Circassian* (unlocated). The first two, as noted in an earlier section, were the most Pre-Raphaelite–inspired works Hunt ever painted. Yet even they did not conform to a critical taste for highly detailed and finished compositions – a style given full support by *The New Path*. This publication had begun in 1863 under the leadership of Clarence Cook, who had recently been appointed art critic of the *New York Daily Tribune*. Reviewing the 1865 exhibition, Cook wrote on Hunt's work for the first time.

> Mr. Hunt who in former years showed ability that we watched with interest, as hoping that it would ripen into noble fruit, has reappeared after a long absence in a most disappointing way. We look upon these three pictures of his as mere simulacra, the dead presentment of dead things. They have no meaning, no intention, they are idle vagaries of a person who has nothing whatever to say, and so says it. It is recorded of somebody, "He knew not what to say and so he swore." We might parody the statement: "Mr. Hunt knew not what to paint so he daubed." But we admit that, even in his daubing, which is flagrant, there is evident the power to paint.[78]

In contrast, the reviewer for *Harper's New Monthly* was effusive in his enthusiasm for Hunt's "purely poetic pictures."[79]

In the spring of 1866, Hunt sent to New York a more varied group of works, including two charcoal portraits, one of which was probably *Horace Gray;* two oil portraits, the *Portrait* [Mrs. Milton Sanford] (unlocated) and *Mother and Child;* and his *alto-rilievo* of the *Horses of Anahita*.[80] The *Nation*'s reviewer (who may have been the architect and critic Russell Sturgis), like the reviewer in *Harper's New Monthly* the year before, was full of praise, comparing Hunt's portraits of Mrs. Sanford and Mrs. Hunt favorably with the portraits by the then dean of American portrait painting, Charles Loring Elliott:

> This [Elliott's portrait of a school-boy] is probably the best
> portrait in the exhibition unless the two oil portraits by Mr.
> William M. Hunt, of Boston and Newport, are better. . . . No.
> 342 [*Mother and Child*] is a very vigorous portrait, life-size and
> about three-quarter length, of a lady holding a child, a picture
> showing considerable power of drawing and great skill in lay-
> ering in color. No. 405 [*Portrait*] is smaller, half-length and
> also life-size, a lady's head shown against a background of light
> grey and gold, wall-paper, namely, and framed with angular
> appropriateness. We know of no work of Mr. Hunt's so good
> as his portraits, and these are among the best of his portraits.[81]

Yet this same writer roundly condemned Hunt for submitting the two char-
coal sketches: "Useful studies they may be but only as a private memorandum
of the artist, and the disposition on the part of some people to admire such
things is very harmful."[82]

As already mentioned, Hunt was committed to the charcoal medium, and
his presumption in submitting these sketches went to the heart of the con-
troversy surrounding the influence of modern French painting in this country
and in France itself. At that time (and for several preceding decades) the most
innovative French painters – Delacroix, Corot, the Barbizon painters, and
later the Impressionists – saw the sketch as prime evidence of an artist's
originality. It was the spontaneity and originality of the first impression in a
sketch that they, as well as Hunt, sought to retain in their finished work.
Hunt's dedication to the sketch was first absorbed in Couture's studio, and
he applied these lessons in his own work and passed this advice along to his
students. "Paint every day, as a matter of course . . . Paint a hundred sketches
of anything you please, and stack them up. Perhaps one of them will be a
picture."[83]

Cook, too, was enraged that Hunt chose to exhibit his sketches:

> His charcoal sketches ought not to have been exhibited; not
> merely because they are ill done, but because they betray the
> artist's vicious way of working. It is not often that a man shows
> so little reserve as to confess—"Here is my finished picture;
> you see how bad it is. Well, the reason it is so bad, is that this
> is all the study I had for it!" Mr. Hunt might just as well have
> written these words on the frames.[84]

Nevertheless, these reviews do not give the full story; by the mid–1860s,
Hunt was an influential and important American artist, and his reputation and
paintings were sufficiently well known to warrant notice in two major books
on contemporary American art: *The Art-Idea* (1864), by James Jackson Jarves,
who cited Hunt as "evidently on the road to eminence"; and *The Book of the
Artists* (1867), by Henry Tuckerman, who hailed him as an "original artistic

genius."[85] In addition to their enthusiasm for Hunt's work, both writers held in common a belief that the modern French school offered the best hope for American painting.

Jarves (who had been educated at Harvard) spent many years in Europe, where he assembled a notable collection of early Renaissance paintings (which, to his disappointment, were rejected by the Boston Athenaeum in 1859). Jarves's first book, *Art-Hints, Architecture, Sculpture and Painting* (1855), was conceived as a "primer of art history written for Americans having no knowledge of the Old Masters." But his second book, *The Art-Idea: Sculpture, Paintings and Architecture in America* (1864), included a critique of contemporary American art. The first half of *The Art-Idea* was, again, a history of art, interspersed with thoughtful admonitions on art's beneficial effect and its compatibility with contemporary attitudes toward God and nature. In this connection, Jarves wrote as an enthusiastic follower of Ruskin, who greatly influenced him in his appreciation of Quattrocento Italian painting. Yet Jarves, unlike some other followers of Ruskin, never advocated or trumpeted a particular style or aesthetic and thus escaped the narrow dogmatism of Stillman and Cook.

Jarves's important contribution, however, came in the second half of *The Art-Idea*, where he discussed at length the work of contemporary American artists. In a chapter entitled "The New School of American Painting," he cited the various European schools in which American artists were trained, singling out the strength of the French school, which "mainly determines the character of our growing art." He then explained why he thought this study should be encouraged:

> Were the French school what it was under the Bourbons, or the Empire even, conventional, pseudo-classical, sensual, and sentimental, deeply impregnated with the vices of debauched aristocracy and revolutionary fanaticism, we should have been less inclined towards it than to any other. But it crosses the Atlantic refined, regenerated, and expanded by the force of modern democratic and social ideas. The art of France is no longer one of the church or aristocracy. It is fast rooting itself in the hearts and heads of the people, with nature as its teacher.[86]

Jarves identified La Farge, J. Foxcroft Cole, William Babcock, and Hunt as American artists who were actively following a French model. On Hunt, he commented:

> William Hunt is one of those who are over-inclined to disregard force of design for subtleties of expression, and color; but it is so deliciously done, and with so tender or fascinating sentiment, that one scarce notes the deficiency of special artistic virtue in the attractiveness of the whole picture. . . . His style is

vaporous, diaphanous, and unpronounced in outline, in fact, too insubstantial, but singularly clear, broad, and effective; nothing little or forced, though sometimes slight and incomplete in details of modeling.[87]

Like Jarves, Tuckerman was pro-French and not unsympathetic to the artists working in Boston (he had been raised there and had attended Harvard). He was also a close friend of Richard Hunt's and among the earliest to occupy space in Hunt's Tenth Street Studio Building, where Tuckerman maintained a residence until his death in 1871.[88] In his discussion of William's work, he touched on all aspects: portraits, monumental painting, sculpture, genre, lithographs, and illustrations. He began by acknowledging Hunt's contribution to the field of portraiture, stating that some of Hunt's portraits "are among the best produced by native art." Tuckerman's was also the first published mention of *The Flight of Night*, which he referred to as the *Morning Star*, "a picture which has long occupied this gifted artist." He then went on to predict that this painting "will prove a remarkable evidence of his original skill and feeling." He also saw Hunt's *alto-rilievo* of the horses of Anahita and noted: "For spirit, genuine action, and true character, the Horses of the Sun in this powerful conception show masterly talent. He first modelled them, and the cast is a fine study for sculptor or painter." But Tuckerman was most enthusiastic about Hunt's genre paintings: "Whether dealing with the animated expression of real life, or the *naïve* phases of nature, or the simple expression of character, there is a truth, grace, and power in his work that instantly reveal original artistic genius."[89]

In these appraisals of Hunt's art, one can discern the two schools of thought that dominated American art criticism in mid-1860s: one favoring a highly detailed rendering of natural phenomena as advocated by Ruskin and the American Pre-Raphaelites; the other endorsing the more suggestive and experimental treatment of form promoted by Hunt and the Barbizon painters. The consistent impression one gets from reviews of Hunt's work before 1866 (when he left Boston for a two-year tour of Europe) is that his great promise was widely acknowledged, and that his art was, to say the least, controversial. Critics who supported his work did so because they believed he brought a fresh, more expressive approach to American painting, particularly in the field of portraiture. Those who were critical of Hunt, particularly Cook, felt his work had no meaning, that it suffered because he did not work directly from nature. For Cook, the only way that nature, God's handiwork, could be faithfully recorded was with scientific accuracy. Speaking of Hunt's *Mother and Child*, he remarked: "The painter of this 'mother and child' has no method of his own, very little digested knowledge, and insists on thinking that the less he has to do with nature directly, the better."[90] Almost in rebuttal, Hunt later told his students: "The painter has to go directly to nature, or he is a mere copyist."[91] For Hunt, nature was inspiration and his approach to re-

cording it was broader, more expressive, and more conceptual than the di-
dactic approach of the American Pre-Raphaelites. What Hunt and the
Barbizon painters meant by "working from nature" was in marked contrast
to the view of John Ruskin and his followers. The painters associated with
the Barbizon school were more interested in observing and re-creating the
effects of light and atmosphere in the out-of-doors than they were in the
recording of detail. Furthermore, the painting of landscape was not an op-
portunity for sermonizing, but an occastion for highly personal and expressive
interpretations of nature. In contrast, the artists influenced by Ruskin's writings
believed that a true impression of nature was possible only through precise,
accurate rendering. Each school had its own conception of "nature," and each
its own approach to interpreting the natural world. It was, however, the
American followers of the Barbizon – George Inness, Homer Dodge Martin,
Alexander Helwig Wyant, George Fuller, Robert Loftin Newman, and Albert
Pinkham Ryder – whose more personal and expressive approach to the re-
cording of nature would triumph. Given the embrace by American collectors
and artists at the end of the century of Impressionism, in which the elusive
and changeable aspects of nature are celebrated, it is difficult not to cast Hunt
in the role of prophet.

3

Second European Trip and Teaching in Boston

BACK TO EUROPE: BRITTANY, PARIS, AND ROME

AFTER ELEVEN YEARS AT HOME and with the trauma of the Civil War behind them, Hunt and his wife decided to go abroad. In May 1866, they and their three daughters Mabel, Eleanor, and Enid left for Paris, which they used as a home base for a year. Hunt wanted to renew his friendships with Millet and other artists, but the trip's real purpose was to attend the 1867 Paris Universal Exposition, to which he had submitted six paintings. For Louisa, the trip was undertaken to revitalize their marriage: "We had grown old and hard," she recalled in her diary, "and needed a little romance peppered among our everyday life of cares."[1]

Hunt had been in correspondence with his friend Elihu Vedder, then living in Paris, who suggested a sketching trip to Brittany. Shortly after their arrival, Hunt and his family left for northern France, where he, Vedder, and Charles Caryl Coleman, an artist friend of Vedder's, set up a studio in the small medieval town of Dinan. (The better-known Pont-Aven, the Breton village made famous by the Nabis and Gauguin in the 1880s, is farther west and south, on the Atlantic Coast.) These three were among the earliest Americans to live and work in this primitive region, which had already attracted other artists (including Gustave Courbet and James Abbott McNeill Whistler) interested in working out-of-doors in an unspoiled natural environment.[2] In his autobiography, *Digressions of V*, Vedder described their studio and Hunt's enthusiasm for the locale.

> We found or made a large studio on the ground floor of an old house. It was literally the ground floor, for the floor was the ground, and Hunt delighted in it. You could make holes and pour in your dirty turpentine and fill them up again, and generally throw things on the floor, and Hunt used to clean his brushes by rubbing them in the dirt and dust. I remember his

84

once saying, "Wouldn't you like to take that mud in the road and make a picture with it?" The simplicity of Millet was strong upon him those days, and indeed affected his art the rest of his life.[3]

Vedder was right in his assessment, for Hunt felt a renewed vitality in Dinan – reflected in the number of canvases he did (some of which he later completed in Paris), two of which, *Dinan, Brittany* (fig. 76) and *The Quarry* (unlocated), he submitted to the Paris Universal Exposition.[4] These, along with other rural subjects – *Knitting in a Doorway* (unlocated); *Brittany Peasant Children* (fig. 77); *Cabbage Garden, Dinan, France* (1867, Graham Gallery, New York); and *Three Generations* (unlocated) – suggest that once back in Europe, Hunt again felt Millet's influence.[5]

Yet Hunt no longer aped Millet's style. By the late 1860s he had evolved his own technique – a firm contour, freer handling of paint, with less melodramatic coloring. Absent, too, is the melancholy infusing such works as *Belated Kid* or *The Little Gleaner*. Instead, Hunt rendered his subjects more naturalistically, incorporating them informally into their milieu. For instance, in *Brittany Peasant Children* his bold rendering of the stone and wood buildings, which shelter two small children, give the composition structure and assurance. His landscape painting *Dinan, Brittany* attests that he was also becoming more adept at painting directly from nature. Like the Barbizon painters, Hunt abandoned studio conventions and tried to represent with color alone: space and distance, naturalistic light, and the relationship between figure and landscape. Although not wholly successful – Hunt was not fully aware of how to capture the play of natural light (as he himself would later remark: "It's not easy to get a sky both light and colored") – this was a more complex landscape than he had attempted before, and his free application of paint suggests he knew that color would lead him to a new understanding of plein-air painting.[6]

Hunt's study of the landscape was further enhanced by the use of charcoal for his outdoor sketches in Dinan.[7] He had previously used this medium for still lifes and portraits but had never worked with it outside. Charcoal not only led him to a new understanding of color values but suited his impatient work habits as well. Long used by artists, charcoal was particularly valued by nineteenth-century artists, like Hunt, who wanted quickly to capture a first impression.[8]

Following his stay in Brittany, Hunt traveled to England. It is not certain when he went or how long he stayed, but while there he met Dante Gabriel Rossetti and other members of the Pre-Raphaelite Brotherhood. He also began a portrait of Charles Francis Adams, American ambassador to the Court of St. James, which he completed later in Paris.[9]

By the late 1860s, the revolutionary phase of Pre-Raphaelitism was over as its new leaders – Rossetti, Edward Burne-Jones, and William Morris – exerted enormous impact on all aspects of late Victorian taste. Hunt enjoyed

FIGURE 76. *Dinan, Brittany,* 1866. Oil on canvas, 22″ × 36″. Frederick D. Ballou. Photo: Courtesy of Vose Galleries, Boston.

his meetings with the Pre-Raphaelites and respected their support of each other's work, yet he found their exotic, literary paintings not at all interesting.[10] His training with Couture and Millet had put him at odds with their aesthetic, which prized the precise rendering of detail, whereas he himself was increasingly interested in capturing the spirit of a subject rather than a factual representation. Several years later Hunt described this philosophy to his students: "You see a beautiful sunset, and a barn comes into your picture. Will you grasp the whole at once in a grand sweep of a broad sky and a broad mass of dark building, or will you stop to draw in all the shingles on the barn, perhaps even the nails on each shingle; possibly the shaded side of each nail? Your fine sunset is all gone while you are doing this."[11] These sentiments, expressed in the the mid-1870s, not only stood in opposition to the dictates of Pre-Raphaelitisim, they were conceptually at variance with the prevailing aesthetic of the Hudson River School which favored the factual and the grandiose over the poetic and intimate.

In the late 1860s, however, these ideas of spontaneously recording a subject were not reflected in the dark, serious three-quarter-length portrait of Ambassador Adams (fig. 78), in which Hunt continues the unadorned naturalistic style of his Boston work. With its rich but subdued color harmonies of black, white, and gold, the Adams portrait is a respectful tribute to the man who only a few years earlier had successfully persuaded Great Britain to remain neutral during the Civil War. Although it is not as sparkling or as stylish as a portrait by Whistler, the family was happy with the result. Henry Adams, the historian, described it to his brother Charles Francis Adams, Jr., as being

FIGURE 77. [*Brittany Peasant Children*] *French Village*, 1866–7. Oil on canvas, 16¼″ × 11¾″. Virginia Museum of Fine Arts, Richmond. (Museum purchase: The Arthur and Margaret Glasgow Fund)

"just what a portrait of our papa should be; quiet, sober, refined, dignified, a picture so unassuming that thousands of people will overlook it; but so faithful and honest that *we* shall never look at it without feeling it rise higher in our estimation."[12] This evaluation would have pleased Hunt, for it was precisely those qualities of simple, honest representation that he wished to achieve in his portraits.

Back in France, Hunt spent five days with Millet in Barbizon.[13] This visit did not seem to have much impact; there is little mention of their reunion and, with the exception of the paintings done in Dinan, there is no further work by Hunt reflecting this renewed contact. In fact, two other Barbizon painters, Camille Corot and Charles Daubigny, would now influence him. Both became important models for Hunt's late landscapes, but Corot became an immediate inspiration for a series of figure paintings of Italian models. Corot's figure paintings, which today are among his most admired work, were not often exhibited during his lifetime. Hunt visited him, and it is assumed that works such as the *Italian Girl* (or *Roman Girl* [fig. 79], as she is sometimes called) were influenced by similar works by Corot, such as *Reverie (The Greek Girl)* (fig. 80); *Pensive Gipsy Girl* (1865–70, private collection); *Gipsy Girl at the Fountain* (1865–70, Philadelphia Museum of Art); and *Woman with a Book in Her Lap (Interrupted Reading)* (1865–70, Art Institute of Chicago).[14] In all of

these studies, as in Hunt's several versions of the *Italian Girl*, young women, often in ethnic costume, are recorded with a pensive air in classic, timeless poses and melancholic moods.

 The model for Hunt's paintings was no doubt one of the *pifferari*, or young Italians who had flocked to Paris in search of work at the time of the Exposition.[15] He also painted her male counterpart, two versions of which he exhibited at the Universal Exposition. One of these, *Italian Peasant Boy*, is at the Museum of Fine Arts, Boston (fig. 81); the other *Italian Peasant Boy* may be the oil sketch at the Metropolitan Museum of Art (fig. 82).[16] If so, it was a daring move on Hunt's part to exhibit both the oil sketch and the finished painting, for this was a highly controversial practice, only recently initiated in France.[17] In the preparatory sketch, Hunt proceeded in a straightforward manner, first drawing in the figure with a firm contour and then establishing his color values, a method of working he stressed time and again to his students: "Learn a simple manner of proceeding. Attack things in a broad, simple way; and, when done, you will find certain faults of color which you can correct – *in another picture*."[18] And there are "faults" in the sketch. The head is too dark, and the facial features are coarse and ill-defined, but he has

FIGURE 78. *Charles Francis Adams*, 1867. Oil on canvas, 59⅜″ × 34¼″. Harvard University Portrait Collection, Cambridge, Massachusetts.

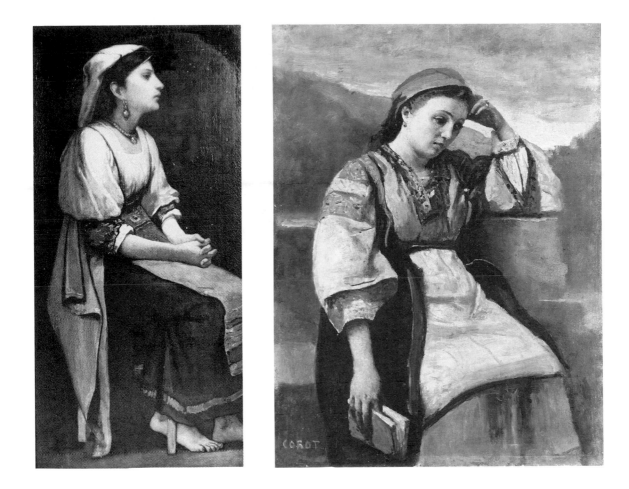

captured the slouched pose and jaunty air of his model. The finished, or Boston, version is more assured and more carefully painted, and in contrast to the city types Hunt painted earlier, such as *The Hurdy-Gurdy Boy* (see fig. 11), it is more factual and less anecdotal. He has also eliminated all background detail and the figure is effectively set off against a light background. Similarly, the same shift from sentimental genre to the more formal, naturalistic concerns of modern figure painting is seen in a comparison of his earlier *The Violet Girl* (see fig. 15), with the *Italian Girl*.

Hunt also found time during the late winter and spring of 1867 to complete a number of other paintings, including several begun earlier in Dinan and two posthumous portraits: one of Lt. Wolcott (see fig. 62) and another of Thomas Wren Ward (private collection), father-in-law of Mrs. Samuel Gray Ward, whom Hunt had painted a few years earlier (see fig. 44). Samuel Gray Ward, Baring Brothers' American representative, was in Europe and probably made arrangements to have his father's portrait painted at this time. Ward also agreed to loan the portrait of his wife to be shown at the Exposition.

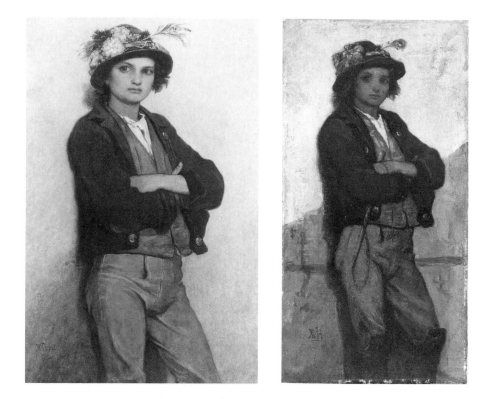

Hunt submitted it along with his portrait of *Abraham Lincoln,* two versions of the *Italian Peasant Boy,* and two Dinan landscapes.[19]

Europeans at the Exposition were more impressed by U.S. locomotives, Corliss engines, and McCormick reapers than by American art. Even Frank Leslie, the United States Commissioner of the Fine Arts, criticized the selection of artworks as being hastily arranged by influential dealers and collectors.[20] Yet the U.S. submissions were representative of the work being done by American artists during this transitional post–Civil War period. One could view the accomplishments of the Hudson River school painters Frederic Church and Albert Bierstadt; the debut of Winslow Homer as a painter; important works by Whistler, America's most famous expatriate artist; and a full range of paintings by Hunt. The only American painting awarded a medal, however, was Church's *Niagara* (1857, Corcoran Gallery of Art). The French – just as Americans and English had been – were overwhelmed with both the site and Church's ability to capture with such fidelity its awesome nature. The 1867 Exposition was also the occasion for Homer's first and only trip to Paris, where he exhibited his first major oil, *Prisoners from the Front* (1866, Metropolitan Museum of Art), a poignant reflection of his Civil War experiences as a reporter-illustrator for *Harper's Weekly.* Whistler took the occasion to display his notorious *Symphony in White No. 1: The White Girl* (1862, National Gallery of Art, Washington, D.C.), which, along with Manet's *Olympia* and *Luncheon on the Grass,* had caused a scandal at the 1864 Salon des Refusés.

FIGURE 81. *Italian Peasant Boy,* 1866. Oil on canvas, 38½" × 25". Courtesy, Museum of Fine Arts, Boston. (Gift of George Peabody Gardner)

FIGURE 82. *Italian Peasant Boy,* c. 1866. Oil on canvas, 16¼" × 8⅝". The Metropolitan Museum of Art, New York. (Bequest of Mrs. Martha T. Fiske Collord in memory of Josiah M. Fiske)

On the basis of the number of awards, however, the Americans not only ranked far below the French and English but, even more humiliatingly, won fewer prizes than the Norwegians, Swedish, or Swiss. National pride was shaken; Leslie, in his official report, took it upon himself "to indicate the causes why American art has not achieved for itself a higher position."[21] He began by stating that even though, relative to European nations, we were still a young country, we could no longer ignore our lack of progress in the fine arts. We were hampered by a lack of art schools and public galleries with "accredited works of competent masters." Most important, from his point of view, was the absence of "sound and judicious criticism."[22] Leslie's concerns were not just his own, for citizens of New York and Boston had already begun plans to establish public art museums. The Metropolitan Museum of Art in New York opened in 1870, and the Boston Museum of Fine Arts, in 1876 with its Museum School opening the following year. Cultural chauvinism was routed temporarily when, over subsequent decades, American art students left in droves for European academies.

After Hunt returned home he would play a central role in bringing modern European training to the United States; by June 1867, however, he and his wife needed a respite from the fair and took a two-week trip to Holland and Belgium. Louisa kept a diary or, rather, a memoir for her children, in which she made careful note of where they stayed, whom they saw, and the sights they visited – but other than a spiteful comment about her mother-in-law, she included little of a private or personal nature.[23] After spending the balance of the summer in Paris, the Hunt family left in September for a leisurely trip to Rome. They traveled first to Lyons, where they spent a few days, and then along the French Riviera to San Remo, Italy, where they spent the month of October in the Villa Rocco.[24]

There Hunt had time to paint, and did several sketches of the monks at the nearby Capuchin monastery with whom he had become friendly. In the painting *Monk Reading* (fig. 83) a bearded friar, dressed in the coarse woolen habit of his order, reads from a book of prayer on a tall lectern, recalls Hunt's Dinan painting *Brittany Peasant Children,* in which architectural forms order the composition.[25] The drier and more static quality of both these paintings suggests the linear manner of Vedder.

A stylistic connection between Hunt and Vedder has yet to be made, primarily because these few examples of Hunt's second European trip, when Vedder's influence was strongest, are not very well known. Similarly, little attention has been paid to Vedder's work of the late 1860s. Yet a number of works done by him at this time – such as *Woman Planting a Flower Pot, Vitre* (fig. 84) – display his characteristically strong contours, dry surface, and sharply contrasting color values, all qualities that distinguish Hunt's Dinan and San Remo paintings. Curiously, Vedder also did a series of paintings of monks in 1859; one of these, *The Monk's Walk – In a Garden Near Florence* (unlocated) was owned by Hunt or his sister.[26] At the time Hunt did these

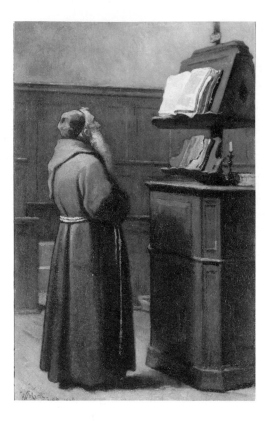

Sam Remo works, Vedder may have been on his mind, as one of the few friends Hunt was looking forward to seeing in Rome.

Upon their arrival, the Hunts were immediately swept up into the activities of the international colony of artists and writers, as well as socially prominent families from the United States. Louisa wrote: "We found ourselves surrounded by Americans, the Motleys our neighbors and very kind friends, the Carys, the [Edmund] Cushmans, etc. etc., and at the Story's house we saw all the nobby English people."[27] They also met Charlotte Cushman and Harriet Hosmer at the horse races in the Campagna. But this frenzy of socializing after the almost idyllic calm of San Remo upset Hunt, and Vedder, who had settled in Rome permanently, saw that his friend was not happy. Hunt was "like a fish out of water...he did not seem to thrive nor did he do much work."[28] In her journal Louisa confirmed Vedder's observation and noted that even after they had visited all the sights that "Murray's guide book considers imperative" and had been presented to the pope, the winter "was anything but a happy one." The problem was that none of them were well; as Louisa reported, William was "so nervous that he could do no work."[29]

Hunt was always excitable, but the particular cause of his nervousness is not known, although the relationship between him and Louisa had deteriorated. One could speculate that the social ambitions of the artist's wife were

FIGURE 83. *Monk Reading*, c. 1868. Oil on canvas, 8″ × 11″. Private collection. Courtesy, Vose Galleries, Boston.

FIGURE 84. Elihu Vedder. *Woman Planting a Flower Pot, Vitre,* 1866. Oil on canvas mounted on board, 7³/₄″ × 11¼″. Collection of the Hudson River Museum, Yonkers, New York. (Gift of the American Academy of Arts and Letters)

at odds with his need to be left alone to work, and to judge from the scant evidence in Louisa's diary, Hunt was also suffering from too much family togetherness. Louisa noted reproachfully that he was going home alone: "It was decided that we [she and the children] should move on to Florence and that there William and I were to separate. *He* to go to America for rest and for business, while I was to spend my summer at some German watering place seeking strength and renewal before appearing at home to the many criticizing friends who undoubtedly would decide that Loo Hunt had grown dreadfully old during her two years ½ sojourn in Europe."[30] In light of the Hunts' final separation in 1874, their hope of revitalizing their marriage on the trip had not been accomplished. Their last child – a son, Paul, born in 1869 – may have been the issue of their final attempt at reconciliation.

RETURN TO BOSTON: TEACHING AND PORTRAITURE

Characteristically, Hunt's disposition improved as soon as he was aboard ship and, as noted by a companion, the sculptor Thomas Ball, he was full of enthusiasm to begin teaching again. Ball had known Hunt in Boston: both had had studios in the Mercantile Building. He admired Hunt, and in his autobiography, *My Threescore Years and Ten,* devoted an entire chapter to him, in which he described their homeward journey:

> [When] I crossed the Atlantic, Boston-bound, in 1868, we were fellow-passengers. He was enthusiastic as ever, this time with the idea of going home to establish a class for the instruction of young ladies in Art. He thought there was a vast deal of talent among them that only required to be directed. Being confident of his faculty for imparting his knowledge, he considered it his duty, and that of every artist, to do all he could to lighten the path of those groping in the dark.[31]

93

Hunt was true to his word. In the fall of 1868, he announced in the *Boston Transcript* that he would accept students for instruction in charcoal drawing at his studio in the Mercantile Building on Summer Street. Many women applied and, during the seven years Hunt's school was in operation, more than fifty women enrolled in his class.[32] Among them were Helen Knowlton, Elizabeth Boott Duveneck, Rose Lamb, Sarah Wyman Whitman, and Elizabeth H. Bartol. Unlike Philadelphia and New York, Boston had no art academy, and instruction for women was thereby limited to the study of the useful arts at the Boston School of Design, or to attendance at Dr. Rimmer's spellbinding lectures on art anatomy at the Lowell Institute. Hunt himself taught for three years, but in 1871, his close friend, later biographer, and star pupil, Helen Knowlton, assumed responsibility for day-to-day instruction, although Hunt continued to visit the class daily for the next four years.[33]

Much of what is known about Hunt's teaching methods can be found in his book *Talks on Art*, the first volume of which was published in 1875. Judging from its contents, and the testimonies of several students, Hunt was a charismatic teacher whose methods were unorthodox. Unlike students at most European art academies, his did not have to advance through successive levels of instruction beginning with drawing from casts, then from live models, and finally to painting in oils. Instead, Hunt had them begin to work immediately in charcoal, to record spontaneously their first impression of a subject. For Hunt, drawing skill was not a prerequisite to artistic success. "There is force and vitality in a first sketch from life which the after-work rarely has. You want a picture to seize you as forcibly as if a man had seized you by the shoulder!"[34]

In reality, Hunt's method was an amalgam of Couture's instruction combined with twenty years of his own experience as an artist. Its strength was that his students were directly engaged with artistic expression uninhibited by years of academic drill. This strength also proved to be its weakness because his students were seldom able to develop their work beyond their initial impressions. As noted by the American artist Francis Millet, Hunt's students were "like people who have learned the beauties of a language before they can write or speak it."[35] Yet Millet, whose detailed and anecdotal paintings of historical genre are quite unlike Hunt's work, was a strong supporter of Hunt's philosophy:

> By his example and precept no less than by his direct teaching, he carried on a vigorous crusade against the mechanical and soulless practice of the profession, and fought with keen weapons against the tendency to conventionality that is rooted in the very subsoil of American art.... The pity is that more serious students, who were far enough advanced to digest and assimilate his teachings, should not have availed themselves of the great privilege of his leadership.[36]

94

In addition to teaching women privately in his atelier, Hunt was also active, along with Rimmer and La Farge, in setting up the School of the Museum of Fine Arts, which was established following the opening of the Museum of Fine Arts in 1876. Hunt was aware of the value of the new school's systematic method of instruction in the fine arts as contrasted to his own informal, unregimented approach. He conjectured that his students might have received better training there:

> I'm dreadfully afraid that they'll beat you at the Art-Museum School. There they are made to be as careful as can be about all their drawing. Perhaps I should have done better to have begun so with you. I preferred to show you how to make pictures, and to *will* you to learn, and to give you as much of my own life as I could. And that's a good way, if you'll take pains about the important things. But not one in a dozen of you ever uses a vertical line. You don't know what it is to dig.[37]

This may seem to contradict his constant exhortations to his students to capture the first impression of a subject; but Hunt believed equal attention had to be paid to the construction of the figure and to the overall composition. "I only ask you to take precautions at first; to hold up your perpendicular line and get the movement, to block your figure out in cubes, or whatever, and to keep the right relation of parts."[38] He took as his authorities not Couture or Millet or other contemporary artists but the old masters and the Egyptians. "Michel Angelo measured. Raphael measured. Albert Dürer passed many years trying to get a system of measurement for the human figure; carrying it so far that he found certain parts of the body to be so many lengths of the eye. One half of the art of the Egyptians is in their wonderful knowledge of proportion; but the Yank thinks it is smart to sit down and do horrible things without measuring."[39] Works by these old masters would have been familiar to his students, for his studio was filled with engravings, photographs, and casts. Examples of Egyptian sculpture were also available at the Museum of Fine Arts, which had acquired C. C. Way's collection of Egyptian art in 1872, four years before its formal opening.

After his return from Europe, Hunt resumed an active role in the social and cultural life of Boston, continuing to exhibit there as well as in New York. In 1868, he was officially reinstated as a member of the Harvard Class of 1844; and the following year, he was invited to join the Saturday Club. In 1871, he was elected an associate member of the National Academy of Design (although he was never officially instated, since he did not submit the required diploma portrait), and there exhibited the mistitled *Portrait of William Wardner*. (Lent by Maxwell Evarts, a prominent New York lawyer and politician, and friend of Richard Hunt's, this was in fact a portrait of Evarts's father-in-law, Allan Wardner.)[40]

Unlike his late figure and landscape paintings, Hunt's portraits do not
seem to have been affected by his travels in Europe. This may be due, in part,
to his often expressed frustration with the social demands of portraiture. Yet
his Wardner portrait and others are evidence that Hunt continued to be active
in this field. Many of his late portraits – *Francis Gardner, Mrs. Charles Francis
Adams, Judge John Lowell,* and *Ida Mason* – are among his finest. The Wardner
commission, a bust-length portrait of an old man with a beard, (known only
through a photograph), was one of three that Hunt did of the Evarts family
in Windsor, Vermont. Hunt, in some of his few remarks about his working
methods, said that he completed Wardner's portrait in an afternoon and took
it outside to see how it looked in natural light. "Some of the neighbors came
over to see it. They thought that it would do pretty well when it was finished."
Believing he had captured the spirit of the old man, Hunt said that the only
"finish" it needed was a coat of varnish.[41]

None of the completed Evarts family portraits have been located, but there
exist three studies for Hunt's portrait of Maxwell Evarts – one in oil and two
in charcoal (fig. 85).[42]

In his charcoal Hunt began by quickly sketching in his sitter's salient fea-
tures, ably capturing Evarts's informal yet elegant pose in a manner similar
to that employed for his earlier portrait of *Horace Gray* (see fig. 69). As in the
Gray portrait, Hunt's control of the charcoal is seen in his sure delineation
of Evarts's jacket, vest, trousers, and hair all done in various intensities of

FIGURE 85. *Maxwell Evarts,*
1870. Photograph of draw-
ing. The American Architec-
tural Foundation, Prints and
Drawings Collection, The
Octagon Museum, Washing-
ton, D.C.

96

FIGURE 86. *Francis Gardner, LLD*, 1871. Oil on canvas, 50″ × 41″. Boston Latin School.

black. Over these Hunt drew the outlines of lapels, collar, cuff, lips, eyebrows, and skin creases, rubbing out and lightening areas to show variations in color and texture. What emerges is an image of a determined and confident man who was soon to be appointed secretary of state in the Arthur B. Hayes administration.

Close in spirit to the Evarts sketch is the oil portrait *Francis Gardner, LLD* (fig. 86), headmaster of the Boston Latin School. Hunt had accepted this commission with pleasure because it came from the students themselves. Hunt's remarks on this commission confirm that he was less interested in the representation of social or professional status than in capturing his subject's character and energy: " 'At first thought I felt that he ought to be painted with a Latin grammar in one hand, and a ferule in the other; but when I came to see the man I knew that he should be painted for himself alone.' "[43] The qualities Hunt stressed were Gardner's direct gaze and open natural pose (unlike Hunt's self-absorbed pose in his 1866 self-portrait), which suggest a man both assured and accessible – ideal qualities for a headmaster. Gardner's portrait, like Evarts's, represents a confident man in an unceremonious attitude whose vital character is revealed through Hunt's sure handling of form.

The following year (1872) Hunt did two other notable works: *Portrait of Abigail Brooks Adams* (fig. 87) and *Judge John Lowell* (fig. 88). By 1871 the Adamses had returned from England, and that summer went to visit Hunt at his home in Readville, to commission him to paint Mrs. Adams's portrait.

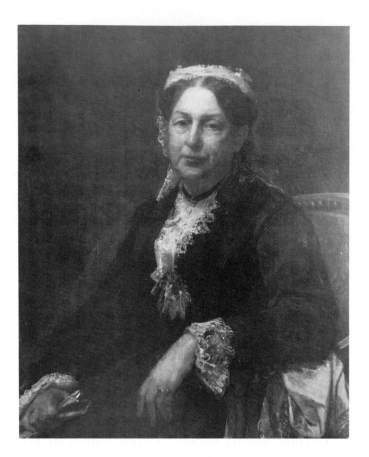

FIGURE 87. *Portrait of Abigail Brooks Adams* (Mrs. Charles Francis Adams), 1872. Oil on canvas, 40½″ × 35½″. Adams National Historic Site, Quincy, Massachusetts.

They also discussed this commission with their son Henry, who eventually negotiated a price with Hunt in January 1872: "By the way Hunt charges from $1000 to 1200 for a half-length such as you want.... Preliminary arrangements are all made." Hunt finished the portrait in April, and Charles Adams noted in his diary that he "was very well satisfied with its style, both as a likeness and a work of art."[44]

The painting of Mrs. Adams, for which there are no known studies, is both technically and expressively one of Hunt's most handsome female portraits. Set within a warm brown-and-gray interior enlivened by crimson highlights, she gazes out at the viewer from a French-styled upholstered chair. Her even gaze is complemented by her pleasant demeanor and relaxed yet dignified pose. Hunt's use of color – warm grays, ruby reds, and whites – gives this portrait a lovely radiance.

Unlike Mrs. Adams's, little is known about the John Lowell commission or even about the relationship between Lowell and Hunt, who were classmates at Harvard and fellow members of the Saturday Club. The Lowell portrait, in which Hunt omitted all indications of the man's office or status (although Lowell was, at the time, federal district court judge for the the State of Massachusetts), is in the same spirit as the genial seated portrait of Gardner. Hunt

98

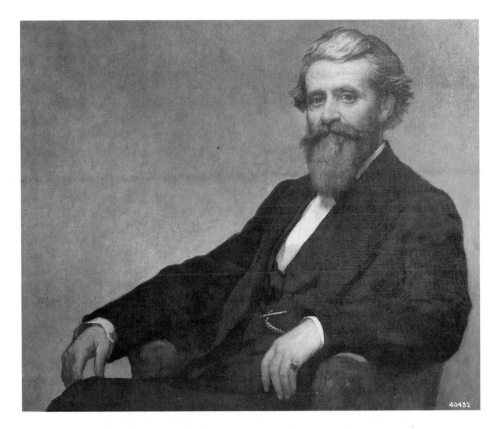

FIGURE 88. *Judge John Low-ell*, 1872. Oil on canvas, 31″ × 36″. Harvard University Portrait Collection, Cambridge, Massachusetts. (Gift of the Estate of Ralph Lowell)

made an interesting compositional change, however, using a horizontal instead of a vertical format and placing Lowell's seated figure comfortably along this extended base. In addition, Hunt, by pulling the figure even closer to the picture plane, gives it greater command over the composition. Even more than in his earlier standing full-length portrait of Judge Lemuel Shaw, the greater informality of Lowell's portrait is in keeping with Hunt's desire to render portraits as personal tributes rather than as symbols of office.

This new strength in his portraits paralleled the increased attention Hunt gave to figure painting. Figure painting, as opposed to portraits or genre figures, was common in Europe but, with the exception of works by artists such as Allston, William Page, and Henry Peters Gray — all of whom had studied abroad — was relatively unknown in America. Whether for puritanical reasons or simply a devotion to landscape, artists in the United States were slow to appreciate that a thorough grounding in figure study was the traditional basis of Western pictorial composition. Most often female, the human face and form become objects for artistic contemplation without the distraction or need to represent personality, status, or anecdote. In Hunt's case, the study of the figure offered him the opportunity to explore new formal problems: the way color values expressed volume and the relationship of the figure to its surrounding space. And, in fact, Hunt developed two different kinds of

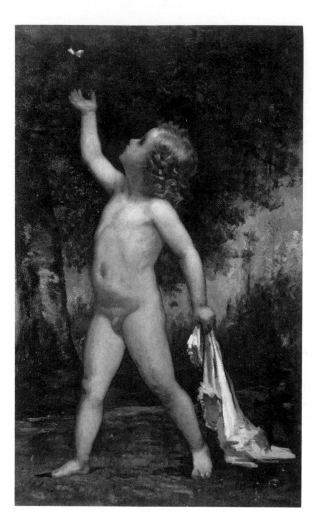

figure painting: full-length figures in landscape settings; and profile heads, often done as demonstration pieces for his classes. In two full-length figure paintings – one of his son, Paul, entitled *Boy with Butterfly,* and a third version of *La Marguerite,* known as *Marguerite* – Hunt tackled one of the most challenging artistic problems in late-nineteenth-century painting – the representation of a figure in real space without recourse to illusionistic devices.

Although frequently referred to in the Hunt literature, *Boy with Butterfly* (fig. 89) (which has been in a private collection until recently) is not well known.[45] It is a large, life-size composition of a darkly lit garden dominated by the figure of a nude male child reaching for an elusive butterfly barely discernible in the left-hand corner of the canvas. His contrapposto pose is artificial, yet it forms the principle axis of the composition and is a crucial element in Hunt's determination to connect the image of the young boy to his outdoor surroundings. He attempts to link the figure and background through repetition of similar shapes and colors, but the crucial elements of light and atmosphere are missing.

FIGURE 89. *Boy with Butterfly,* 1870. Oil on canvas, 50¾" × 30¼". William Morris Hunt II. Photo: Courtesy of Vose Galleries, Boston.

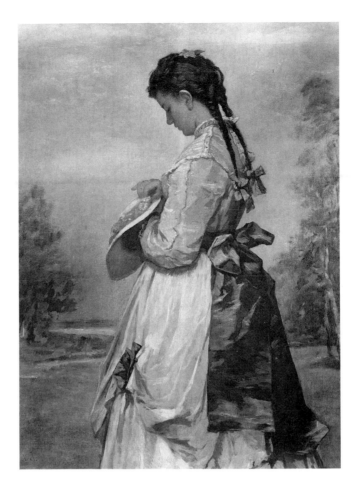

The second figure painting, *Marguerite* (fig. 90), like *Boy with Butterfly*, is both a figure study and a portrait placed in an outdoor setting.[46] The sitter was Berthe Williams, the daughter of the Archbishop of Boston, A. D. Williams.[47] The story goes that at the end of one of her sessions for her formal seated portrait (private collection), Miss Williams, while "arranging the date for her final sitting, . . . stood for a moment, hat in hand, toying with the flowers that surrounded it. 'I must paint you like that!' exclaimed Hunt."[48] Her unselfconscious pose reminded him of his earlier *La Marguerite* painted in France, and on the spot he decided to paint an updated, American version.

As in its French counterpart, there is nothing coy about the pose; it is entirely natural, with a quiet, reflective quality that is becoming to the girl's fresh beauty. In comparison with Hunt's earlier Marguerites, there is far greater assurance in his rendering of the figure, and the light striking her face and clothing is more faithfully rendered; yet this figure study, like *Boy with Butterfly*, still smacks of the studio. The sketchily outlined trees that frame the sitter seem to be painted on a backdrop against which the vividly painted figure is flatly depicted. In these two very different but equally ambitious works, Hunt, with varying degrees of success, investigated the new challenge of

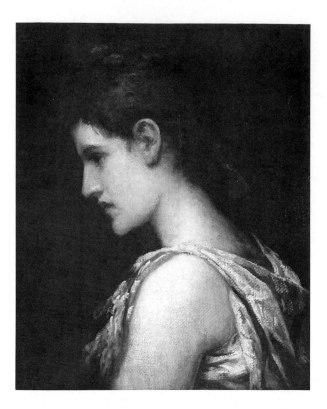

integrating the figure and space. He would later achieve more convincing results with his two versions of *The Bathers* done in 1877.

The other type of figure painting explored by Hunt at this time, profile heads set against undefined backgrounds, were, like his earlier *Lost Profile*, much more experimental and often used as demonstration pieces for his students. In fact, two of them – *His First Model – Miss Russell* (c. 1873, Cleveland Museum of Art) and *Miss Jane Tuckerman* (unlocated) – were probably done in large part by Hunt's students.[49]

Two of his best-known studies from this period were based on literary themes: *Elaine*, a return to the Tennyson subject he had lithographed in 1860; and *Priscilla*, a figure based on Henry Wadsworth Longfellow's *The Courtship of Miles Standish* (1858). Neither, however, contains any literary associations other than its title. *Elaine* (fig. 91), with its beautifully integrated gold and brown tonalities and free brushwork, is an updating and transformation of the artist's early lessons with Couture. Yet it is not nearly as freely painted as two studies of the same model. Both called *Priscilla*, the Pennsylvania Academy version, formerly known as *Girl with White Cap* (fig. 92), was probably the first of the two. It is a bravura display as Hunt deftly defines the planes of the face, the texture of hair, and the shape of the white collar and cap through color alone. In this version he proceeded just as he instructed his students to

FIGURE 91. *Elaine*, c. 1873–4. Oil on canvas, 20″ × 16″. Bennington Museum, Bennington, Vermont.

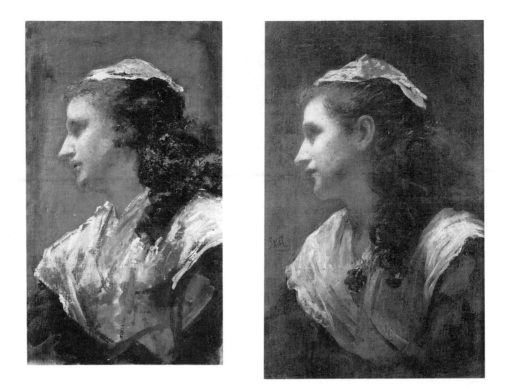

FIGURE 92. *Priscilla* (for-
merly *Girl with White Cap*), c.
1873. Oil on canvas, 24″ ×
14″. Courtesy of the Penn-
sylvania Academy of the
Fine Arts, Philadelphia.
(Henry D. Gilpin Fund)

FIGURE 93. *Priscilla*, c.
1873. Oil on canvas, 24″ ×
15¼″. Courtesy, Museum of
Fine Arts, Boston. (Bequest
of Mrs. Edward Jackson
Holmes)

do: "Consider masses – values, only.... At first sacrifice the beauty of your drawing to getting values."[50]

In the second and more finished version, *Priscilla* (fig. 93), the contrast between lights and darks is better modulated as Hunt worked toward a more harmonious integration of tonal values. The salient details of the face are drawn in and the brushwork is more suppressed. One can almost imagine that Hunt was completing this work in front of his raptly attentive students when he said: "What makes an eye beautiful? Not the eye itself, although there are intrinsic forms which we acknowledge to be beautiful. It is the *regard*, the soul; and, in part, what surrounds the eye."[51]

There are two other sets of figure studies: two done from a model known as Miss Jane Tuckerman, and two known as *Portrait of a Young Woman*, all of which further illustrate Hunt's innovative approach to figure painting. Jane Tuckerman, the niece of Rose Lamb (a favorite pupil of Hunt's, to whom he later wrote many letters regarding his work in Albany), appears in two studies – *The Amazon* (fig. 94) and *The Gainsborough Hat* (fig. 95).

In both, Jane Tuckerman, chic in a feathered hat, is Hunt's gayest and most vivacious model. She obviously took great delight in striking various poses and moods, which he recorded quickly and deftly. The first study was probably the inaptly named *The Amazon;* Miss Tuckerman hardly looks ama-zonian. This study was not a revelation of character but, rather, Hunt's record

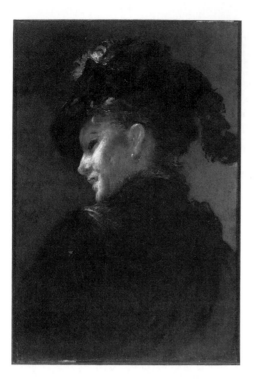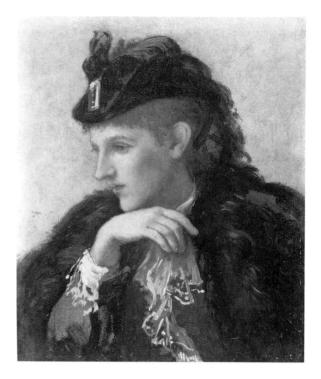

of his model's dazzling backward glance, which he captured through a virtuosic application of light and dark values. The second version, *The Gainsborough Hat,* is much more studied and less spontaneous, and unlike *Priscilla* or *Elaine,* it comes closest to being a finished portrait. Yet Hunt created – through quick, expert brushwork, which delineates her jaunty hat, the lace collar and cuffs – another bravura study.

The last set of figure studies – both known as *Portrait of a Young Woman,* both the same size – returns to the two-step development of *Priscilla.* In the *Portrait of a Young Woman* (fig. 96), Hunt drew in the outline of her shoulder and then with rapid strokes rendered her upswept hair and dress. Her face was quickly brushed in, its contours defined by Hunt's perception of light and how it models form. Only a faint outline separates the figure from the background, which appears as a thin wash of tonal values. In the more finished version (fig. 97) there is greater contrast between the background and the figure, and the details of the face and hair are more carefully rendered. Her dress, however, was left as an undefined mass of expressive brushwork.

PERSONAL LOSS: THE BOSTON FIRE AND ITS AFTERMATH

These four productive years – 1868–72 – were tragically interrupted by the great fire which on November 6, 1872, destroyed not only large areas of

FIGURE 94. *The Amazon,* c. 1876. Oil on canvas, 24″ × 16″. Collection Akron Art Museum, Akron, Ohio. (Bequest of Edwin C. Shaw)

FIGURE 95. *The Gainsborough Hat,* c. 1876. Oil on canvas, 22″ × 18¼″. Courtesy, Museum of Fine Arts, Boston. (Gift of the Estate of Mrs. James T. Fields)

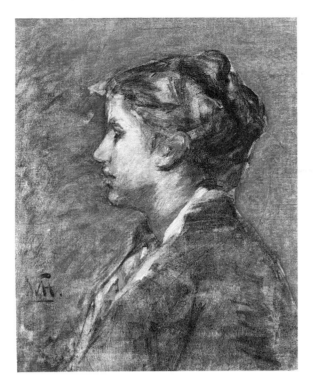 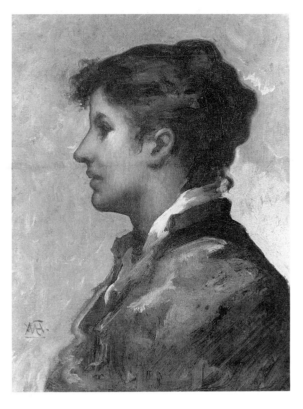

FIGURE 96. *Portrait of a Young Woman*, c. 1872. Charcoal and oil on canvas, 20″ × 16½″. M. R. Schweitzer Gallery, New York.

FIGURE 97. *Profile of a Young Woman*, c. 1872. Oil on canvas, 20″ × 16″. Location unknown.

central Boston but much of Hunt's life's work – including, a nearly completed canvas of *Anahita;* the standing portrait of Abraham Lincoln; and many paintings by the Barbizon masters Millet, Corot, Diaz, and others that he had acquired for his children.[52] This disaster was recorded by Hunt in a charcoal drawing, *Boston Fire* (fig. 98) whose blackened, smoke-filled sky above and devouring flames below recall Turner's *Burning of the Houses of Parliament* (1835, Cleveland Museum of Art).

These years following Hunt's return from Europe were also marred by further difficulties with his wife, problems that resulted in a final separation in 1874. Although little mention is made of the their estrangement in published accounts of Hunt's life, what actually transpired can be pieced together from the journals of William's sister, Jane. She was extremely loyal to her brother, so her version may be prejudiced; she makes no mention of Hunt's impulsive behavior, nervous temperament, and close friendships with many of his female students, particularly Helen Knowlton, which led his wife to accuse him "of leading an immoral life."[53] Jane, who never married, and lived with her mother until the latter's death in 1877, was an artist. She studied with Hunt periodically, and with Helen Knowlton in 1873–4. In her journals (as yet unpublished) she recorded her own comings and goings and those of her mother, her brothers (William, Leavitt, Jonathan, and Richard) and their families.[54]

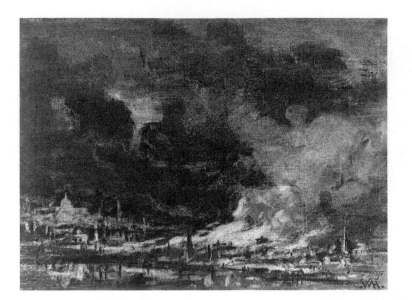

FIGURE 98. *Boston Fire*, 1872. Charcoal on paper, 8½" × 11¼". Courtesy, Museum of Fine Arts, Boston. (Gift of Misses Aimee and Rosamund Lamb)

According to Jane, the relationship between William and Louisa (called Loo by her family and friends) worsened in the summer of 1873. Hunt, still depressed six months after the fire, complained bitterly to his mother and sister about his financial losses.[55] But by early August, he was well enough to join his family (including Jane) and Helen Knowlton for a short – but fateful – trip to Plymouth, Massachusetts. It is not clear from Jane's journal whether the family's troubles were due to the hot weather, poor accommodations, or the provocative presence of Helen Knowlton. Evidently the children enjoyed the journey and were unaffected by the charged emotional atmosphere; but by the time the party arrived in Plymouth, trunks had been lost, Jane had had a "bilious attack," and Louisa would not leave her room.[56] An undated notation at the end of Jane's entries for August suggest that Loo had had a nervous breakdown and was sent to Squantum (probably a sanitorium) for six weeks.[57] Insanity, Jane felt, ran in the Perkins family.[58]

In contrast, Hunt's health improved, and by November 1873 he was back at work in a temporary studio in the Mason and Hamlin Building, 154 Tremont Street, where he did a number of portraits, including one of his wife, which would indicate they were briefly reconciled.[59] But by the spring their separation was final. Hunt had not been home for months, and Louisa threatened divorce. Jane's assessment was that it would "be the best thing for all."[60]

Yet it is not clear from her account whether or not William and Louisa were ever legally separated or divorced. Louisa's enmity toward Hunt continued the rest of his life for, according to Jane, she accused "Wm [*sic*] of different things. He said nothing to her but felt horribly. Went to see her most she could say was that Wm swore at her. She prejudiced the children against him." Richard's wife, Catharine, also confirmed that Hunt and his

wife were never reconciled and stated that Louisa even refused to attend to William's funeral.[61]

What is difficult to assess, given the defense of Hunt by all the members of his family, is Lousia's true villainy. She remains a shadowy figure barely mentioned in Knowlton's understandably biased account. The most important document is Louisa's diary, which reveals a woman of little reflection, someone concerned with status and important tourist sights. Yet this is not the full story. Louisa, not Richard or Jane, was the executor of Hunt's estate. She inherited a great many of his paintings and sketches, which she and her children sold over the years. Nor can one easily explain her vigorous campaign to save Hunt's murals when they were threatened with destruction. Was this done out of genuine concern for her husband's artistic reputation, or was it the hollow gesture of a widow who needed to maintain her identification with her artist husband?

The years 1868 to 1872 marked an important transitional period in Hunt's personal life and career. Those spent in Europe, even though overshadowed by family tensions, were productive. There, Hunt began to appreciate the particular expressive qualities of charcoal, a medium that would later aid him in a new investigation of landscape. Through Corot and others he gained a new appreciation for the figure as a principle base of compositional design. Such lessons and insights he later shared with female students in Boston. In fact, he probably felt the most productive and the most at peace with himself during the early years of his teaching.

This period of professional renewal following Hunt's European sojourn was tragically interrupted by the loss of his studio in the Boston Fire. It would take two years for him to recover, a time made more difficult by the estrangement with his wife. Yet during this period, trips with friends to Florida and to Latin America rejuventated him physically and emotionally, and in the last years of his life he would go on to make a lasting contribution to American art in landscape and mural painting.

4

Years of Recovery and Renewal: 1873–1878

PREOCCUPIED WITH HIS LOSSES FROM THE BOSTON FIRE and the ongoing problems with Louisa, Hunt was depressed and unable to work. In March 1873, his friend John Murray Forbes invited him to his home in Magnolia Springs, Florida. As usual, travel restored Hunt's spirits. The following spring he took another trip with Forbes to Florida by way of Cuba, and in 1875 went back to Cuba and then to Mexico with another friend, Greeley S. Curtis. In these exotic southern locales, away from his studio, his students, and family distractions, Hunt turned to sketching out-of-doors. Over the next three years, 1875 through 1878, Hunt continued his exploration of the landscape in Massachusetts and New York, evolving a new aesthetic that inspired his students as well as an entire generation of Boston painters.[1] For Hunt, landscape became the ideal subject that, along with figure painting, allowed him to put into practice his commitment to capturing the true impression of a subject. As he told his class: "All that makes anything live is expression. *Look through form* for expression. The *essence* of form is a great deal finer than form."[2]

FLORIDA AND OTHER LANDSCAPES, 1873–1875

Although Hunt already had done a few landscapes, it was in Florida that he saw nature anew, abandoning artificial formulas of linear or aerial perspective for a direct and personal interpretation of the scene before him. At the Forbes's winter home on the St. John's River, Hunt found a new freedom, both personally and artistically, which had eluded him in Boston and even in Europe. He was inspired by the uninhabited semitropical vistas along the rivers and bayous of northeastern Florida. Unlike such contemporaries as Church and Inness, Hunt seldom painted panoramic views, confining himself to a more intimate engagement with his subject. Done in muted colors, many

of these unpopulated views convey a vague melancholy and sense of loneliness, characteristics that may reflect Hunt's depressed psychological state.

The most important discovery Hunt made in Florida was that when he confined himself to recording a few essentials, he could more effectively record his personal response to nature. In one of his earliest attempts, a loosely sketched rendering of *Sunrise, St. John's River* (fig. 99), Hunt, with an economy of means, re-created the quiet, atmospheric impression of dawn. The narrow riverbank, a series of dark diagonal strokes, is connected to the water beyond by two pieces of driftwood, right and left, while the horizon is marked only by a rising sun and long dark gray strands of fog. Early Florida views like this are among Hunt's starkest and most abstract compositions.

Many of his Florida works were done in charcoal on standard 8½-by-11-inch drawing paper. Normally, he began by creating a frame within which he quickly transcribed the basic elements of the scene before him — an overhanging limb, a small boat, a river's edge. He would then structure his composition through a series of horizontal planes, in which the banks of a river run parallel to the horizon with a flat zigzag pattern that leads the eye from foreground to background. To achieve spatial depth, the foreground is left empty and linked to the middle distance through reflections on the water. Building on these basic elements, Hunt created works of pure compositional design enhanced by the subtle rendering of tonal values. A good example of his approach is a charcoal *Governor's Creek, Florida* (fig. 100), in which the foreground is an open expanse of water with the middle distance marked by two men in a boat, behind whom is a dark densely forested peninsula. To the right, in lighter tones, is another more distant shore. A calm stillness pervades this scene enhanced by the stable reflections on the smooth surface of the water. The result is a decidedly modern, and French, interpretation of landscape composition found in the contemporary work of Corot and Daubigny.

In a later example of his Florida work, *Rainbow Creek* (fig. 101), Hunt continued his fascination with these river vistas. The fugitive play of light and shadow on water, in particular, dominates the composition — recalling the work of Daubigny, who, of all the Barbizon painters, is the one most often associated with the rendering of the riverbanks and flat marshes of northern France. As was Hunt in his Florida views, so too was Daubigny compelled to re-create the luminous reflective light and vaporous atmosphere along French rivers. Hunt, an admirer of Daubigny's, spoke of him in reference to a landscape he was working on in the mid–1870s: "I've just finished this little sketch, painting it in twenty minutes, with the intention of getting light in a sky.... I wasn't trying to paint like any one: but I know that when I look at nature I think of Millet, Corot, Delacroix, and sometimes of Daubigny."[3]

In contrast, Hunt's Florida views are very different from the work of the Luminist Heade, who also painted the marshes and rivers of Florida, as well as the northeastern coastal areas of Newport and Gloucester. Heade's work

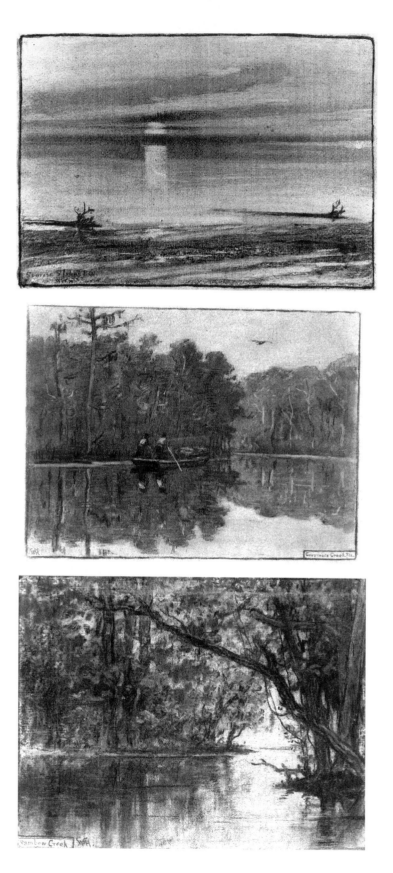

FIGURE 99. *Sunrise, St. John's River, Florida*, 1873. Charcoal on paper, 8″ × 11″ (sight). Courtesy, Museum of Fine Arts, Boston. (Purchased from the Estate of William Morris Hunt)

FIGURE 100. *Governor's Creek, Florida*, 1873. Charcoal on paper, 8⅜″ × 11⅛″. Courtesy, Museum of Fine Arts, Boston. (Gift of L. Aaron Lebowich)

FIGURE 101. *Rainbow Creek*, 1873. Charcoal on paper, 7⅞″ × 9⅞″. Courtesy, Museum of Fine Arts, Boston. (Gift of Mary W. Bartol, John W. Bartol and Abigail Clark)

– for example, *Great Florida Sunset* (1887, The Henry Morrison Flagler Museum, Palm Beach, Fla.) or even smaller, quieter works like *Stranded Boat* (1863, Museum of Fine Arts) – shares certain compositional similarities with Hunt's but reveals very different artistic ideals. Heade had an almost microscopic interest in the recording of detail with a coloristic intensity that lifts his work beyond the mere recording of fact. Whereas Heade wanted to create a timeless infinite space, Hunt wanted to capture the here and now.

The first exhibition of Hunt's new landscapes was in February 1874 in the library sales room of Leonard & Co. in Boston. Of the sixteen works exhibited, seven were Florida views. An anonymous writer, obviously familiar with Hunt's painting and reputation, was not only highly complimentary but wrote with evident understanding of the landscapes: "The scene on the banks of the St. John's River is full of soft southern light and warmth, pulsating with tropic heat but dreamy with tropic languor." In a later piece, the same writer noted with pleasure Hunt's charcoals, valuing them (as had Henry James earlier) above the oils: "The little collection of charcoal drawings . . . are even more attractive than some of his color studies, several of the Florida sketches being so admirably done that they suggest everything the brush could supply."[4]

After his last southern trip with Forbes in March, Hunt spent the summer traveling and recording landscape views in Massachusetts: Watertown, Newton, Weston, Waltham, and Milton – all then rural communities, to the west and south of Boston. Hunt exhibited his new landscapes at the annual Boston artists' exhibition the following spring.[5] These works included *Summer Sunset; Autumn Foliage – Newton Lower Falls; Silver Lake and Factory; Storm; Autumn Afternoon – Watertown; Milton Farm; Spring – Watertown; Charles River Above Waltham;* and *Beach Scene with Horses.*

The last named, known today as *Beach Scene with Two-Horse Cart* (fig. 102), is one of the few that can be identified from the listings in the catalogue of the Artists' Annual Sale.[6] With its strong horizontal emphasis, it is a painting closely related to Hunt's Florida landscapes. The group of two men, with their horses and cart, placed between a deeply recessed space and an empty foreground, gives strong definition to the middle distance of the painting and makes this a very felicitous composition. Hunt's principle concern, however, is not with the figures or the topography but with recording the particular light found on that North Atlantic beach.

Hunt's new landscapes were not without their detractors. Those he exhibited in 1875 incited the wrath of several Ruskinian critics in Boston, including the Harvard professor Charles Herbert Moore, who expressed complaints similar to those voiced about Hunt's paintings in New York in the mid–1860s.[7] Moore had for many years lived in New York, where he was a founding member of the American Pre-Raphaelite group, the Society for the Advancement of Truth. Another one of its members, and editor of its journal *The New Path*, was Clarence Cook, Hunt's most vocal detractor. Through Cook,

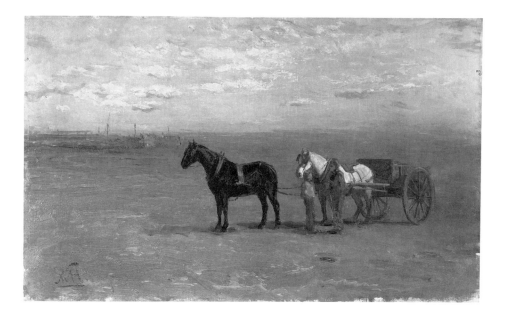

FIGURE 102. *Beach Scene with Two-Horse Cart*, c. 1874. Oil on canvas, 15″ × 24″. Courtesy, Museum of Fine Arts, Boston. (Bequest of Miss Mary Frothingham Hooper)

Moore's dislike of Hunt's work may have been long-standing; in any case, Hunt's new impressionistic landscapes were the antithesis of Moore's own work and that of the American Pre-Raphaelites. Moore moved to Cambridge in 1871, having been invited to lecture on art at Harvard by Charles Eliot Norton, Ruskin's closest friend in the United States, who himself had only recently been appointed to the Harvard faculty.[8]

The exhibition, which opened on March 9, was reviewed three days later in the *Boston Daily Advertiser*. In this short announcement the writer attributed the work being done in Boston to the French school and singled out Hunt's work for praise: "In his studies of the landscape he shows his genius in a keen and subtle observation of the important and poetic features of it, and his daring and brilliant management of color and effects oftentimes is surprising."[9] By 1875, other American artists, notably Whistler and Inness, had begun to make an impact with their landscapes of mood. Hunt's contribution to this important shift from the documentary and literal in American landscape painting to the more personal and evocative, is not well known. The battles Hunt fought in Boston to gain acceptance for this new approach paralleled the contemporaneous French Impressionists' challenge to the academic establishment. Like the Impressionists, Hunt inspired a new generation of artists in New York to disregard the dominance of the older academicians and to declare the validity of individual and personal interpretations of nature.

Central to Hunt's new aesthetic was the importance of the sketch as the genesis of one's true response to nature. This attempt to capture his first impression led many critics to decry the lack of finish or sketchlike quality found in many of his works. These objections, raised by three disgruntled critics – an anonymous writer who was identified by three asterisks, and the

artists Christopher Pearse Cranch and Moore – created a firestorm on the editorial pages of the *Daily Advertiser*, a controversy intensified by the contemporaneous publication of excerpts from Hunt's *Talks on Art* in many local newspapers. In their minds Hunt's words only served to promote the new sketch aesthetic and modern French school.[10] The writer identified by three asterisks began his letter with a quote from *Talks on Art* (which were first known as "Studio Talk") and went on, "these words quoted from 'Studio Talk' of Mr. Hunt, . . . have, I know, roused in many minds a wish to protest against teachings false in theory, vicious in practice, whose effects upon art are well illustrated by the canvases Mr. Hunt exposed lately for sale."[11]

The next day, Cranch, a painter of landscapes and still lifes from New York who had recently moved to Cambridge, joined the debate but confined his remarks to lamenting the works' sketchlike quality: " . . . the eye naturally demands details of drawing, gradation of tint, etc., which it fails to find. These artists will paint a face at a short distance by a dab of flesh-color, without any suggestion of features. Ought not so important a truth as eyes, nose and mouth be at least *suggested?*"[12] In response, the writer of the Fine Arts column for the *Daily Advertiser*, known as "B," came to the defense of the Boston artists, declaring: "There is no academy here where they can study; they have little opportunity to see the world's famous pictures; they are artists because they love art, and love nature; they have made the most of what teaching and opportunities have been within their reach."[13] This writer went on to applaud, in particular, Hunt's work, stating that although he had seen many works that were quickly executed, seldom had he "seen one which showed signs of carelessness, and rarely one which failed to leave a clear impression of its purpose upon any observer whose perception was not dimmed by some theory of 'finish.' "[14]

In this same issue of the *Advertiser*, Moore for the first time joined the criticism of Hunt's "Studio Talks." Moore placed his comments in the context of another issue that was of great concern to Bostonians at the time – that of art education. For Moore there was little difference between the "loose teaching [of Hunt's] on the one hand, and the amazingly stupid and mechanical teaching now furnished under the auspices of the State on the other."[15]

Hunt did not reply to Moore's attack, probably because he was in Cuba with his friend Greeley, but Walter Smith, director of the Massachusetts State Normal Art-School, defended his institution and Hunt's "Studio Talks," which he considered "friendly criticism in the words of an artist rather than as maxims for the instruction of a student." His defense of the state system, which he administered, was detailed and amazingly free of rhetoric. In it Smith pointed out that an experiment with the Ruskinian approach to drawing had been unsuccessful and that in any case, the state system was charged with teaching "*industrial* art" not "*fine* art."[16]

This debate over art education was summarized in the August issue of the *Atlantic Monthly*, the influential Boston-based journal published by Hunt's friend

James Fields. The anonymous writer of the "Art" column (who may have been Hunt's friend and Harvard classmate Edward Wheelwright) began by discussing Hunt's *Talks on Art*, which he described as "full of sparkling and epigrammatic sayings" and, unlike Cranch and Moore, compared favorably to Hunt's paintings: "It [*Talks on Art*] gives the impression, as do Mr. Hunt's paintings, of a frank, fearless single-minded artistic nature, with keen perceptions and great power of expression, mature study and convictions, and withal singularly free from egotistic assumption."[17] He then went on to describe the debate that surrounded the simultaneous publication of Hunt's *Talks* and the studio exhibition, linking both to "other controversies concerning the different systems of art instruction in use among us." Although he admitted to not knowing which system was best, he deplored any system that stressed "the mere power of execution – that is, to take the means of art for art itself." This was intended as a rebuke not so much to Moore but to the state system, which, although it was instituted to teach "mechanical and industrial drawing," still needed to instruct students "to render the essential character or beauty of the subject drawn." The best form of instruction would be one that reminded students that "the object of learning to draw is not to make pictures or drawings, but to develop and train perceptions."[18] Interestingly, he concluded by linking Hunt and Ruskin: although "their methods and results differ outwardly," both were committed to "the development of the artistic sense, against mechanical and technical display."[19]

This debate over the appropriate type of instruction for both the fine and practical arts, which went on for several years, was also reflected in the discussions surrounding the creation of the Museum School, which opened in 1877 as part of Boston's new Museum of Fine Arts. Hunt, La Farge, and Rimmer, along with nine prominent Bostonians, were members of the Permanent Committee for the Museum School.[20] After deliberating they decided to establish a program of study in which students, "surrounded by the best of influences . . . in the collections of the museum," would be trained as artists, not as teachers, and the instructors would themselves be "*artists* rather than schoolmasters." Sylvester Baxter, writing in *The Art Journal*, noted that this method of instruction was based more on "the academic freedom prevailing in the greater school of the Continent, than the conventional rules and restrictions of the Royal Academy in London."[21]

But the controversy surrounding Hunt and his "clique," as it was called, continued into the summer. In June, Moore denounced examples of modern French art included in the loan exhibition of the Boston collector Quincy Adams Shaw, several of which he acquired from Hunt, who in the mid-1870s, following the fire, had severe financial problems. In his letter Moore accused Corot and Millet of "vague and inaccurate drawing" and a "shallow grasp of a subject," comparing them unfavorably to the old master works included in Shaw's collection, specifically Paul Veronese's *Marriage of St. Catharine*, " . . . in point of mere drawing; in which respect it may be a very well timed and

salutary lesson. . . . Let one's eyes get filled with this work and then turn toward the loose sketching of modern French pictures which hang in the same room."[22]

Hunt, after his return from Cuba, wrote a scathing reply, which he began by indicting Harvard (and indirectly Moore himself), where in his opinion art education was "carried to [such] a dizzy height . . . [that men such as] Jean François Millet are ranked as triflers."[23] He then went on to defend members of the modern French school – Géricault, Delacroix, Ingres, Courbet, as well as the Barbizon painters – all of whom, according to Hunt, were "devoted students of the qualities in Veronese of which few beside them know anything!" Moore had, in fact, chosen the wrong example, for Veronese was an artist Hunt admired and, as he told his students, "Paul Veronese has more qualities as a *painter* than any man who ever lived. Our idea of making a 'faultless' thing is all nonsense."[24]

This dispute was carried on in the newspapers and was significant enough to warrant an extended discussion during the autumn in the *Atlantic Monthly*, where it was mentioned as part of the ongoing discussion concerning art education. "It [the controversy between Moore and Hunt] has brought forward for a second time the sharp difference of opinion among teachers of art and painters in Boston and Cambridge, which the publication of Mr. Hunt's Talks on Art had revealed in the spring." In his avowed attempt to ameliorate the debate, the writer expressed his own point of view: "As for detail, it seems to us that two things have been included under this term, actual detail, and the *effect* of detail. Now Veronese's *Marriage* gives us both; but in Millet we find the two separated."[25]

The truth is that the heyday of Pre-Raphaelite influence in America was past. By 1870, even Moore had abandoned oil painting unable to fulfill the stringent and painstaking demands of the detailed work advocated by this group. In Boston its influence had never been strongly felt anyway; early on, critics and connoisseurs objected to the literalness and dry factuality of Pre-Raphaelitism. Instead, Boston artists and collectors embraced the modern French school and the French-inspired work of Hunt. In addition, the spring of 1875 saw yet another influence appear in Boston, the Munich-inspired paintings of Frank Duveneck. And it was Hunt who had invited Duveneck to exhibit at the Boston Art Club, where he had his first critical success in America.[26]

The Duveneck exhibition was favorably discussed by the "Art" writer for the *Atlantic Monthly*, who singled out *Head of a Professor* (fig. 103, now known as *The Old Professor*), which was bought by Hunt's friend Henry Angell. In the context of Bostonians' familiarity and appreciation of art that was not just about surface detail, this writer's probing comments indicate a sophisticated appreciation for Duveneck's boldly aggressive painting. "The relief into which the face is thrown, by the management of light and shade and the liberal application of thick paint to the illuminated portions, is high and startling;

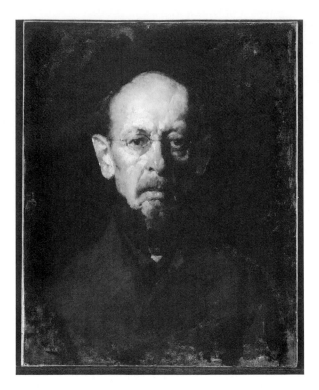

FIGURE 103. Frank Duveneck, *The Old Professor*, 1871. Oil on canvas, 24″ × 19¼″. Courtesy, Museum of Fine Arts, Boston. (Gift of Martha B. Angell)

the small canvas is fairly blistered with the pigment that goes to the construction of the rough chin, protuberant cheeks, and warworn nose."[27]

These were no doubt the same qualities that fascinated Hunt, who studied the portrait at length one June evening on a visit to Angell. "He took it in his lap and fondled it for a half hour or more, even while talking of other matters. A few evenings later he begged us to lend it to him for a few days; he wished to see how it looked in his studio."[28]

The success of a new generation of European-trained American artists was also beginning to be felt in New York, which was dominated by the conservative exhibition-policies of the National Academy of Design and a second generation of Hudson River school artists.[29] In April 1875 a group exhibition was organized by La Farge, Francis Lathrop, and others at the Daniel Cottier Gallery in New York. Hunt was represented by an early work, *Girl at the Fountain*, and an example of his freer, more expressive figure-painting style, *Priscilla* (see fig. 93). On the whole, the works exhibited were primarily Barbizon-inspired. Among the participants, many of whose works had been rejected by the National Academy of Design, were Albert Ryder, Abbott Thayer, and female pupils of Hunt and La Farge, including Knowlton, Elizabeth B. Greene, Susan Minot Lane, Alice M. Curtis, Elizabeth Boott, Adelaide E. Wadsworth, and Elizabeth Howard Bartol. To further emphasize their desire to separate themselves from the restrictive exhibition practices of the National Academy of Design, and perhaps in emulation of the 1874 Salon des Indépendants in Paris, these artists referred to this as an exhibition of

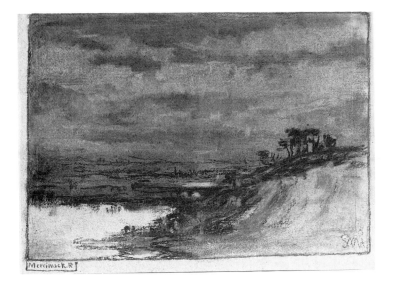

FIGURE 104. *Merrimac River*, 1875. Charcoal on paper, 8″ × 10¾″. Courtesy, Museum of Fine Arts, Boston. (Purchased from Estate of William Morris Hunt.

independent artists. In other words, works representing all "schools" were included. This early group attracted others, mainly artists who were trained in Paris and Munich, and a new association emerged, the Society of American Artists, which, with its first exhibition in the spring of 1878 at the Kurtz Gallery in New York, successfully challenged the aesthetic hegemony of the National Academy of Design.

Meanwhile, Hunt continued to explore the Boston environs for landscape vistas in a painting van he had especially built to facilitate his traveling. Angell recalled:

> During August of this year [1875] Mr. Hunt was very busy in the construction of what he called his van, – a large covered sketching wagon, commodious enough to live in while on a sketching tour; built, as he said with great glee, "by a man who builds gypsy wagons." It had all kinds of drawers in it for pots, kettles, and painting utensils, and was to be drawn about to eligible sketching grounds by a span of horses.³⁰

Hunt immediately put the van to good use by inviting Salisbury Tuckerman, the marine and landscape painter and former head of the New England School of Design, to join him on a sketching trip to Curzon's Mill, West Newbury, Massachusetts, near the North Shore and the Merrimac River.

In December, Hunt exhibited at Leonard & Co. the works done that summer. They included *Across the Merrimac; On the Banks of the Artichoke River; Landscape – West Newbury;* and *Wood Interior – Artichoke River.* As with the landscapes done the year before, no works with these exact titles have been located, but several with similar names have been found: one charcoal, *Merrimac River* (fig. 104), and two oils with almost identical titles: *Sand Dunes, West*

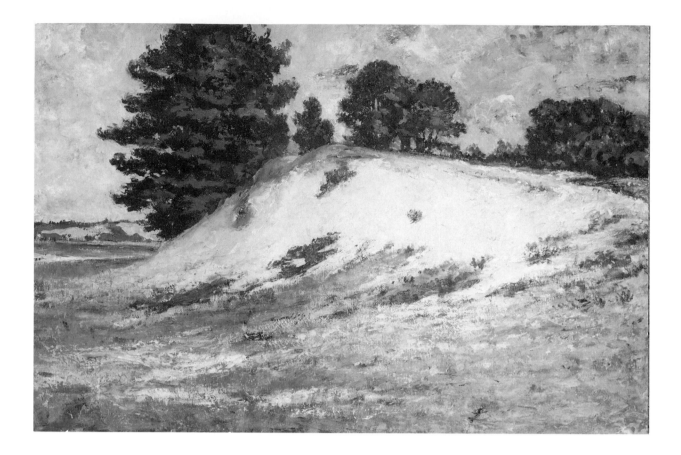

Newbury (fig. 105, location unknown), and *Sand Dunes, Newbury* (fig. 106, Amherst College Amherst, Mass.).

All three are of different locales, yet Hunt seemed to be particularly intrigued by the motif of a high sandbank, which is a dominant feature in each. In *Merrimac River*, one of the few panoramic views Hunt undertook, there is little evidence of a foreground. Seen from a distant vantage point, a wide river winds past a high bluff on the right. The bluff is topped with trees, diminished in scale and set high above the horizon line. But the true subject of the work is the gray, overcast sky, whose pearly light sheds a silver reflection on the water below. In works such as these, evocations of vaporous atmosphere and incandescent light, the influence of both Whistler and Corot, are evident.

The two oils of Newbury, equal in size and nearly identical in composition, are of two different sites but perhaps the same area. In contrast with the charcoal, in both these paintings the horizon line is in the center, and the sandbank, or bluff, dominates the composition. However, as we look at their features in detail, they become dissimilar paintings. In the Bell version, densely leafed dark green trees atop and behind the dune interrupt the cloudy blue sky. These dark forms arrayed across the top of the canvas form a vivid contrast to the empty sweep of light, barren space in the foreground. In the Amherst version, the sand dune does not as aggressively dominate the horizon.

FIGURE 105. *Sand Dunes, West Newbury*, c. 1875. Oil on canvas, 20″ × 30″. Mr. and Mrs. Harold Bell.

118

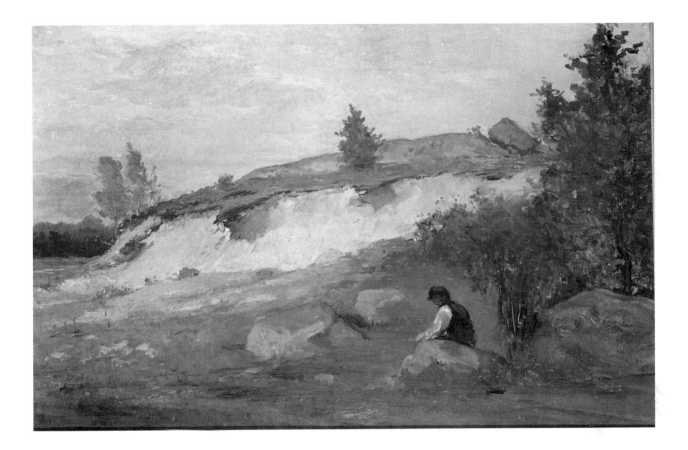

FIGURE 106. *Sand Dunes, Newbury*, c. 1875. Oil on canvas, 20½" × 30½". Mead Art Museum, Amherst College, Amherst, Massachusetts. (Gift of Herbert W. Plimpton, The Hollis W. Plimpton '15 Memorial Collection)

And the trees, instead of being next to each other at the top of the painting, are along a diagonal on the right-hand side, the middle, and the background to the left so that our eye moves naturally from the front to the back of the painting. Most important, though, is the figure seated in shadow at the bottom of the painting. This humanizing presence, along with a tall, shaded clump of bushes on the right-hand side, serves as a balance and foil to the brightly illuminated face of the sand dune. No longer a vacant landscape, the Amherst version is the recording of a peaceful view of nature in the late afternoon.

Most of these works, the basis of several exhibitions Hunt participated in early in 1876, were favorably received, and the controversy sparked by Moore and Cranch as spokesmen for Pre-Raphaelitism had disappeared. In fact, a writer for the Boston *Evening Post* saw the winter 1876 exhibition of the Boston Art Club as now representing the "two schools of American painting" – their sources Paris and Munich.

TALKS ON ART

As already mentioned, Hunt's *Talks on Art* (First Series) received a great deal of local attention even before it was published by Houghton Mifflin on March 29, 1875. The response, nationally and internationally, was such that an ad-

ditional volume of *Talks,* known as the Second Series, was brought out in 1883, after Hunt's death. A British edition was also published, by Macmillan in 1878, with an introduction by the British painter Lowes Dickinson, who, on a trip to Boston in 1873, had met Knowlton and Hunt and encouraged them to publish Hunt's studio notes.[31] Dickinson's introduction also contained, surprisingly, extracts from a letter by the Pre-Raphaelite painter John Everett Millais, who acknowledged that Hunt "says vigorously a good many things we [artists] say amongst ourselves."[32]

Originally, Knowlton had recorded Hunt's lectures in preparation for taking over his classes in 1871, and Hunt was reluctant to publish them because they might not be understood by the general public, and because "parts of the book would arouse enmity, especially in the minds of literary people." It is not clear whether Hunt meant that professional writers would object to their informal and discursive style, or whether he was anticipating the objections of his Ruskinian critics. In any case, "his objections were finally overcome by [Dickinson] and by several American friends who were in the habit of meeting at Levi Thaxter's house in Newtonville."[33] (Thaxter, whose portrait Hunt painted in 1871 [private collection], was a Browning scholar and husband of the poet Celia Thaxter. Levi's influence is found in Hunt's marginalia, which included several quotations from Browning, whose verbally complex but essentially optimistic poetry found an enthusiastic American audience in the 1870s.)

As a direct transcription of Hunt's teaching method, *Talks on Art* is neither a painting manual nor coherent course of study. Rather, it is a compilation of Hunt's comments on his students' work and his observations on art and artists. Neither Hunt nor Knowlton made any attempt to organize his statements systematically, and on every page there are abrupt jumps from one topic to another. Yet there are several "lessons" Hunt sought to give, lessons that are echoed in the writings of later American artists: don't draw reality, draw the appearance of reality; get your impressions from nature; look for the big things; strive for simplicity; be persistent; draw from memory; be carefully careless; paint for fun; facts are not poetry; get the effect of light and you won't miss color; substance is better than finish.

Shortly after the appearance of *Talks on Art,* Inness discussed for *Harper's New Monthly Magazine* his own ideas on contemporary art and artists, which in many way are remarkably similar to Hunt's. Inness, the most important landscape painter of his generation, led the change in American landscape painting from the factual pictorial demands of the Hudson River school to the more personal and evocative aesthetic of the late nineteenth century. Because of his acknowledged indebtedness to European art, particularly the masters of Barbizon landscape – Rousseau, Corot, and Daubigny – he has, like Hunt, retained an equivocal role in American art. Like Hunt, Inness believed it was the artist who evolved the rules of art, not the academy, and that the aspiring painter should paint freely what he saw. In response to the

question "What is it that the painter tries to do?" Inness replied: "Simply to reproduce in other minds the impression which a scene has made upon him."[34] In Inness's view art, like poetry, was not to point a moral or tell a tale but was to be valued on its own terms.

A younger artist, and one very different in temperament, Albert Pinkham Ryder, shared with Hunt and Inness a passion for representing what the mind and emotions understood, not what the eye perceived. In his almost abstract, often small, visionary landscapes, influenced equally by nature and literature, Ryder's paintings are far removed from the detailed and monumental land-scapes of midcentury. In 1905, Ryder, writing on his progress as a painter, came close to summarizing many of Hunt's ideas: "The artist should fear to become the slave of detail. He should strive to express his thought and not the surface of it.... It is the first vision that counts... Nature is a teacher who never deceives."[35]

The genesis of Hunt, Inness, and Ryder's new views on art was European, particularly nineteenth-century French, painting. Hunt's *Talks* is therefore valuable as an overview of the leading French influences in American art. In many respects the artists he admired form the history of early modernism from Romanticism through Realism, from Géricault and Delacroix to Courbet and the Barbizon masters. *Talks* also speaks of their accomplishments in the context of the old master tradition that included, among others, Michelangelo, Velázquez, Titian, Veronese, and Rembrandt. Hunt's ideas reflect foremost his training with Couture and study with Millet – their heroes were his – but his *Talks* also embodies the ideals of late romanticism with its elevation of heroic genius and reverence for individual expression.

Such ideas are also found in the writings of William Hazlitt and Hippolyte Taine, whose work Hunt urged his students to read – specifically Hazlitt's *Criticisms on Art* and *The Round Table*, and Taine's *Art of Greece*.[36] Neither writer has received much attention from historians of American art, so their influence on aesthetics in this country is not widely known. Hazlitt, one of the foremost English essayists of the nineteenth century, wrote on all the arts during the heyday of English romanticism. His writings on art were an antidote to the academic rules of beauty set down earlier by Sir Joshua Reynolds in "Discourses on Art." Like Hunt, Hazlitt expressed strong personal enthusiasms, endorsing works by Rubens, Rembrandt, Hogarth, and the Elgin marbles because of their "truthfulness." Hazlitt contended that beauty was not an abstract concept but one that emerged through the painter's observation of the reality that was true for his times. Thus the painfully honest paintings by Hogarth (whose work Reynolds abhorred) were as beautiful in their way as the Elgin marbles were in theirs. The same sentiments were more fully de-veloped by Taine in his quasi-scientific theory that true art was the product of the artist's race, moment, and milieu.

Taine, a French philosopher, critic, and historian, succeeded Viollet-le-Duc as a professor of aesthetics and art history at the Ecole des Beaux-Arts

in 1864. His lectures, which were translated and published in the 1870s in the United States, were widely read, even by the young Louis Sullivan, who, as a high school student in Boston, was introduced to his teachings. Taine believed that the true artist was the one who could most sensitively perceive the currents of his time through the ideas he read in books and discussed with others – all these sources being manifestations of the artist's times and the country in which he lived. Therefore, art modeled on formulas of the past is not appropriate for the present. Instead, true art is a reflection of those images and ideas closest to the artist in spirit and time. Although this deterministic theory makes the artist seemingly a passive agent, for Hunt, and for others, Taine's theories confirmed the central role of the artist, not the critic or theoretician, as the one true judge of art. Taine's theories lent strength to Hunt's conviction that expressiveness in art was more valuable than correct drawing and the accurate representation of factual detail. Hunt exhorted his students and the public to prize sentiment and feeling over pure mechanical skill, urging his students and readers to value the expressive simplicity of Corot and Millet over the technical virtuosity of Meissonier and Bougereau: "When I say great Frenchmen, I mean great painters – Géricault, Delacroix, Millet, Corot, Diaz, etc. Do not confound them with Gérôme, Cabanel, Bougereau, and the like."[37]

Hunt was not the only artist influenced by Taine's concepts. Although not cited as such, Taine's ideas also formed the basis of La Farge's art theories as expressed in a series of lectures he gave at the Metropolitan Museum of Art in 1893, later published as *Considerations on Painting*. In his introduction to these lectures, La Farge tells his audience (and readers) that he will "consider how the artist has expressed his view of the world, how he has seen it, with what body and senses, what hereditary memories, what memories of acquired liking, what development of memory through study, and what personal combination of all these factors."[38]

These views – that it was the individual artist, often at odds with popular taste, who determined the nature of art and beauty – were further reinforced by quotes Hunt included in the margins of his First Series. Appearing in the last twenty pages, the quotes were placed at right angles to the text, which itself ran the width and not the length of the page. (In addition, the quotes have to be read from the last page forward.) By choosing this seemingly eclectic mix from the writings of Hazlitt, Ruskin, William Blake, and Browning, Hunt demonstrated the wide currency of his ideas.

The first selection is two stanzas (one stanza per page) from Browning's "Old Pictures in Florence" (published in *Men and Women* in 1855), a poem Hunt quotes from again on page 68. The poet deplores his contemporaries' misunderstanding of the old masters, expressing Hunt's own view:

> But the wronged great souls – can they be quit
> Of a world where all their work is to do,

Where you style them, you of the little wit,
Old Master this and Early the other,
Not dreaming that Old and New are fellows,
That a younger succeeds to an elder brother,
Da Vincis derive in good time from Dellos.[39]

In addition, Hunt cited three other poems by Browning, all of which expressed the same sentiments: five stanzas from "Red Cotton Night-Cap Country" (1873); ten lines from "Fra Lippo Lippi" (also included in *Men and Women*); and the entire poem "The Book and the Ring," which was the concluding passage from the much longer *The Ring and the Book* (1869).[40] In this latter, Browning also describes the power art has to express truth in a way often unavailable to the poet:

But Art, – wherein man nowise speaks to man,
Only to mankind, – Art may tell a truth
Obliquely, as the thing shall breed the thought,
Nor wrong the thought, missing the mediate word.
So may you paint your picture, twice show truth,
Beyond mere imagery on the wall, –
So, note by note, bring music from your mind,
Deeper than ever the Andante dived, –
So write a book shall mean, beyond the facts,
Suffice the eye and save the soul beside.[41]

Also echoing Hunt's sentiments were homilies by Blake, such as "the eye sees more than the heart knows," "enthusiasm is the all in all," "we are led to believe a lie when we see with, not through the eye," and "*servile* copying is the great merit of copying." As it turns out these quotes are from a broad range of Blake sources, all of which were included in Alexander Gilchrist's important two-volume biography, *The Life of William Blake*, which, when it appeared in 1863, effectively resurrected Blake's reputation and established his importance for a new generation. It is doubtful that Hunt was acquainted with Blake's work earlier, and it may be that his sole knowledge of Blake came from Gilchrist's writings. Perhaps Hunt identified with Blake's legendary status as an artistic genius unappreciated in his time, whose visionary paintings were thought to have been done by a madman.

The one curious note about these quotations is that they are all by English writers and artists and not by French ones, a rather surprising selection given Hunt's many years of study on the Continent. But in view of the roles Dickinson and Millais played in the publication of the *Talks*, Hunt may have been making a deliberate attempt to appeal to a British audience. One British admirer was the photographer Peter Henry Emerson, who, in his book *Naturalistic Photography for Students of the Art*, includes quotes from *Talks on Art* and recommends it to his readers.[42] In any case, the quotations were all clearly

chosen to reflect his own views on spontaneity, originality, personal expression, and tradition in art. Yet many of them also reflect his pessimism and disdain for popular opinion.

In keeping with his devotion to individual expression, Hunt also makes frequent reference to innumerable painters, writers, musicians, composers, and other figures of note – past and present, European and American. However different in their time and achievements, most of these individuals had qualities Hunt admired – dedication, creativity, and integrity. References to such figures were intertwined with his art instruction and should not be thought of separately. Obviously, Hunt believed it was just as important to provide inspirational models as to transmit the specifics of drawing and painting. And he communicated to the women who studied with him that the creative life was all-consuming, being well aware that some of his students viewed his art classes as an alternative to going to their dressmakers: "They little know the suffering that one must undergo before he can paint anything in Art. What do they know about sacrifice?"[43]

When excerpts from his *Talks* first appeared in newspapers, one even-handed commentator noted: "But with all these apparent drawbacks, and for all its faults – for there *are* faults – this compilation of Mr. Hunt's 'Talks' is by all odds the soundest and best text-book on art in the English language." Farther along he described Hunt as an iconoclast who "tramples upon the old traditions of the profession, laughs at the various 'schools,' kicks over the carefully and laboriously reared 'methods' [and] defiantly breaks the rules which young art students are taught to look upon as sacred."[44]

This was in fact Hunt's achievement. His *Talks* remains important as the most complete document we have on his views on art. It also came at a time of enormous change in American art and reveals Hunt's crucial role in precipitating not only the acceptance of European models and teaching, but a vision of art that did not rely on formula, an art whose power derived from the individual artist's sensibility. There was no formula for good art; art instruction, although it could be enhanced by the study of the old masters, should be free from recipes.

It would be inappropriate to claim that these ideas originated with Hunt; nevertheless, he was the first American artist of stature to attack the problems of earlier art instruction and appreciation, and to put forward new ideas that made art a more immediate and personal experience. Although Hunt is not valued so highly as an artist today as others of his era, artists have continued to value his courage and ideas. In the twentieth century, the group of artists in Robert Henri's circle, known historically as the Ashcan school, were familiar with Hunt's *Talks*. For them, *Talks*, with its emphasis on individual expression rather than academic formula, echoed their own advocacy of independent and diverse styles. Henri, also a great teacher, shared many of Hunt's views and is known to have quoted Hunt at length in his classes.[45] Henri's *The Art Spirit* (1923), although it contains more practical, technical advice than *Talks*

on Art and is not nearly as discursive, shows the same concerns with spontaneity, finish, and memory. Like Hunt, Henri believed acquisition of mechanical skills was less important than the ability to re-create the sensation or impression of a scene or object.

Finally, *Talks* gives us a unique insight into Hunt as a thinker. He was impatient with artistic pretensions of the academic writers, or *"litterateurs,"* as he called them, of Boston and Cambridge, yet one is continuously impressed with the broad range of art with which he was acquainted and, in light of the authors he quotes, the cogency of his ideas. There is no doubt that as we acquire a larger view of late-nineteenth-century American art, Hunt's ideas will be increasingly valued.

LANDSCAPE PAINTING IN MASSACHUSETTS, 1876–1877

The year 1876 found Hunt as busy as he had been the year before. In January he exhibited a number of works at the Boston Art Club, participated in Williams & Everett's spring sale, was represented by three paintings – *The Boot Black* (location unknown), *The Drummer Boy* (see fig. 61), and *Portrait of Barthold Schlesinger* (1873, Museum of Fine Arts, Boston) – at the Philadelphia Centennial exhibition, and exhibited a number of charcoal drawings in the Black and White room at the annual exhibit of the American Society of Painters in Watercolor, New York.[46]

Hunt and his "school" continued to receive a good deal of favorable attention in the local press, and the *Atlantic Monthly* declared that Hunt "in his earnest and frank manner of painting, and in the highly artistic quality of his productions [stood] alone among American painters."[47] That summer, at the suggestion of his students, Hunt went to Deerfield to look at the work of the landscape and figure painter George Fuller. Fuller had worked as an artist for many years, but during the 1860s and early 1870s had withdrawn from artistic activity to work on his farm. Hunt, impressed by Fuller's paintings, encouraged Mr. Doll of the Doll & Richards Gallery to visit him. Doll's enthusiasm was equal to Hunt's, and he arranged to have fourteen of Fuller's paintings exhibited in his Boston gallery.[48] Fuller's suggestive, poetic style of figure painting is found even in his early *Girl with Cloak* (c. 1871–76, Museum of Art, Rhode Island School of Design), a work that Hunt would have appreciated. Yet Fuller's best works – *The Dandelion Girl* (1877, Museum of Fine Arts, Boston), *Winifred Dysart* (1881, Worcester Art Museum, Worcester, Mass.), and *The Quadroon* (1880, Metropolitan Museum of Art) – were done after he had established a studio in Boston, which suggests the positive influence of a community of artists and the supportive and encouraging presence of Hunt.

During the spring and summer, Hunt continued to paint out-of-doors. In *Plowing* (fig. 107), one of the few landscapes Hunt signed and dated (1876), pairs of horses, oxen, and men move parallel to the horizon in a manner

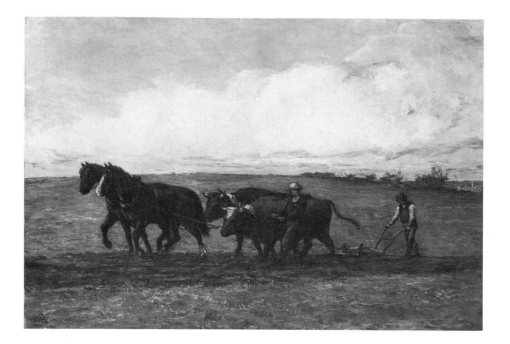

FIGURE 107. *Plowing*, 1876. Oil on canvas, 38″ × 56″. The Chrysler Museum, Norfolk, Virginia.

similar to the placement of figures in *Beach Scene with Two-Horse Cart*. In *Plowing*, however, Hunt focuses more on the task of the group and their relationship to the earth. Paint is applied freely, its rough texture suggesting the rugged nature of the men and beasts. The painting's success lies in Hunt's better grasp of the sky and natural light, and he renders to great effect the full billowing clouds, whose shadow falls on the group and throws their presence into sharp relief. In its simplicity and unity, the scene recalls Millet.

When *Plowing* was exhibited during the spring, the critic for the *Atlantic* singled it out as one of Hunt's most successful landscapes. He also admired the vital quality of the sketches, which he felt would be compromised if brought to a higher degree of finish: "What Mr. Hunt has lost by ignoring finish he has much more than made up by vigor and simplicity."[49] The critic eloquently described the feelings Hunt's new work engendered: "In the sad tones of the skies, in the mellow richness of the ground, in the sober hues of the foliage and in the simplicity of the lines of composition, there is a sentiment of solemn quiet, which even occasional masses of warm rich color do not dispel, but rather heighten by contrast."[50]

A good example of this quiet solemnity is *Hay-Cart, Moonlight* (fig. 108), a small horizontal painting dominated by an oxcart heaped with hay. On top a small figure, precariously balanced, holds a long pole to keep the hay in place. The whole scene is backlit by a silver gray light emanating from the moon at the horizon. This somber light combines with the dull browns and ochers of the landscape to imbue the labors of man and beast at harvest with a timeless quality.

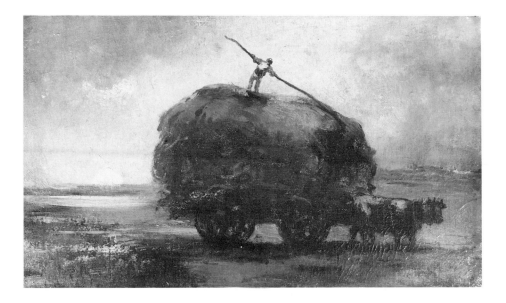

FIGURE 108. *Hay-Cart, Moonlight*, c. 1876. Oil on canvas, 14″ × 20″. Private collection.

There is, however, a decided change in mood in a pair of landscapes, *June Clouds* (fig. 109) and *Meadows in Summer* (fig. 110), done the summer of either 1876 or 1877. In both, Hunt has abandoned a horizontal format for a vertical one. Unlike *Plowing* or *Hay-Cart in Moonlight*, these two works, with their sunny cloud-filled skies dominating the compositions, are representations of a more genial and hospitable nature. In both, small figures at leisure reinforce these qualities and help define and order the lower sections of the paintings. All four works, however, reflect Hunt's technique of quickly capturing the scene before him. Often roughly painted with details suggested by single strokes of color, these landscapes successfully embody the freshness and vitality noted by his contemporaries.

Also in this same year (1876), Hunt created one of his best-known images – *The Bathers*, of which there are two versions: the first and smaller version (fig. 111), or Fairchild Hunt (named for its first owner, Mrs. Charles Fairchild of Boston), is at the Worcester Museum; the second, larger version (fig. 112) is at the Metropolitan Museum of Art. According to Knowlton's account, Hunt had seen two youths bathing along the Charles River while he was out driving and, "powerfully impressed by . . . this vision of beauty, [he] drove back into town, drew at once a small charcoal sketch [Worcester Art Museum, Worcester, Mass.] of the subject, and from this made his painting."[51] Both versions embody Hunt's full realization of a naturalistic subject. He had learned a great deal since *Boy with Butterfly* and *Marguerite* – primarily through his study of landscape painting – about outdoor light and the integration of the figure in a natural setting.

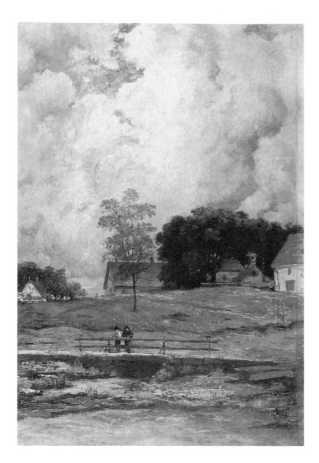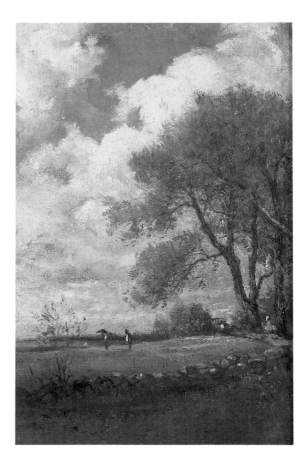

Hunt's principal concern in these works was to capture the impression of the moment, as is clear from this comment he made to Angell:

> I don't pretend that the anatomy of this figure [the standing bather] is precisely correct. In fact, I know it is not. It's a little feminine; but I did it from memory, without a model, and was chiefly occupied with the pose. I *do* think the balancing idea is well expressed, and it is the fear of disturbing that which prevents my making any changes in the contour of the figure. I know that I could correct the anatomy, but if the pose were once lost I might never be able to get it again.[52]

Although the Worcester version might be thought of as a sketch for the larger work, it is fully complete. Knowlton reported that the first version was sold so quickly that Hunt made a replica in order to keep a record of the work. Even so, he made changes in the second version by correcting the anatomy and moving toward a greater integration of the figures within their setting. In the earlier version the figure of the standing boy is rounder, softer, and lighter – more "feminine," as Hunt said – a flat shape against the brownish

FIGURE 109. *June Clouds*, c. 1877. Oil on canvas, 30″ × 20½″. Location unknown.

FIGURE 110. *Meadows in Summer*, c. 1877. Oil on canvas, 30″ × 20″. Courtesy, Museum of Fine Arts, Boston. (Gift of Miss Mary C. Wheelwright)

green of the river's wooded shoreline. In the later version the flesh tones are more carefully modulated and harmonize more fully with the background. A telling detail is Hunt's treatment of the hands – in the Worcester version they are clearly depicted; in the later painting they are dark red, blending into the dark golden colors of the background. The color of the Worcester version is more varied. Hunt's touches of green in the water, the overhanging trees, and the background rapids are rendered effectively, linking these different areas of the painting. The earlier version captures the precarious moment of balance, especially in the lift of the lower legs, reinforced by the upward gesture of the boy's arms, but the moment was somewhat dissipated in the replica when Hunt worked to refine the anatomy and other details of the painting.

Hunt's continued critical success in Boston was such that the winter exhibition of his works at William & Everett's was covered by the writer for the New York-based *Art Journal*. He was impressed by the "variety of subjects" displayed by Hunt and believed that "on the whole, the exhibition fully sustains Mr. Hunt's fame, and indicates that his talent is even yet ripening by the lapse of time and unfaltering devotion of the artist to his work."[53] Hunt had won the day by deliberately exhibiting more often and a greater variety of his work to a public sensitive to its particular qualities of subtle observation and direct expression. But he was still not exempt from the scathing attacks of his New York nemesis, Clarence Cook, then art editor of the *New York Tribune*. In 1877, Cook created a controversy where none existed – between Hunt and Duveneck. "In Boston the presence of a strong man [Duveneck] was needed to temper – not to destroy – the rule of one artist who immensely more through social and personal influences – among them a streaming eloquence of dogmatic assertion, headstrong opinions, and blistering scorn of all opposition – immensely more through such influences than through his art, had imposed his theories and his practice on a crowd of blind adorers."[54] Evidently, Cook was unaware of Hunt's enthusiasm for Duveneck's work and that it was Hunt himself who had had invited Duveneck to Boston. Cook went on to say that "Boston people have been crammed, in these later years, with the belief that there is not art but French art, and that Couture and Mr. Wm. Hunt are its prophets."

This indictment did not go unnoticed by Hunt, who wrote a reply to Cook, which was published not by the *Tribune* but by the *Atlantic Monthly*, nine months after Hunt's death, in Henry Angell's article "Records of W. M. Hunt." In his lengthy rejoinder Hunt challenged the notions that he, and by extension Boston, were inhospitable to new artists and that he only promoted the "French school." "The sister city, over which I am described as holding such autocratic rule, has always been the first to accept most cordially fresh examples of art. Boston was the first to recognize Millet, Corot, Daubigny, and of our own non-resident artists, Inness, La Farge, Vedder, Duveneck, and others." In fact, since colonial times, and later through the influence of Allston,

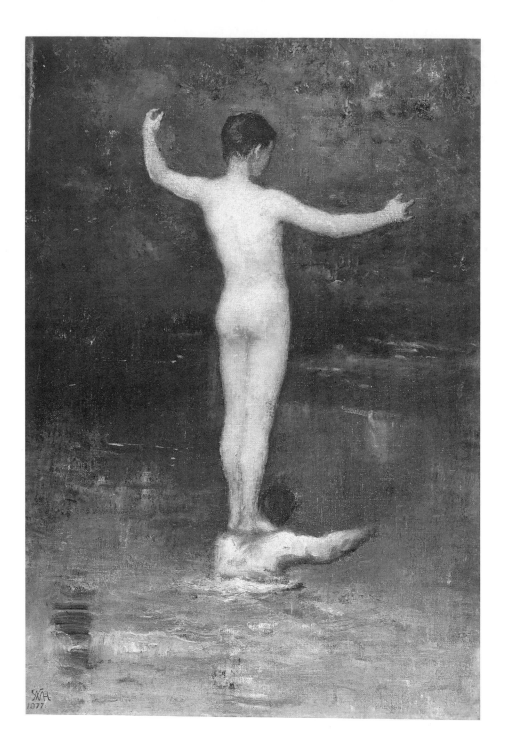

FIGURE 111. *The Bathers*,
1877. Oil on canvas, 24⅜″
× 16⅛″. Worcester Art Mu-
seum, Worcester,
Massachusetts.

FIGURE 112. (*opposite*) *The
Bathers*, 1877. Oil on canvas,
38″ × 25″. The Metropolitan
Museum of Art, New York.
(Morris K. Jessup Fund)

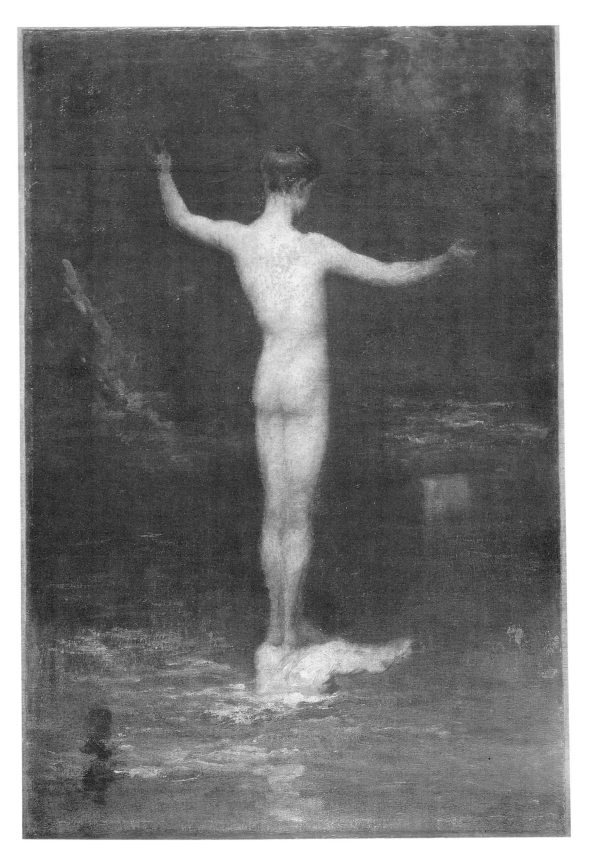

131

Boston had seen itself as a cosmopolitan city with regard to art matters; one reason they rejected Pre-Raphaelitism was its seeming provincialism. To confirm further his own catholicism, Hunt went on to list the modern European painters he most admired, making sure, in light of Cook's devotion to Ruskin, to include a number of English artists: "Hogarth, Géricault, Constable, Turner, Delacroix, Ingres, Flandrin, Corot, Millet and others."[55] By the late 1870s, Cook was fighting a losing cause. There is no question that Hunt was a charismatic figure in Boston and that he did indeed have "blind admirers." But the artists he supported – Inness, Duveneck, Vedder, and La Farge – were becoming the leading members of a new generation in New York. They may have disagreed with Hunt in some matters, but none ever accused him of aesthetic tyranny or of being anything other than a supportive and generous colleague. The only thing Hunt was dogmatic about was that true art did not emerge from a formula. Nor did he want others to paint as he did, and he encouraged his students to find their own style. He championed Millet and the Barbizon school but not to the exclusion of other artists. By being true to his own vision he became a hero for younger artists who also sought to declare their professional and artistic independence.

MAGNOLIA, CAPE ANN, MASSACHUSETTS

In June 1877, Hunt was invited by Oliver Ames to his home in North Easton to paint his portrait (c. 1877, Ames Free Library, North Easton, Mass.) and a double portrait of his sister-in-law and nephew, known as *Mrs. Oakes Angier Ames and her son Winthrop* (c. 1877, Dr. Winthrop Burr, Brookline, Mass.). (The Ames family, long prominent in North Easton, had recently been touched by scandal; Ames's brother Oakes Ames, a former U.S. senator, was implicated in the Crédit Mobilier affair.) The Ameses had also hired H. H. Richardson to design several public buildings for the town as memorials to their father and brother, and during the summer of 1877, Richardson discussed plans for the Oliver Ames Free Library. It is possible he and Hunt met at this time, since Richardson would shortly be party to Hunt's Albany commission.

During his month in North Easton, Hunt took walks, as an antidote to working inside all day, to a nearby pond. The observations he made led to a series of charcoal sketches that record different times of day – early afternoon, late afternoon, and dusk from approximately the same location. In the first, *North Easton, Massachusetts* (fig. 113), the whole scene is filled with light; details of the village across the pond and reflections on the water are carefully rendered. The spaciousness of this view is contracted in the subsequent *Pond at North Easton* (fig. 114), in which vision is partly obscured in the diminishing light of late afternoon; there is a sharper contrast between the darks of the village at the horizon and the light areas of the sky and water, which still hold the afterglow of sunset. Lamplit windows are among the few details that can

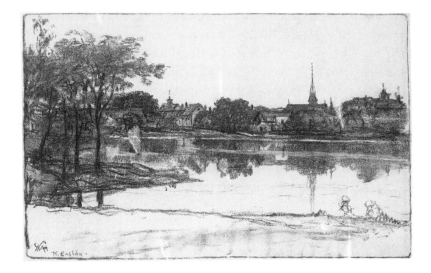

FIGURE 113. *North Easton, Massachusetts*, 1877. Charcoal drawing, 10″ × 16″. The Cleveland Museum of Art, (Gift of Mrs. G. Tappan Francis)

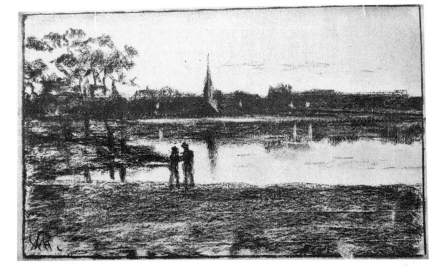

FIGURE 114. *Pond at North Easton*, 1877. Charcoal on paper. Location unknown.

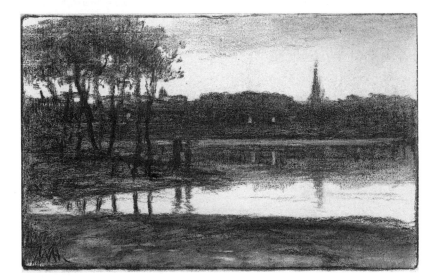

FIGURE 115. *Reflections at Dusk, North Easton*, c. 1877. Charcoal on paper, 9¾″ × 15″. Private collection. Courtesy of Vose Galleries, Boston.

still be discerned. For the scene at dusk *Reflections at Dusk, North Easton* (fig. 115), possibly done a few minutes later on the same day, Hunt stood closer to the shore, and, as if to record the passage of time, shifted the two figures who had been standing on the foreground bank to a small promontory jutting out into the middle of the pond. The town is now just a dark mass on the horizon, with a few small light patches for windows and a blurred conical form representing the church steeple. Although small in scale and done in charcoal, Hunt's investigations are similar in intent to the various series Monet would later paint at Rouen and Giverny.

In contrast, Hunt's Ames portraits do not represent his best efforts and their cursory manner was the casualty of his eagerness to join friends on the Massachusetts north shore. He left North Easton in early July and went directly to Magnolia, a small fishing village on Cape Ann where Helen Knowlton and Lillian Freeman Clarke were spending the summer. Lillian Clarke, also a student of Hunt's, was the daughter of James Freeman Clarke, a Unitarian minister whose portrait he had recently completed (c. 1875, Arlington Street Church, Boston). Magnolia itself had recently become a popular summer retreat for artists, offering, like Newport, "a combination of dramatic ocean, craggy rocks, pastoral fields, and quaint fishing structures."[56] Hunt was so taken with the locale, he bought a barn that he converted into a two-story studio known as "The Hulk," "a picturesque structure with galleries on the outside" and space for his painting van, "a phaeton and a dog-cart, as well as . . . stalls for two or three horses. The upper room was known as the 'barracks,' and half a dozen cot-beds were ranged around the sides, as seats by day and beds by night."[57] That summer, Hunt was joined in Magnolia by other students and his two assistants, the former wagon-painter John G. Carter and his wagon-boy, Tom Robinson, both of whom later worked with Hunt on the Albany murals.[58]

Even though the summer and fall of 1877 were the only extended period Hunt spent in Magnolia, it was here that he created some of his best-known landscapes and figure studies, including *Ball Players* and views of Magnolia and Gloucester Harbor. These works differ from his rural landscapes of the previous summer, and in several of them the figure occupies a prominent role. The problems he deals with – the recording of light and the capturing of decisive moment – are the same, but the compositions are more complex and less reliant on the strict horizontality of his earlier work.

Based on a charcoal sketch (*Baseball*, fig. 116), *Ball Players* (fig. 117), like *The Bathers*, is a painting of young men playing out-of-doors. Here his translation of the sketch into the more static medium of oil is not successful.[59] In *Baseball*, the composition is controlled by a group of figures set along a diagonal that begins in the left foreground figure of the catcher – rather formally attired in hat, jacket, and long pants – who stands with his back to the viewer. In front of him is the batter and beyond, in the middle distance, is the pitcher, whose stance mimics that of the catcher. In the outfield one can barely make

FIGURE 116. (*opposite, top*) *Baseball*, 1877. Charcoal on paper, 13¾" × 19⅞" (limits of drawing). Courtesy, Museum of Fine Arts, Boston. (Gift of the subscribers through Miss Ellen Dale Hale and Miss Adelaide E. Wadsworth)

FIGURE 117. (*opposite, bottom*) *Ball Players*, 1877. Oil on canvas, 16" × 24". The Detroit Institute of Art. (Gift of Mrs. John L. Gardner)

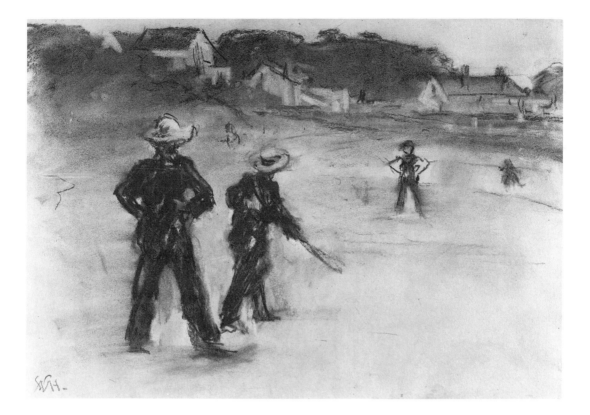

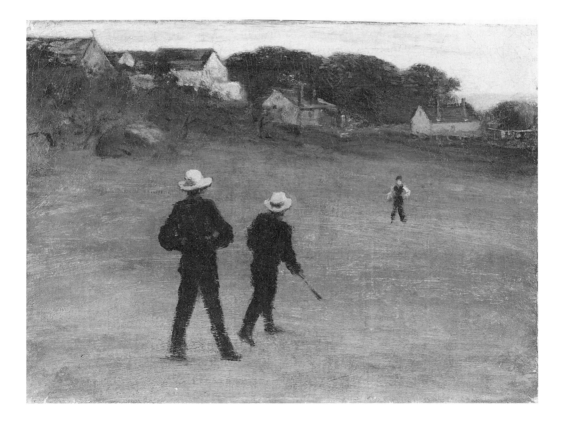

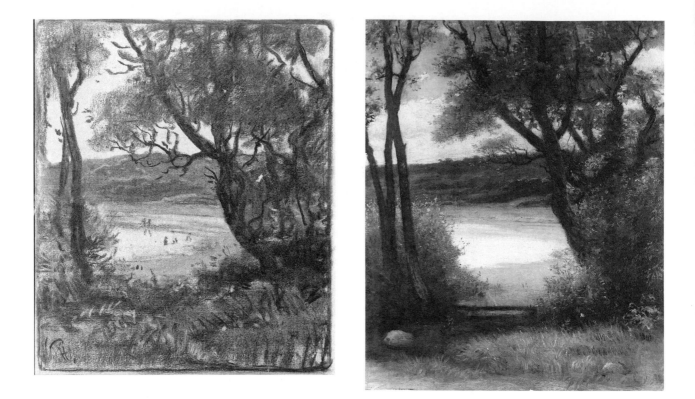

out two hastily drawn figures who stand left and right. The whole scene is closed out at the top by houses situated along the periphery of the field. Unfortunately, Hunt was not able to transfer the spontaneity of the sketch to the oil, which seems strangely empty. He eliminated two of the players, and the three remaining are frozen in a dull wasteland of light brown space.

This two-part procedure is found in a number of others works done in Magnolia and, as in *Baseball,* translations from the charcoal to the oil often involved the deletion of figures found in preparatory sketches. Two good examples are the oils *Magnolia* and *Twilight at Magnolia.* In both the sketch (fig. 118) and the finished version (fig. 119) of *Magnolia,* the foreground, bordered by a thin stand of trees, is shallow. An opening between the trees leads the eye to a crescent beach below. Branches frame this view that in the charcoal is accented by several sketchily drawn figures playing at the water's edge. The background is closed out by a range of rolling hills, which balances the high vantage point of the foreground so that the middle distance is comfortably contained between the two. The same motifs are also found in the oil version. However, the color of the water is too light, forming too sharp a tonal contrast with the dark sepia browns of the foreground. Lacking the anchoring presence of figures, this milky space floats aimlessly in the center. Yet one can still admire Hunt's recording the play of warm golden-red sunlight throughout the work. This play of light is perhaps the painting's true subject.

FIGURE 118. *Magnolia,* 1877. Charcoal on paper, 12¾″ × 11″. The Wm. Frank McCall, Jr., Collection of Works on Paper, Colquitt County Cultural Center, Moultrie, Georgia. Photo: Courtesy of Vose Galleries, Boston.

FIGURE 119. *Magnolia,* 1877. Oil on canvas, 36″ × 29″. Location unknown.

A more successful transition was made from the charcoal sketch *Twilight at Magnolia, Mass.* (fig. 120) to the oil of the same title (fig. 121). In both works, with their broad foregrounds and horizontal formats, in contrast to the tighter vertical format of the versions of *Magnolia*, Hunt accentuates the spaciousness of these vistas. Our eye travels through this deep foreground of bushes and low trees until it reaches a narrow bay formed by a promontory beyond. In an open space in the lower right-hand corner of the charcoal are two figures that tie down and balance the composition. Yet their presence is not missed in the oil, in which color and detail give weight and balance to the scene. Here, color is employed more effectively than in *Magnolia:* Bright tones of peach, white, gray, and blue for the sunset sky are reflected in the water below. These warm, light colors at the horizon form a strong foil for the dark greens and browns of the shadowed foreground where night descends.

Hunt took advantage of Magnolia's proximity to Gloucester Harbor, an area popular with American artists throughout the nineteenth century, to paint several seascapes.[60] One unique view is *The Spouting Whale* (fig. 122), in which no land mass is visible. It may have been painted not from the harbor but from a boat Hunt took to either the Forbes home on Naushon or the Levi Thaxters' retreat on the Isle of Shoals off the coast of Portsmouth, New Hampshire. Hunt again uses a vertical format, an ideal one for the picture's focal point, a slender white column of spume from a spouting whale, barely visible in this concentrated view of sea and sky.

Better known than *The Spouting Whale* are Hunt's two versions of the harbor itself: *Gloucester Harbor* (fig. 123) and *Nautilus Fleet, Gloucester* (fig. 124), both oils and, both the same size. Hunt painted the former in a single afternoon and "returned to Magnolia aglow with enthusiasm" because he believed he had painted "a picture with *light* in it!"[61] In this he succeeded, for the subject of both is not the picturesque sailing ships and the bustle of harbor activities, but the particular illumination emanating from the sky and the reflective surface of the water. In *Gloucester Harbor*, light is recorded with a bright palette -- yellows, whites, and blues predominate. In *Nautilus Fleet*, this high key is replaced by a unifying silvery light of browns and grays. Hunt is also interested in how light changes our perception of space. In *Gloucester Harbor*, the foreground is in shadow, thus forms, such as a dory on the right and a pier on the left, are clearly defined. Beyond lies the harbor itself, a collection of shrouded, misty images at the horizon. Space here is expansive and infinite. In *Nautilus Fleet*, Hunt eliminated the pier (the overpainting in this area of the canvas suggests that the pier was, in fact, there in an earlier stage of the painting) and the eye slips easily into the still glassy center. The sailing ships and warehouses are larger in scale and the clear gray light that precedes a storm brings them into the same sharp focus as the dory. The entire scene is here more contained and less open.

Works such as these fall between two traditions in late-nineteenth-century American landscape painting -- the refulgent luminism of Fitz Hugh Lane

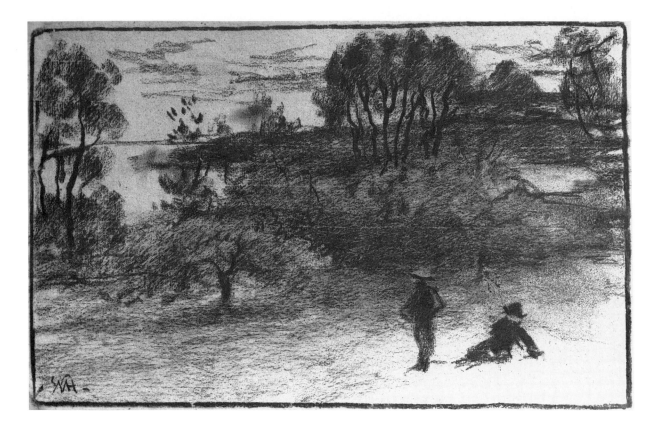

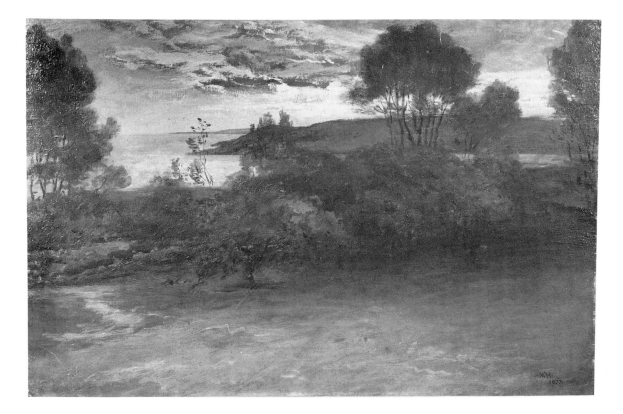

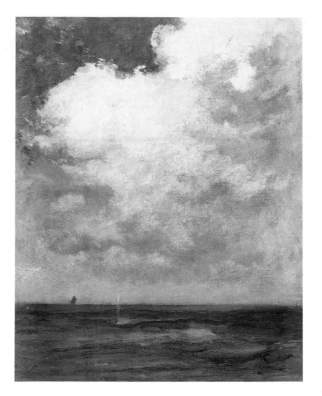

FIGURE 122. *The Spouting Whale*, c. 1877. Oil on canvas, 19½″ × 16⅛″. National Museum of American Art, Smithsonian Institution, Washington, D.C.

FIGURE 120. (*opposite, top*) *Twilight at Magnolia, Mass.*, October 1877. Charcoal on paper, 10⅜″ × 16¼″. Courtesy, Museum of Fine Arts, Boston. (Gift of the subscribers through Miss Ellen Dale Hale and Miss Adelaide E. Wadsworth)

FIGURE 121. (*opposite, bottom*) *Twilight at Magnolia*, 1877. Oil on canvas, 20½″ × 30½″. Location unknown.

and Martin Johnson Heade, and the tonalism of Whistler and John Henry Twachtman. In Hunt's Gloucester paintings, objects retain their structure as they do in Luminist works; simultaneously the compositions are suffused with the vaporous play of light characteristic of Whistler's nocturnes. The more scientific recording of light found in early Impressionist works such as Monet's *Impressionism: Sunrise* (1873, Paris, Musée Marmottan) was, in the late 1870s, still unknown in the United States. If anything, these harbor scenes reflect Hunt's continued desire to re-create the atmospheric rendering of light found in the work of Corot and Daubigny.

A New Studio in Boston and a Visit from William Dorsheimer

When Hunt left Magnolia the end of October, he moved into a new studio, at 1 Park Square on the corner of Boylston Street, which replaced the earlier one destroyed in the Boston Fire. This lavishly decorated studio and exhibition space was designed by J. Philip Rinn, a Boston architect and designer who later advised Hunt on his work in Albany. It was filled with divans, rugs, tapestries, furs, pictures, photographs, and engravings; Hunt, as Boston's foremost artist, had created a congenial ambience for himself. In the late nineteenth century, artists' studios had replaced communal workshops and

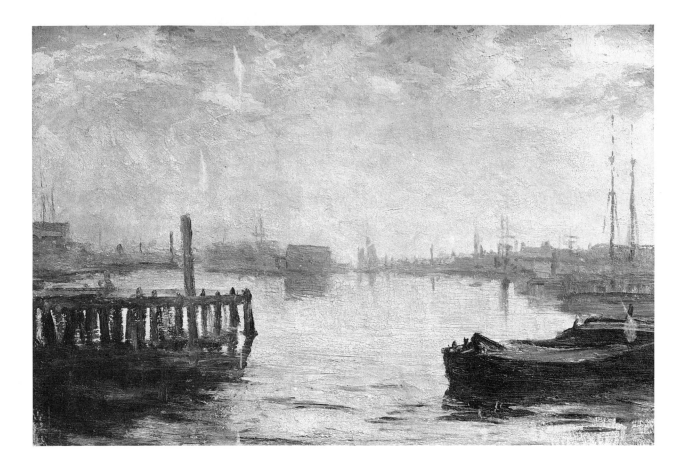

had become instead places to work, salons in which to entertain, and classrooms for teaching. With its rich display of aesthetic artifacts, the studio also conveyed the artist's authority in matters of fashion and taste.

Fittingly, it was at the time of his studio exhibition that Hunt was first approached about a commission for two murals for the Albany statehouse. The exhibition, almost a mini-retrospective, included portraits, ideal heads, figures, photographs and charcoal studies of early works, and, of course, the landscapes done the previous summer in Magnolia. One of these, a figure study, *The Young Headsman* or *Constantinople Woodchopper* (c. 1877 Portland Art Museum, Maine), was bought by New York's lieutenant governor, William Dorsheimer, who had visited Hunt to seek his advice about mural painting. Such a discussion is confirmed by a drawing of *The Discoverer* and a letter written later by Hunt to the *Albany Argus:* "It is entirely an error to suppose that my work in this room [the Albany Assembly Chamber] is in any respect an afterthought. The whole scheme of its decoration, including two allegorical pictures to be placed on the stone walls where I am now painting them, was laid down in a drawing prepared and approved in 1877."[62]

William had come to Dorsheimer's attention, perhaps through Richardson, but most probably through his brother Richard, who, ironically, had been in

FIGURE 123. *Gloucester Harbor*, c. 1877. (Oil on canvas, 21″ × 31¼″. Courtesy, Museum of Fine Arts, Boston. (Gift of H. Nelson Slater, Mrs. Esther Slater Kerrigan, and Mrs. Ray Slater Murphy, in memory of their mother, Mabel Hunt Slater)

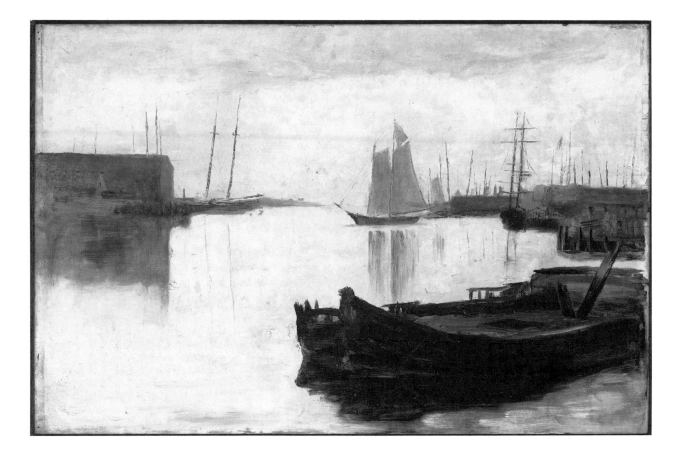

FIGURE 124. *Nautilus Fleet, Gloucester*, c. 1877. Oil on panel, 20½″ × 31″. Courtesy, Museum of Fine Arts, Boston. (Gift of Miss Aimee Lamb)

fierce debate for two years with New York State officials over the redesign of the Albany Capitol. Richard, as president of the New York chapter of the American Institute of Architects, opposed the new plans submitted by the architects Richardson and Leopold Eidlitz. The AIA's primary criticism was of their plan for the exterior, which called for the completion of the upper stories in the Romanesque style, not the Italian Renaissance style chosen by its original architect, the Englishman Thomas Fuller. This conflict between the new architects of the capitol and the New York chapter of the AIA came to be known as the "Battle of Styles."[63]

Richard and the AIA objected on the grounds that the "suggested alterations are no improvement on the original design, and, furthermore, that the style adopted is totally at variance with the portions of the building already erected."[64] The man who had hired Eidlitz and Richardson was the lieutenant governor of New York State, William Dorsheimer, appointed by Governor Samuel Tilden to head a New Capitol Commission to oversee the completion of the problem-plagued, scandal-ridden edifice. Dorsheimer, a lawyer and journalist from Buffalo, was no hick. He was a skillful politician and a well-known figure in the cosmopolitan circles of New York City's men's clubs, where he probably became acquainted with Richard, whom he later employed

to design a house in Newport.[65] Earlier, Dorsheimer had been instrumental in hiring Frederick Law Olmstead to plan the Buffalo park system, and through Olmstead he met Richardson who in 1869 was engaged as architect of Dorsheimer's house in Buffalo.[66] Given his personal interest in landscape and architectural design, Dorsheimer was personally committed to completing the Albany state capitol and equally determined that the building be a fitting symbol of the Empire State.

Plans to build a new statehouse were initiated as early as 1863, and construction had already begun under the governorship of John T. Hoffman, a crony of William ("Boss") Tweed. By 1875 only the basement and first floor had been completed, and Dorsheimer, ostensibly concerned with charges of graft in connection with the building's construction, reviewed Fuller's plans in detail. Needing expert help, he sought the advice of Richardson and Olmstead, as well as Leopold Eidlitz, who was experienced with the particular demands of monumental architecture. Constituted as an advisory board, the three were critical of every aspect of Fuller's plan: the exterior design did not reveal the location of the principal rooms; the floor plan was arbitrary; cheap materials were proposed for the roof, for the exterior, and for the interior, including cast-iron and plaster work for the Assembly and Senate chambers.[67] In contrast, the advisers recommended – despite the pressure to complete the building and keep expenses down – that the New Capitol Commissioners demand only the best in terms of materials and workmanship including costly marbles, stained glass, mosaic inlay, Turkish rugs, mahogany furniture, and carved and gilded stonework (but not, at this early date, mural paintings). Their recommendations, despite the controversy they aroused, were heeded, and, in September 1876, Fuller was fired and Richardson and Eidlitz were hired to complete the work on the capitol. (Olmstead was not formally included in their partnership but was hired independently to oversee the landscaping and design of the eastern approach.)

The AIA's opposition to the new plan continued for the next year but ceased in late 1877, at the time William's advice was sought regarding mural paintings for Eidlitz's Assembly Chamber. There was no formal solicitation for proposals, nor a competition; it seems entirely possible that Dorsheimer, the consummate politician, offered the commission to William in order to mitigate the objections of Richard and the AIA to the revised building plans.

Accounts, however, are sketchy. No correspondence exists between any of the principles – Dorsheimer, Eidlitz, or Hunt – and most official papers relative to the building's construction were destroyed in a 1911 fire. It is curious, though, that Dorsheimer consulted William and not John La Farge, who by late 1877 had completed most of his painted decoration for Richardson's Trinity Church. Dorsheimer could easily have seen this highly admired and well-publicized project and through the good offices of Richardson could have obtained an introduction to meet La Farge. There is no evidence, however, that such a meeting took place between Dorsheimer and La Farge, or even

between La Farge and Hunt. Given La Farge's recent experience as a muralist and his earlier study and association with Hunt, one might assume some contact, especially since both were involved simultaneously in two major architectural programs overseen by Richardson.

Earlier, Hunt and La Farge had been asked separately to design a stained glass for Harvard's Memorial Hall (a building designed by two of Richard Hunt's pupils, William Ware and Henry Van Brunt). This commission was initiated by Hunt's Harvard classmates who, on the occasion of their thirtieth reunion in 1874, invited him to design and execute a memorial window. He declined "on the ground of his unfamiliarity with the kind of work that would be required."[68] They next approached La Farge, whose travels in Europe in the early 1870s had rekindled his enthusiasm for medieval art and architecture, particularly stained glass. The commission presented La Farge with his first opportunity to work in stained glass, a medium in which he would become an American master. But La Farge's design – two tiered scenes, one of the Chevalier de Bayard, the other of Columbus – proved too costly to execute, and a British commercial firm was retained instead.

Although there is no evidence they were in touch, both artists were involved in projects – Trinity Church and the Albany statehouse – cited by critics as important milestones in the history of American architecture. Furthermore, Hunt's murals at Albany and La Farge's at Trinity Church were seen in the context of a new decorative aesthetic, based on European precedent, that called for the integration of architecture, sculpture, and painting. Later, at the turn of the century, this beaux-arts ideal became the hallmark of many important building projects including the Boston Public Library, the Library of Congress, and Manhattan's New York Appellate Division Courthouse.

Today, it is hard to evaluate fairly the decorative success of the Albany Assembly Chamber, given the extensive alterations done in 1888, when the painted and gilded stonework was removed and a false ceiling placed beneath Hunt's murals. A description of Eidlitz's polychromed interior written by a correspondent from the *Brooklyn Times* gives us some idea of the room's original luxurious appearance:

> The glory of the Capitol is the Assembly Chamber, perhaps the handsomest legislative hall in the world; noble in proportion, with decorations and furniture of a prevalent warm red tint, subdued enough to be grateful to the eye.... Here are a lofty vaulted ceiling with arabesques in color laid in chiseled grooves, polished columns of red granite, deep galleries, retiring far back into shadowy recesses, windows of stained glass, gasoliers of burnished brass, copious fireplaces..., Turkish rugs of intricate pattern and costly as cloth of gold, mahogany furniture, and above the windows, the lunettes, by William Morris Hunt, executed in a style broad and firm, and pure and grand in sentiment.[69]

Hunt, however, was not officially notified of his commission until June 1878. While awaiting word he continued to paint portraits and exhibit actively. In March 1878 he lent one painting, *Portrait of a Lady* (unlocated), to the first exhibition of the Society of American Artists, and in the fall sent two works – *The Bathers* (second version) and *Boy with Butterfly* – to a National Academy of Design exhibition for the benefit of the Decorative Arts Society.[70] He also did a portrait of a young woman, *Ida Mason* (fig. 125), for which he created a large preparatory charcoal sketch (private collection). Set against a neutral background, the portrait of *Ida Mason* is a less stagy conception than *Marguerite* (see fig. 90) and comes close to the candid naturalism of his male portraits. The loose technique of the charcoal with its agitated line is also striking, and its vitality was ably translated by Hunt into oil. It remains, along with those of Gardner, Mrs. Adams, and himself (1866), one of his finest portraits.

In late May, Hunt traveled with his sister to Niagara Falls, which, as one of the most extraordinary natural wonders on the North American continent, had an enormous impact on the American and European imagination. Throughout the nineteenth century, artists vied to capture in a single image the majesty of this awesome site.[71] Hunt, too, was overwhelmed and promptly sent for Carter and his studio van so he could work there in comfort. The locale and scenery invigorated him; as he wrote to a student, " 'there is nothing like Niagara in June.' "[72]

This was a vista different from the broad fields and intimate interiors of rural Massachusetts that Hunt had painted the summer before. To meet the challenge of trying to re-create the falls, he chose to work in a variety of media – charcoal, pastel, oil. He was intent on capturing the transient moment, an essential in recording rushing water, but Hunt also used color in a way that was new for him, as can be seen in various views: some of the American Fall from below, others of the Horseshoe Fall and rapids from above. The vantage point he preferred was from the base of the American Fall, which offered the most panoramic view of the entire site. Altogether he did five versions of the American Fall: one in charcoal, *Niagara Falls* (fig. 126, Cleveland Museum of Art); one in pastel (1878, Harvard University Art Museums, Cambridge, Mass., also called *Niagara Falls*); and three in oil: *American Falls* (fig. 127, Corcoran Gallery of Art); *Niagara Falls* (fig. 128, Smith College Museum of Art, Northampton, Mass.); and *Niagara* (fig. 129, Museum of Fine Arts, Boston) – all from the same vantage point, yet all of them different. The charcoal and Corcoran Niagaras are both horizontal, but the charcoal is a panoramic vista, whereas the oil is a close-up view of the extraordinary display of froth and spray, and the perpetual rainbow held captive in the tumultuous foam. In the smaller, vertical, Smith College version, in which the actual locale is dissolved in color and light, the waterfall becomes an abstraction. In contrast, the Boston version of the American Falls is huge (62″ × 100″), larger than

FIGURE 125. (*opposite*) *Ida Mason*, 1878. Oil on canvas, 42″ × 30¼″. Courtesy, Museum of Fine Arts, Boston. (The Hayden Collection)

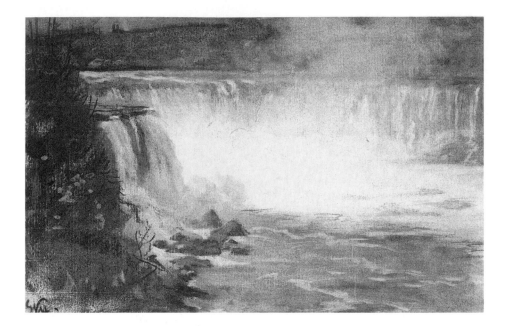

FIGURE 126. *Niagara Falls*, 1878. Charcoal drawing, 10¾" × 16⅝". The Cleveland Museum of Art. (Gift of Mrs. G. Tappan Francis)

Church's famous *Niagara*. Hunt's Boston *Niagara* and its pendant at Williams College, also called *Niagara* (fig. 130), are the largest easel paintings Hunt ever did. The Williams College version, however, was done from a different perspective atop Horseshoe Fall – the same view made famous by Church. Hunt's rendering from this vantage point emphasizes, even more dramatically than Church's, the chasmlike precipice filled with churning water and the mist thrown up by the thundering cascade.

Unlike these two monumental representations of familiar Niagara panoramas are several renderings of the rapids between the Sister Islands at the top of the falls. These are rare views, since most artists attracted to Niagara focused on the drama of the cataract, and if they recorded the rapids at all, it was within a grander vision of the falls themselves. Hunt's *Sister Islands, The Rapids, Niagara* (fig. 131) is a surprisingly intimate scene, done on an overcast day, giving no hint of the abyss that lies two thousand feet beyond.

At Niagara, Hunt received a letter from Eidlitz to come to Albany to discuss a commission for two mural paintings.

> My Dear Sir, It is proposed to have some allegorical or legendary paintings in the Assembly Chamber of the New Capitol at Albany. Lieutenant-Governor Dorsheimer thinks that you would be willing to give us some advice – perhaps assistance in the matter; and requests that you will call at my office to examine a sketch indicating the work to be done, with a view to a proposed engagement. Will you be good enough to inform me when I may have the pleasure of a visit from you? Yours most truly, Leopold Eidlitz.[73]

146

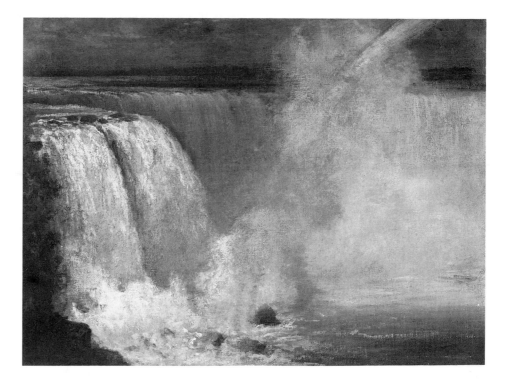

FIGURE 127. *American Falls*, 1878. Oil on canvas, 30" × 41⅛". The Corcoran Gallery of Art, Washington, D.C. (Gift of Cecil D. Kaufmann)

Yet according to Hunt's assistant, Carter, the artist had misgivings:

> When urged to undertake those mural paintings near the lofty ceiling of the Assembly Chamber, he objected. "It would kill me to climb up there." "They can hoist you up, like a lot of mortar," was the reply. Lieutenant-Governor Dorsheimer, Mr. Eidlitz, the architect, and Mr. Richard M. Hunt, his brother, used strenuously their influence. "You have the cartoons in your studio now, Bill," said the last named gentleman, referring to the artist's large drawings of Anaita [*sic*] (the Indian goddess of the Night driving her three steeds into the darkness at the approach of Dawn), and of Columbus the discoverer, led on by Faith, Hope, Science, and Fortune.[74]

As stated earlier, there is evidence that Hunt had begun working on these subjects before that summer, but he was so impressed with the grandeur of Niagara that he suggested the falls, the most important natural wonder in New York State, as appropriate images. By the 1870s, Niagara had become the most popular scenic landscape in America and an unofficial symbol of this country's vast resources and future power. The Albany commission was the most important of Hunt's career, and views of Niagara would establish him as one of America's preeminent landscapists. In fact, his two monumental *Niagara* oils (see figs. 129, 130) may have served as presentation pieces. By

147

desiring to put them on permanent display, Hunt would place himself within a tradition that included Cole, Church, Jasper Cropsey, and Albert Bierstadt, all of whom had created memorable images of the falls. Thomas Moran, with his *Grand Canyon of the Yellowstone* (1872, now in the National Museum of American Art, Washington, D.C.) for the United States Capitol, already had set a precedent and helped make American landscape an appropriate subject for civic art. But as Knowlton remarked, "the authorities preferred that each of the great panels should be filled with a composition embracing figures rather than scenery alone."[75]

Although most of the official documents on the construction of the capitol were destroyed, an extant copy of the *Annual Report of the New Capitol Commission* presented to the State Senate in January 1879 confirms that Hunt was paid fifteen thousand dollars in two installments: five thousand dollars on November 15, 1878, and ten thousand dollars on December 23, 1878, "for paintings in the Assembly Chamber."[76] The particulars of Hunt's commission were not detailed in this report, but various sources confirm that he was hired to paint two round-arched murals, each fifteen by forty-five feet, for two facing lunettes on the south (*The Discoverer*) and north (*The Flight of Night*) walls, forty feet above the Assembly Chamber floor. His assistant, Carter, also stated that Hunt was given from September 1 to December 21, 1878, to complete the two paintings in Albany.[77] With so short a deadline, Hunt, after his return from meeting with Eidlitz and Albany officials, began to organize

FIGURE 128. *Niagara Falls*, 1878. Oil on canvas, 28″ × 24″. Smith College Museum of Art, Northampton, Massachusetts.

FIGURE 129. (*opposite, top*) *Niagara*, 1878, oil on canvas, 62½″ × 100″. Courtesy, Museum of Fine Arts, Boston. (Lent by the Estate of Mrs. Enid Hunt Slater)

FIGURE 130. (*opposite, bottom*) *Niagara*, 1878, oil on canvas, 62⅝″ × 99½″. Museum of Art, Williams College, Williamstown, Massachusetts.

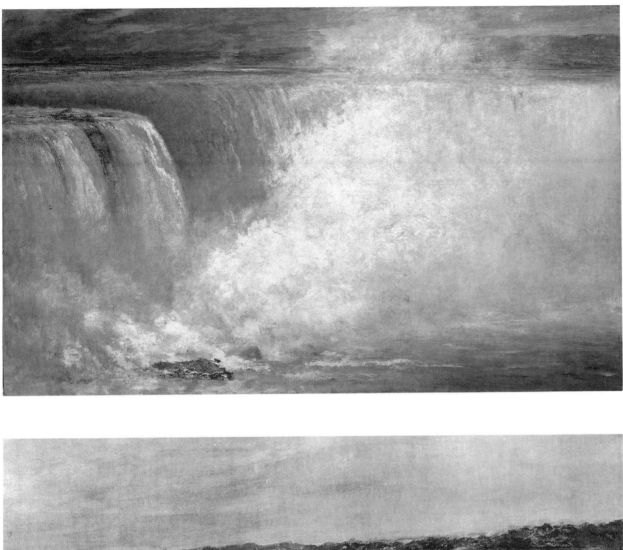

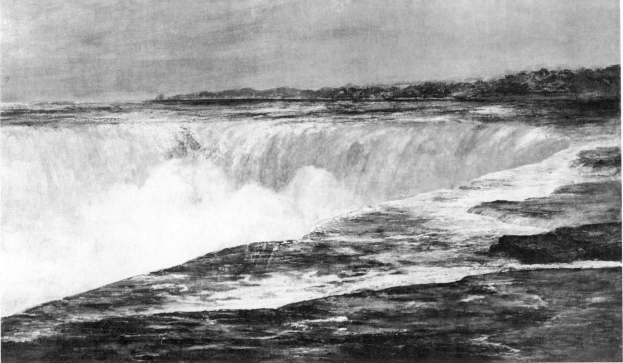

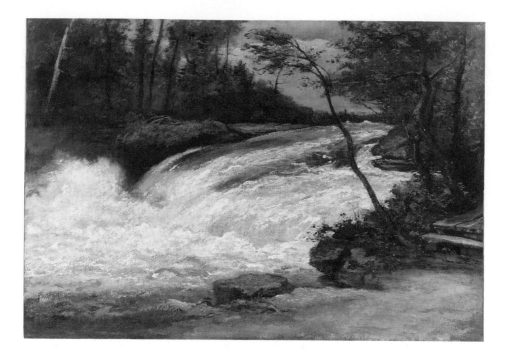

his grand undertaking: development of the color harmonies, adaptation of the designs to the arched frame of the lunettes, and creation of the cartoons.

The renown Hunt achieved through his new landscapes and his *Talks on Art* helped bring him to the attention of the men responsible for the design and construction of the Albany statehouse. No doubt influenced by his brother's prestige as a leading architect in New York City, they invited Hunt to create the first civic murals in the United States that were by an American artist.[78] Hunt was not a specialist in this branch of art; nevertheless, he brought to the enterprise many years of study abroad and twenty-five years of experience as a professional artist. Neither tentative nor experimental, Hunt's paintings were regarded as a success because they recalled the great European mural tradition of the past, a tradition that, for Hunt, extended from Michelangelo to Delacroix. Nor was his recasting of these precedents regarded as retrograde, because his murals were thought to signify American civilization's coming-of-age.

FIGURE 131. *Sister Islands, The Rapids, Niagara,* 1878. Oil on canvas, 30″ × 43″. Ball State University Art Gallery, Muncie, Indiana. Permanent loan from the Frank C. Ball Collection, Ball Brothers Foundation.

5

Hunt's Mural Paintings and His Last Years

HUNT'S TWO MURALS, *The Flight of Night* and *The Discoverer,* although badly deteriorated and concealed above a false ceiling in Albany's Assembly Chamber, remain among the most important paintings in late-nineteenth-century American art. With these paintings, Hunt was acknowledged as the first American artist to come close to creating civic murals with the formal excellence and expressive power of European art. Even his lifelong detractor Clarence Cook stated that "nothing as yet undertaken here in the art of monumental decoration at all approaches these mural paintings of Mr. Hunt, in the dignity of the composition as a whole, in the beauty of the parts, in the mastery of the execution."[1]

Also, Hunt's allegorical compositions, in contrast to the historical narratives installed twenty years earlier in the United States Capitol Rotunda, were thought to have universal, humanistic meaning. Only tangentially, through the figure of the Discoverer, do his murals refer to American history. Instead, *The Flight of Night* and its pendant, *The Discoverer,* conjured up a host of historic, artistic, and literary associations that were timeless. For the informed nineteenth-century viewer, the central figure of Anahita in *The Flight of Night* was at once a Zoroastrian goddess, a seated Aphrodite, and Luna – a figure who combined Near Eastern, Greek, and Roman mythological traditions and who represented simultaneously barbarism and ignorance before the dawn of civilization. In *The Discoverer,* Columbus, an American hero born in the Renaissance, who linked two continents – Europe and North America – was also the symbol of visionary genius and enlightenment. Further, Columbus and Anahita together represented eternal polarities – male and female, day and night, sea and air – a pairing extended by the complementary images of Fortune in *The Discoverer* and Anahita or Luna in *The Flight of Night,* who, when seen together, became symbols of fortune and destiny.

Summer 1878: Sketches and Designs for the Albany Murals

Long before the Albany commission, Hunt had been at work on *The Flight of Night*. In the late 1840s his brother Leavitt, who was studying law and oriental languages in Heidelberg, sent him the English translation of a Persian poem titled "Anahita," suggesting that it serve as the narrative basis of a modern pendant to Guido Reni's seventeenth-century masterpiece *Aurora:*

> Enthroned upon her car of light, the moon
> Is circling down the lofty heights of Heaven;
> Her well-trained courses wedge the blindest depths
> With fearful plunge, yet heed the steady hand
> That guides their lonely way. So swift her course,
> So bright her smile, she seems on silver wings,
> O'er-reaching space, to glide the airy main;
> Behind, far-flowing, spreads her deep blue veil,
> Inwrought with stars that shimmer in its wave.
> Before the car an owl, gloom sighted, flaps
> His weary way; with melancholy hoot
> Dispelling spectral shades that flee
> With bat-like rush, affrighted, back
> Within the blackest nooks of caverned Night.
> Still Hours of darkness wend around the car,
> By raven tresses half concealed; but one,
> With fairer locks, seems lingering back for Day.
> Yet all with even measured footsteps mark
> Her onward course. And floating in her train
> Repose lies nestled on the breast of Sleep,
> While soft Desires enclasp the waist of Dreams,
> And light-winged Fancies flit around in troops.[2]

Intrigued with this idea, William did a small sketch representative of the entire poem (see fig. 6), and later, two bas-reliefs of Anahita's horses (see fig. 5). He continued to work on this theme after his return, creating at least two large versions (one done in the 1860s and a second, larger painting begun in the early 1870s), and undoubtedly other studies, many of which were destroyed in the Boston Fire. If it were not for the Albany commission, given his new interest in landscape painting, it is doubtful that Hunt would have returned to this theme. It was his brother Richard, instrumental in promoting William for this job, who reminded him of his earlier enterprise.[3] In fact, Richard owned one of the plaster reliefs of the *Flight of Night – Horses of Anahita* (Metropolitan Museum of Art), and Jane possessed several sketches including a small oil painted on a Japanese tea tray (Museum of Fine Arts, Boston). There was also a photograph of the 1870s version that unfortunately

152

has not been found. Over the years, however, other incidental studies have been located.[4]

In addition to these fragments, Hunt created two different, but same-size, rectangular presentation paintings for the architects and Dorsheimer, the only officials apparently responsible for his commission. One study, *The Flight of Night* (fig. 132) is now at the Pennsylvania Academy of Fine Arts, Philadelphia, the other, *Anahita: The Flight of Night* (fig. 133) is at the Museum of Fine Arts, Boston. Hunt also did a same-size replica of *The Discoverer* (fig. 134), which was recently cut into fragments.

The final versions of both murals are known today only from photographs taken from Hunt's scaffold. In the center of *The Flight of Night* (fig. 135), the Persian goddess Anahita sits on a crescent moon, supported by a cloud-shaped throne or chariot. Glancing warily to her left in anticipation of dawn's arrival, she urges forward three magnificent steeds who charge at breakneck speed across the late night sky. A nude youth carrying an inverted torch, leads them into a dark abyss. Accompanying Anahita in her flight are a mother and child – Sleep and Repose – who float in a cloudlike drapery supported by a flying putto. These tranquil images conjure up both the innocence of sleep and the loneliness of death.

Opposite *The Flight of Night*, which was painted on the north wall of the Assembly Chamber, and eighty seven feet across the great auditorium, is *The Discoverer*. As seen in a contemporary photograph (fig. 136), it is dawn, somewhere at sea. The pensive figure of Columbus stands in the middle of a small boat. Behind him the figure of Fortune holds the sail and tiller. In the waves surrounding the front of the boat are female personifications of Faith, Hope, and Science. The foremost, with her back to the viewer, is Faith, who buries her face in her arm floating on the crest of a wave. Hope, the middle and the most prominent of the three figures, faces forward supporting herself on the bow while gesturing with her right arm to the horizon. Science, who faces Columbus, extends a scroll for his consultation. To reinforce the meaning of *The Discoverer* as a symbol of the dawn of a new era, Hunt took artistic license and had Columbus contemplate the rising sun in the east, while sailing west to the New World.

Unlike Hunt's extended work on *The Flight of Night*, there is only one known early sketch for *The Discoverer*, dated "1850 or 1860" (fig. 137).[5] This sketch, with its central motif of a single figure standing in a small boat surrounded by fiendish figures who swarm and cling to the side of the craft, recalls Delacroix's *Barque of Dante*. This well-known painting secured Delacroix's reputation when shown at the Salon of 1822; eventually bought by the state, it was placed in the Musée du Luxembourg. It was often reproduced and was included in a series of lithographs by Celestine Nanteuil in 1849.[6] As further evidence of its popularity with younger artists, it was copied by Courbet and Manet. Hunt was also an admirer of Delacroix's and, like these

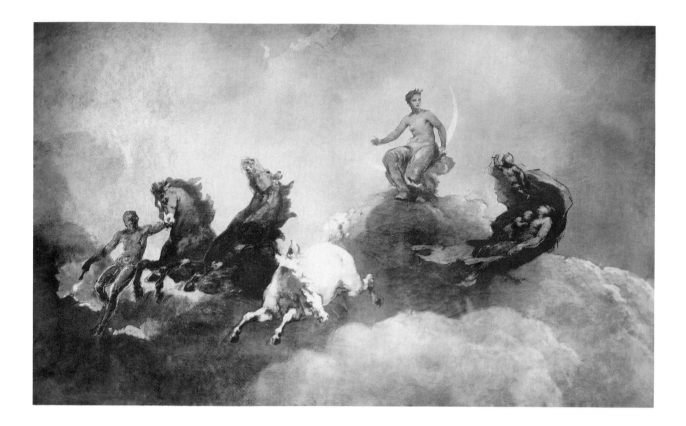

French artists, may have done this sketch in response to seeing the painting while he was in Paris.

As far as can be established, Hunt did no further work on the Columbus theme until December 1877, when he was first approached by Dorsheimer. In response to his invitation, Hunt resurrected the earlier drawing and adapted it for a preliminary presentation of *The Discoverer* dated December 1877 (fig. 138).[7] In this later sketch he has tamed the turbulent sea, rearranged some of the figures, and eliminated their grotesque features. He has also included an important figure, known as Fortune, in the rear of the boat. What was originally a frenzied composition is now tranquil and composed; a romantically inspired rendering has been transformed into a stately representation of the introspective discoverer: a mood more appropriate for civic art.

Hunt did not continue to refine his ideas until he had secured a contract for the Albany commission. Once it was signed, he did a number of sketches in which he evolved the final compositional scheme. In these later drawings, the figures are more clearly represented and the design further manipulated, including the position of Fortune, who now sits holding a billowing sail in the stern, to conform to the upper curve of the tympanum (fig. 139).

To aid him in his planning, Hunt during the summer sought the guidance of two friends, William Rimmer and the architect-designer J. Philip Rinn.[8]

FIGURE 132. Study for *The Flight of Night*, 1877. Oil and chalk on canvas, 62″ × 99″. Courtesy of the Pennsylvania Academy of the Fine Arts, Philadelphia. (Henry D. Gilpin Fund)

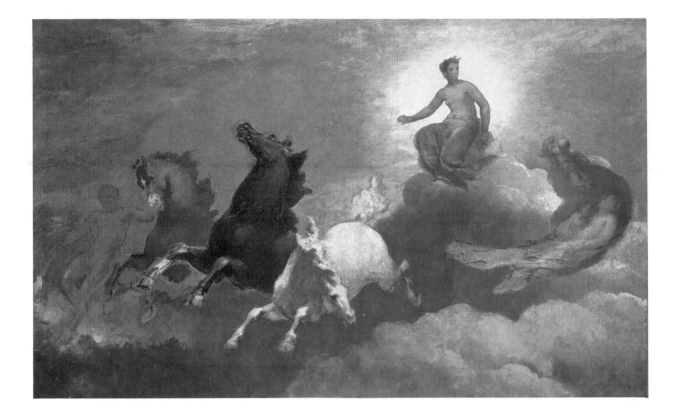

FIGURE 133. *Anahita: The Flight of Night*, c. 1878. Oil on canvas, 62″ × 99″. Museum of Fine Arts, Boston. (Gift of H. Nelson Slater, Mrs. Esther Slater Kerrigan, and Mrs. Ray Slater Murphy in memory of their mother, Mabel Hunt Slater)

With the stunning example of the newly completed Trinity Church decorations nearby, Hunt was sensitive to the decorative as well as narrative function of his murals. (Whether he sought the counsel of La Farge, in Boston completing his work at Trinity, is not known.) Hunt had worked with Rinn earlier on the decoration of his own studio and once again turned to him for advice. He sent him a photograph of the 1872 version of *The Flight of Night*, seeking Rinn's opinion on the suitability of this painting as decoration.[9] Unfortunately, the photograph is lost, along with any evidence of what Rinn and Hunt may have discussed.

Hunt sent Rimmer, too, a version of his new work, an arched-frame version of *The Discoverer*. Rimmer did both a tracing and a sketch that, although the tracing is almost invisible (#1956.240, Fogg Art Museum, Cambridge, Mass.), clearly shows Rimmer's reworkings (fig. 140).[10] With a hard, wiry line Rimmer transformed Hunt's drawing into a more formal and monumental friezelike design reflecting traditional notions of mural painting – flat, linear, two-dimensional – the same criteria for architectural decoration that the critic Henry Van Brunt would later articulate in his review of Hunt's murals. Yet Rimmer's drawing suggests a static monumentality that was at variance with Hunt's more animated and painterly conception. Even so, Rimmer's influence is found in several powerfully modeled sketches of individual figures below

a lunette-shaped drawing of the entire work (fig. 141). Here, Hunt freely works the figure reflecting a knowledge of anatomical structure that he may have gained from Rimmer. Above, the drawing itself is now very close to the final work and shows Fortune returned to her previous standing position. This change not only helped balance the composition but gave the figure of Fortune greater narrative power. This was important because by enlarging Fortune's presence, Hunt was able to connect her to *The Flight of Night*'s central figure, Anahita, who in nineteenth-century descriptions of the murals was often referred to as Luna. Historically, Luna (Anahita) and Fortune are bound as symbols of man's destiny and fate. Through this pairing of female personifications, Hunt established a narrative link between *The Flight of Night* and *The Discoverer*. Evidence that Hunt, too, thought of Anahita as Luna are the several studies he did of her in which she is sometimes surrounded by an aureole of light (fig. 142), or at other times seated on a crescent moon, as she is in the final version.[11] Hunt also did separate studies of Fortune; one of the most impressive is *Winged Fortune*, a gorgeously colored larger-than-life-size oil (fig. 143).[12] Lastly, there is a pair of same-size paintings, one known as *Night* (fig. 144), the other *Fortune* (fig. 145), both at the Metropolitan Museum of Art, which further confirms their connection.

In addition to organizing his compositions, Hunt also had to prepare his paints, which he did by testing the durability of some new pigments he had invented on blocks of Ohio sandstone, the building material used in the Assembly Chamber.[13] Unfortunately, Hunt's new paint formula proved unsuccessful – he used too little binder and the pigments were not well mixed. A recent conservatorial report has also shown that Hunt was unaware that the stonework was only a facing, and that over the years salts from the bricks and mortar would permeate the surface of the mural from behind. Hunt's murals, in addition to being concealed above a false ceiling, are now also tragically defaced.[14]

These problems highlight the difficulties Hunt and other nineteenth-century artists encountered in their search for pigments and binding mediums to replace the Renaissance formulas for fresco, which did not remain stable in cold, damp northern climates. The search for alternatives to traditional fresco accompanied a mural-painting revival that was international in scope. With the growth of popular government in Europe and the United States, new state buildings such as courthouses, treasuries, post offices, and the like were needed. As new space was constructed and old buildings renovated and refurbished, mural painting was incorporated to give visual expression to the ideals of new state governments. It was in England in the 1840s, with the construction of the new Houses of Parliament, that historical investigation into Renaissance fresco technique was first undertaken. One of the best-known researchers, Mrs. M. P. Merrifield, in 1844 had translated Cennino Cennini's *Treatise on Painting*, and two years later had compiled *The Art of Fresco*, a

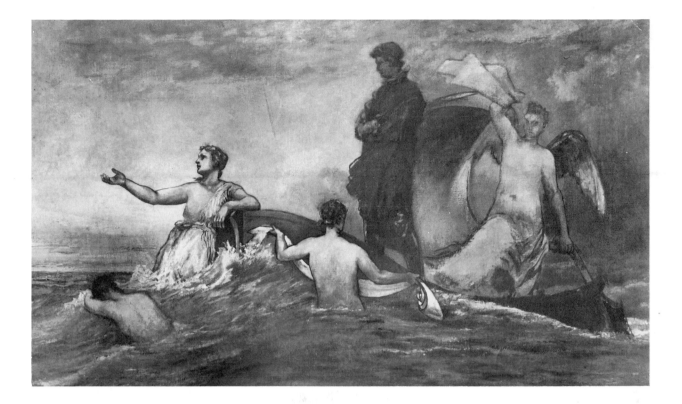

FIGURE 134. *The Discoverer*, c. 1878. Oil on canvas, 64″ × 99″. Destroyed. Photo: Courtesy of Vose Galleries, Boston.

collection of "historical texts on the techniques and materials employed by fresco painters at various dates from the twelfth to the eighteenth century."[15] Some of these and other researches authorized by the British Commissioners of the Fine Arts were later reported in *The Crayon* in 1861. Much of this information was known to Hunt, who referred to Mrs. Merrifield's writings in his *Talks on Art*.[16]

Hunt's contemporaries, La Farge and Leutze, also experimented with new techniques of wall painting. At Trinity Church, La Farge used a wax encaustic method; in the nation's Capitol, Leutze, for his fresco *Westward the Course of Empire* (1862), experimented with a stereochromatic, or water-glass, method that involved grinding pigments in a mixture of potassium silicate and water.[17] Hunt, himself may have been influenced by the researches into the spirit fresco process developed in the nineteenth century by the Englishman T. Gambier-Perry.[18] Such speculation arises from the presence of a detailed recipe in a "Sketchbook" of Hunt's kept by his sister, which included sketches for *The Flight of Night*. This recipe called for dissolving mastic (a soft resin) in alcohol with the tincture of lead. Portions of his notation read as follows:

> Dissolve mastic in alcohol in the proportions of 100 grammes
> [*sic*] of mastic to 80 centilitres of alcohol in a water bath. Stir

157

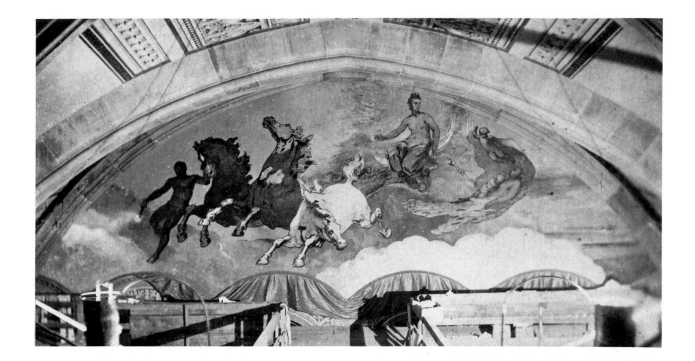

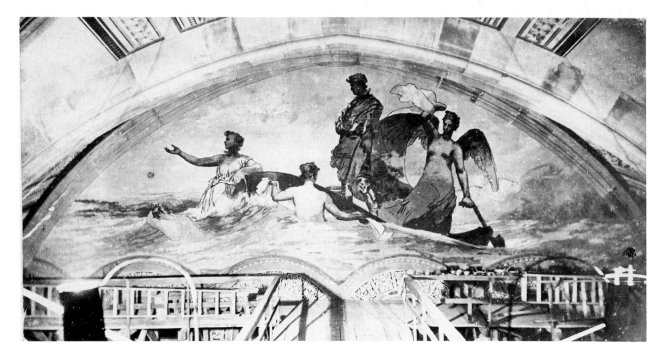

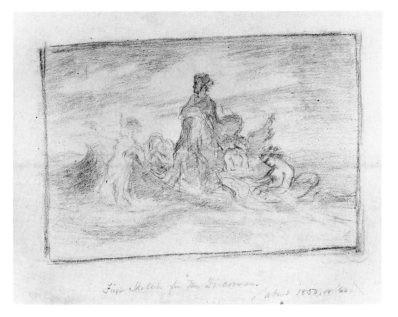

First Sketch for "the Discoverer" *[About 1850, or '60.]*

FIGURE 137. Sketch of *The Discoverer*, 1850 or 1860. Pencil on paper, 11½″ × 17″. Private collection.

FIGURE 135. (*opposite, top*) *The Flight of Night*, 1878. Photograph of mural taken from scaffold, December 1878. The American Architectural Foundation, Prints and Drawings Collection, The Octagon Museum, Washington, D.C.

FIGURE 136. (*opposite, bottom*) *The Discoverer*, 1878. Photograph of mural taken from scaffold, December 1878. The American Architectural Foundation, Prints and Drawings Collection, The Octagon Museum, Washington, D.C.

up the sediment and let it stand to clarify. Dissolve [?] of lead to saturation in a water bath and filter it. When the solutions are clear and about at the temperature of 15 degrees centigrade drop the solution of mastic slowly into four times its bulk of the solution of [?] of lead. Stirring the latter vigorously while the [?].[19]

Nor did Hunt's preparations stop here: he also had to plan his color program. This he did by creating studies in various color combinations to determine which would look best in the given light of the Assembly Chamber and would fairly compete with the surrounding decorative surfaces. His ideas can be traced through a series of small paired pastel drawings in lunette-shaped frames, of which at least six pairs exist. (However, only three pairs are together at the Museum of Fine Arts, at the Octagon Museum, and in a private collection). Aside from their importance as investigations of color harmonies, they also reveal Hunt's new understanding of color's expressive as well as decorative possibilities. For instance, in a gouache study of *The Flight of Night* (fig. 146), color is modulated from a crimson-hued, sun-streaked dawn on the right to a pitch-black nighttime sky on the left. Through color alone Hunt expresses the flight of night. In its companion, *The Discoverer* (fig. 147), light pink clouds give way to a clear blue behind the figure of Columbus, which becomes a gray turbulence on the right behind the figure of Fortune. Color here dramatically conveys the significance of Columbus's journey.

Hunt has never been thought of as a colorist, a condition he himself admitted. It is therefore doubly tragic that only at the end of his life did his

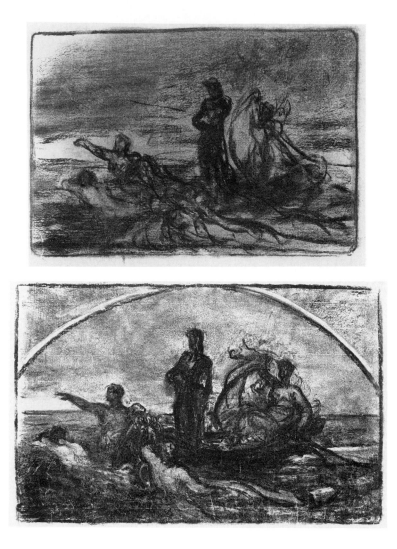

full powers as a painter emerge, first in his extraordinary Niagara paintings and later in his Albany murals. Yet it takes an experienced muralist to be able to gauge accurately the strength of color needed to project a painting successfully over a great distance. As Hunt stated:

> It is an entirely new kind of work for me, different from anything else.... To disengage the clear figures from the light sky, I have, in places, to use a *brun rouge* line as thick as your finger. Every mistake or weakness "carries" perfectly. It won't do, either, to have things vapory. A fascinating little head, dissolving into nothing, won't do at all.[20]

Hidden above a false ceiling, the success of Hunt's efforts cannot be evaluated today. We therefore must rely on contemporary critics who noted that his work was done in too high a key and that he had not sufficiently considered the impact of the surrounding decorative stonework.

FIGURE 138. Study for *The Discoverer*, 1877. Charcoal on cream paper, 9″ × 11½″. Courtesy of the Fogg Art Museum, Harvard University, Cambridge, Massachusetts. (Gifts for Special Uses Fund)

FIGURE 139. Study for *The Discoverer*, 1878. Charcoal on cream paper, 11⅜″ × 17½″. Courtesy of the Fogg Art Museum, Harvard University, Cambridge, Massachusetts. (Louise E. Bettens Fund)

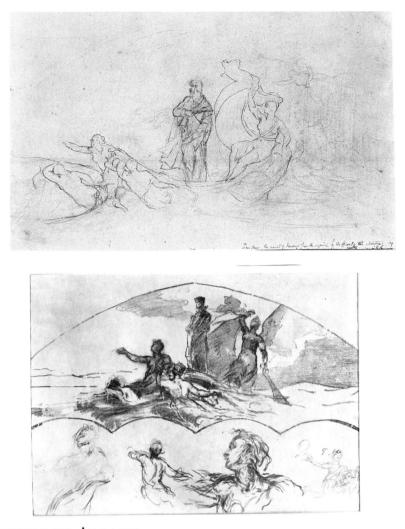

FIGURE 140. William Rimmer. *The Discoverer*, after William Morris Hunt, 1878. Black chalk and graphite on cream paper, 11⅜" × 17⁷⁄₁₆". Courtesy of the Fogg Art Museum, Harvard University, Cambridge, Massachusetts. (Louise E. Bettens Fund)

FIGURE 141. *The Discoverer: Composition Study and Figure Sketches*, 1878. Charcoal on thin paper, 14" × 20". The Art Museum, Princeton University, Princeton, New Jersey. (Gift of Frank Jewett Mather, Jr.)

Painting in Albany

After completing his studies and color sketches, Hunt drew a pair of six-by-eight-feet cartoons (now lost) which he took, along with his secret pigments, to Albany in early October 1878. Once at work, Hunt was exultant, and wrote of his success to friends. His letters, along with a number of charcoal sketches done by his sister Jane, provide an almost daily chronology of his work at the capitol. All aspects of the enterprise impressed him, even the construction of his scaffold, which he described in a letter to his student Rose Lamb: "The men finished the bridge connecting the two scaffolds yesterday and a fine bridge it is spanning the whole width of the immense room forty feet from the floor; it crosses the room at one stretch without any centre posts and is 7 feet in width and has a hand rail on both sides."[21] An untitled sketch by Jane (fig. 148) complements Hunt's description.

As soon as the scaffolding was in place, Hunt, aided by an innovative transfer process, immediately began to sketch in the design for his murals. Instead of using the traditional laborious method of pouncing to reproduce

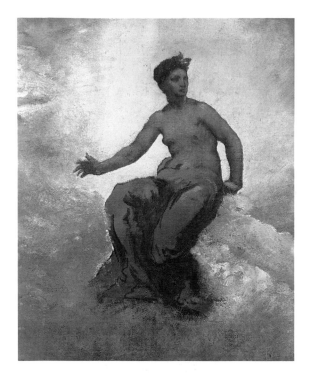

his drawings, he had his cartoons photographed onto glass slides, which could then be projected onto the surfaces of the lunettes. Both Eidlitz and the architectural critic Montgomery Schuyler traveled to Albany to see Hunt and to observe his first experiments with his slide-projection process – which made it imperative to work at night. Hunt, his assistants, Eidlitz, and Schuyler were all on the scaffold when the walls were first illuminated. "An oxyhydrogen light behind the camera threw [the cartoons], magnified to their full size, into their true position.... The artist, with a movement, could shift the picture downwards or upwards, to the right or left, enlarge it or diminish it, at will; and when it was finally adjusted, could fix the outline on the wall from the photographic image."[22] Hunt reported with delight Eidlitz's and Schuyler's reaction: "when the picture of the horses was thrown up full size in the dark room across the space of 87 feet on to the arched stone gable they gave me three cheers."[23]

In his next letter to Miss Lamb, he described his first night's work:

> Saturday [October 19] at 6 pm we made our first working visit to the Capitol, having made an arrangement with the night watchman to let us in and provide us with a torch and a carpenter.... After a good many experiments in placing the picture in different ways we decided to attack ... I used ladders to draw from and Tom [Robinson] and the young carpenter

FIGURE 142. *Anahita*, 1878. Oil on canvas, 25″ × 21½″. Museum of Fine Arts, Boston. (Bequest of Anna Perkins Rogers)

FIGURE 143. (*opposite*) *Winged Fortune*, 1878. Oil on canvas, 99½″ × 62¾″. The Cleveland Museum of Art, Cleveland, Ohio. (Purchase from the J. H. Wade Fund)

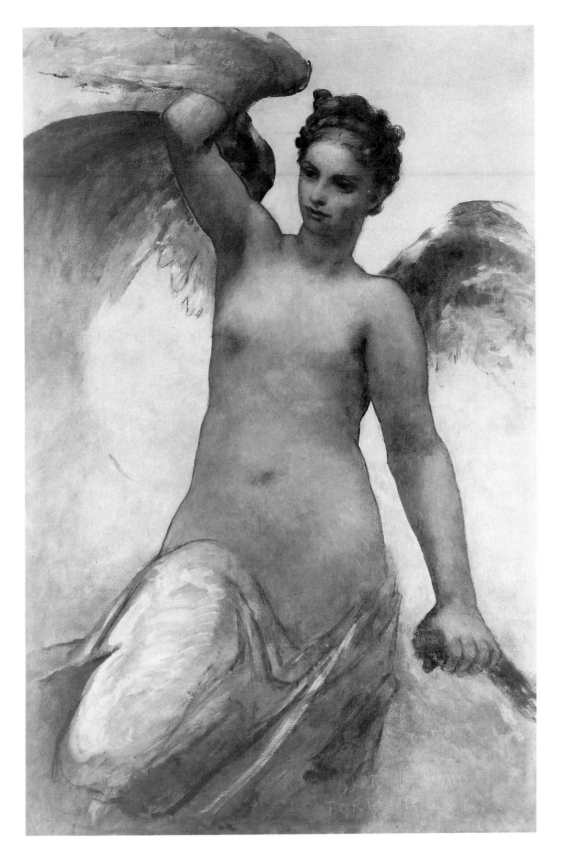

163

were kept pretty busy putting them up, taking them down and changing them. I drew in the group of the horses [fig. 149] and sketched in the place of Anahita and the Sleeping Figures.[24]

He did not like the placement of these first efforts, however, and the next night he "began by brushing out all the work and washing the marks out with large damp sponges."[25] But the work for the next few days proceeded well and rapidly; and by October 28 he could report to his friend Angell:

> One week at work, and the outlines are about completed, and painting begins, I hope, to-morrow.
> I can tell you, it is like sailing a seventy-four, or riding eight horses in a circus. It fills one's lungs to breathe in front of such spaces. The figure of Columbus, or the Discoverer, is eleven feet from his crown to the boat where his shins disappear. His hand is broader than this page is long.[26]

Having completed his preliminary sketches with the aid of the slide-projection process, Hunt and his two assistants, Robinson and Carter, were able to work during the day. On November 3, he wrote:

> We began painting on Wednesday [October 29] morning, it was a little embarrassing to put the first big daub of paint on to the clean stone wall, in fact I did not really like to do it – and time flies so fast that one has not time to hesitate, although I will say that so far there has been no hurrying in the work, and I hope it may continue to be done at least with deliberation, for the slightest movement of hurry would put the work back.[27]

It was probably sometime in December that the painter Will Low, recently back from Paris and living in Albany, visited Hunt on his scaffold. Low had not met Hunt before but had heard Millet and the American painter William Babcock sing his praises in Barbizon. He also knew and admired Hunt's work. So Low was annoyed when Hunt ignored him, and finally got his attention when at the end of the day he shouted: " 'Before I go I ought to tell you that a few months ago I was in Barbizon, where I knew the Millets and Babcock' "[28] This announcement worked like magic and Hunt told him to wait, relit the murals, and talked with him for several hours. Hunt was an intimidating presence yet Low said that he was "not likely to ever forget the few hours I passed, high in the air, in his impressive presence, listening to his conversation, filled with enthusiasm and wise with the knowledge of his craft, though larded with strange oaths."[29]

Although Hunt had other visitors besides Low, and had to stop work early some days because of the cold, he was able to complete the murals by December

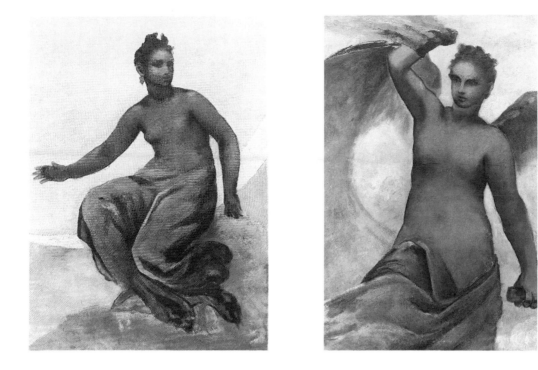

FIGURE 144. *Night*, sketch for mural decoration in the State Capitol at Albany, 1878. Oil on canvas, 37″ × 25½″. Metropolitan Museum of Art, New York. (Rogers Fund)

FIGURE 145. *Fortune*, sketch for mural decoration in the State Capitol at Albany, 1878. Oil on canvas, 37″ × 25½″. The Metropolitan Museum of Art, New York. (Rogers Fund)

21. The scaffolds were removed, and finishing work was completed by the carpenters. The room was ready for its official opening, January 7, 1879. The inauguration of the new State Capitol (although only the North Center) was marked by a gala reception and ball. More than four thousand people had been sent invitations, and an estimated ten thousand attended. In the press it was noted as "the most brilliant social event in the history of Albany."[30] Hunt and his brother Richard attended, although it is said that William stayed on the sidelines, content to observe the visitors' enthusiastic responses to the hall's magnificence and his murals.

AN APPRAISAL

Unlike large-scale grand-manner easel painting, there were few precedents in this country for public-mural painting; the most ambitious before Hunt's were the frescoes for the United States Capitol by the Italian Constantin Brumidi, hired in 1855 to paint the walls and ceilings of the corridors and committee rooms in both houses of Congress. No one was happy with Brumidi's work. American artists were outraged that a European had been chosen for such a plum, and critics found the work compositionally weak and illustrations of such classical myths as Leda and the Swan silly and inappropriate.[31]

The other projects that preceded the Albany murals were, significantly, by two of Hunt's colleagues: his friend from student days in Düsseldorf, Leutze, who painted *Westward the Course of Empire Takes Its Way [Westward Ho!]*

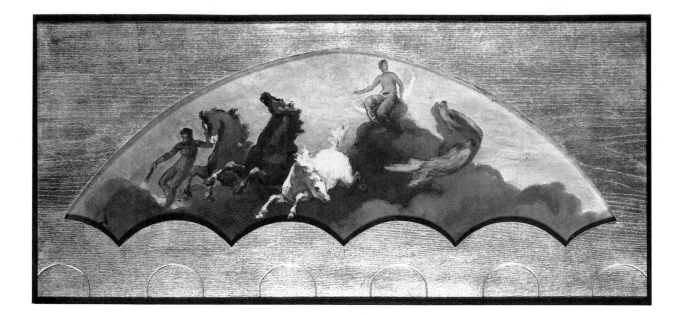

FIGURE 146. *Sketch for the State Capitol at Albany (The Flight of Night)*, 1878. Gouache sketch in lunette frame, 16 × 36¾". Photo, Courtesy, Museum of Fine Arts, Boston. (Lent by Mrs. Enid Hunt Slater)

(1862) for the west stairwell in the new House wing of the Capitol; and Hunt's former student La Farge, who created an entire decorative program for the interior of Trinity Church, Boston.

Leutze, hoping that a replica of his *Washington Crossing the Delaware* would someday find a home in the nation's Capitol, had been in correspondence with Congress regarding a commission for this painting and another to serve as its pendant, *Washington Rallying the Troops at Monmouth*. In 1854, Leutze's inquiry had come to the attention of the newly appointed superintendent of construction for the Capitol extension, Captain M. C. Meigs, who disappointingly only requested his advice about mural painting instead of offering him a commission. There were no further developments until 1859, when Leutze returned to the United States. Again he was in touch with Meigs, who, after a two-year delay, gave the painter a small stairwell area for his fresco *Westward Ho!* Although rarely noted in discussions of American mural painting, Leutze's mural is noteworthy on three counts. First, it is the earliest-known fresco done by a professional American painter in the United States. Second, it was here that Leutze used a new modern fresco technique called "stereochromy." Third, Leutze, as he had done in *Washington Crossing the Delaware*, undertook to create another modern historical work, this time of westward expansion.

However, it was not critically well received: "the historical school [and Leutze was considered one of its noted practitioners] which had attracted so many painters and produced so much history painting in the twenty-five years beginning around 1840, fell rapidly into disfavor."[32] As William Gerdts discussed in *Grand Illusions, History Painting in America*, one of the few modern studies on the subject, artists, critics, patrons, and institutions involved with

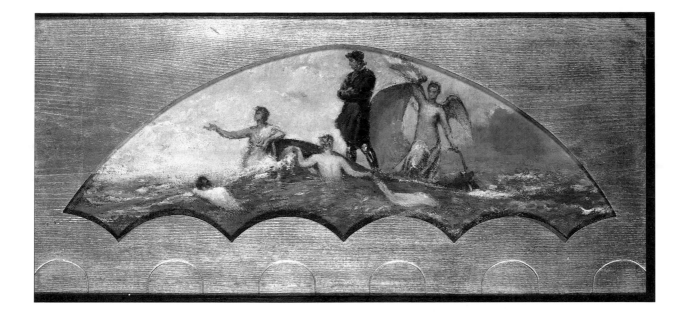

FIGURE 147. *Sketch for the State Capitol at Albany (The Discoverer)*, 1878. Oil on panel in lunette frame, 16″ × 36¾″. Photo, Courtesy, Museum of Fine Arts, Boston. (Lent by Mrs. Enid Hunt Slater)

commissioning such works after the Civil War were dissatisfied with, if not downright contemptuous of, older types of historical painting, including the mural-scale commissions for the Capitol Rotunda by John Trumbull, Robert Weir, John Gadsby Chapman, John Vanderlyn, and William Powell. Their work was found too provincial and too self-congratulatory, and technically too unrefined.

The need for a new school of national painting was coupled with an awareness that in Europe mural painting was increasingly an important element in the decoration of new public buildings. For instance, in England, with the new Houses of Parliament, a national mural-painting school arose that produced nostalgic illustrations of significant incidents in British history; in Germany, Peter von Cornelius, the dean of early-nineteenth-century muralists, created learned renderings of classical allegory and personification. A transformation occurred in France, however, with projects such as Delacroix's murals for the Palais Bourbon.[33] Here Delacroix borrowed elements from the Baroque, a style traditionally associated with the glorification of the monarch or the church, and adapted it for a program that glorified the state. Others followed, namely Théodore Chassériau and Puvis de Chavannes – who, along with Delacroix, invested traditional symbols with new meaning and constructed visual programs reflecting current democratic developments and new historical research.[34]

By the third quarter of the nineteenth century, sophisticated Americans – architects, painters, churchmen and politicians, most of whom had traveled abroad – were acquainted with these European developments in architecture and decoration and knew the symbolic importance such buildings held. In the United States, a new nation that was quickly becoming a world power,

there was a desire that the decoration of public and religious buildings begin to reflect this coming-of-age. In the forefront of such developments were the men involved with the design and construction of the Albany statehouse. Of these, H. H. Richardson had already proposed the idea of a painted interior for Boston's Trinity Church and had given La Farge his first opportunity to address the problem of integrating mural painting into an architectural space.[35]

With the full confidence of the architect, and the active support of Trinity's progressive rector Phillips Brooks, La Farge had the ideal commission for this new enterprise. Richardson had been trained at the Ecole des Beaux-Arts, the second American after Richard Hunt, and was familiar with European precedents. The examples he followed at Trinity Church were medieval, specifically French Romanesque, and a great deal of interior wall space was available for decoration. Here, La Farge created an overall red color scheme enriched by complex patterned decorations in blues, greens, and golds, that articulated Richardson's architectural structure. His painted decorations were further augmented by his effective introduction of figural work in the transept tower and two facing murals at the back of the nave. Stained glass designed at a later date for many of the windows further unified his conception. La Farge's success was such that the decorative principles embodied in Trinity Church were widely admired and emulated. La Farge himself spent the rest

FIGURE 148. Jane Hunt. "Albany," 1878. Charcoal sketch. The American Architectural Foundation, Prints and Drawings Collection, The Octagon Museum, Washington, D.C.

168

FIGURE 149. Jane Hunt.
"Albany," 1878. Charcoal
sketch. The American Ar-
chitectural Foundation,
Prints and Drawings Collec-
tion, The Octagon Museum,
Washington, D.C.

of his life working in architectural decoration, extending his commitment
beyond mural painting to stained glass, and beyond churches to interiors of
private homes, including a sumptuous design done between 1880 and 1883
for the Watercolor Room of Cornelius Vanderbilt II's house on Fifth Avenue,
and important public buildings such as the Supreme Court room for the
Minnesota State Capitol, St. Paul (1904).

This idea of a colored interior was later repeated by Richardson, without
mural paintings, in the Albany Senate Chamber, and even more lavishly by
Eidlitz in the Assembly Chamber. Unlike La Farge, who participated in the
planning stages of the Trinity Church's decoration, Hunt was called in, almost
as an afterthought, at the last minute to add murals to Eidlitz's magnificent
interior of painted stonework. It is in light of this dilemma faced by Hunt
that Henry Van Brunt, an architectural critic and former student of Richard
Hunt's, discussed the relative success of La Farge's and Hunt's efforts. This
important article, published in the *Atlantic Monthly* shortly after the Assembly
Chamber opened, is a sophisticated critical appreciation of their efforts and
a plea for further American work in the fields of mural painting and archi-
tectural decoration.

In his article "The New Dispensation of Monumental Art," Van Brunt
began by comparing the work of La Farge and Hunt to Brumidi's work in
the nation's Capitol. Van Brunt found the latter's work technically competent
but "born of a cold artisan spirit," and not a good model on which to base a
national school of mural painting.[36] For Van Brunt, it was important to crit-

ically discuss mural painting, or "monumental art," a term he used synonymously, because "it is a duty of civilization to subject such examples as these to serious critical examination."[37]

Van Brunt, who only a few years earlier had collaborated with William Ware on the construction of Memorial Hall in Cambridge, a prime example of the Victorian Gothic in this country, was devoted to uniting painting and other decorative arts with architecture, as had been the practice in the Middle Ages. His aesthetic principles evolved from his study of the writings of Ruskin and the French architect Viollet-le-Duc, both of whom were avowed medievalists.[38] Their passionate polemical writings on architectural decoration were primarily concerned with sculpture: its organic relationship to the architectural structure evident in the Italian Romanesque churches favored by Ruskin, and in the French Gothic cathedrals studied by Viollet-le-Duc. Yet both writers also discussed the role of painting in architecture. Ruskin in *Stones of Venice* contended that later Italian architecture – namely, Renaissance – was undistinguished because its interior walls only served as a painter's canvas.[39] Viollet-le-Duc's writings on mural painting were more learned and technical. In an article on painting in his ten-volume *Dictionary of French Architecture from the 11th to the 16th Century* he wrote at length on the history of painted decoration, declaring that during the Middle Ages painting was most truly allied with architecture. The decline of this supportive relationship, according to Viollet, was signaled by Michelangelo's *Last Judgment,* which failed as decoration because the painting overwhelmed the architectural environment of the Sistine Chapel.[40]

Using their criteria, which he had adopted as his own, Van Brunt credited La Farge with successfully bringing the "whole interior...to a condition of unity."[41] In contrast, Van Brunt felt that Hunt, although handicapped by being brought in late to the project, had in several instances violated the basic criteria of successful mural decoration. His first concern was that Hunt's colors were too high in key: "We cannot but think...that [Hunt] was deceived as to the amount of light which these surfaces would receive from the opposite windows...[and] betrays a coarseness of outline and color."[42] He was further disturbed that there was no separation between the "aerial spaces of his compositions from the hard colored lines of the belts in the vaulting, which attack the very edges of his clouds."[43] It was in his discussion of the lack of framing for the pictorial field that he compared Hunt's murals to Michelangelo's *Last Judgment,* which also failed as decoration because of "the rawness of its boundary lines."[44]

From these observations Van Brunt went on to explain the difference between decorative and pictorial design. "These great examples [Michelangelo's *Last Judgment*]...have seduced nearly all subsequent art from a fair recognition of the flat surfaces which it occupies, and have tempted it to feats of illusion which are not in harmony with the principles of decorative as opposed to pictorial design."[45] Furthermore, Michelangelo, in his *Last Judg-*

ment (which Van Brunt refers to as a "magnificent apostasy"), by introducing illusionism also violated the basic principle of "decoration as opposed to pictorial design." So, too, did Hunt, who, in Van Brunt's opinion, should have been more cognizant of the "medieval setting" of the Assembly Chamber's interior.

Van Brunt is very cautious in his criticism of Hunt for he greatly admired his effort yet felt that if Hunt's figures were flatter and his composition more symmetrical or hierarchical they would have been more in keeping with medieval design of the chamber. Hunt's "free pictorial treatment," by which he meant that Hunt's work – too colorful, too fully modeled, and too full of movement – was unsuitable for this particular environment.

Van Brunt then admits, and it obviously pains him to do so, "that work of a far lower grade than that of Mr. Hunt would have better served the purpose."[46] The importance of Hunt's murals resides in their importance as "works of art."[47] After criticizing Hunt's murals as decoration Van Brunt goes on to acknowledge them as effective allegories. Of all the many contemporary interpretations, Van Brunt's comes closest to capturing the spirit of Hunt's work and also suggestively connects Hunt's murals to the era of the Italian Renaissance by linking Columbus's discovery of America to the rebirth of Italian painting. He closes with the encomium, "there are few modern painters who can surpass him" and "we sincerely trust that his genius may have better scope in his next trial." Tragically, the next opportunity afforded Hunt was withdrawn.

HUNT'S MURALS

Although we must rely on his contemporaries' judgment of his mural success as decoration, we can still interpret them, investigate their sources, place them in the context of their time, and judge their effectiveness as conveyors of national purpose, for even though they were placed in the New York State Capitol, their meaning was not parochial.

THE FLIGHT OF NIGHT

Because *The Flight of Night* was an idea that occupied Hunt throughout his whole career it should be considered first. Outwardly, the composition is clear, recalling with its cloud-chariot and centrally placed, classically inspired figure and plunging horses, myriad aerial compositions of Apollo and, certainly, Aurora. Yet when one moves beyond these superficial associations, the mural frustrates easy understanding. The question arises, why did Hunt need to transform an essentially traditional image, who could equally be Artemis, Aphrodite, or Athena, into the personna of an obscure goddess in the pantheon of Zoroastrianism?

Hunt is mute, yet Anahita's unique presence in American art can be related to larger issues in American cultural history. For instance, Anahita can be interpreted as a symbol of oriental culture. When represented as a classical Greek goddess, she simultaneously personifies East and West. This desire to link the Greco-Roman tradition to the orient was a manifestation of much research, both historical and philological, undertaken in Boston, often by Unitarians, that sought to find commonality among all cultures. These learned amateurs were fascinated with the religions and literature of India and Hinduism, China and Buddhism, as well as Persia and Zoroastrianism. Their researches, whether in person or through books, took them to Germany (although the first translation of the Zend-Avesta, the holy books of Zoroastrianism, was done by a Frenchman, Anquetil-Duperron, in 1771, and the first English translation was by Arthur Henry Bleeck in 1864), particularly Heidelberg, where Leavitt studied. Here philological inquiries were being conducted that examined the linguistic basis of non-Western languages and brought into translation an enormous literature theretofore unknown. One result was the poem "Anahita," which Leavitt sent to Hunt. The German researches of the 1840s also influenced American writers and intellectuals, including Ralph Waldo Emerson, who translated a number of these Persian poems from the German into English.[48] (Later, a translation of the most famous, *The Rubáiyát* of Omar Khayyám, was illustrated by Hunt's friend Vedder.) The Persian poems that Emerson translated, as well as his own poetry, which they inspired, were often about the transiency of life and love with references to nature, the passage of time, and the fickleness of Fortune, similar to the sentiments found in the poem "Anahita."[49]

To some degree this interest in orientalism in the United States was influenced by the English Romantic poets, whose works were widely read and admired by the American transcendentalists. References to the Near East and specifically Zoroaster are found in Lord Byron's "Childe Harold," Book 3 (1816); William Wordsworth's "The Excursion," Book 4 (1814); Thomas Moore's "Fire Worshippers" in *Lalla Rookh* (1817); and Percy Bysshe Shelley's "Prometheus Unbound" (1819).

Emerson's devotion to oriental literature and religion went beyond an attraction for the exotic; for him, these writings provided an alternative to the narrow Calvinistic view of life and salvation. The Persian texts, in particular, described a sensuous joy in the physical world, but they also acknowledged that life was essentially unknowable, and that man lived in doubt and his destiny was controlled by fate, a view that was decidedly non-Christian. As interpreted by Emerson and later by Hunt, this view of life and the world was based on the dualistic principle of eternal polarities. Emerson discussed these principles in his essay "Compensations," published in 1841, an essay cited by the European scholar Duchesne-Guillemin as reflecting the nineteenth century's rediscovery of Zoroastrianism.[50] As with most of his early essays,

Emerson began with a poem in which images of day and night represent the polarities of life. Following his introduction he described all of life as a series of compensations:

> Polarity, or action and reaction, we meet in every part of nature; in darkness and light; in heat and cold; in the ebb and flow of waters; in male and female; in the inspiration and expiration of plants and animals; in the equation of quantity and quality in the fluids of the animal body; in the systole and diastole of the heart; in the undulations of fluids and of sound; in the centrifugal and centripetal gravity; in electricity, galvanism, and chemical affinity. Superinduce magnetism at one end of a needle the opposite magnetism takes place at the other end. If the south attracts, the north repels. To empty here, you must condense there. An inevitable dualism bisects nature, so that each thing is a half, and suggests another thing to make it whole; as, spirit, matter; man, woman; odd, even; subjective, objective; in, out; upper, under; motion, rest; yea, nay.[51]

The Zoroastrian principle of dualism is not contained in the single image of Anahita, who is rarely mentioned in the best-known accounts of Zoroastrianism but is expressed through the eternal struggle between its major deities, Ormuzd (symbol of light and goodness) and Ahriman (symbol of darkness and evil). These deities were reintroduced in the West in the late eighteenth century by the historian Edward Gibbon, who in *The Decline and Fall of the Roman Empire* (1776–87) describes Zoroastrianism's historical importance and emphasizes the dualistic nature of the religion: "The principle of good [Ormuzd] is eternally absorbed in light, the principle of evil [Ahriman] eternally buried in darkness."[52] Knowledge of the Zoroastrian religion was popularized in the mid-nineteenth century by Thomas Bulfinch, whose *Age of Fable or Beauties of Mythology* was published in Boston in 1855. In it, Bulfinch described the principle doctrine of Zoroastrianism in terms similar to Gibbon's: "Evil and good are now mingled together in every part of the world, and the followers of good and evil – the adherents of Ormuzd and Ahriman – carry on incessant war."[53] By the late 1870s, knowledge of these Zoroastrian deities was such that Clarence Cook in a description of Hunt's *The Flight of Night* published in the *New York Tribune* made a specific reference to them: "On the north wall is the allegory of Ormuzd and Ahriman, the flight of evil before good, of Night before the Dawn."[54]

Interest in Zoroastrianism in the 1870s was furthered by researches into comparative mythology and religion, undertakings that sought to describe Christianity's historical evolution. Some of these were published in Boston, two in particular – *Myths and Mythmakers* (1872) by the scholar John Fiske, and *Ten Great Religions* by the Unitarian clergyman James Freeman Clarke –

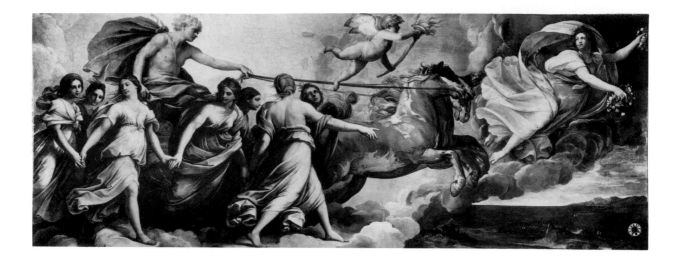

were enormously important because both believed Zoroastrianism to be a precursor to Christianity. Fiske, a historian and philologist of great erudition, traced the development of Zoroastrian dualism, seeing it as the forerunner of Christian monism. Ahriman being the forerunner of Satan, while Ormuzd was the harbinger of Christ.[55]

Clarke, whose portrait Hunt painted in 1875 and whose daughter, Lillian Freeman Clarke, was a student of Hunt's, believed Zoroastrianism to be one of the world's ten greatest religions and devoted and entire chapter to its history, in which he summarized contemporary research and included an extensive scholarly bibliography. Like Fisk, Clarke undertook his investigations primarily to support his theory that Christian monotheism evolved out of earlier religions, and he focused on Zoroastrianism because it "was the most ancient system of Dualism."[56]

Hunt's murals, however, have no religious or Christian content and in fact reflect the earlier, more secular, dualism of Emerson. Thus the appearance of the Persian goddess Anahita and the Italo-Hispanic discoverer Columbus on the walls of the New York State Assembly Chamber reflects a fatalistic view of man's existence, an aura that surrounds both of Hunt's murals, which honor neither Christian faith nor national heroes. They contain no inspirational message, nor are they an idealized view of statehood. Salvation is suggested by Hunt through the image of Science in *The Discoverer*. It is she, rather than blind Faith (who hides her face in the sea), who will determine the fate of modern man.

Sources for *The Flight of Night*

Although she is understood as an oriental goddess, Hunt in *The Flight of Night* created the figure of Anahita from elements of the most familiar monuments

FIGURE 150. Guido Reni. *Aurora*, 1613–14. Casino Rospigliosi, Rome. Alinari/ Art Resource.

174

of Western classicism. To understand Hunt's eclecticism, one must begin with his known references, one of which, Guido Reni's *Aurora* (fig. 150), was the source first suggested to Hunt by his brother Leavitt. Yet no one writing on Hunt has analyzed his indebtedness to Reni, or the reasons why Reni's painting was an important genesis. Reni's *Aurora*, with its friezelike composition, antique references, and mythological subject matter, was a seventeenth-century summary and interpretation of the classical tradition, which was subsequently revived and revered in the nineteenth. Reni himself – esteemed second only to Raphael for his draftsmanship and classicism – was extremely popular in the United States during the first half of the nineteenth century through engraved reproductions and painted copies by such American artists as John Gadsby Chapman, George Peter Alexander Healy, and Charles Robert Leslie, which were exhibited regularly at the Boston Athenaeum. In the 1870s, a copy of *Aurora* graced the wall of James Freeman Clarke's study.[57]

Primarily a library, the Boston Athenaeum was established in 1807 to promote several branches of learning – literature, science, philosophy, and theology, as well as the fine arts. This latter was ignored, however, until the 1820s when, through the generosity of the Perkins family (Louisa's grandfather and uncle), the Athenaeum opened a lecture hall and art gallery to house its growing collection of paintings and plaster casts. Bostonians, acknowledging the role of the fine arts in furthering refinement and knowledge, felt it was better to have copies of antique sculpture and old master paintings than nothing at all. Questions about authenticity were less important than exposure to the visual ideas communicated by artists such as Raphael, Reni, Correggio, and Michelangelo. Earlier, with the establishment of the American Academy of Fine Arts in New York and the Pennsylvania Academy of Fine Arts in Philadelphia, plaster casts and copies of old master paintings were considered essential tools for the instruction of aspiring artists. It is known, in fact, that Hunt studied casts of Michelangelo's sculptures *Night* and *Day*, which had been executed by Horatio Greenough in the late 1830s for Thomas H. Perkins and were bequeathed to the Boston Athenaeum in 1855.[58]

The repertoire of the elements found in Reni's painting – Apollo in his chariot, pulled by four different-colored horses led by a female personification of Dawn toward dark clouds of receding night at the right, crowned by a putto flying overhead carrying a lighted torch – includes many of the same elements Hunt used in *The Flight of Night*. In the Albany design, however, Hunt reversed the composition, which suggests he may have consulted an engraving.

Nor should it be forgotten that at the time Hunt began this work, he was in Europe, where he had ample opportunity to study the old masters. Like many other artists, he began by borrowing the design of a highly admired work by an esteemed artist, adding other details, and transforming the subject

to make it relevant to his generation. This practice was not considered copying but rather the adoption of a visual language that had grown and evolved over the centuries. (A parallel development, called eclecticism, also dominated architectural design of the period.) In addition, the details in his painting alluded to a variety of sources ranging from the Roman bas-reliefs of the Sacrifice of Mithra (a figure of later Zoroastrianism, often associated with the passage of time), to the innumerable representations from every period of Apollo, Artemis, and Diana in chariots – in vase paintings, cameos, bas-reliefs, murals, and easel paintings. In addition, collections of these antiquities were illustrated in multivolumed catalogues. One of the most famous and popular was by the French scholar Abbé Bernard de Montfaucon's five-volume *L'Antiquité expliquée et représentée en figures*, published between 1719 and 1724. In this work, which is not as well known today as Cesar Ripa's *Iconologia* (1593), Montfaucon reproduced actual antiquities to illustrate the traditional attributes and poses of mythological stories, personifications, and allegories. This is an important aid for nineteenth-century iconographic research because Montfaucon's book is organized not by artist, era, or country but by type. This book and others like it provide important clues as to how these images were transmitted, and often transformed, from one generation to the next. In many cases the references became so commonplace in the nineteenth century that their original source is obscure. In this respect, the seated figure of the Persian goddess Anahita also stands for Aphrodite, Artemis, and Athena. Classical allusions abound for both Anahita and for the half-nude, standing figure of Fortune, the latter reminiscent of any number of famous antique models, including the Aphrodite from Melos at the Louvre, the Aphrodite of Knidos, a Roman copy after Praxiteles at the Vatican Museum, or the Amazon, a Roman copy of a sculpture by Phidias, now in Hadrian's Villa near Tivoli. These and other antique sources, such as the seated fourth-century Tyche from Antioch at the Vatican Museum, may have served for the representation of Anahita as well.

Hunt would have known works like these not only from his European travels and from illustrated catalogues of antiquities but also from the plaster casts of antique and other sculptures, standard accessories in the studios of nineteenth-century artists. Richard Hunt's studio was filled with them, as was Hunt's own. Later in the century no self-respecting museum or art-school was without them.[59]

THE DISCOVERER

In contrast to the complex obscurity of Anahita as a subject is the enormous and enduring fame of her pendant, Columbus. The nineteenth-century writer credited with popularizing the Columbus legend was Washington Irving. His *Life and Voyages of Christopher Columbus* inspired many nineteenth-century paintings of Columbus, including two by Delacroix – *Christopher Columbus at the Convent of Santa Maria de Rabida* (1838, National Gallery of Art, Washing-

ton, D.C.) and *Christopher Columbus Returning from the New World* (1839, Toledo Museum of Art, Toledo, Ohio) – and at least eight paintings by Hunt's friend Emanuel Leutze.[60] Irving's history was not an allegorical treatment of the mariner's life, but a factual narrative written while he was serving as United States consul to Spain. Based on a translation of original documents assembled, in this case, by the seventeenth-century Spanish scholar Martin Fernandez de Navarette in Madrid, Irving's book was immensely popular in the United States and Europe because it was thought to be a true account of the discoverer's achievements. For the United States Capitol, two artists, the painter John Vanderlyn and the sculptor Randolph Rogers, created monumental works based on Irving's narrative. Vanderlyn's *Landing of Columbus at the Island of Guanahani, West Indies, October 12th, 1492* was placed in the Rotunda in 1847, and Roger's 1858 designs for eight panels and tympanum illustrating Columbus's history from his appearance before the Council of Salamanca to his death, adorned a pair of bronze doors for the East Rotunda entrance.

In contrast to these many historical recreations of Columbus's life, Hunt chose to represent him allegorically as a heroic symbol of someone whose life and discoveries had incalculable importance for all mankind. Consequently, Hunt's mural contains no reference to the narrative aspects of Irving's history; instead, it was inspired by Irving's view of Columbus's genius and vision, summarized in the last chapter of his book:

> To his intellectual vision it was given to read the signs of the times, and to trace in the conjectures and reveries of past ages the indications of an unknown world, as soothsayers were said to read predictions in the stars, and to foretell events from the visions of the night. "His soul," observes a Spanish writer, "was superior to the age in which he lived. For him was reserved the great enterprise of traversing a sea which had given rise to so many fables, and of deciphering the mystery of his age."[61]

In this short passage Irving claims it was Columbus's ability to interpret ancient predictions and visions, and to overcome superstition that made him uniquely able to find the new world. Likewise, *The Discoverer* in Hunt's painting is a man of thought guided by his faith and hope, aided by navigational science, and trusting in fortune.

SOURCES FOR *THE DISCOVERER*

It is tempting to look for a single compositional source – like Reni's *Aurora* for *The Flight of Night* – for Hunt's allegory of discovery. A clue is found in the word allegory itself, for an exhaustive review of paintings based on the Columbus theme in the nineteenth century has shown that Hunt's mural was one of the few representations that was allegorical rather than historical. In

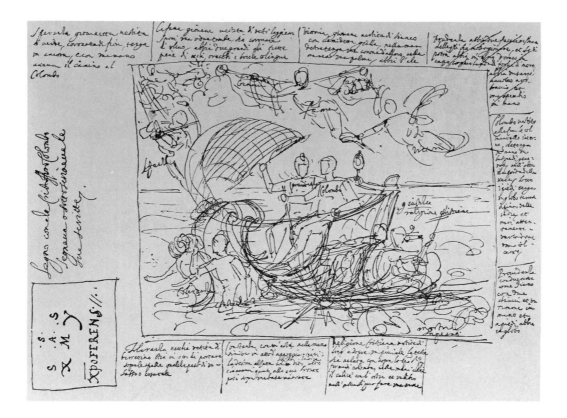

fact, before Hunt's mural there were very few visual interpretations treating the subject of the Columbus legend symbolically.[62] One of the rare examples is a drawing, reputed to be by Columbus himself, titled *The Triumph of Columbus* (fig. 151), housed in the Ducal Palace in Genoa. Although Hunt's knowledge of this drawing cannot be documented in the same manner as Guido's *Aurora*, its allegorical nature and Hunt's possible familiarity with it, makes it a suggestive source. Hunt may have seen it in 1868, when he and his wife spent several days in Genoa. More probably he saw a copy of it in Boston, because it was reproduced and its history described in some detail by Justin Winsor, then chief librarian at Harvard, in his *Narrative and Critical History of America* published between 1884 and 1889.[63]

More persuasive is that the composition of the Genoa drawing is remarkably close to that of Hunt's final version of *The Discoverer*. In the drawing, Columbus is seated in the center of a small boat surrounded by allegorical figures in the water and the air; in addition, a helmeted figure, called Providence, holds the sail. According to Winsor: "Envy and Ignorance are hinted at as monsters following in his wake; while Constancy, Tolerance, the Christian Religion, Victory, and Hope attend him. Above all is the floating figure of Fame blowing two trumpets, one marked 'Genoa,' the other 'Fama Columbi.'"[64] The elements Hunt retained, as well as the changes he made, are instructive. First of all, he seems to have adapted the overall composition in toto, including its

FIGURE 151. Christopher Columbus (attributed). *Triumph of Columbus*, n.d. Ducal Palace, Genoa. From: Nestor Ponce de Leon, *The Columbus Gallery*, (1893) p. 170, #95. The General Research Division, The New York Public Library, Astor, Lenox and Tilden Foundations.

right-to-left orientation. He kept the small boat, but placed the secondary figure, Providence or Fortune (still holding the sail), in the stern. He eliminated the figures of Envy and Ignorance and conflated those of Constancy, Tolerance, Christianity, Victory, and Hope into three – Faith, Hope, and the modern virtue Science.

Although the Columbus legend was seldom treated allegorically in painting, there are literary sources from the late eighteenth and early nineteenth centuries that evoke Hunt's imagery. In the early days of the republic, an American writer and public official, Joel Barlow, wrote two long epic poems in which Columbus is depicted as a modern-day Aeneas. The first, written in 1787, was a poetic celebration of America; entitled *The Vision of Columbus,* it was expanded and republished in 1807 as *Columbiad,* the change in title alluding to both both Virgil's *Aeneid* and Homer's *Iliad.* Modeling his poem on these classic epics, Barlow created what he called a "fictitious narrative" in which Columbus's thoughts and actions were, guided by the evening star, Hesper.[65] This allegorical figure is analogous to Fortune in Hunt's *Discoverer,* and at the same time alludes to Anahita, who can also be thought of as an "evening star."

The English Romantic poet Samuel Rogers also wrote an epic on the theme of Columbus, entitled *The Voyage of Columbus.* First published in 1810, it was included in his collected works that were published in Boston in 1854 and again in New York in 1871.[66] The Columbus of Roger's epic, like Barlow's Columbus, is guided by supernatural forces; and the poem is filled with recurring images of day and night, moon and sun:

> Twice the Moon filled her silver urn with light.
> Then from the Throne an Angel winged his flight.
> He, who unfixed the compass, and assigned
> O'er the wild waves a pathway to the wind;
> Who, while approached by none but Spirits pure,
> Wrought, in his progress thro' the dread obscure,
> Signs like the ethereal bow – that shall endure!
> As he descended thro' the upper air,
> Day broke on day as God Himself were there!
> Before the great Discoverer, laid to rest,
> He stood, and thus his secret soul addressed.[67]

Although there is no specific reference in the Hunt literature to Barlow or Rogers, these images of a mariner braving the unknown seas aided by mythical spirits pervade his painting.

FORTUNE AND LUNA

In addition to *The Discoverer* and *The Flight of Night* representing various polarities – male and female, light and darkness, day and night, air and water,

sky and sea, and, in some observers' opinions, good and evil – Hunt developed a related theme, as already mentioned, through the figures of Anahita, or Luna, in *The Flight of Night* and Fortune in *The Discoverer*. These two goddesses, Fortune and Luna, have been linked since antiquity as the forces that capriciously control man's destiny. According to Howard Patch in *The Goddess Fortuna in Medieval Literature:* "Because Fortuna has a dual nature, she is often equated with Luna, since the moon is considered as ever-changing, a tradition established in antiquity."[68] The moon controls time; Fortune controls destiny.[69] Hunt's friend Elihu Vedder also used images of Fortune repeatedly, as well as images of the sun, moon, and stars.[70] In one of Vedder's earliest representations of Fortune, painted in 1877, he included her traditional attributes – dice, cards, keys, and money. Hunt's image, however, has different symbols – a sail and tiller. This is the Fortune of mariners, who controls the wind and the sea and, by extension, the destiny of man. As Patch observed: "The sea-figure, comparing life to a sea and one's career to a vessel of which Fortune is in charge, is used with such great frequency in discussions of the work of Fortune that it becomes a theme of unusual importance."[71] Another key to interest in the images of Fortune and astral imagery is Persian poetry, in Vedder's case particularly *The Rubáiyát* of Omar Khayyám, as he was commissioned in the early 1880s to illustrate a deluxe edition of Edward Fitz-Gerald's 1859 translation.[72] *The Rubáiyát's* influence on Hunt is less direct but can be found in the poem's references to the transiency of life, the flight of time, and man's unknown destiny. The opening stanza of *The Rubáiyát* is reminiscent of the poem "Anahita."

> Wake! for the Sun, who scattered into flight
> The Stars before him from the Field of Night,
> Drives Night along with them from Heav'n, and strikes
> The Sultán's Turret with a Shaft of Light.[73]

These underlying nineteenth-century intellectual and cultural currents (Persian poetry, Zoroastrianism, dualism, the legend of Columbus, and a fatalistic view of man's destiny) running through Hunt's murals were reflected in contemporary descriptions soon after the murals were unveiled. Typical are the impressions of a writer for the *Brooklyn Times:*

> The one on the northern wall is supposed to be the flight of ignorance and evil, before the dawn of righteousness and wisdom. Perhaps it is. I only know that the swift career of the horses drawing the cloud car of dawn is magnificently represented; that the female dawn and the sleeping woman from whose face the veil (probably symbolical of bigotry and unprogressiveness) is being torn, are vastly more interesting than the bland and smouchy old saints of the Italian painters....

[The image of Columbus he preferred] to regard as the type of all mankind, and which the painter perhaps meant should represent the State.... In his face there is seriousness of a mortal conscious of the awful doom of eternal life, yet it is not a despairing but a serene and reflective seriousness. Fortune, a winged figure of fine proportion, steers the boat and three naiads, who may be Science, Poetry, Imagination, Art, Hope, Faith, or any other human attributes, or achievements but which unquestionably represent only pleasing ones, float beside the vessel and cheer the lonely voyager.[74]

Yet for all their sensitive appreciations of Hunt's accomplishment, none of the contemporary accounts offered a definitive explanation as to the meaning of the murals. Nor did Hunt leave any indication of his own interpretation. And strangely enough, writers who best knew Hunt – Frederick Vinton, Angell, and Knowlton – were reluctant to commit themselves to one. Vinton quoted Van Brunt's article; Angell did not include an interpretation; and Knowlton, writing at the end of the century, quoted Louisa Hunt's description published in 1888.

Louisa Hunt's interpretation may be idiosyncratic, but she constructed a philosophic system related to dualism that reinforces the link between both murals.

These two mural paintings... are allegorical representations of the great opposing Forces which control all nature....

They must absolutely be taken *in conjunction* to be rightly understood, as each is the complement of the other.

They represent Negative and Positive – Night and Day – Feminine and Masculine – Darkness and Light – Superstition and Science – Pagan and Divine Thought – Self and Altruism.

The second page of her four-page description was devoted to an explanation of " 'Anahita' Persian Goddess of the Moon and Night, [who] represents Negative or Feminine Force"; and the third page, to a description of " 'Columbus' [who] represents Positive or Masculine Force."

"Anahita" driven forth from her realms of Fantasy and Unreality, impelled by the dawn of civilization, plunges with her airy car into the dark and hidden caverns of superstition and barbaric thought.

"The Slave," who bears an inverted torch, holds back the horses, that Anahita may look her last upon the Kingdom she so soon must relinquish.

"The Horses" obey her will without the ribbons by which, in earlier sketches, they were guided. (This suggests the power of mind over matter.)

By the side of the "Cloud Chariot" floats in a dark-blue translucent ether, the sleeping forms of a human "Mother and Child." A cherub flies about to shelter them from the faint glimmer of a crescent moon, before withdrawing them from this phantom band to return them again to mother Earth.

This "Vision" hints to the Queen of Night of other Worlds than hers, where love and rest belong, and, as she hurries on her course, between the contending forces of Day and Night, Light and Darkness, a look of HUMAN DOUBT surprises the beauty of her Pagan countenance and renders her as tragic and typical a figure as that of the Columbus, and the fitting counterpart.

Not surprisingly, Louisa, wishing to associate herself with the forces of good, wrote a more sympathetic description of Columbus:

Lonely, and led by Faith, Science, Hope, and Fortune, Columbus crosses the Waters of Destiny.

"FAITH," nearly engulfed, leads on this spirit band, breasting the waves, while with one arm she hides her eyes.

"HOPE" stands at the prow and prophesies fulfillment.

"SCIENCE" holds the chart or scroll, that Columbus may be guided by it.

"FORTUNE" is at the helm, but, with wings half outspread; she is placed *behind* Columbus (which is very significant). Her left hand grasps the tiller which guides this whale-shaped craft; around her right arm is wreathed the rude sail. Storm winds fill it full, and drive them onward to the West.

"THE CHAINS" are visible beside the solitary figure, but Columbus peers with intensity of Will into the future, and ignores them.

The Central Figure has no theatrical posture-making character of the Conqueror, but is, as it were, bowed down with the greatness of his mission, while neither danger nor the chains of Ignominy can divert him from his heart's desire and conviction.

Both these paintings represent the Thought of their period in the World's History. It is not without intention that both seem suspended between Faith and Doubt. She, with the intensity of feminine sympathy; He, with the calm majesty of patience of manhood.

Both are moving to their destiny, and both are meant to teach a fundamental and Eternal Truth, though canvas and even stone shall crumble away.[75]

In addition to these various interpretations, Hunt's murals were also seen within the context of the debate that went on throughout the century – the

desire to create a national art versus the American need to rely on European precedence and training, a debate that still colors American understanding of late-nineteenth-century art. The problem was twofold. What historical incidents, heroes, or allegories could best represent the national purpose and how were those events or citizens deemed worthy of commemorating to be represented? For artists in the second half of the nineteenth century who were concerned with monumental art – and this meant sculptors and architects as well as painters – the European model was the only one available and worth emulating. Following the Civil War, even with the alarming political disarray of the South, there was enormous expansion in the West, the creation of large fortunes in the East, and an increasing involvement of the United States in international affairs. As its borders expanded and its international presence was asserted, the nation sought self-definition. What symbols or works of art could now represent the United States to itself and to the world? Artists throughout the century had similarly struggled. Through his paintings in the Capitol Rotunda, Trumbull sought to document the history of the Revolution. These didactic stage sets that retold popular stories nonetheless failed to connect the events to their larger implications. Allston eschewed history painting and admonished his countrymen through an Old Testament story, but his struggles to complete *Belshazzar's Feast* overshadowed its larger, public meaning. Thomas Cole, who also sought to instruct his fellow citizens through his series *The Course of Empire* and *The Voyage of Life,* was more successful. Conceptually, these are the closest to Hunt's ambitions. Yet the public and critics, as well as present-day art historians, preferred Cole's landscapes to the European inspiration of his serial allegories. Of all the earlier artists it was Leutze, trained in Europe, who, in his best-known works such as *Washington Crossing the Delaware* and *Westward the Course of Empire,* dealt the most directly with the desire to create paintings to honor our past and celebrate our future.

Hunt's murals were neither allegorical clichés like Brumidi's murals in the Capitol nor awkward renderings of historical events like the paintings for the Rotunda. Hunt also abandoned the religious and moralizing overtones of Allston and Cole. Instead, his subjects were based on the lessons of European humanism that linked the New World with the Old, the East with the West, and projected the progress of civilization from the age of ignorance to the Enlightenment. Conceptually, Hunt chose to work on a grand scale, with figures and a compositional framework that effectively communicated his ideas. He did not clutter his composition with extraneous detail but expressed his ideas within simple formats that were clear and legible. The images he used were adapted from the most accepted models of Western art and as such were timeless. For Hunt there was no need to create a separate American tradition. America's cultural ideals and ambitions, with their roots in the classical past, were ones it shared with Europeans. On the contrary, it could only be to the credit of Americans to further these ideals so that they could declare their place within the pantheon of civilized nations.

HUNT'S DEATH

In light of the enthusiastic response to Hunt's murals, there was a movement among his friends and officials in Albany that he should be given further opportunity to decorate the state capitol with murals. It was Dorsheimer's "wish that the Albany Capitol should be filled with historical pictures, and that Hunt should work there as long as he lived."[76] This was Hunt's chance once again to propose representations of Niagara Falls, but Governor Lucius Robinson – who had been appointed to complete Tilden's term in 1876, after Tilden had left Albany to run for president (unsuccessfully) on the Democratic ticket – hated the new capitol and deplored the continuing expense.[77] Given his vehement opposition to the building's decorations, it is no surprise that he blocked a $100,000 appropriation for additional murals by Hunt. Knowlton reported that she and many of his friends believed that Robinson's veto was tantamount to Hunt's death knell.

When Hunt returned to Boston from Albany he was exhausted. Angell remarked: "He seemed very tired, mentally and physically, at this time, and although cheerful it was not the sunny, wayward cheerfulness of old times."[78] Although his spirits did not improve, he managed to complete several portraits, including his last *Self-Portrait* (fig. 152), a telling document of the phys-

FIGURE 152. *Self Portrait*, 1879. Oil on canvas, 20″ × 17¼″. Courtesy, Museum of Fine Arts, Boston. (Gift of Mrs. Richard M. Saltonstall)

ical toll the Albany work had taken and the emotional strain he felt that spring. In March he held a studio sale, which included his recent paintings of Niagara Falls and sketches and photographs of his Albany murals. For reasons that are not clear, given his success of previous years and the publicity generated by his murals, little sold and the disappointment served only to aggravate his despondency.

To improve his health and state of mind, he spent the late spring and summer traveling with his sister and Carter. They went first to Wethersfield, Vermont, to visit Leavitt, then to Appledore, the Isles of Shoals, New Hampshire, to spend a few months with Celia Thaxter and her husband, Levi. According to Knowlton, "Hunt's life at the Shoals, during the eight weeks of his stay, was a constant struggle to be cheerful."[79] Hoping that a trip to the mountains might rejuvenate him, Hunt took a brief trip with his physician, Dr. Henry Ingersoll Bowditch, to the White Mountains in late August, but soon returned to the Thaxter's cottage on Appledore. On Monday morning, September 8, 1879, he was found by Celia Thaxter in a small reservoir behind the cottage, "floating upon his face while the wind fluttered a fold of his long coat which lay on the water, dark in the still and sunny glitter of the surface elsewhere unbroken."[80]

Published reports, as well as the accounts of friends, were divided as to whether or not Hunt had committed suicide. The first public notice, datelined Portsmouth, New Hampshire, September 9, assumed suicide:

> The suicide by drowning of William M. Hunt, artist, at the
> Isles of Shoals yesterday, was caused by melancholia, induced
> by close application, his gloomy condition for several weeks
> being such that he had been carefully but secretly watched....
> The discovery of his hat on the bank was the first intimation
> of suicide....Coroner Whittier of this city went to Appledore
> this morning to view the body. Nothing was found among the
> effects of the deceased to indicate premeditation of suicide.[81]

On September 11, Celia Thaxter addressed a letter to the *New York Daily Tribune* in which she gave an account of Hunt's last days attempting to exonerate herself and others of any blame.

> To the many friends of William Hunt it may be grateful to
> hear some trustworthy account of his sad end less shocking
> than the bare and often incorrect statements of the current
> journals. He had been living with his devoted sister at the Isles
> of Shoals, eight weeks, the centre of a bright and friendly circle
> in the cottage at Appledore, and in spite of the disease of
> nervous prostration under which he was laboring, I am thank-
> ful to believe he had hours of peace and even happiness during
> that time. He was sure of all our sympathy, and everyone was

glad to cheer and comfort him whenever and wherever the least opportunity offered itself to do him any service. He wore such a brave heroic front over all he suffered, we never dreamed of such a terrible end at hand.[82]

Notices of his death were broadcast everywhere, some of which bordered on the sensational. One headline read: "Well-known artist throws himself into a cistern on the Isles of Shoals."[83] From all the available accounts, it remains unclear whether Hunt took his own life. Even Knowlton, in her tribute published at the time, admitted to uncertainty. "Whether his drowning was accidental or not may certainly never be known," she stated, "but enough has not been said of his extremely weak physical condition, with depression so great as to closely border on possible insanity."[84] Hunt's funeral took place in the Unitarian Church in Brattleboro, where he was buried in the local cemetery in a family plot beside his father.[85]

Tributes to him were numerous, both in the daily press and in leading magazines and art journals. Even Hunt's lifelong critic, Clarence Cook, called him a "distinguished artist" and said that his was an "unlooked for death." Along with special praise for Hunt's Albany murals, he linked Hunt and Washington Allston, saying: "Since Washington Allston, no American artist has played a part of such influence among his countrymen as Mr. Hunt; but in his case, as in that of the elder painter, there is lamentably little left whereby to explain that influence to future generations."[86] James Jackson Jarves, writing from Florence, added his tribute.[87]

Two important memorial exhibitions of Hunt's work were held in Boston and New York. In Boston, over 60,000 persons attended the Memorial Exhibition at the Museum of Fine Arts, which included more than three hundred paintings, drawings, and pastels.[88] In New York, fifty-five paintings by Hunt were included in the inaugural exhibition at the opening of the Metropolitan Museum of Art's Central Park building in April 1880. As further indication of Hunt's renown, an auction of his works in Boston in February 1880 netted more than $60,000, an amount in sharp contrast to the negligible sales of his work only a year earlier.[89]

THE LOSS OF THE MURALS

In one respect, however, Hunt's death had come at a fortunate hour – not long before the destruction of his masterpiece. Just a year after his death, the ceiling of the Assembly Chamber had started to leak, putting Hunt's murals into jeopardy. At first it was thought that moisture had seeped through the unlined stone gutters on the roof, a problem that was easily remedied. But the real cause was later found to be fractures in the huge ceiling. From the beginning there was a dispute between Eidlitz and consulting engineers over the origin of the cracks and what should be done to halt further deterioration.

Unfortunately, damage had already been done to *The Flight of Night,* and in 1882 Carter went to Albany to repair it. In his report he noted that not only was the paint scaling off but the stonework itself was falling.[90] Over the next six years many efforts were made to save the ceiling, but in February 1888 an advisory team of architects and engineers recommended that the Assembly Chamber be immediately vacated; in April, after further study, they condemned the vaulted ceiling, and with it Hunt's murals. They specifically recommended that a flat ceiling of wood or metal be constructed to "throw upon the walls and foundations as small a weight as is consistent with good construction and proper architectural effect." They concluded their report by stating it was not the workmanship that was at fault but Eidlitz's vaunted engineering skills.[91]

When news reached Boston that a new ceiling would hide the murals, efforts, were made to save at least *The Discoverer.*[92] Various fund-raising efforts were immediately launched in New York and Boston. Jane and Richard set up a subscription in New York, while in Boston the Hunt Memorial Committee, established shortly after his death, sent the artist J. Foxcroft Cole to Albany to report, from an artist's point of view, on the true condition of the murals, how they could be saved and where they might be relocated.[93] But time was short, and work on the ceiling could not be delayed. Unfortunately, neither money nor a new location was found. In August 1888, a new ceiling was put in place and the murals concealed from public view. As *The Studio* poignantly reported: "There is, we are assured, no longer any ground for hope that the pictures painted by the late William M. Hunt on the walls of the Assembly Chamber in the Capitol at Albany may be saved for the public."[94] The writer noted that the only way to save the murals was to saw them off the wall, a process that had already been rejected as too expensive. Suggesting that "the pictures should be copied on canvas by some one of Mr. Hunt's many pupils," the writer then concluded on this fatalistic note: "We have not, however, the least hope that any such effort will be made, and perhaps it is as well that when the room has been destroyed for which the pictures were painted, the pictures themselves should pass away, and the memory of what in the minds of both the architect and the painter was an ideal dream, in part, at least, fulfilled, should pass into the limbo of forgotten things."[95]

Today, what remains of the murals can still be seen only at great risk above the Assembly Chamber's false ceiling. Yet, with increasing awareness of their importance as documents of American cultural ambitions and their integral value as decoration within the Assembly Chamber by preservationists and a few concerned historians of American art, there have been several recent attempts to evaluate the condition of the murals and to suggest means of restoring them.

In 1974 conservators from the New York State Historical Society in Cooperstown examined them and reported that with modern techniques of restoration, the murals could be reconstructed. Fifteen years later, during a

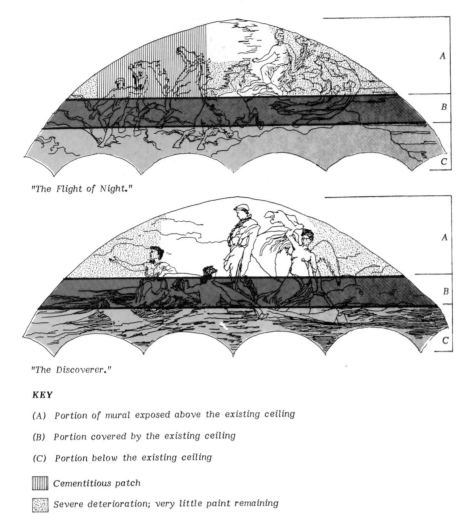

"The Flight of Night."

"The Discoverer."

KEY

(A) *Portion of mural exposed above the existing ceiling*

(B) *Portion covered by the existing ceiling*

(C) *Portion below the existing ceiling*

||||| *Cementitious patch*

▓ *Severe deterioration; very little paint remaining*

☐ *Fair condition*

general study on restoring the whole of the Assembly Chamber, an extensive analysis of the murals was undertaken by two conservators, Ian S. Hodkinson and Morgan W. Phillips, hired by the New York State Commission on the Restoration of the Capitol. Established in 1979 by Governor Hugh Carey, this commission was vested with the long-range responsibility for a complete capitol restoration following the successful rehabilitation of Richardson's Senate Chamber in the late 1970s.

The architects and consultants finished their evaluation in 1989. Among much else in their highly technical and complete report are diagrams indicating precisely the location of the false ceiling in relation to Hunt's murals (fig. 153). They also identified the physical and chemical agents that caused

FIGURE 153. Diagrams of murals showing existing conditions [*The Flight of Night* and *The Discoverer*], 1989. Assembly Chamber, New York State Capitol, Albany, New York.

188

the drastic deterioration of the murals: it had not been water alone that caused the damage, but the salts from the underlying mortar and brickwork, which "migrated" to the stone surface and crystallized. In areas where the salts had hardened, whole sections of the murals had been defaced.

Even so, they recommended that the murals be restored, and suggested several alternatives. One was that copies of the murals be placed over the originals, which would, unfortunately, continue to deteriorate. Another proposal was that the murals be cut off the face of the stone blocks, cleaned, and their surfaces physically stabilized in a manner that would prevent further loss. This recommendation also called for a large portion of the mural to be inpainted. This, in itself, they noted, would be controversial because it would be a matter of debate whether to restore the original color or use a color that would more closely harmonize with the remaining painted areas. The group also conceded that the murals could be removed, placed in a museum (which had been the original wish of Hunt's supporters), and replaced by copies.

The fact that the state had already undertaken this much research was encouraging. Yet a major obstacle, unmentioned in the report, was the extraordinary cost any of these proposals would incur. Unfortunately, New York State's fiscal problems in 1990 deferred immediate efforts to restore the murals.

LEGACY

At the turn of the century mural painting's new status in the United States was acknowledged by writers as diverse as Royal Cortissoz, Russell Sturgis, Pauline King, Samuel Isham, and Charles Caffin. American painters such as Will Low, John La Farge, Edwin Blashfield, and Kenyon Cox also wrote on this art form new to the United States.[96] Both Isham in his *History of American Painting* (1905) and Caffin in *The Story of American Painting* (1907) devote entire chapters to American mural painting, crediting its beginnings to John La Farge's murals for Trinity Church and Hunt's murals in the Albany State Capitol. Similarly, La Farge's and Hunt's contributions were lauded by Pauline King, who, in her book *American Mural Painting* (1902), the first on the subject, acknowledged the primacy of Hunt's achievement by devoting an entire chapter to his paintings in Albany.[97] Writers continued to cite the importance of Hunt's murals, although (with the exception of the painter Will Low) they probably never saw the murals in place. As noted by King, "photographs of the drawings and cartoons for the paintings in Trinity Church and the Albany Capitol hung in the art schools, and were owned by a very few persons with decidedly artistic tastes, who looked upon them with something of the awe with which the works of the Old Masters are regarded."[98] Even though the work could not be seen in Albany, the images became well known and Hunt's premier efforts as a mural painter acknowledged.

In an article, "Modern Mural Decoration in America," written in 1911, Selwyn Brinton (who knew only the version of *The Flight of Night* in the Pennsylvania Academy of Fine Arts) expressed the esteem in which even the memory of Hunt's murals was held.

> We can well imagine the enthusiasm which these fine mural paintings created when they were unveiled in the State Capitol. ...Ten years after their completion these fine frescoes had entirely disappeared from sight, while their creator himself had passed away before them. The decorations of the Albany Capitol, the first serious work of the kind in modern America, were a memory only – a memory of high hopes destined to failure and disappointment.[99]

Nonetheless Hunt's murals *The Flight of Night* and *The Discoverer* were a fitting culmination to his lifelong commitment to instructing his contemporaries on the meaning of art and its importance for the cultural progress of the United States. Hunt's murals are challenging because they are not the time-honored allegories with which we are the most familiar. Instead, Hunt avoided the customary personifications of the state – truth, justice, good and bad government, and the like (which would come to dominate mural programs at the turn of the century) – and invested venerable images and traditional compositional arrangements with contemporary significance. This new meaning had particular importance in the late nineteenth century: Hunt's murals illuminated America's relationship to European culture, and its unique destiny to further the goals and ideals of Western civilization.

6

Hunt and Art in America

HUNT DECIDED TO BECOME AN ARTIST when he was twenty-two and studying with the neoclassical sculptor Henry Kirk Brown in Rome; but it is not known when he decided to become an apostle of art. Perhaps he made the decision while in Barbizon with Millet; certainly the commitment was fully formed by the time he returned from his second European trip in 1868 and began formal teaching in his studio. Fortunately the full range of his knowledge, dedication, and enthusiasm is recorded in his *Talks on Art*. Without it and the evidence of his Albany murals, it would be difficult to assess why Hunt was so admired by his contemporaries.

Hunt's contribution to American art was to make his colleagues, and members of the public who were interested, aware of art as a calling. He considered expression in the visual arts as important as communication through literature. As Low stated after the turn of the century "our scheme of civilization through education and the printed book is but partial, and leaves the sister force of art, which older civilizations have fostered on an equality with literature, out of consideration."[1] Hunt was admired because he challenged a certain uninformed attitude and puritanical distrust of painterly expression. Art for him was neither an imitative nor illustrative endeavor but a combination of craft and concept. This attitude had a long history in Western art and was one that Americans had to learn at its source. It is true that American artists had for one hundred years sought exposure and training in the fine arts in Europe, but Hunt's absorption of this influence was different: he shunned the surface and sought the substance.

Around 1880, the critic Samuel Benjamin confirmed many contemporaries' appraisal of Hunt and his contribution to American art, noting in a number of writings that Hunt, through the "force of personal character" and his introduction of "foreign methods," had been "the most considerable individuality in contemporary American art."[2] Reviewing Hunt's 1879 Memorial Exhibition held in Boston, Benjamin was impressed by the artist's versatility

and praised his portraits of Shaw and Mrs. Adams, the figure study *The Bathers,* and the mural paintings in Albany. But he criticized Hunt's tendency to value expression at the expense of technique, an evaluation that continues to haunt appraisals of Hunt's work:

> But the final impression left upon one, after a careful obser-
> vation of Mr. Hunt's works, is that he was more bent on rightly
> expressing an idea that upon the character of the idea itself.
> Inspired to a degree uncommon in this country with a true
> perception of the aim of Art, he yet failed of wholly achieving
> that aim, because he was more concerned with means than
> with ends.[3]

This failing, which Benjamin cites, that Hunt's work did not live up to its promise, is consistently expressed. Sympathetic critics did not dislike his work but felt that, as one other contemporary declared, it "never culminated into masterpieces rounded and complete, where the painter could be said to have given the full measure of his temperament."[4] To put the matter baldly, Hunt's reach was larger than his grasp. Over the years various factors have been put forth as to why he did not become an artist of first rank. Some commentators, namely Knowlton, have claimed it was the indifference to his work in literary Boston – an indifference said also to have plagued Allston – that discouraged and depressed him. Others have felt that Hunt's work suffered because of the uncritical endorsement of his art by friends and admirers; his work would have been stronger if he had stayed in Europe, where it would have had to have met higher standards. In the United States he had to paint portraits in order to make money and win acclaim. Because they took time away from what he preferred to be doing, his portraits, when hastily done, appear in- different, although those he did of sitters toward whom he felt some sympathy are excellent and throughout his career he did ones that are of first rank.

When Hunt returned to this country in 1855, he was well on his way to becoming a successful painter of genre. He took pride in these works, exhib- iting them in Boston and New York. He also briefly considered opportunities in printmaking and illustration to further his ideas. After another sojourn in Europe, his commitment to art was even stronger. He began to teach, and the portraits and figure studies of this period express his renewed vitality. One of the most tragic events of his career was the loss of his studio by fire in late 1872. This experience prompted him to turn finally to landscape, a subject that allowed him a new freedom. In his landscapes he is a master of the charcoal medium, spontaneously recording his first impression. He loved the challenge of landscape and worked hard to translate his sketches into oils. It is in these translations that Hunt's difficulties as an artist are most apparent. The lauded spontaneity is often absent and not compensated for by greater conceptual effort. Hunt was an impatient man, and he had trouble overcoming

this impatience along with his nervous temperament, poor health, and erratic work habits. One senses he never felt truly free to paint the way he wanted to. At the end of his life, when colleagues were beginning to appreciate the intimate, poetic nature of his late landscapes, and when he felt triumphant with his work at Niagara and Albany, he collapsed, never to recover. Success had come too late, and after these final efforts, which left him exhausted mentally and physically, he could not work.

It is undeniable that Hunt's importance was not solely through the example of his work but, perhaps even more persuasively, through the force of his ideas, his thorough knowledge of the European tradition and the new manner in which contemporary French artists were finding expression. The artist's contribution was acknowledged by Benjamin around 1880 in many articles about Hunt. Beginning with an essay, "Present Tendencies of American Art," published March 1879 in *Harper's New Monthly Magazine* (revised somewhat for his book *Art in America: A Critical and Historical Sketch*), Benjamin credited Hunt with inaugurating the "new tendencies in American art." These "tendencies" are not stylistic but, rather, new methods of art instruction, associations of independent artists, and new technical knowledge of "foreign styles from the ateliers of Paris and Munich."[5] In Benjamin's opinion these are fundamentals necessary for the birth of a great national art, and Hunt's pioneering efforts to establish these fundamentals were acknowledged by Benjamin and many of his contemporaries.

At a time when the younger, European-trained generation of artists were challenging the dominance of the National Academy of Design, Benjamin's was an evenhanded voice; he believed that critics, in their rush to support the work by young artists trained in France and Munich, should not dismiss the earlier American tradition of colonial portraiture or the magnificent landscape painting of the Hudson River school. He further cautioned that although these "new tendencies" showed promise, they had not yet reached a point of culmination.[6] In Benjamin's opinion, this contemporary "age of style," which already showed signs of imitation and "materialism," was nonetheless important. "Before the nation can create enduring schools of art, it must know how to create them, it must understand method or style."[7] In other words, Benjamin felt that the important lesson these younger artists learned in Europe was the language of art:

> Art consists of aesthetics and the language or style that gives it concrete form. It is of little use to have great thoughts, lofty aspirations, or beautiful ideals, if one lacks the language that makes them forcible and attractive. . . . In order to come within the domain of art, [imagination] must have adequate forms of expression, whether with simple line, or *chiaroscuro*, or color, or all combined; and the proper, effective use of these media based on intelligent observation is what constitutes style.[8]

And he credited Hunt with ushering in this watershed phase in the development of American art:

> Whether consciously or not, Mr. Hunt seems to have been the first to make the deliberate attempt to import foreign methods into our art.... We undoubtedly owe a debt of gratitude to Mr. Hunt for starting a movement of such importance in America, even if style be only a means to an end, although what an indispensable means![9]

His book *Art in America* described more specifically Hunt's contribution: "...the going of Mr. Hunt to Paris meant that technical knowledge and the perception of underlying principles of art were now, as never before, to be systematically mastered and imported to America."[10]

At the turn of the century, Isham, in *History of American Painting*, summarized the two sides of the Hunt dilemma – he had made an incalculable contribution to American art, but had never achieved first rank as an artist:

> [His] work is most varied and most unequal, but it leaves an unsatisfied feeling in the mind. It was so promising, so promising to the end.... This feeling for color united with that for large, simple form made Hunt impatient of minute handling and forced him into a freer *technique* than had been used previously in America, and it is through this large handling and the feeling for texture involved with it that he exerted his greatest influence.[11]

Hunt's most ardent champions were his students and friends in Boston, many of whom wrote enthusiastically about his contribution.[12] The most thoughtful was William Downes, who in 1888 wrote a history of Boston art for the *Atlantic Monthly*, and summarized the high regard in which Hunt was held. "[Hunt was] a painter of rare gifts, he had the uncommon faculty of communicating to others his own noble ardor and devotion to the artist's ideal. Hunt was a born painter, with the susceptible and moody temperament of a genius."[13]

In the last analysis, Hunt was less interested in producing masterpieces than in plumbing the nature of art itself. For Hunt, art was not an intellectual or philosophical inquiry but a visual engagement with an object; an intense pursuit of that elusive moment when paint and canvas, charcoal and paper, are transformed into art. For him, the careful rendering of details was craft, not art, and he shunned the repressive and deadening effect of finish. His quest was that alchemic reaction that occurred when an artist transcended his materials. This quest, which he pursued all his life, was given full expression in the 1870s in many of his portraits, figure, landscape, and mural paintings.

Hunt concluded his *Talks on Art* with a fateful meditation that is also an

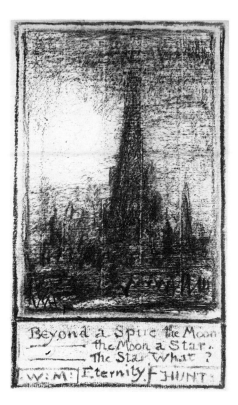

Beyond a Spire the Moon
— the Moon a Star.
— The Star What?
[W:M:] Eternity [F HUNT]

FIGURE 154. *"Beyond a Spire,"* n.d. Charcoal drawing. The American Architectural Foundation, Prints and Drawings Collection, The Octagon Museum, Washington, D.C.

appropriate ending for this book about an artist who struggled all his life to give feeling and expression to what he saw (fig. 154):

> I was thinking of this subject of Eternity the other night, when I looked at the moon, and saw, before it, a church-spire, a finger pointing upward into space. Next the spire, the moon. Beyond the moon, a fixed star. Next – what? Eternity. A ripple closes over us.[14]

Notes

Introduction

1. Laura Lee Meixner, "Jean-François Millet: His American Students and Influences" (Ph.D. diss., Ohio State University, 1979), and *An International Episode: Millet, Monet and Their North American Counterparts* (Memphis, Tenn.: Dixon Gallery and Gardens, 1982).

2. Henry James, *Notes of a Son and Brother*, reprinted in *Henry James Autobiography* (Princeton, N.J.: Princeton University Press, 1983), p. 286.

Chapter 1

1. Edward Wheelwright, *Harvard College, Class of 1844* (Cambridge: J. Wilson & Son, 1896), p. 134.

2. Henry C. Angell, "Records of William Morris Hunt," *Atlantic Monthly*, April 1880, 562.

3. Angell, "Records," May 1880.

4. Ibid., p. 630.

5. Many of these can be found in "William Morris Hunt – Anecdotes," Scrapbook (Octagon Museum, American Architectural Foundation, Prints and Drawings Collection), Washington, D.C.

6. Paul Baker, *Richard Morris Hunt* (Cambridge, Mass.: MIT Press, 1980), chap. 1. This book, the first modern study of Richard Morris Hunt, contains a great deal of important information on the Hunt family.

7. Letter written by Jonathan Hunt to his wife from Mountain Cove Inn, Fayette County, then Virginia now West Virginia, March 31, 1831 (Hunt Family Archives, Weston, Connecticut, chap. 6, "General Jonathan Hunt, Member of Congress, 1787–1832," n.p.). In addition, the following chapters of the Hunt Family Archives were consulted: chap. 5, "Colonel Jonathan Hunt, Lieutenant Governor of Vermont, 1738–1823"; chap. 7,

"Richard Morris Hunt, 1828–1895"; and appendix 1, "The Jane Hunt papers."

8. R. De Witt Mallary, *Lenox and the Berkshire Highlands* (New York: G. P. Putnam's Sons, 1902), p. 112. Also see Mary E. Dewey, ed., *Life and Letters of Catharine M. Sedgwick* (New York: Harper Bros., 1871). For a modern evaluation of Sedgwick and other "lady scribblers," see Mary Kelley, *Private Woman, Public Stage: Literary Domesticity in Nineteenth-Century America* (New York: Oxford University Press, 1984).

9. Mary R. Cabot, ed., *Annals of Brattleboro, 1681–1895*, 2 vols. (Brattleboro, Vt.: E. C. Hildreth, 1921), p. 391.

10. An interesting, but not always reliable, "who's who" of Unitarians in nineteenth-century America: George W. Cooke, *Unitarianism in America* (Boston: American Unitarian Association, 1902). The few modern histories of Unitarianism and its influence include: Daniel Walker Howe, *The Unitarian Conscience, Harvard Moral Philosophy, 1805–1861* (Cambridge, Mass.: Harvard University Press, 1970); Sydney E. Ahlstrom and Jonathan S. Carey, *An American Reformation: A Documentary History of Unitarian Christianity* (Middletown, Conn.: Wesleyan University Press, 1985); and Conrad Edick Wright, ed., *American Unitarianism, 1805–1865* (Boston: Massachusetts Historical Society, 1989).

11. Baker, *Richard Morris Hunt*, p. 14. Like many artists of the period, Gambardella was active as a portrait and landscape painter. While in the United States he exhibited at the National Academy of Design (1838–9), the Boston Athenaeum, and the Pennsylvania Academy of the Fine Arts. He returned to Europe sometime before 1842, when it was noted that he settled in London. George C. Groce and David H. Wallace, *The New-York Historical Society's Dictionary of Artists in America, 1564–1860* (New Haven, Conn.: Yale University Press, 1957), p. 249. In the Brooks Memorial Library, Brattleboro, Vermont, there are two portraits, one of Jane, the other of Mrs. Hunt, that were probably done by Gambardella in 1835. In addition, Mrs. Hunt, under Gambardella's tutelage, did a portrait of William (unlocated), that was exhibited in the Town Hall, Milton, Massachusetts, *Loan Exhibition of the Works of William Morris Hunt*, 1905. A copy of this portrait done by the Boston Impressionist painter Edmund C. Tarbell was owned by Hunt's daughter, Mabel Hunt Slater (Mrs. Horatio Nelson Slater). Tarbell may have been asked to make this copy at the time he did the portrait *Mrs. Slater and Family*. Tarbell's copy of Mrs. Hunt's portrait of William, and his painting *Mrs. Slater and Family*, hung in the William Morris Hunt Room, Museum of Fine Arts, Boston, until 1944, when the room was closed and the paintings were removed by the Estate of Mabel Hunt Slater. See correspondence and memoranda in William Morris Hunt files, Department of American Paintings, Museum of Fine Arts, Boston.

12. Catharine Sedgwick may have recommended the Welles School, which she had visited in 1835. Dewey, *Sedgwick*, p. 249.

13. Both William and Jonathan attended Harvard. Richard was also slated to go but remained in Paris to study architecture at the Ecole des Beaux-Arts.

14. *Faculty Record*, vol. 12, "Hunt, William Morris," Harvard University, Cambridge, Massachusetts. Hunt was awarded an honorary degree of Master of Arts in 1864 and reinstated with his class in 1868. *Corporation Records*, vols. 10:351 and 11:78, Harvard University, Cambridge, Massachusetts.

15. Edward Wheelwright, *Harvard College, Class of 1844* (Cambridge, Mass.: J. Wilson & Son, 1896), p. 134.

16. Wayne Craven, *Sculpture in America* (New York: Thomas Y. Crowell, 1968), pp. 178–217. For information on Mount Auburn Cemetery, see Neil Harris, *The Artist in American Society, The Formative Years, 1790–1860* (Chicago: University of Chicago Press, Phoenix Books, 1982), pp. 201–8.

17. Parker's wife, Eliza, writing in September 1843 included Catharine Sedgwick's recommendation on the benefits of Rome, but noted that William would not be able to resist the temptations this historic city offered. Appendix 1, "The Jane Hunt papers," Hunt Family Archives, n.p.

18. Helen M. Knowlton, *The Art-Life of William Morris Hunt* (Boston: Little, Brown, 1899), p. 5. Knowlton, Hunt's pupil and amanuensis, recorded his teachings later published as *Talks on Art* (1875). Her biography of Hunt is invaluable.

19. Baker, *Richard Morris Hunt*, pp. 18–19.

20. For information on this revival, see Sara Webster, "The Albany Murals of William Morris Hunt" (Ph.D. diss., City University of New York, 1985), appendix 1.

21. See Harris, *The Artist in American Society*, chaps. 5 and 6.

22. Mason Wade, ed., *The Journals of Francis Parkman*, 2 vols. (Cambridge, Mass.: Harvard University Press, 1947; New York: Kraus Reprint, 1969), 1:181–9.

23. "Jane Hunt papers," March 20, 1844, p. 25.

24. See Wayne Craven, "Henry Kirke Brown in Italy, 1842–1846," *American Art Journal* 1 (Spring 1969): 65–77.

25. Knowlton, *Art-Life*, p. 5. Jane noted in her journal, "Jane Hunt papers," p. 15: "Mother later had it [*Psyche*] put in marble at Mr. Brown's studio and gave Mr. Brown an order for her bust. (The bust later became Leavitt [Hunt's] and was at his home in Weathersfield [Vermont])." The bust of *Psyche* has not been located; however, Brown's bust of Mrs. Hunt is at the Brooks Memorial Library, Brattleboro, Vermont.

26. Henry Kirk Brown Collection, Library of Congress, Washington, D.C. Letter from Lydia Brown to Adoline, her sister, Rome, April 2, 1845: "I have had a present of a cameo likeness of Henry from William Hunt, and his Mother has had it set for a pin for me." Typescript copy of letter, courtesy of Professor Wayne Craven.

27. "Jane Hunt papers," p. 16.

28. Born in Germany, Emanuel Leutze came to the United States as a child.

He studied painting briefly in Philadelphia and then went to Düsseldorf, where he enrolled in the academy in 1840. Between 1843 and 1845 he traveled throughout Europe.

29. For further information on Leutze and American painters in Düsseldorf, see Barbara S. Groseclose, *Emanuel Leutze, 1816–1868: Freedom Is the Only King* (Washington, D.C.: Smithsonian Institution Press for National Collection of Fine Arts [National Museum of American Art], 1975), and *The Düsseldorf Academy and the Americans* (Atlanta, Ga.: High Museum of Art, 1972).

30. Groseclose, *Emanuel Leutze*, p. 110.

31. Knowlton, *Art-Life*, p. 6–7.

32. Baker, *Richard Morris Hunt*, p. 24.

33. Knowlton, *Art-Life*, p. 7. On Pradier, see: *Statues de Chair, sculptures de James Pradier* (Paris: Editions de la Réunion des musées nationaux, 1985), and Peter Fusco and H. W. Janson, *The Romantics to Rodin* (Los Angeles: Los Angeles County Museum, 1980), pp. 313–22.

34. Knowlton, *Art-Life*, p. 7. The painting is dated c. 1846 by the Toledo Museum of Art, an approximate date confirmed by Albert Boime in *Thomas Couture and the Eclectic Vision* (New Haven, Conn.: Yale University Press, 1980), p. 561. Boime also notes, p. 429, that "Deforge was the enterprising colour merchant and dealer on the Boulevard Montmartre who regularly exhibited new paintings."

35. Albert Boime, *The Academy & French Painting in the Nineteenth Century* (London: Phaidon Press, 1971), p. 65.

36. For further information on Couture's *Romans of the Decadence*, see Boime, *Thomas Couture*, chap. 6.

37. See Boime, *Thomas Couture*, and Marchal E. Landgren, *American Pupils of Thomas Couture* (College Park: University of Maryland Art Gallery, 1970).

38. Boime, *The Academy*, pp. 66–7.

39. See Louise d'Argencourt et al., *Puvis de Chavannes* (Ottawa: National Gallery of Canada, 1977).

40. Another relief, *The Flight of Day* (Vose Galleries, Boston), probably preceded Hunt's *Flight of Night – Anahita*. It is illustrated in *The Return of William Morris Hunt* (Boston: Vose Galleries, 1986), p. 28.

41. Reproduced in Leavitt Hunt's brief biographical sketch of William for Henry Burnham's *Brattleboro, Windham County, Vermont: Early History* (Brattleboro, Vt.: D. Leonard, 1880), p. 140. The poem was prefaced by the following comment: "The idea of 'Anahita' as a pendant to Guido's 'Aurora,' was first suggested in 1847, by the writer of this notice."

42. Henry Adams, "The Development of William Morris Hunt's *The Flight of Night*," *American Art Journal* (Spring 1983): 44–5.

43. These six drawings, which belonged to Helen Knowlton, bear the notation "made while studying in Paris."

44. Knowlton, *Art-Life*, p. 8.

45. Hunt began *The Violet Girl* in 1851. Later he reworked it in the United States and dated it 1856. It was then exhibited at the National Academy of Design and the Washington Art Association in 1857 (Knowlton, *Art-Life*, p. 26).

46. The writer credited with first voicing these concerns and actively supporting the work of this new generation of painters was Charles Baudelaire. See in particular his "Salon of 1846," reprinted in Jonathan Mayne, ed. *Baudelaire, Art in Paris 1845–1862,* (New York: Phaidon, 1965 [paperback, 1970]), pp. 41–120. This period in French painting has received a great deal of attention over the past three decades: Joseph C. Sloane, *French Painting Between the Past and the Present: Artists, Critics, and Traditions from 1848 to 1870* (Princeton, N.J.: Princeton University Press, 1951); Linda Nochlin, *Realism* (Baltimore, Md.: Penguin Books, 1971); T. J. Clark, *Image of the People: Gustave Courbet and the Second French Republic, 1848–1851* (Greenwich, Conn.: New York Graphic Society, 1973) and *The Absolute Bourgeois, Artists and Politics in France 1848–1851* (London: Thames & Hudson, 1973); and Gabriel P. Weisberg, *The Realist Tradition: French Painting and Drawing 1830–1900* (Cleveland: Cleveland Museum of Art, 1980).

47. For information on Manet's sources, see Anne Coffin Hanson, *Manet and the Modern Tradition* (New Haven, Conn.: Yale University Press, 1977).

48. For instance, David Teniers the Younger did several versions of *The Five Senses* in which hearing is personified as a bagpiper or hurdy-gurdy player.

49. Known only from a photograph in Frick Art Reference Library, #520–23/a.

50. According to Weisberg, *The Realist Tradition*, p. 7, "The most famous of these books of 'street criers' was Bouchardon's *Etudes prises dans le bas peuple, ou les cris de Paris*, first published in 1737 . . . and undoubtedly still used by artists of the nineteenth century."

51. Two examples of single images of musicians are David Gilmour Blythe's *The Fiddler* (c. 1854–8, Museum of Art, Carnegie Institute, Pittsburgh) and William Sidney Mount's *Banjo Player* (1856, Museums at Stony Brook, Stony Brook, N.Y.). In fact, several of Mount's paintings of young musicians – such as *Just in Tune* (1849) and *Right and Left* (1850) (both Museums at Stony Brook) – were known internationally through lithographs published by the French art dealers Goupil and Co.

52. See Maybelle Mann, *The American Art-Union* (Otisville, N.Y.: ALM Associates, 1977).

53. The companion to *Hurdy-Gurdy Boy* is *Girl with Cat*, which Hunt painted in 1856 at the request of its owner, Edmund Dwight. See *American Paintings in the Museum of Fine Arts, Boston*, 2 vols. (Boston: Museum of Fine Arts, 1969), 1:155, 157.

54. Illustrations and descriptions of the lives of these itinerant children were included in nineteenth-century albums of city types used by French painters, including Manet, such as *Les Français peints par eux-mêmes*, which was

published in England as *Pictures of the French* (London: Wm. S. Orr, 1840). Also see Anne Coffin Hanson, "Manet's Subject Matter and a Source of Popular Imagery," *Museum Studies, Art Institute of Chicago* 3 (1969): 63–80.

55. The influence of this particular painting and the evolution of the theme were the subjects of an exhibition and brochure published in 1977 by the *Editions des Musées Nationaux*. See Jean-Pierre Cuzin, "La diseuse de bonne aventure de Caravage," *Les dossiers du département des peintures* 13 (Paris: Louvre, 1977).

56. See Marchal E. Landgren, *Robert Loftin Newman, 1827–1912* (Washington, D.C.: Smithsonian Institution Press for National Collection of Fine Arts [National Museum of American Art], 1974).

57. Another American artist, Robert Wylie, painted this theme in *A Fortune Teller of Brittany* (1871–2, Corcoran Gallery of Art, Washington, D.C.)

58. It is not certain whether it is this version or another, formerly at the Provident National Bank, Philadelphia, now at the Yamanashi Prefectural Museum, Japan, that was shown at the Salon of 1850. See Alexandra R. Murphy, *Jean-François Millet* (Boston: Museum of Fine Arts, 1984), pp. 32–3, n. 2, and *Jean-François Millet* (Paris: Grand Palais, 1975–6), pp. 89–92.

59. *Talks on Art*, p. 168.

60. In addition to *The Sower*, Hunt bought *Seated Nude (Les Regrets)* (c. 1847–8); *Two Reclining Figures* (c. 1848); *Shepherdess Sitting at the Edge of the Forest* (c. 1848–9); *Man Turning over the Soil (Le Bêcheur)* (c. 1847–50); *Three Men Shearing Sheep in a Barn* (c. 1852); *Shepherdess Leaning on Her Staff* (c. 1852–3); and two paintings shown at the Salon of 1853 – *Shepherd and Flock at the Edge of the Forest, Evening* (1853) and *Shearing Sheep* (1852–3). Paintings bought by Boston friends included *The Winnower* (Salon of 1848; bought in 1854 by Robert Loftin Newman, private collection, United States); *Harvesters Resting (Ruth and Boaz)* (Salon of 1853, bought by Martin Brimmer, first president of the Museum of Fine Arts, Boston, where it is today); and *The Angelus* (1855–7, commissioned by Thomas Gold Appleton, the Louvre).

61. For instance, in 1959, John Canaday, who later became art critic for the *New York Times*, wrote: "Millet's noble poor seem a little self-conscious of their symbolical importance, a little too cleaned up to smack convincingly of the soil of which they are supposed to be an emanation.... The generations between Millet's death and his current fall from favor admired him as a painter who had achieved the ultimate statement of the nobility of the simple man." *Mainstreams of Modern Art* (New York: Holt, 1959), p. 122.

62. Serious reevaluation of Millet's reputation was undertaken by Robert L. Herbert through two exhibitions: *Barbizon Revisited* (Boston: Museum of Fine Arts, 1962), and *Jean-François Millet* (Paris: Grand Palais, 1975–6). For recent appraisals of Millet's *The Sower*, see Sloane, *French Painting*, pp. 144–5; T. J. Clark, *Image of the People*, p. 145, and *The Absolute Bourgeois*, pp. 93–4; and Murphy, *Jean-François Millet*, p. 31–3.

63. Peter Bermingham, *American Art in the Barbizon Mood* (Washington, D.C.: Smithsonian Institution Press for National Collection of Fine Arts [National Museum of American Art], 1975); and Meixner, "Jean-François Millet" and *An International Episode*.

64. Meixner, "Jean-François Millet," p. 87: "Cited in both nineteenth-century and modern scholarship, Hunt's double version of his painting, *La Marguerite*, has become the archetypical example of his transition from the method taught by Couture to one inspired by Millet."

65. *Talks on Art*, pp. 169–70. "You asked if he painted much out-of-doors. He used to take walks, and look at things, and study them in that way. We would start out together, and perhaps come to a cart by the roadside. We would sit down, and he would make me notice how it sagged, and how the light fell on the wheels, and all sorts of things about it."

66. Murphy, *Jean-François Millet*, p. 25.

67. Millet's first studies for this painting include a conté crayon sketch, *Girl Tending a Cow* (c. 1852–3, Museum of Fine Arts, Boston), and a drawing, *Peasant Woman Guarding Her Cow* (1852, Boymans–van Beuningen Museum, Rotterdam). There are other versions of the girl sitting (*Shepherdess Sitting on a Rock*, 1856, Cincinnati Art Museum) and of the girl knitting while tending sheep (*Shepherdress Knitting [La Grande Bergère]*, 1862, etching, Museum of Fine Arts, Boston); and one, a pastel of a girl with two cows (*Peasant Girl with Two Cows*, 1863, Museum of Fine Arts, Boston).

68. Murphy, *Jean-François Millet*, p. 50.

69. See "Le dossier des 'Glaneuses,' " in *Jean-François Millet*, pp. 143–9.

70. Weisberg, *The Realist Tradition*, p. 83.

71. Admired by Ruskin, Frère, who lived in Ecouen, France, was hugely popular in the United States in the late nineteenth century. For a brief biographical sketch and examples of his work, see Weisberg, *The Realist Tradition*. On the influence of Jules Breton, see Hollister Sturges, *Jules Breton and the French Rural Tradition* (Omaha, Neb.: Joslyn Art Museum, 1982).

72. A second version in the Corcoran Gallery of Art, Washington, D.C., signed and dated 1857, is a replica. A third, smaller, version, dated 1865, is owned by Willard Clark, Hanford, California.

73. Millet's *Newborn* (1846) is illustrated in Meixner, *An International Episode*, fig. 4. In the Museum of Fine Arts, Boston, there is a pastel *Newborn Lamb* by Millet dated 1866. See Murphy, *Jean-François Millet*, pp. 170–1, for further information on Millet's interpretation of this subject. The term *manière fleurie* (literally, a florid or flowery manner) was used by Millet's biographer Alfred Sensier to describe Millet's adoption of a light, flickering rococo painterly technique for his playful, erotic subjects painted in the 1840s.

1. Baker, *Richard Morris Hunt,* p. 98.

2. See Carol Troyen, "The Boston Tradition: Painters and Patrons in Boston 1720–1920," in *The Boston Tradition, American Paintings from the Museum of Fine Arts, Boston* (New York: American Federation of Arts, 1980), pp. 5–42.

3. William H. Gerdts and Theodore E. Stebbins, Jr., *"A Man of Genius," The Art of Washington Allston (1779–1843)* (Boston: Museum of Fine Arts, 1979), p. 114.

4. Louisa Hunt, " 'Peeps at me for my babies.' When they arrive at years of discretion." European Diary (1866–8), sec. 5. In this memoir, which Louisa began while in Antwerp with William in 1867, she reminisced about a trip taken fifteen years earlier (1852) when she had "two [lovers] in the same family and knew not what it was to have a 'Mother in Law'!" Since this corresponds to the time she and Hunt probably met, one assumes the reference is to him and possibly one of his brothers.

5. Baker, *Richard Morris Hunt,* p. 61.

6. For additional information on Perkins, see Jean Gordon, "The Fine Arts in Boston, 1815–1879" (Ph.D. diss., University of Wisconsin, 1965).

7. Alice Forbes, daughter of John Murray, wrote in her diary in 1857: "Mr. Hunt brought Sarah's pictures. The one that is finished is perfectly fascinating, and a very good likeness. The other is a beautiful picture but not much like her." Sarah was the youngest Forbes daughter, then aged four or five, neither picture has been located. Mary's portrait is owned by a member of the Forbes family. Excerpts from Alice's diary are included in *An Anthology of Naushon, 1833–1917,* edited by Kathleen Allen Forbes and Edith F. W. Gregg (privately printed, 1979).

8. Information on the history of the Athenaeum Gallery and Boston artists' organizations can be found in Mable Munson Swan, *The Athenaeum Gallery, 1827–1873: The Boston Athenaeum as an Early Patron of Art* (Boston Athenaeum, 1940); Robert F. Perkins, Jr. and William J. Gavin, III, eds., *The Boston Athenaeum Art Exhibition Index 1827–1874* (Boston: Library of the Boston Athenaeum, 1980); William Howe Downes, "Boston Painters and Paintings, Part III." William Morris Hunt, *Atlantic Monthly* 62 (September 1888): 382–94; Troyen, *The Boston Tradition;* and Leah Lipton, "The Boston Artists' Association, 1841–1851," *American Art Journal* 15 (Autumn 1983): 45–57.

9. In the Museum of Fine Arts, Boston, *Exhibition of the Works of William Hunt,* 1879 (hereafter, 1879 Memorial Exhibition *Catalogue*) the notation for *Girl at the Fountain* (#57) reads: "Painted 1852. Begun when with Millet; finished at Brattleboro." In this same catalogue, the notation for *The Violet Girl* (#29) reads: "Begun at Paris 1851." Knowlton adds (*Art-Life,* p. 26): "The *Violet Girl* also begun abroad, was completed in Brattleboro, Vt., in 1856." According to Mary Cabot in *Annals of Brattleboro* (2: 838): Hunt "had a studio in the Town Hall building in 1856, and

returned at intervals, to the year of his death, to visit his friend Richard M. Bradley."

10. According to a letter from Edmund Dwight dated January 3, 1898, in the files of the Museum of Fine Arts, Boston: "In 1856 Hunt came to my home to lithograph this picture [*Hurdy-Gurdy Boy*]. Upon the stone which he was using was a sketch of the 'Girl with a Kitten.' I asked him to paint it for me as a companion to the 'Hurdy Gurdy Boy' – which he did."

11. *New York Daily Tribune*, April 12, 1856, 4, col. 2.

12. "Exhibition of the National Academy of Design," *The Crayon* 3 (May 1856): 147.

13. See Robert G. Workman, *The Eden of America, Rhode Island Landscapes, 1820–1920* (Providence: Museum of Art, Rhode Island School of Design, 1986). See also Gibson Danes, "William Morris Hunt and His Newport Circle," *Magazine of Art* 44 (April 1950): 144–50.

14. *New York Daily Tribune*, May 23, 1857, 5, col. 3, and "Sketchings – The National Academy of Design," *The Crayon* 4 (July 1857): 223.

15. For general information on European printmaking at this time, see Roger Passeron, *Impressionist Prints* (New York: Dutton, 1974).

16. Janet Flint, "The American Painter-Lithographer," *Art & Commerce: American Prints of the Nineteenth Century*, conference proceedings (Boston: Museum of Fine Arts, May 8–10, 1975), pp. 126–42.

17. According to a notation in the files of the National Museum of American Art, these lithographs were "published in a paper folder of 6 prints for $3. *Pictures/Painted & Lithographed/-By-/Wm. M. Hunt/1857*." The lithographic stones were destroyed in the Boston Fire of 1872; see *Exhibition and Public Sale of the Celebrated Paintings and Charcoal Drawings of the Late William Morris Hunt*, February 23 and 24, 1898, p. 5.

18. There is a photograph titled *Stag in Moonlight* (P79.2051), Octagon Museum, American Architectural Foundation, Prints and Drawings Collection, Washington, D.C., which bears the notation "one of the earliest pictures painted [by Hunt] about 1850 – owned by Frank Brooks, Esq. Photographed from picture." Presumably this is a photograph of *Stag in Fontainebleau* "owned by Francis Brooks," dated 1851 in the 1879 Memorial Exhibition *Catalogue* (#109). Also at the Octagon Museum is a photograph of *Deer* (P79.2053) with the following inscription: "Companion picture [to *Stag in Fontainebleau*] painted same time and owned by Frank Brooks, Esq."

19. Hunt's study with Barye has never been confirmed. According to Knowlton (*Art-Life*, p. 6), Hunt studied with the sculptor briefly in 1844 before attending the Düsseldorf Academy. She later quotes (p. 24) a friend of Hunt's as stating: " 'During his residence in Paris he saw much of Barye, the animal sculptor, who gave him a friendship and assistance of which he spoke with continued pleasure. Barye taught him how much there was in the construction and composition of a single figure; of the unity and comprehension of a subject, and of the steadiness necessary to work it out.' "

20. Quoted in Richard Ormond, *Sir Edwin Landseer* (New York: Rizzoli, 1981), p. 177.

21. Knowlton, *Art-Life,* p. 37.

22. "Sketchings – Domestic Art Gossip," *The Crayon* 6 (March 1859): 92; and Henry T. Tuckerman, *Book of the Artists, American Artist Life* (New York: G. P. Putman & Son, 1867), p. 449.

23. See James Yarnall, "Tennyson Illustrations in Boston, 1864–1872," *Imprint* 7 (Autumn 1982): 10–16.

24. Eleanor (Mrs. Kurt Diederich) was born in 1858 shortly after their return from Fayal, the Azores; a second child, Enid (Mrs. Samuel Slater) was born three years later, in 1861. Mabel Hunt (Mrs. Horatio Nelson Slater) was born in 1863; and their last child and only surviving son, Paul, was born in 1869. Enid married the father of Mabel's husband.

25. Marchal E. Landgren, *The Late Landscapes of William Morris Hunt* (College Park: University of Maryland Art Gallery, 1976), p. 62.

26. Additional works done in Fayal, and included in the 1879 Memorial Exhibition *Catalogue,* are *Sketch of a Wreck at Fayal* (#174); *Study. Sketch in Fayal* (#267); and *Coast Scene, Fayal* (pastel, #312).

27. See Martha J. Hoppin, "William Morris Hunt: Portraits from Photographs," *American Art Journal* 11 (April 1979): 44–57. Hoppin also noted two other portraits (unlocated) done by Hunt of Mr. and Mrs. Dabney in Fayal.

28. Knowlton, *Art-Life,* p. 33. Hunt was eventually paid $500 by the Essex County Bar Association for this portrait, which now hangs in the Court House, Salem, Massachusetts.

29. Reproduced in Robert A. Sobieszek and Odette M. Appel, *The Spirit of Fact, the Daguerreotype of Southworth and Hawes, 1843–1862* (Rochester, N.Y.: International Museum of Photography, 1976), pp. 12–13.

30. Knowlton, *Art-Life,* p. 33.

31. Information on midcentury American portraiture is scant. Modern exhibitions focusing on portraiture of this period include: William James Hennessey, *The American Portrait from the Death of Stuart to the Rise of Sargent,* (Worcester, Mass.: Worcester Art Musuem, 1973); Michael Quick, *American Portraiture in the Grand Manner: 1720–1920* (Los Angeles: Los Angeles County Museum of Art, 1981); and Leah Lipton, *A Truthful Likeness, Chester Harding and His Portraits* (Washington, D.C.: National Portrait Gallery, 1985).

32. *Boston Evening Transcript,* December 13, 1859, and December 17, 1859.

33. Gay Wilson Allen, *Waldo Emerson* (New York: Penguin Books, 1982).

34. The Thayer portrait illustrated here is a replica of the original shown at the National Academy of Design. The current whereabouts of the original is unknown. According to the files at the Smith College Museum of Art, their version was "probably a replica commissioned by the donor [Sarah S. Thayer]" after the death of her brother in 1864. Thayer, who grew

up in Northampton, Massachusetts, was on the staff of the *New York Evening Post* and was the consul general to Egypt during Lincoln's administration.

35. The term "lost profile," or *profil perdu,* refers to a type of portraiture in which the subject is rendered almost entirely from the back; the profile is barely represented, or almost "lost."

36. *New York Daily Tribune,* March 27, 1861, p. 8, col. 2.

37. According to Baker, *Richard Morris Hunt,* p. 487, n. 9, William sold Hill Top to Richard in 1864. "Hill Top cottage was located on a large lot at the point where Touro Street comes into Bellevue Avenue. It was built by Henry Schroeder of Baltimore as a one-story house; his son-in-law, a Mr. Gilliatt, from whom William Hunt purchased the house, had the original building lifted up and a new lower story added.... In 1915, it was further enlarged and altered to become the Hilltop Inn. In 1923, it was razed and the Viking Hotel was built on the site.... The Viking Motor Inn now occupies most of the site."

38. As can best be determined, Hunt's pupils in Newport included the following:

 1859 – Edward Wheelwright
 John La Farge

 1860 – Edmund Quincy, painter and early student of Richard Hunt's
 Frank Furness, the Philadelphia architect and student of Richard's

 1860–61 – William James
 Henry James
 Thomas Sargent Perry

 Others known to have studied there during the same years are Thomas Gold Appleton, John Bancroft, Sarah Wyman Whitman, Theodora Sedgwick, and Sarah Gibbs.

39. See Edward Wheelwright, "Three Boston Painters," *Atlantic Monthly* 40 (December 1877): 710–18; and "Personal Recollections of Jean-François Millet," *Atlantic Monthly* 38 (September 1876): 257–76. Also see Meixner, "Jean-François Millet," pp. 128–42, for valuable information on the life and career of Edward Wheelwright.

40. Also see Annette Blaugrund, "The Tenth Street Studio Building: A Roster, 1857–1895," *American Art Journal* 14 (Spring 1982): 64–71.

41. Royal Cortissoz, *John La Farge: A Memoir and a Study* (Boston: Houghton Mifflin, 1911), p. 96.

42. Ibid., pp. 111–13.

43. M. A. DeWolf Howe, *Later Years of the Saturday Club, 1870–1920* (Boston: Houghton Mifflin, 1927), p. 155.

44. Henry James, *Notes of a Son and Brother,* p. 277. For further information on Henry James and the visual arts, see John L. Sweeney, ed., *The Painter's Eye* (Cambridge, Mass.: Harvard University Press, 1956), and Viola Hop-

kins Winner, *Henry James and the Visual Arts* (Charlottesville: University Press of Virginia, 1970).

45. Martha Shannon in *Boston Days of William Morris Hunt* (Boston: Marshall Jones, 1923), pp. 75–6, identified *The Lost Profile* as a portrait of Hunt's wife.

46. Unfortunately, only *The Singers*, dated 1859 in the 1879 Memorial Exhibition *Catalogue* (#92), has been located.

47. See Susan Casteras, "The 1857–58 Exhibition of English Art in America: Critical Responses to Pre-Raphaelitism," *The New Path, Ruskin and the American Pre-Raphaelites* (Brooklyn, N.Y.: Brooklyn Museum, 1985), pp. 109–33.

48. Reproduced in *American Paintings in the Museum of Fine Arts, Boston,* 1:158. First published in 1819, the poem was, along with "Three Little Graves" and "Fair Charlotte," among Smith's most popular. Originally called "The Mother Perishing in a Snowstorm," it is an early work by Smith, who also wrote under the pseudonym Major Jack Downing. Said to be based on a true incident, "Snow Storm" maintained its popularity for most of the century. Reprinted widely, it was translated into many foreign languages, was included in school readers, and was also set to music.

49. Earlier a reproduction of *The Newsboy*, a painting by the New York artist Henry Inman, had accompanied a story by Seba Smith, "Billy Snub, the Newsboy," in *The Gift* of 1843.

50. *The Bugle Call* was lithographed by D. C. Fabronious, and *Our Sick Soldier,* also known as *Playing Field Hospital* or *Field Hospital,* was lithographed by Hunt and printed by Oakley & Thompson. The painting *Bugle Call* has not been located. The painting *Our Sick Soldier* is owned by J. V. Hawn, Shreveport, Louisiana.

51. *Talks on Art,* p. 173.

52. Tuckerman, *Book of the Artists,* p. 450.

53. For information on the image of the drummer boy, see Albert Boime, "Thomas Couture's Drummer Boy Beating a Path to Glory," *Bulletin of the Detroit Institute of Art* 56 (1978): 108–31.

54. Harry T. Peters, *America on Stone* (New York: Doubleday, Doran, 1931), p. 183.

55. The photograph of this painting in the Octagon Museum (#P79.2015) has the notation "Photograph from a life-size picture of Lincoln – almost finished, and burned in the Boston fire." There is also a small oil sketch of the Lincoln portrait, dated 1865, in the Museum of Fine Arts, Boston.

56. Hoppin, "William Morris Hunt: Portraits from Photographs," pp. 54–5.

57. Ibid., pp. 44–57.

58. *Talks on Art,* p. 122.

59. Jeffrey Weidman, "William Rimmer: Critical Catalogue Raisonné" (Ph.D. diss., Indiana University, 1982), pp. 94–6, n. 87.

60. Downes, "Boston Painters, III. William Morris Hunt," p. 388.

61. See Troyen, *The Boston Tradition,* pp. 23–6, and Martha J. Hoppin, "Women Artists in Boston, 1870–1900: The Pupils of William Morris Hunt," *American Art Journal* 13 (Winter 1981): 22–3.

62. Henry Adams, "John La Farge's Discovery of Japanese Art," *Art Bulletin* 67 (September 1985): 449–85.

63. Knowlton, *Art-Life,* p. 126.

64. Reproduced in Adams, "John La Farge's Discovery of Japanese Art," p. 454.

65. Theodore E. Stebbins, Jr., *The Life and Work of Martin Johnson Heade* (New Haven, Conn.: Yale University Press, 1975), pp. 56–7.

66. Catharine Howland Hunt, "Scrapbook," Typescript, Avery Library, Columbia University, New York, p. 78.

67. Portraits of Saturday Club members by Hunt included *Louis Agassiz* (1874–5, Fogg Museum, Cambridge, Mass.); *Richard Henry Dana, Jr.* (n.d., unlocated); *Ralph Waldo Emerson* (begun January 1874, unlocated); *Charles Sumner* (c. 1875–6, Metropolitan Museum of Art); *John Albion Andrew* (c. 1867, Faneuil Hall, Boston); *Martin Brimmer* (1874, unlocated); *Charles Francis Adams* (1868, Adams House, Harvard University); *Horace Gray* (1865, location unknown); *William Barton Rogers* (1855, Detroit Institute of Art); *James Freeman Clarke* (1875, Arlington Street Church, Boston); and *John Lowell* (1872, Lowell House, Harvard University).

68. Edward Waldo Emerson, *The Early Years of the Saturday Club, 1855–1870* (Boston: Houghton Mifflin, 1918), p. 341.

69. Ralph Waldo Emerson, quoted in E. W. Emerson, *Saturday Club,* p. 341.

70. Hunt exhibited *Hamlet* again in 1870, at the gallery of Doll & Richards, but did not sell it. *Hamlet* remained in his family until 1913, when it was given to the Museum of Fine Arts, Boston, on permanent loan from the Estate of Louisa D. Hunt. Hunt did several sketches of Hamlet, four of which were listed in the *Exhibition and Public Sale of the Celebrated Paintings and Charcoal Drawings of the Late William Morris Hunt,* Warren Chambers, Boston, February 23–4, 1898: *Small Hamlet* (#3); *Head of Hamlet* (#4); and two small studies, each titled *Study of Hamlet* (#13, #14).

71. *Talks on Art,* p. 167.

72. Ibid., pp. 149–50.

73. Quoted in Knowlton, *Art-Life,* pp. 56–7.

74. Angell noted, in "Records," April 1880, p. 564: "May 13, 1875. Mr. Hunt invited a few friends to his studio to meet [the actors] William Warren and Joseph Jefferson. The affair was very enjoyable, and passed off to his entire satisfaction." According to Eugene Tompkins, *The History of the Boston Theatre, 1854–1901* (Houghton Mifflin, 1908), p. 215, Warren was in Boston with his Comedy Company at the same time Jefferson was playing there in *Rip Van Winkle.*

75. One version of *Felix Regamey*, dated c. 1864, is in the Museum of Fine Arts, Boston; a second is at the Vose Galleries, Boston. According to Tompkins (*History of the Boston Theatre*, p. 203), Regamey in December 1864 performed a specialty act along with the ballet *The Naiad Queen*. There are three other known paintings of actors by Hunt: *Portrait Head of an Actor* (n.d. John Herron Art Institute, Indianapolis); *Portrait of a Young Actor*, said to be of Edwin Booth (c. 1876, Bennington Museum, Bennington, Vt.); and *The Tragedian* (c. 1878, unlocated).

76. Knowlton, *Art-Life*, pp. 36–7. According to Tompkins, *History of the Boston Theatre*, pp. 105–6, Bandmann played Hamlet in Boston in February 1864: "Edwin Forrest opened on February 1, 1864 for six weeks of his repertoire, the performances on the off-nights being given by Daniel E. Bandmann, who presented 'The Merchant of Venice,' 'Narcisse,' 'Othello,' 'Hamlet,' and 'Richelieu.' "

77. Annie West Fields, *James T. Fields, Biographical Notes and Personal Sketches* (Boston: Ticknor & Fields, 1881), p. 183.

78. *New York Daily Tribune*, July 3, 1865, 6, col. 2.

79. "Editor's Easy Chair," *Harper's New Monthly Magazine* 31 (June 1865): 129.

80. *Portrait* was owned by Milton H. Sanford, and, according to the review, was of a woman and may be the portrait (unlocated) of Mrs. Sanford mentioned by Knowlton. There is a photograph of Mr. Sanford's portrait in the Octagon Museum and a large charcoal drawing in the Museum of Fine Arts, Boston.

81. "Fine Arts – The Forty-First Exhibition of the National Academy of Design," *The Nation*, May 11, 1866, 603.

82. Ibid.

83. *Talks on Art*, p. 117.

84. *New York Daily Tribune*, July 4, 1866, 5, col. 1.

85. James Jackson Jarves, *The Art-Idea* (1864; Cambridge, Mass.: Harvard University Press, 1960), p. 185; and Tuckerman, *Book of the Artists*, p. 450.

86. Jarves, *Art-Idea*, p. 181.

87. Ibid., p. 184.

88. Baker, *Richard Morris Hunt*, p. 133.

89. All quotations in this paragraph are from Tuckerman, *Book of the Artists*, pp. 449–50.

90. *New York Daily Tribune*, July 4, 1866, 5, col. 1.

91. *Talks on Art*, p. 75.

CHAPTER 3

1. Louisa Hunt, European Diary (1866–8), sec. 1.

2. For further information on American artists in Brittany, see David Sellin,

Americans in Brittany and Normandy, 1860–1910 (Phoenix, Ariz.: Phoenix Art Museum, 1982).

3. Elihu Vedder, *Digressions of V* (Boston: Houghton Mifflin, 1910), p. 294.

4. *The Quarry* (9″ × 12″) is #51 in the catalogue *Sale by Public Auction of Paintings and Drawings, February 1880*, second day. It is listed with a notation "Dinan, France. 'By the sweat of thy brow thou shalt earn thy bread' Painted in 1867," which suggests that it represents men working in a stone quarry rather than a hunting scene. Other Dinan paintings listed in this catalogue are also dated 1867. Either the dates are wrong or Hunt began them in 1866 and completed them sometime in 1867.

5. On the basis of dimensions and subject matter, the painting known as *A French Courtyard Scene* . . . (Graham Gallery, New York) has been identified as *Cabbage Garden* (12″ × 16″), #54, *Studio Sale*, 1880, second day, with notation "Dinan, France. Painted in 1867." Similarly, *French Village* (Virginia Museum of Fine Arts, Richmond) has been identified as *Brittany Peasant Children* (14″ × 17″), #1, *Public Sale*, 1898, with notation "painted at Lyons, France, 1867." Other Dinan paintings include *Knitting in a Doorway* (11″ × 15″), #60, *Studio Sale*, 1880, second day, with notation "Dinan, France, 1867"; and *Three Generations* or *Brittany Peasants at a Fête Listening to Music* (9″ × 12″), #36, *Studio Sale*, 1880, first day, with notation "Painted at Lion [Lyons?] France in 1867."

6. *Talks on Art*, p. 104.

7. Ibid., p. 87.

8. See Philip Gilbert Hamerton, *The Graphic Arts* (London: Seely, Jackson & Halliday, 1882), on the use of charcoal by artists in the late nineteenth century. Hamerton was an English critic whose books on contemporary art were widely read in the United States.

9. Worthington Chauncey Ford, ed., *Letters of Henry Adams, 1858–1918*, 2 vols. (Boston: Houghton Mifflin, 1930; New York: Kraus Reprint, 1969), 1:132.

10. *Talks on Art*, pp. 158–9.

11. Ibid., pp. 3–4.

12. *Letters of Henry Adams*, 1:133.

13. Etienne Moreau-Nélaton, *Millet raconté par lui-même*, 3 vols. (Paris: Henri Laurens, 1921), 3:17.

14. Angell, "Records," April 1880, p. 559. Little attention has been given to the wide influence of Corot's painting on American art. Of French influences on American landscape painting, his may have been second only to that of the Impressionists.

15. There are also two bust-lengths studies – one in left profile (c. 1867, Museum of Fine Arts, Boston), another in right (Mrs. Diane Edgerton, California) – of this same model. There is also a small oil sketch called *Italian Girl in Sunlight*, dated 1868 (Worcester Art Museum, Worcester, Mass.), which may have been done for his students after his return to the

United States, because it is signed with two dates: "68" (the date he completed the work) and "Nov 9 72" (the date he discovered it was in the possession of one of his students, Almira Fenno-Gendrot, and thus had been saved from the Boston Fire of November 6, 1872). In addition, there is a large painting of a young girl in peasant costume pictured in a landscape setting titled *Italian Peasant Girl* (private collection). Signed and dated 1868, it may have been done during the fall in Italy.

16. A photograph of the head of this model is in the Vose Gallery files; and a large charcoal sketch titled *Italian Boy* is at the Bennington Museum. A second painting, *Italian Peasant Boy II*, at the Museum of Fine Arts, Boston, formerly attributed to Hunt, is now acknowledged to be by Hamilton Wilde. See 1979 Memorial Exhibition *Catalogue*, p. 66.

17. See, Boime, *The Academy*.

18. *Talks on Art*, p. 16.

19. Hunt also submitted a pair of portraits, called simply *Portrait of M.* and *Portrait of Mme.*, to the Paris Salon in 1867. These may have been the portraits of Mr. and Mrs. Long, done shortly before Hunt's departure and representative of his latest style.

20. Carol Troyen, "Innocents Abroad: American Painters at the 1867 Exposition Universelle, Paris," *American Art Journal* 16 (Autumn 1984): 2–29.

21. Frank Leslie, "Report on the Fine Arts," Paris Universal Exposition. Contained in *Reports of the United States Commissioners* (Washington, D.C.: Government Printing Office, 1868), p. 14.

22. Ibid., p. 15.

23. One of the few personal remarks in Louisa's diary is this bitter observation on her mother-in-law (secs. 5–6): "In those innocent days I thought a Mother in law [*sic*] meant 'sugar n spice and all that's nice' but 'cauldron bubble, toe of newt and finger of birth-strangled/babe' *my* Mother in law has been to me instead. May God in his infinite Mercy and who does all in wisdom and love, grant you my children a woman and a lady for your *Mother in Law*."

24. Ibid., secs. 80–2.

25. *Monk Reading* is probably #172 in the 1879 Memorial Exhibition *Catalogue*. In addition, several charcoal sketches have been identified: *Monk Reading* (#252 and #290), *Study, Monk on Convent Stairs* (#209), and *Monk on Steps* (#258). A reproduction of one of the latter entitled *Monk Coming Down Stairs* was made into a Copley Print in 1898 and reproduced in *Public Sale*, 1898, first day, charcoal drawings, #6.

26. Listed in Regina Soria's *Elihu Vedder, American Visionary Artist in Rome (1836–1923)* (Rutherford, N.J.: Fairleigh Dickenson University Press, 1970) as #26, p. 282. A photograph of this painting is in the Octagon Museum.

27. Louisa Hunt, Diary, secs. 94–5.

28. Vedder, *Digressions of V*, p. 371.

29. Louisa Hunt, Diary, secs. 98–9.

30. Ibid., secs. 108–9.

31. Thomas Ball, *My Threescore Years and Ten* (Boston: Roberts Bros., 1892), pp. 301, 304.

32. Martha Hoppin in "Women Artists in Boston, 1870–1900," states (p. 18) that it is uncertain "whether or not Hunt originally intended to exclude male students."

33. Ibid.

34. *Talks on Art*, p. 4.

35. F[rancis] D. Millet, "Mr. Hunt's Teaching," *Atlantic Monthly* 46 (August 1880): 191.

36. Ibid., pp. 190–1.

37. *Talks on Art*, p. 133.

38. Ibid., p. 107.

39. Ibid.

40. A photograph of the *Allan Wardner* portrait (P79.2006), dated 1870, is in the Octagon Museum. It was also reproduced in "William Morris Hunt," *Masters in Art* 9 (August 1908): 336, as *Head of an Old Man*.

41. Quoted in Knowlton, *Art-Life*, pp. 47–8.

42. This is one of two charcoal sketches Hunt did of an as yet unlocated finished portrait. The photograph of the other charcoal drawing of Evarts, which is similar to the version reproduced in the text, is found in Shannon, *Boston Days of William Morris Hunt*, p. 25. The oil sketch is in the collection of the Yale University Art Gallery.

43. Quoted in Knowlton, *Art-Life*, p. 54.

44. Quoted in Wilhelmina S. Harris, *Furnishings Report of the Old House*, vol. 2 (Quincy, Mass.: Adams National Historic Site, 1966–8), p. 268.

45. *Boy with Butterfly* is also known as *Boy and Butterfly* and *Boy Chasing a Butterfly*.

46. Although the seated portrait *Berthe Farnham Williams* (the model for *Marguerite*) is dated 1871, it was begun before *Marguerite*, which is dated 1870 in the 1879 Memorial Exhibition *Catalogue*. Evidently, Hunt finished Williams's portrait a year later.

47. A photograph of Hunt's portrait of *Archbishop Williams* is in the Octagon Museum (#P79.1899).

48. Knowlton, *Art-Life*, p. 50.

49. *His First Model – Miss Russell* (Cleveland Museum of Art) is similar to Hunt's *Priscilla* and *Girl with White Cap*, yet as noted in the 1979 Memorial Exhibition *Catalogue* (p. 68), it is "probably a replica by Hunt or one of

his students, rather than another preliminary study." Similarly, the figure study *Miss Jane Tuckerman* (the same model for Hunt's *The Amazon* and *Gainsborough Hat*) was, according to the owner, Eliot Tuckerman (the sister's brother), "begun by Rose Lamb...and finished by Hunt." Note in files of Frick Art Reference Library, New York.

50. *Talks on Art,* p. 6.

51. Ibid., p. 7.

52. Knowlton, *Art-Life,* pp. 80–1. Knowlton is no doubt in error when she states that the canvas for *Anahita* was 50 feet wide, since this would have been an unprecedented size. Even his mural, painted directly on the wall, was only 45 feet wide when completed.

53. "Journals of Jane Hunt," September 23, 1874, p. 144.

54. At the time of these entries (1873–4), Jane and her mother lived in New York, as did Richard, his wife, and their three children (two more children would be born to them in 1875 and 1877). Leavitt, his wife (Kate Jarvis), and their five children lived in Weathersfield, Vermont. Jonathan, who still lived in Paris, had a common-law wife and one daughter. By 1873, William and Louisa had four children: three daughters – Eleanor, aged fifteen; Enid, aged twelve; Mabel, aged ten – and one son, Paul, aged four.

55. "Journals of Jane Hunt," July 26, 1873, p. 124.

56. Ibid., August 5, 1873, p. 125.

57. Ibid., p. 128. According to Lippincott's *Gazetteer,* Squantum was once a subdivision of Quincy, Massachusetts. No other information has been found to identify further the Squantum referred to in Jane's journal.

58. "Journals of Jane Hunt," undated, p. 128.

59. Ibid., p. 130. It was about this time that Jane began her study with Helen Knowlton, and she recorded in her journals a visit from the English artist and art instructor Lowes Dickinson. He encouraged Knowlton to publish Hunt's studio notes, which served as the basis for Hunt's *Talks on Art.* Dickinson was one of the first three art instructors to be hired in 1854 (along with Ruskin and Rossetti) by the Working Men's College, London.

60. "Journals of Jane Hunt," May 24, 1874, p. 137.

61. Catharine Hunt, in her "Diary" (pp. 159–60), wrote of William's death in September 1879: "It was a great grief to Richard, indeed to all of us. Death the great purifer [*sic*] and obliterator, left only the memory of intimate boyhood relations, and the still stronger ones of early manhood, though it was hard to forgive and forget the wife who had separated him from his children and family, and whose resentment even kept her away from his funeral."

1. An important survey of Hunt's late landscapes was organized in 1976 at the University of Maryland Art Gallery by Marcel Landgren, the first modern scholar to isolate and honor this influential and relatively unknown body of work done by Hunt.

2. *Talks on Art,* p. 81.

3. *Talks on Art,* p. 35.

4. In the "William Morris Hunt – Notes on Exhibitions," Scrapbook, n.p. Hunt had done landscape studies even before the fire since a number of them were exhibited at Doll & Richards in 1871. Henry James reviewed this earlier exhibition and much preferred Hunt's charcoals to his oils. "The thoroughly agreeable works of last month's exhibition were neither the 'Hamlet,' nor the 'Boy and the Butterfly,'... but half a dozen small canvases, chiefly landscapes of the most charming quality." See Henry James, "Pictures by William Morris Hunt, Gérôme and Others," *Atlantic Monthly* (1872): 246.

5. The exhibition, installed in the Studio Building gallery, ran for one week, March 9–16, 1875. This exhibition was followed by a sale of the artists' work at Williams and Everett's gallery.

6. Another painting, *Milton Pastures* (c. 1875, Portland Art Museum, Portland, Ore.), may be the painting listed in the *Artists' Annual Sale* catalogue as *Milton Farm.*

7. Martha J. Hoppin, "William Morris Hunt and His Critics," *American Art Review* 2 (September – October 1975): 79–91.

8. Norton would go on to become the first professor of art history at Harvard, but as far as is known he did not participate in the debate around Hunt's work, nor is his opinion of Hunt known.

9. "The Fine Arts, the Exhibition in Studio Building," *Boston Daily Advertiser,* March 12, 1875, n.p.

10. Excerpts from Hunt's *Talks on Art,* published as "Studio Notes," appeared in the Worcester weekly newspaper (Worcester, Mass., was Helen Knowlton's hometown) as early as October 1874. They began to appear in Boston newspapers early in March 1875.

11. ***, "Duty and Feeling in Art," *Boston Daily Advertiser,* March 19, 1875, n.p.

12. C.P.C. [Christopher Pearse Cranch], "The Fine Arts, Art Schools and Cliques," ibid., March 20, 1875, n.p.

13. B., "The Artists' Exhibition at Williams and Everett's," ibid., March 22, 1875, n.p.

14. Ibid.

15. C.H.M. [Charles Herbert Moore], "Theory and Practice in Art, ibid.

16. Walter Smith, "The Picture Controversy, The Theory and Practice of the

Fine Arts and Industrial Drawing – The State System," ibid., March 24, 1875, n.p.

17. "Art," *Atlantic Monthly*, August 1875, 250.

18. Ibid., p. 251.

19. Ibid., p. 252.

20. The other members of the Museum School committee included three trustees of the museum, Martin Brimmer, C. C. Perkins, and Charles C. Loring; three architects, Edward Clarke Cabot, Robert S. Peabody, and William R. Ware; three other painters, Francis William Loring, Francis D. Millet, and Frank Hill Smith; plus the treasurer of Harvard College, Edward W. Hooper. See Walter Muir Whitehill, *Museum of Fine Arts, Boston: A Centennial History* (Cambridge, Mass.: Belknap Press, Harvard University Press, 1970), p. 41.

21. Sylvester Baxter, "The Art-Schools of Boston," *Art Journal* (June 1878), 190. Also see George P. Lathrop, "The Study of Art in Boston," *Harper's Monthly* 58 (July 1879): 818–39.

22. Charles H. Moore, "The Marriage of St. Catharine," *Boston Daily Advertiser*, June 2, 1875, n.p.

23. William Morris Hunt, "French Art," ibid., June 9, 1875, n.p.

24. *Talks on Art*, p. 39.

25. "Art," *Atlantic Monthly*, September 1875, 374.

26. The paintings Duveneck exhibited at the Boston Art Club were *Whistling Boy* (1872, Cincinnati Art Museum); *Lady With a Fan* (1873, Metropolitan Museum of Art); *Portrait of William Adams* (location unknown); *The Old Professor* (1871, Museum of Fine Arts, Boston); and *Portrait of Professor Ludwig Loefftz* (1873, Cincinnati Art Museum).

27. "Art," *Atlantic Monthly*, June 1875, 751.

28. Angell, "Records," April 1880, 565.

29. See Jennifer A. Martin Bienenstock, "The Formation and Early Years of the Society of American Artists" (Ph.D. diss., City University of New York, 1983).

30. Angell, "Records," April 1880, 565.

31. In all, fifteen reprints of both series were published between 1875 and 1911. Houghton Mifflin reprinted the first edition of the First Series four times between 1878 and 1884. Hunt's English publisher, Macmillan, reprinted the First Series eight times between 1878 and 1895. The Second Series was published only by Houghton Mifflin, first in 1883, then reprinted three times between 1884 and 1911. See "William Morris Hunt – Notes on Exhibition," Scrapbook, n.p., for extensive contemporary notices on, as well as excerpts from, the *Talks on Art*. For a modern analysis of Hunt's *Talks on Art*, see Roger Anthony Welchans, "The Art-Theories of Washington Allston and William Morris Hunt," Ph.D. diss., Case Western Reserve University, 1970.

32. Quoted in Knowlton, *Art-Life*, p. 91.

33. Ibid., p. 88.

34. "A Painter on Painting," *Harper's New Monthly Magazine* 56 (February 1878): 458–61, reprinted in Nicolai Cikovsky, Jr., and Michael Quick, *George Inness* (Los Angeles: Los Angeles County Museum of Art, 1985), p. 205.

35. A. P. Ryder, "Paragraphs from the Studio of a Recluse," *Broadway Magazine* 14 (September 1905): 10–11, reprinted in John W. McCoubrey, *American Art, 1700–1960, Sources and Documents* (Englewood Cliffs, N.J.: Prentice-Hall, 1965), pp. 186–8.

36. William Hazlitt's *Criticisms on Art: and Sketches of the Picture-Galleries of England* was published posthumously in 1843 and reprinted in 1854 and 1873. *Round Table. Northcote's Conversations. Characteristics*, another anthology of Hazlitt's writings edited by his grandson William Carew Hazlitt, appeared in 1871. "Art of Greece," a lecture Taine delivered at the Ecole des Beaux-Arts in 1864 (and later included in his *Lectures on Art*), was translated by John Durand and published in New York by Henry Holt in 1875.

37. *Talks on Art*, p. 159.

38. John La Farge, *Considerations on Painting*, Lectures given in the year 1893 at the Metropolitan Museum of Art (New York: Macmillan, 1895), p. 4.

39. *Talks on Art*, p. 76.

40. The selection from "Red Cotton Night-Cap Country" appears in *Talks on Art*, pp. 75–71; from "Fra Lippo Lippi," pp. 70–69; and "The Book and the Ring," pp. 61–58.

41. Ibid, pp. 59–58.

42. Peter Henry Emerson, *Naturalistic Photography for Students of the Art* (New York, 1890), pp. 124, 292–3.

43. *Talks on Art*, p. 140. In this same passage, Hunt commented that no men ever enrolled in his classes: "People ask, 'Why do you teach women instead of men?' Because they came and asked me to show them, and offered to pay me for my time. I have told the young men again and again that I would do the same for them, if they would get a large room and all work together. But some of them would not be as teachable as the women are."

44. "William Morris Hunt – Notes on Exhibitions," Scrapbook, n.p.

45. Bernard B. Perlman, *The Immortal Eight: American Painting from Eakins to the Armory Show, 1870–1913*. (Cincinnati: North Light Publishers, 1979), p. 45.

46. Owned by John H. Wright, *Boot Black* was also exhibited at the Boston Art Club the same year.

47. "Art," *Atlantic Monthly*, May 1876, 631.

48. According to Knowlton (*Art-Life*, pp. 115–16): "A number of Hunt's pupils had formed the habit of visiting, during each month of June, some

picturesque locality for the purpose of sketching. When their two weeks' stay was nearly ended, it was their custom to invite Hunt to come and see their sketching ground and criticise their work.

In one of these excursions they had discovered a genius, – no less a person than George Fuller, who was painting in a studio in the midst of his beautiful rural surroundings at South Deerfield. . . .

Hunt was sent for, and he saw at once the merit of the work of the poet-artist. Mr. Doll, the autocratic picture-dealer of Boston, was called upon to introduce him to the public. . . . Mr. Doll came, saw, and was conquered; and George Fuller was at once launched upon a successful artistic career, which continued through life." This anecdote is at only slight variance with the version of Fuller's rediscovery in Sarah Burns, "A Study of the Life and Poetic Vision of George Fuller (1822–1884)," *American Art Journal* 13 (Autumn 1981): 21.

49. *Atlantic Monthly*, May 1876, 630.

50. Ibid.

51. Knowlton, *Art-Life*, pp. 120–21.

52. Angell, "Records," July 1880, 79–80.

53. "Notes," *Art Journal* (February 1877): 64.

54. Clarence Cook, "The Academy Pictures," *New York Tribune*, May 26, 1877, 3.

55. Angell, "Records," June 1880, 756–7.

56. Frederic A. Sharf and John H. Wright, *William Morris Hunt and the Summer Art Colony at Magnolia, Massachusetts, 1876–1879* (Salem, Mass.: Essex Institute, 1981), p. 5.

57. Knowlton, *Art-Life*, p. 117.

58. It is doubtful that Tom Robinson, Hunt's "wagon-boy," who Knowlton (ibid., p. 118) says later "became a successful painter of horses in a Western city," was Thomas R. Robinson, a painter from Providence, active in New York and Boston at this time; he was also the Paris agent for the Seth M. Vose Gallery, than located in Providence. See Troyen, *Boston Tradition*, p. 138.

59. As noted in the catalogue of Hunt's *Studio sale* in 1880 (first day), the full title of the painting is *Ball Players, Magnolia* (#27), with the notation "Front of Studio, 1877."

60. For more information on Gloucester painters, see *Portrait of a Place, Some American Landscape Painters in Gloucester* (Gloucester, Mass.: Cape Ann Historical Society, 1973).

61. Quoted in Knowlton, *Art-Life*, p. 119.

62. "The New Capitol. A Communication from W. M. Hunt, the Boston Artist. To the Editor of the *Argus*" (November 27, 1878), "William Morris Hunt – The Capitol at Albany," Scrapbook, n.p.

63. For a discussion of the "Battle of Styles" that surrounded the design of

the Albany State Capitol, see Susan R. Stein, "The New York State Capitol Controversy and the Rise of Architecture as Practice," *Proceedings of the New York State Capitol Symposium*, pp. 71–6. Also see Webster, "The Albany Murals of William Morris Hunt," pp. 114–26.

64. *American Architect and Building News*, April 1, 1876, 107.

65. This Newport house (now known as the Joseph R. Busk mansion) was unfinished at the time of Dorsheimer's death in 1888. See Baker, *Richard Morris Hunt*, p. 547.

66. See Francis Kowsky, "The William Dorsheimer House: A Reflection of French Suburban Architecture in the Early Work of H. H. Richardson," *Art Bulletin* (March 1980), 134–47.

67. *American Architect and Building News*, March 11, 1876, 82–3.

68. Wheelwright, *The Class of 1844*, p. 345.

69. "The Capitol," *Brooklyn Times*, April 25, 1879, in "William Morris Hunt – The Capitol at Albany," Scrapbook, n.p.

70. According to Hoppin, the *Portrait of a Lady* may be *Portrait of Mrs. John Murray Forbes* (c. 1875–6, Museum of Fine Arts, Boston); see Hoppin, "Handlist," #70, in "William Morris Hunt: Aspects of His Work."

71. See Jeremy Elwell Adamson, *Niagara, Two Centuries of Changing Attitudes, 1697–1901* (Washington, D.C.: Corcoran Gallery of Art, 1985); and Elizabeth McKinsey, *Niagara Falls, Icon of the American Sublime* (New York: Cambridge University Press, 1985).

72. Quoted in Knowlton, *Art-Life*, p. 122.

73. Ibid., p. 158.

74. "William Morris Hunt," *Art Journal* 5 (November 1879): 347.

75. Knowlton, p. 158.

76. *Schedule 'B,' Annual Report of the New Capitol Commissioners for the Year, 1878*, New York State Senate Documents, 102nd sess., 1879, v. 1, no. 20 (January 23, 1879), 25.

77. *Harper's Weekly*, November 29, 1879, 943.

78. Although Emanuel Leutze's stereochromatic wall painting for the U.S. Capitol, *Westward the Course of Empire Takes Its Way,* preceded Hunt's murals, it is most often considered a history painting rather than a work imbued with the symbolic content of civic art. Nor is Leutze's work referred to in historical accounts of American mural painting. Instead, John La Farge in church decoration and Hunt in public art are given pride of place.

CHAPTER 5

1. C[larence] C[ook], "A Tribute to the Dead Artist. To the Editor of the *Tribune*," New York, September 9, 1879, Obituary Notices, Scrapbook, n.p.

2. First published in Leavitt Hunt's brief biographical sketch of William in 1880 for Henry Burnham's *Brattleboro, Windham County, Vermont*, pp. 140–41. Also reprinted with some slight changes in Knowlton, *Art-Life*, p. 79.

3. See "William Morris Hunt," *Art Journal* 5 (November 1879): 347.

4. Other studies include two details (the head of a putto [Octagon Museum, #79.4317] and *Head of Sleep* [Octagon Museum #79.1841]), and a sketchbook (private collection) that contains drawings of the horses and figures of the mother and child. Also see Henry Adams, "The Development of William Morris Hunt's *The Flight of Night*," pp. 43–52; and Webster, "Albany Murals," pp. 170–88.

5. The full inscription reads: "First sketch of 'The Discoverer' / about 1850 or '60." Both Angell and Knowlton acknowledge that there was an early study for *The Discoverer*. Angell, "Records of William M. Hunt," July 1880, p. 83: "[*The Discoverer*] was first drawn in charcoal, twenty-three years ago." Knowlton, writing at the end of the century, confirmed its presence (*Art-Life*, p. 159): "A pencil drawing is in existence, showing his first conception of this subject."

6. Henry James in *A Small Boy and Others* remarked: "I could see in a manner, for all the queerness, what W.J. meant by that beauty and, above all, that living interest in La Barque du Dante, where the queerness, according to him, was perhaps what contributed most; see it doubtless in particular when he reproduced the work, at home, from a memory aided by a lithograph." Henry James, *Autobiography*, p. 194.

7. The inscription on the back of the drawing reads: "Drawn in Studio December 1877 in presence of J. G. Carter."

8. Truman H. Bartlett, *The Art Life of William Rimmer: Sculptor, Painter, and Physician* (Boston: J. R. Osgood, 1882), p. 81.

9. This practice of consulting or hiring a decorator (or "color decorator," as the job came to be called), whose primary responsibility was to integrate with its surroundings the artist's image through color and decorative motifs, was a common procedure at the turn of the century.

10. According to Bartlett (*Art Life of William Rimmer*, p. 81), a second drawing by Rimmer, *Studies of Agriculture or Commerce* (1878, Fogg Art Museum, Cambridge, Mass.), may be related to a second series of murals proposed by Hunt "embrac[ing] the principal elements of the character of the State treated symbolically." Hunt had hoped for additional work at Albany, but no extant sketches of his indicate his specific intentions. It is more likely that Rimmer's study, with its woman in a chariot pulled by horses, is a reworking of Hunt's *Flight of Night*.

11. Other studies of the figure of Anahita include: one small oil at the Museum of Fine Arts, Boston; a photograph of a charcoal drawing at the Octagon Museum, #p79.1835, which served as the basis for a reproduction, copyrighted in 1898 by Curtis and Cameron and published in an unidentified clipping in "William Morris Hunt – The Capitol at Albany," Scrapbook, n.p.

12. There are a large-scale oil of Fortune at the Shepherd Gallery, New York,

and two large-scale drawings (one at the Fogg Museum, Cambridge, Mass., the other at the Museum of Fine Arts, Boston). These and other drawings related to both *The Flight of Night* and *The Discoverer* are reproduced in Webster, "Albany Murals," pp. 358–96. In contrast, there is only one known sketch of the separate figure of Columbus, a photograph of a drawing at the Octagon Museum, #P79.1870.

13. Carter mentioned these tests in an article in *Harper's Weekly* (November 29, 1879), 943: "It must be remembered that the paintings which now adorn those walls are put directly upon the bare, cold stone. . . . Two years [1877] before he had invented a marvellous set of pigments which when dried were as hard as flint, and as luminous almost as light itself.

 "He was therefore sure of his paint, but he determined to become doubly sure by trying it on slabs of Ohio sandstone. He submerged these painted slabs in water for days in order to test the paint. The winter before he had subjected similar painted slabs to the action of the frost. The writer has seen one of them that had been frozen for six months, and then thawed out. The colors were of unparalleled brilliancy and freshness, and the pigments seemed as hard and firm as stone."

14. Ian S. Hodkinson and Morgan W. Phillips, "Alternatives in Treating the Hunt Murals," *Excerpts from the Feasibility Study on the Restoration of the Assembly Chamber New York State Capitol, Concerning the William Morris Hunt Murals* (June 1989). According to Angell ("Records," July 1880, 82): Hunt, in secret in a room under his studio, ground and mixed his special pigments which were then "hermetically sealed in five-pint tin cans, to be in readiness for transportation to the scene of his great work. Why all this grinding and mixing was done in secret no one knows; but Mr. Hunt never made his appearance in this room until the grinder, who knew nothing of the destination of his products, had gone home for the day; then he went down and inspected the results with the greatest interest."

15. Also see M. H. Port, ed., *The Houses of Parliament* (New Haven, Conn.: Yale University Press, 1976).

16. "Fresco Painting," from "Painting Popularly Explained," *The Crayon* 8 (January 1861): 15–41. This was the first part of a two-part article that was never printed owing to *The Crayon's* demise. *Talks on Art,* p. 91.

17. For information on the pigments La Farge used in Trinity Church, see H. Barbara Weinberg, "John La Farge and the Decoration of Trinity Church, Boston," *Journal of the Society of Architectural Historians* 33 (December 1974): 329–31. For information on the water-glass technique, see Frederic Crowninshield, *Mural Painting* (Boston: Ticknor, 1887). According to Crowninshield, a German, Dr. J. N. Von Fuchs, in 1825 invented the formula for stereochromatic painting that Wilhelm von Kaulbach used for his six stereochromatic frescoes done between 1845 and 1865 for the stairwell of the New Museum, Berlin. See Crowninshield, "Water-Glass," in *Mural Painting,* p. 108.

18. According to Ralph Mayer, *A Dictionary of Art Terms and Techniques,* (1969; New York: Barnes & Noble, 1981), p. 371: "[Spirit fresco is] mural painting with colors made by grinding pigments in varnish; a process developed about 1880 in England by T. Gambier-Perry. . . . Spirit fresco was devised

in an attempt to find a reasonably simple technique for producing paintings with the visual effects of true fresco that could survive rigorous British climatic conditions."

19. William Morris Hunt Sketchbook, n.p. This Sketchbook, inscribed "Jane Hunt's Sketchbook," is owned by a family descendant. Although the inscription is of Jane Hunt's name, William's initials are engraved in brass on the spine. The subject matter as well as the style of many of the drawings relate to known works of Hunt's, including sketches for the horses of Anahita.

20. *Talks on Art*, pp. 165–6.

21. Museum of Fine Arts, Boston, William Morris Hunt file, Hunt to Rose Lamb (typescript), Albany, October 17, 1878.

22. [Montgomery Schuyler], "Correspondence. The State Capitol at Albany, November," *American Architect and Building News*, December 14, 1878, 196.

23. Hunt to Lamb, October 17, 1878.

24. Hunt to Lamb, October 23, 1878.

25. Ibid.

26. Angell, "Records," May 1880, 639.

27. Hunt to Lamb, November 3, 1878.

28. Will Low, *A Chronicle of Friendships* (New York: Charles Scribner's Sons, 1908), p. 259.

29. Ibid., p. 264.

30. Cecil R. Roseberry, *Capitol Story* (Albany: State of New York, 1964), p. 44.

31. See Webster, "Albany Murals," pp. 288–99.

32. William H. Gerdts and Mark Thistlethwaite, *Grand Illusions, History Painting in America* (Fort Worth, Tex.: Amon Carter Museum, 1988), p. 110.

33. See George L. Hersey, "Delacroix's Imagery in the Palais Bourbon Library," *Journal of the Warburg and Courtauld Institute* 31 (1968): 383 403.

34. See Gérard Maurice Doyon, "The Positions of the Panels Decorated by Théodore Chassériau at the Former Cour des Comptes in Paris," *Gazettes des Beaux-Arts*, January 1969, 46–56; and Louise d'Argencourt et al., *Puvis de Chavannes* (Ottawa: National Gallery of Canada, 1977).

35. For a full discussion of La Farge's commission at Trinity Church, see Weinberg, "John La Farge and the Decoration of Trinity Church, Boston," pp. 322–53.

36. Henry Van Brunt, "The New Dispensation of Monumental Art," *Atlantic Monthly* 43 (May 1879): 633–41. Reprinted in *Architecture and Society; Selected Essays of Henry Van Brunt*, ed. William Coles (Cambridge, Mass.: Harvard University Press, 1969), p. 135.

37. Van Brunt, in Coles, ed., *Architecture and Society*, p. 135.

38. Henry Van Brunt translated Viollet-le-Duc's *Entretiens sur l'architecture* as *Discourses on Architecture* (Boston: James R. Osgood, 1875).

39. See John Ruskin, *The Works of John Ruskin*, eds. E. T. Cook and Alexander Wedderburn, vol. 11: *Stones of Venice III* (New York: Longmans, Green, 1903–12), sec. 35, p. 29.

40. See Eugène Emmanuel Viollet-le-Duc, *Dictionnaire raisonné de l'architecture française du XIe au XVIe siècle,* 10 vols. (Paris: B. Bance & A. Morel, 1854–68), 7:56–109.

41. Van Brunt, in Coles, ed., *Architecture and Society,* p. 140.

42. Ibid., 141.

43. Ibid.

44. Ibid., 142.

45. Ibid.

46. Ibid.

47. Ibid., p. 143.

48. See J. D. Yohannan, "Emerson's Translations of Persian Poetry from German Sources," *American Literature* 14 (January 1943): 407–20.

49. See Arthur E. Christy, *The Orient in American Transcendentalism* (1932; New York: Octagon Books, 1972.)

50. J. Duchesne-Guillemin, *The Western Response to Zoroaster,* Ratanbai Katrak lectures, 1956 (Oxford: Oxford University Press, 1958), p. 14.

51. Ralph Waldo Emerson, "Compensation," published in *Essays: First Series* (1841), reprinted in *The Complete Essays and Other Writings of Ralph Waldo Emerson,* p. 172.

52. Edward Gibbon, *The Decline and Fall of the Roman Empire* (1776–87; New York: Dutton, 1963), p. 193.

53. Thomas Bulfinch, *The Age of Fable or Beauties of Mythology* (Boston: S. W. Tilton, 1855), p. 424.

54. C[larence] C[ook], "A Description of the Building," *New York Tribune* (December 24, 1878), in "William Morris Hunt – The Capitol at Albany," Scrapbook, n.p.

55. John Fiske, *Myth and Myth-Makers, Old Tales and Superstitions Interpreted by Comparative Mythology* (1872; Boston: Houghton Mifflin, 1897), pp. 121–2.

56. James Freeman Clarke, *Ten Great Religions: An Essay in Comparative Theology* (1871; Boston: Houghton Mifflin, 1913), p. 175.

57. See Perkins and Gavin, *The Boston Athenaeum Art Exhibition Index,* pp. 117–18. Most of these copies were of Guido's religious paintings – *Magdalene, Judith with the Head of Holofernes, St. Sebastian, St. Catherine,* etc. Curiously, although *Aurora* was a popular subject for engravings, it was not replicated for exhibition at the Athenaeum.

58. According to Knowlton (*Art-Life,* p. 175), "While in Boston for a day or

two, he was found keenly absorbing Michael Angelo's *Day,* studying the turn and foreshortening of the foot, which caught his eye and seemed to remind him of the foot of the sleeping mother in his own *Flight of Night."*

59. See Joshua C. Taylor's essay "The Academic Tradition" in the exhibition catalogue *Academy, The Academic Tradition in American Art* (Washington, D.C.: Smithsonian Institution Press for National Collection of Fine Arts [National Museum of American Art], 1975), pp. 11–28.

60. Washington Irving, *Life and Voyages of Christopher Columbus* (1828; New York: A. L. Burt, 1902). This was followed two years later by a second volume, *Voyages and Discoveries of the Companions of Columbus* (1831).

61. Irving, *Life and Voyages of Christopher Columbus,* p. 396.

62. In the 1890s a number of sculptural images of Columbus were commissioned to honor the quatercentenary of his discovery of America. Many of these treated Columbus or the Columbus theme symbolically. The best known include Gaetano Russo's *Columbus Monument* (1892) for Columbus Circle, New York; Frederick MacMonnies's *The Triumph of Columbia* or *Barge of State* for the 1893 World's Columbian Exposition, Chicago; and Lorado Taft's *Columbus Memorial Fountain* (1908) for Union Station Plaza, Washington, D.C. For representations of Columbus in European art, see Hugh Honour, *The European Vision of America* (Cleveland: Cleveland Museum of Art, 1975).

63. Justin Winsor, *Narrative and Critical History of America,* 8 vols. (Boston: Houghton Mifflin, 1884–9), 2:12.

64. Winsor, 2:12, n. 1.

65. Joel Barlow, *Vision of Columbus* (Hartford, Conn.: Hudson & Goodwin, 1787), p. 1.

66. Samuel Rogers, "The Vision of Columbus," in *Complete Poetical Works,* ed. E. Sargent (Boston: Phillips, Sampson, 1854), p. 3.

67. Ibid., p. 49.

68. Howard R. Patch, *The Goddess Fortuna in Medieval Literature* (New York: Farrar, Straus & Giroux, 1974), p. 107.

69. For instance, in the "Carmina Burana," a collection of thirteenth-century secular poems rediscovered in the early 1800s, the turning of Fortune's wheel was compared to the waning and waxing of the moon: "O Fortuna, variable as the moon, always dost thou wax and wane."

70. It may be that the series of nude images of Fortune seated on a cloud that Vedder worked on between 1882 and 1899 were influenced by Hunt's image of Anahita.

71. Patch, *Goddess Fortuna,* p. 104.

72. See Jane Dillenberger's essay "Between Faith and Doubt: Subjects for Meditation," in *Perceptions and Evocations: The Art of Elihu Vedder* (Washington D.C.: National Collection of Fine Arts, Smithsonian Institution, 1979), p. 130.

73. "The Rubáiyát of Omar Khayyám," trans. Edward Fitzgerald, in *A Treasury of Great Poems* (New York: Simon & Schuster, 1942), p. 841.

74. "The Capitol," *Brooklyn Times*, April 25, 1879, in "William Morris Hunt —The Capitol at Albany," Scrapbook, n.p.

75. Louisa Dumaresq Hunt, "Paintings on Stone" (Washington, D.C., 1888), pamphlet in Artists' File, New York Public Library.

76. Knowlton, *Art-Life*, p. 175

77. Roseberry, *The Capitol Story*, p. 47.

78. Angell, "Records," May 1880, p. 640.

79. Knowlton, *Art-Life*, p. 185.

80. Celia Thaxter, "William M. Hunt's Last Days. To the Editors of the *Tribune*," Appledore, Isles of Shoals, September 11, 1879, "Obituary Notices," Scrapbook, n.p.

81. "Mr. Hunt's Sad Death, Portsmouth, N.H., Sept. 9," in "William Morris Hunt – Obituary Notices," Scrapbook, n.p.

82. Thaxter, "William M. Hunt's Last Days," n.p.

83. "William M. Hunt's Suicide, The Well-known Artist Throws Himself in to a Cistern on the Isles of Shoals" (*New York Sun*), Obituary Notices, Scrapbook, n.p.

84. Helen M. Knowlton, "The Last Year of William Hunt's Life," Obituary Notices, Scrapbook, n.p.

85. "William M. Hunt" (*Boston Herald*), Obituary Notices, Scrapbook, n.p.

86. C[larence]. C[ook]. "A Tribute to the Dead Artist. To the Editor of the *Tribune*," New York, September 9, 1879, Obituary Notices, n.p.

87. James Jackson Jarves, "The Late William Hunt. Florence, Italy, November 21, 1879" (*Boston Herald* Supplement, December 3, 1879), Obituary Notices, n.p.

88. It opened November 11, 1879, and was scheduled to close December 15; but interest was such that the exhibition was extended to January 31, 1880.

89. "William Morris Hunt – Notes on Exhibitions," Scrapbook, contains innumerable notices of these exhibitions and auction. Of the latter, an unsigned notice stated: "Sixty-three paintings and one hundred and one drawings were sold during the two days [February 3 and 4], and the aggregate receipts were $63,887. The sale was the most remunerative ever made in this city, and one of the most so in the country."

90. According to Carter: "The sandstone which forms the background had apparently absorbed the moisture like a sponge, and pieces of the stone, in some instances to the depth of from one-quarter to one-half inch and a foot in length, have scaled and dropped off, carrying portions of the painting with them." "The Capitol at Albany," Scrapbook, n.p.

91. *Report of the Assembly Chamber Ceiling, New York State Capitol*, April 16, 1888. Copy in Roseberry files, New York State Library, Albany, New York.

92. "Anxious to Save the Fresco," in "William Morris Hunt – The Capitol at Albany," Scrapbook, n.p.

93. Unidentified clipping in ibid.

94. "Notes," *The Studio*, n.s. 3 (August 1888): 141.

95. Ibid.

96. The following is a partial list of writings on American mural painting at the turn of the century. In addition to the specific books and articles mentioned, several of these writers – including Caffin, Cortissoz, Sturgis, La Farge, Blashfield, Low, and Cox – wrote articles on individual projects for the Boston Public Library, the Library of Congress, Appellate Division Courthouse, New York, and so on. The first book on the history and technique of mural painting published in this country was Crowninshield's *Mural Painting*. Subsequent articles and books included Royal Cortissoz, "Mural Decoration in America (First Paper)," *Century*, November 1895, 110–21; Will Low, "A Century of Painting," *McClure's Magazine*, April 1897, 472–82; Russell Sturgis, "Mural Painting in American Cities," *Scribner's Monthly*, January 1899, 125–8; Pauline King, *American Mural Painting* (Boston: Noyes, Platt, 1902); Samuel Isham, "Recent Mural Decorations," in *History of American Painting* (New York: Macmillan, 1905; 2d edition with supplemental chapters by Royal Cortissoz, 1927), pp. 538–60; John La Farge, "The Decoration of Our Public Buildings," *Scrip*, August 1906, 355–7; Charles H. Caffin, "Some Notes on Mural Painting," in *The Story of American Art* (New York: Frederick A. Stokes, 1907), pp. 304–31; Edwin Blashfield, *Mural Painting in America* (New York: Charles Scribner's Sons, 1913); and Kenyon Cox, "Some Phases of Nineteenth-Century Painting, Part III, Mural Painting in France and America," *Art World* 2 (April 1917): 11–15.

97. King, *American Mural Painting*, pp. 39–54.

98. Ibid., p. 55.

99. Selwyn Brinton, "Modern Mural Decoration in America," *International Studio* (January 1911): 176.

CHAPTER 6

1. Low, *A Chronicle of Friendships*, p. 264.

2. Samuel G. W. Benjamin, "W. M. Hunt's Influence on Painting," *American Architect and Building News* 7 (February 14, 1880): 59.

3. Benjamin, "The Hunt Collection of Paintings," *Art Journal* 6 (January 1880): 29.

4. Isham, *History of American Painting*, pp. 313.

5. Samuel G. W. Benjamin, "Tendencies of Art in America," *American Art Review* 1 (1880): 107.

6. Benjamin, "Present Tendencies of American Art," *Harper's New Monthly Magazine*, March 1879, 482.

7. Benjamin, "Tendencies of Art in America," p. 107.

8. Ibid., p. 106.

9. Ibid., p. 108.

10. Samuel G. W. Benjamin, *Art in America: A Critical and Historical Sketch* (New York: Harper & Bros., 1880), p. 194.

11. Isham, *History of American Painting*, pp. 313–14.

12. Among the many laudatory articles written by Hunt's students and friends are: Frederic Vinton, "William Morris Hunt. Personal Reminiscences," and "William Morris Hunt. The Memorial Exhibition – The Paintings at Albany," both in *American Art Review* 1 (1880): 48–52, 93–103; Sarah W. Whitman, "William Morris Hunt," *International Review* 8 (1880): 389–401; Maria Oakey, "William Morris Hunt," *Harper's New Monthly Magazine* 61 (July 1880): 161–6; and numerous unsigned articles in other magazines and journals that have been preserved in four scrapbooks at the Octagon Museum, Washington, D.C.

13. William Howe Downes, "Boston Painters and Paintings, Part III," p. 388.

14. *Talks on Art*, p. 175.

Selected Bibliography

Books and Journal Articles

Adams, Henry. "The Development of William Morris Hunt's *The Flight of Night.*" *American Art Journal* 15 (Spring 1983): 43–52.

"John La Farge, 1830–1870: From Amateur to Artist." Ph.D. diss., Yale University, 1980.

"John La Farge's Discovery of Japanese Art." *Art Bulletin* 67 (September 1985): 449–85.

Adamson, Jeremy Elwell. *Niagara, Two Centuries of Changing Attitudes, 1697–1901.* Washington, D.C.: Corcoran Gallery of Art, 1985.

Allen, Gay Wilson. *Waldo Emerson.* New York: Penguin Books, 1982.

American Architect and Building News. 1876–9.

"American Painters. – William Morris Hunt." *Art Journal* (April 1878): 116–17.

American Paintings in the Museum of Fine Arts, Boston. 2 vols. Boston: Museum of Fine Arts, 1969.

The American Renaissance, 1876–1917. Brooklyn, NY: Brooklyn Museum, 1979.

Angell, Henry. "Records of William Morris Hunt." *Atlantic Monthly* (April 1880, 559–65; May 1880, 630–40; June 1880, 753–79; July 1880, 75–83). Later published in book form: *The Records of William Morris Hunt.* Boston: James R. Osgood, 1881.

Apis. "A Word for William Hunt." *Boston Evening Transcript,* March 23, 1875, p. 8.

"Art." *Atlantic Monthly* (1875 and 1880).

B. "The Fine Arts. The Artists' Exhibition at Williams and Everett's." *Boston Daily Advertiser,* March 22, 1875.

Baker, Paul. *Richard Morris Hunt.* Cambridge, Mass.: MIT Press, 1980.

Ball, Thomas. *My Threescore Years and Ten.* Boston: Roberts Bros., 1892.

Barlow, Joel. *Vision of Columbus.* Hartford, Conn.: Hudson & Godwin, 1787.

Bartlett, Truman H. *The Art Life of William Rimmer: Sculptor, Painter, and Physician.* Boston: J. R. Osgood, 1882.

Baxter, Sylvester. "The Art-Schools of Boston." *Art Journal* (June 1878): 189–90.

Benjamin, Samuel G. W. *Art in America: A Critical and Historical Sketch.* New York: Harper & Bros., 1880.

"The Hunt Collection of Paintings." *Art Journal* 6 (January 1880): 28–9.

"Present Tendencies of American Art." *Harper's New Monthly Magazine,* March 1879, 481–96.

"Tendencies of Art in America." *American Art Review* 1 (1880): 105–110.

"W. M. Hunt's Influence on Painting," *American Architect and Building News* 7 (February 14, 1880): 59–60.

Bermingham, Peter. *American Art in the Barbizon Mood.* Washington, D.C.: Smithsonian Institution Press for National Collection of Fine Arts (National Museum of American Art), 1975.

Berry, Rose V. S. "American Painters – I: William Morris Hunt." *Art and Archaeology* 15 (May 1923): 203–10.

Bienenstock, Jennifer. "The Formation and Early Years of the Society of American Artists." Ph. D. diss., City University of New York, 1983.

Blaugrund, Annette. "The Tenth Street Studio Building: A Roster, 1857–1895," *American Art Journal* 14 (Spring 1982): 64–7.

Boime, Albert. *The Academy & French Painting in the Nineteenth Century.* London: Phaidon Press, 1971.

 Thomas Couture and the Eclectic Vision. New Haven, Conn.: Yale University Press, 1980.

 "Thomas Couture's Drummer Boy Beating a Path to Glory." *Bulletin of the Detroit Institute of Art* 56 (1978): 108–31.

Brinton, Selwyn. "Modern Mural Decoration in America." *International Studio* (January 1911): 175–84.

Burnham, Henry. *Brattleboro, Windham County, Vermont: Early History.* Brattleboro, Vt.: D. Leonard, 1880.

Burns, Sarah. "A Study of the Life and Poetic Vision of George Fuller (1822–1884)." *American Art Journal* 13 (Autumn 1981): 11–37.

C.H.M. [Charles Herbert Moore]. "Theory and Practice in Art." *Boston Daily Advertiser,* March 22, 1875.

C.P.C. [Christopher Pearse Cranch]. "The Fine Arts. Art Schools and Cliques." *Boston Daily Advertiser,* March 20, 1875.

Cabot, Mary, R. *Annals of Brattleboro, 1681–1895.* 2 vols. Brattleboro, Vt.: E. C. Hildreth, 1921.

Caffin, Charles H. *The Story of American Art.* New York: Frederick A. Stokes, 1907.

"The Capitol." *Brooklyn Times,* April 25, 1879.

Catalogue of Plaster Reproductions from Antique, Medieval and Modern Sculpture. Boston: P. P. Caproni & Brother, 1913.

Champney, Benjamin. *Sixty Years' Memories of Art and Artists.* Woburn Mass.: Wallace & Andrews, 1899.

Christy, Arthur E. *The Orient in American Transcendentalism.* 1932; New York: Octagon Books, 1972.

Clarke, James Freeman. *Ten Great Religions: An Essay in Comparative Theology.* 1871; Boston: Houghton Mifflin, 1913.

Cole, Gertrude S. "Some American Cameo Portraitists." *Antiques,* September 1946, 170–1.

C[ook,] C[larence]. "The Academy Pictures." *New York Daily Tribune.* May 26, 1877, p. 3, cols. 4, 5.

 "A Description of the Building." *New York Daily Tribune,* December 24, 1878.

 "National Academy of Design – Fortieth Annual Exhibition, VI," *New York Daily Tribune,* July 3, 1865, p. 6, col. 2.

"The National Academy of Design – Forty-First Annual Exhibition, II," *New York Daily Tribune*, July 4, 1866, p. 5, col. 1.

"A Tribute to a Dead Artist. *New York Daily Tribune*, September 10, 1879, p. 5, col. 2.

Cortissoz, Royal. *John La Farge: A Memoir and a Study.* Boston: Houghton Mifflin, 1911.

Couture, Thomas. *Conversations on Art Methods.* Trans. S. E. Stewart. New York: Putnam's Sons, 1879.

Craven, Wayne. "Henry Kirke Brown in Italy 1842–1846." *American Art Journal* 1 (Spring 1969): 65–77.

The Crayon. Vols. 1–8 (April 1855–61).

Crowninshield, Frederic. *Mural Painting.* Boston: Ticknor, 1887.

Cuzin, Jean-Pierre. "La diseuse de bonne aventure de Caravage." *Les dossiers du département des peintures* 13. Paris: Louvre, 1977.

Danes, Gibson. "A Biographical and Critical Study of William Morris Hunt, 1824–1879." Ph.D. diss., Yale University, 1949.

"William Morris Hunt and his Newport Circle." *Magazine of Art* 44 (April 1950): 144–50.

d'Argencourt, Louise et al. *Puvis de Chavannes.* (Ottawa: National Gallery of Canada, 1977).

Dewey, Mary E., ed. *Life and Letters of Catharine M. Sedgwick.* New York: Harper Bros., 1871.

Downes, William Howe. "Boston Painters and Paintings, Part III. William Morris Hunt." *Atlantic Monthly* 62 (September 1888): 382–94.

Doyon, Gerard Maurice. "The Positions of the Panels Decorated by Théodore Chassériau at the Former Cour des Comptes in Paris." *Gazette des Beaux-Arts,* January 1969, 46–56.

Duchesne-Guillemin, J. *The Western Response to Zoroaster.* Ratanbai Katrak lectures. Oxford, 1958.

The Düsseldorf Academy and the Americans. Atlanta, Ga.: High Museum of Art, 1972.

***. "Duty and Feeling in Art." *Boston Daily Advertiser,* March 19, 1875.

"Editor's Easy Chair." *Harper's New Monthly Magazine* 31 (June 1865): 129.

Emerson, Edward Waldo. *The Early Years of the Saturday Club, 1855–1870.* Boston: Houghton Mifflin, 1918.

Emerson, Ralph Waldo. "Compensation." In *Essays: First Series* (1841), reprinted in *The Complete Essays and Other Writings of Ralph Waldo Emerson,* pp. 170–89. New York: Random House, 1950.

"Exhibition of the National Academy of Design." *The Crayon* 3 (May 1856): 147.

Fairbrother, Trevor. *The Bostonians, Painters of an Elegant Age, 1870–1930.* Boston: Museum of Fine Arts, 1986.

Ferber, Linda S., and Gerdts, William H. *The New Path, Ruskin and the American Pre-Raphaelites.* Brooklyn Museum, 1985.

Fields, Annie West. *James T. Fields, Biographical Notes and Personal Sketches.* Boston: Ticknor & Fields, 1881.

"Fine Art." *Old and New* 10 (October 1874): 524–7.

"Fine Arts." *Boston Daily Advertiser,* March 14, 1875.

"The Fine Arts, the Exhibition in the Studio Building." *Boston Daily Advertiser,* March 12, 1875.

"Fine Arts – The Forty-First Exhibition of the National Academy of Design."
The Nation, May 11, 1866, p. 603.

Fiske, John. *Myth and Myth-Makers, Old Tales and Superstitions Interpreted by Comparative Mythology.* 1872; Boston: Houghton Mifflin, 1897.

Flint, Janet. "The American Painter-Lithographer." In *Art and Commerce: American Prints of the Nineteenth Century,* conference proceedings, Boston: Museum of Fine Arts, May 1975. Charlottesville: University Press of Virginia, 1975, pp. 126–42.

Gerdts, William H., and Stebbins, Theodore E., Jr. *"A Man of Genius" The Art of Washington Allston (1779–1843).* Boston: Museum of Fine Arts, 1979.

Gerdts, William H., and Thistlethwaite, Mark. *Grand Illusions, History Painting in America.* Fort Worth, Tex: Amon Carter Museum, 1988.

Goodrich, Lloyd. "William Morris Hunt." *Arts*, September 1925, 278–83.

Gordon, Jean. "The Fine Arts in Boston, 1815–1879." Ph.D. diss., University of Wisconsin, 1965.

Groseclose, Barbara S. *Emanuel Leutze, 1816–1868: Freedom Is the Only King.* Washington, D.C.: Smithsonian Institution for National Collection of Fine Arts (National Museum of American Art), 1975.

Hamerton, Philip Gilbert. *The Graphic Arts.* London: Seely, Jackson & Halliday, 1882.

Hanson, Anne Coffin. "Manet's Subject Matter and a Source of Popular Imagery." *Museum Studies, Art Institute of Chicago* 3 (1969): 63–80.

Harper's New Monthly Magazine 31 (June 1865): 129.

Harper's Weekly. November 29, 1879, 943–4.

Harris, Neil. *The Artist in American Society, The Formative Years, 1790–1860.* Chicago: University of Chicago Press, 1966; Phoenix Books, 1982.

Hennessey, William J. *The American Portrait from the Death of Stuart to the Rise of Sargeant.* Worcester, Mass.: Worcester Art Museum, 1973.

Herbert, Robert, L. *Barbizon Revisited.* Boston: Museum of Fine Arts, 1962.
Jean-François Millet. Paris: Grand Palais, 1975–6.

Hersey, George L. "Delacroix's Imagery in the Palais Bourbon Library." *Journal of the Warburg and Courtauld Institute* 31 (1968): 383–403.

Hitchcock, Henry Russell, and Seale, William. *Temples of Democracy, the State Capitols of the U.S.A.* New York: Harcourt Brace Jovanovich, 1976.

Hodkinson, Ian S., and Phillips, Morgan W. "Alternatives in Treating the Hunt Murals." *Excerpts from the Feasibility Study on the Restoration of the Assembly Chamber New York State Capitol. Concerning the William Morris Hunt Murals.* Albany, New York, June 1989.

Hoppin, Martha J. "William Morris Hunt: Aspects of His Work." Ph.D. diss., Harvard University, 1974.
 "William Morris Hunt and His Critics." *American Art Review* 2 (September– October 1975): 79–91.
 "William Morris Hunt: Portraits from Photographs." *American Art Journal* 11 (April 1979): 44–57.
 "Women Artists in Boston, 1870–1900: The Pupils of William Morris Hunt." *American Art Journal* 13 (Winter 1981): 17–46.

Howe, Daniel Walker. *The Unitarian Conscience, Harvard Moral Philosophy, 1805–1861.* Cambridge, Mass.: Harvard University Press, 1970.

Howe, M. A. De Wolf, ed. *Later Years of the Saturday Club, 1870–1920.* Boston: Houghton Mifflin, 1927.

Hunt, Catharine Howland. "Scrapbook assembled by Mrs. Richard Morris Hunt and presented to Joseph Howland Hunt on the occasion of the fiftieth [*sic*] anniversary of the death of RMH, July 31, 1900." Typescript, Avery Library, Columbia University, New York.

Hunt, Jane. "Journals of Jane Hunt," in Jane Hunt papers. Hunt Family Archives, Weston, Connecticut.

Hunt, Louisa Dumaresq. "Paintings on Stone." Washington, D.C., April 14, 1888. Pamphlet in Artists' File, New York Public Library, n.p.

"'Peeps at me for my babies.' When they arrive at years of discretion." European Diary (1866–8). Museum of Fine Arts, Boston. Typescript.

Hunt, William Morris. "French Art." *Boston Daily Advertiser*, June 9, 1875.

"The New Capitol. A Communication from W. M. Hunt, the Boston Artist. To the Editors of the *Argus.*" *Albany Argus*, November 27, 1878.

Talks on Art, First and Second Series. Boston: Houghton Mifflin, 1875 and 1883. Reprinted as *On Painting and Drawing*. New York: Dover Publications, 1976.

"William Morris Hunt – Anecdotes." "William Morris Hunt – The Capitol at Albany." "William Morris Hunt – Notes on Exhibitions." "William Morris Hunt – Obituary Notices." Scrapbooks. American Architectural Foundation, Prints and Drawings Collection, The Octagon Museum, Washington, D.C.

Hunt Family Archives. Weston, Connecticut.

Irving, Washington. *Life and Voyages of Christopher Columbus.* 1828; New York: A. L. Burt, 1902.

Isham, Samuel. *History of American Painting.* New York: Macmillan, 1905; 2d edition with supplemental chapters by Royal Cortissoz, 1927.

James, Henry. *Notes of a Son and Brother.* 1914. Reprinted in *Henry James Autobiography.* Princeton, N.J.: Princeton University Press, 1983.

"Pictures by William Morris Hunt, Gérôme and Others." *Atlantic Monthly,* February 1872.

Jarves, James Jackson. *The Art-Idea.* New York: Hurd & Houghton, 1864; reprint, Cambridge, Mass.: Harvard University Press, 1960.

"The Late William Hunt." *Boston Herald,* December 3, 1879.

John La Farge. New York: Abbeville Press, 1987.

King, Pauline. *American Mural Painting.* Boston: Noyes, Platt, 1902.

Knowlton, Helen M. *The Art-Life of William Morris Hunt.* Boston: Little, Brown, 1899.

"The Hunt Studio," *Magnolia Leaves* 2 (September 9, 1882): 13–14.

"William M. Hunt: His Influence upon Art." *Magnolia Leaves* 2 (July 15, 1882): 79–80.

"William Morris Hunt, Artist." *Boston Sunday Sun.* February 7, 1914, special supplement.

Kowsky, Francis. "The William Dorsheimer House: A Reflection of French Suburban Architecture in the Early Work of H. H. Richardson." *Art Bulletin,* March 1980, 134–47.

Lamb, Rose. Letters from William Morris Hunt (1878). Boston, Mass.: Museum of Fine Arts. Typescript.

Landgren, Marchal. *American Pupils of Thomas Couture.* College Park: University of Maryland Art Gallery, 1970.

The Late Landscapes of William Morris Hunt. College Park: University of Maryland Art Gallery, 1976.

Robert Loftin Newman, 1827–1912. Washington, D.C.: Smithsonian Institution Press for National Collection of Fine Arts (National Museum of American Art), 1974.

Lathrop, George P. "The Study of Art in Boston." *Harper's Monthly* 58 (July 1879): 818–39.

Leslie, Frank. "Report on the Fine Arts." Paris Universal Exposition in *Reports of the United States Commissioners.* Washington, D.C.: Government Printing Office, 1868.

Lipton, Leah. "The Boston Artists' Association, 1841–1851." *American Art Journal* 15 (Autumn 1983): 45–57.

A Truthful Likeness, Chester Harding and his Portraits. Washington D.C.: National Portrait Gallery, 1985.

Low, Will. *A Chronicle of Friendships.* New York: Charles Scribner's Sons, 1908.

"Magnolia Sketch Book/Circle of William Morris Hunt, 1872–1908." Cape Ann Historical Society, Gloucester, Mass.; Washington, D.C.: Archives of American Art. (Microfilm roll 2329: 1–46).

Mann, Maybelle. *The American Art-Union.* Otisville, N.Y.: ALM Associates, 1977.

Meixner, Laura Lee. "Jean François Millet: His American Students and Influences." Ph.D. diss., Ohio State University, 1979.

An International Episode: Millet, Monet and their North American Counterparts. Memphis, Tenn.: Dixon Gallery and Gardens, 1982.

Miller, Lillian B. *Patrons and Patriotism, the Encouragement of the Fine Arts in the United States, 1790–1860.* Chicago: University of Chicago Press, 1966; paperback, 1974.

Millet, F[rancis] D. "Mr. Hunt's Teaching," *Atlantic Monthly,* August 1880, 189–92.

***. "Mr. Hunt's Pictures." *Boston Daily Advertiser,* March 20, 1875.

Moore, Charles, H. "The Marriage of St. Catharine." *Boston Daily Advertiser,* June 2, 1875.

Munich & American Realism in the 19th Century. Sacramento, Calif.: E. B. Crocker Art Gallery, 1978.

Murphy, Alexandra R. *Jean-François Millet.* Boston: Museum of Fine Arts, 1984.

Neuhaus, Robert. *Unsuspected Genius, the Art and Life of Franck Duveneck.* San Francisco: Bedford Press, 1987.

New York Daily Tribune. April 12, 1856; May 3, 1856; May 10, 1856; May 23, 1857; March 27, 1861; July 3, 1865; April 17, 1866; July 4, 1866; July 13, 1868.

"Notes." *Art Journal,* February 1877, 63–4; July 1877, 224; August 1880, 255–6.

"Notes." *The Studio,* n.s. 3, no. 9, (August 1888): 141.

Oakey, Maria. "William Morris Hunt." *Harper's New Monthly Magazine* 61 (July 1880): 161–6.

"Painting and a Painter." *Lippincott's Magazine* (January 1873), pp. 111–14.

Perceptions and Evocations: The Art of Elihu Vedder. Washington, D.C.: Smithsonian Institution Press for National Collection of Fine Arts (National Museum of American Art), 1979.

Perkins, Robert F., Jr., and Gavin, William, J., III., eds. *The Boston Athenaeum*

Art Exhibition Index 1827–1874. Boston: Library of the Boston Athenaeum, 1980.

Peters, Harry T. *America on Stone*. Garden City, N.Y.: Doubleday, Doran, 1931.

Ponce de Leon, Nestor. *The Columbus Gallery*. New York: N. Ponce de Leon, 1893.

Port, M. H., ed. *The Houses of Parliament*. Paul Mellon Centre for Studies in British Art. New Haven, Conn.: Yale University Press, 1976.

Portrait of a Place, Some American Landscape Painters in Gloucester. Gloucester, Mass.: Cape Ann Historical Society, 1973.

Proceedings of of the New York State Capitol Symposium. Albany: Temporary State Commission on the Restoration of the Capitol, 1983.

Quick, Michael. *American Portraiture in the Grand Manner: 1720–1920*. Los Angeles County Museum of Art, 1981.

Report of the Assembly Chamber Ceiling, New York State Capitol, April 16, 1888.

Roseberry, Cecil R. *Capitol Story*. Albany: State of New York, 1964.

Rosenfeld, Daniel, and Workman, Robert G. *The Spirit of Barbizon, France and America*. Providence: Museum of Art, Rhode Island School of Design, 1986.

"The Rubáiyát of Omar Khayyám," trans. Edward FitzGerald. In *A Treasury of Great Poems*. New York: Simon & Schuster, 1942, pp. 841–52.

"Schedule 'B.'" In *Annual Report of the New Capitol Commissioners for the year 1878*. New York State Senate Documents, 102nd sess., 1879, 1, #20 (January 23, 1879).

Schuyler, Montgomery. "The Capitol of New York." *Scribner's Monthly* 19 (December 1879): 161–78.

"Correspondence. The State Capitol at Albany, November." *American Architect and Building News* 4 (December 14, 1878): 196–8.

"The Work of Leopold Eidlitz, III – The Capitol at Albany." *Architectural Record* 24 (1908): 364–78.

Sellin, David. *Americans in Brittany and Normandy, 1860–1910*. Phoenix, Ariz.: Phoenix Art Museum, 1982.

Shannon, Martha. *Boston Days of William Morris Hunt* Boston: Marshall Jones, 1923.

Sharf, Frederic A., and Wright, John H. *William Morris Hunt and the Summer Art Colony at Magnolia, Massachusetts, 1876–1879*. Salem, Mass.: Essex Institute, 1981.

"Sketchings – Domestic Art Gossip." *The Crayon* 6 (March 1859): 92.

"Sketchings – The National Academy of Design." *The Crayon* 4 (July 1857): 223.

Simoni, John P. "Art Critics and Criticism in Nineteenth-Century America." Ph.D. diss., Ohio State University, 1952.

Sloane, Joseph C. *French Painting Between the Past and the Present: Artists, Critics, and Traditions from 1848 to 1870*. Princeton, N.J.: Princeton University Press, 1951.

Smith, Walter. "The Picture Controversy, the Theory and Practice of Fine Art and Industrial Drawing – the State System." *Boston Daily Advertiser*, March 24, 1875.

Soby, James Thrall, and Miller, Dorothy C. *Romantic Painting in America*. New York: Museum of Modern Art, 1943.

Soria, Regina. *Elihu Vedder, American Visionary Artist in Rome (1836–1923)*. Rutherford, N.J.: Fairleigh Dickinson University Press, 1970.

Spassky, Natalie. *American Paintings in the Metropolitan Museum of Art.* Vol 2. New York: Metropolitan Museum of Art, 1985.

Stein, Roger B. *John Ruskin and Aesthetic Thought in America, 1840–1900.* Cambridge, Mass.: Harvard University Press, 1967.

Sturges, Hollister. *Jules Breton and the French Rural Tradition.* Omaha, Neb.: Joslyn Art Museum, 1982.

A Stern and Lovely Scene: A Visual History of the Isles of Shoals. Durham, N.H.: University Art Galleries, University of New Hampshire, 1978.

Thaxter, Celia. "William M. Hunt's Last Days. To the Editor of the *Tribune.*" *New York Tribune,* September 11, 1879.

Tompkins, Eugene. *The History of the Boston Theatre, 1854–1901.* Boston: Houghton Mifflin, 1908.

Troyen, Carol. *The Boston Tradition, American Paintings from the Museum of Fine Arts, Boston.* New York: American Federation of Arts, 1980.

"Innocents Abroad: American Painters at the 1867 Exposition Universelle, Paris." *American Art Journal* 16 (Autumn 1984): 2–29.

Tuckerman, Henry T. *Book of the Artists, American Artist Life.* New York: G. P. Putnam & Son, 1867.

Van Brunt, Henry. "The New Dispensation of Monumental Art." *Atlantic Monthly* 43 (May 1879): p 633–41.

Vedder, Elihu. *Digressions of V.* Boston: Houghton Mifflin, 1910.

Vinton, Frederick P. "William Morris Hunt. The Memorial Exhibition – The Paintings at Albany," *American Art Review* 1 (1880): 93–103.

"William Morris Hunt, Personal Reminiscences." *American Art Review* 1 (1880): 48–52.

Weber, Bruce, and Gerdts, William H. *In Nature's Ways: American Landscape Painting of the Late Nineteenth Century.* West Palm Beach, Fla.: Norton Gallery of Art, 1987.

Webster, Sara. "The Albany Murals of William Morris Hunt." Ph.D. diss., City University of New York, 1985.

Weidman, Jeffrey. "William Rimmer: Critical Catalogue Raisonné." Ph.D. diss., Indiana University, 1982.

Weinberg, H. Barbara. *The Decorative Work of John La Farge.* Ph.D. diss. Columbia University, 1972; New York: Garland Publishing, 1977.

"John La Farge and the Decoration of Trinity Church, Boston," *Journal of the Society of Architectural Historians* 33 (December 1974): 322–53.

Weisberg, Gabriel P. *The Realist Tradition: French Painting and Drawing 1830–1900.* Cleveland: Cleveland Museum of Art, 1980.

Welchans, Roger Anthony. "The Art-Theories of Washington Allston and William Morris Hunt." Ph.D. diss., Case Western Reserve, 1970.

Wheelwright, Edward. *Harvard College, Class of 1844.* Cambridge: J. Wilson, 1896.

"Personal Recollections of Jean-François Millet." *The Atlantic Monthly* 38 (September 1876): 257–76.

"Three Boston Painters." *Atlantic Monthly* 40 (December 1877): 710–18.

Whitman, Sarah. "William Morris Hunt." *International Review* 8 (1880): 389–401.

"William Morris Hunt." *Art Journal* 5 (November 1879): 34–49.

"William Morris Hunt." *Masters in Art* 9 (August 1908): 299–338.

William Sidney Mount, Works in the Collection of the Museums at Stony Brook. Stony Brook, N.Y., 1983.

Williams, Hermann, Warner, Jr. *Mirror to the American Past.* Greenwich, Conn.:
New York Graphic Society, 1973.

Winsor, Justin. *Narrative and Critical History of America.* 8 vols. Boston: Hough-
ton Mifflin, 1884–9.

Workman, Robert G. *The Eden of America, Rhode Island Landscapes, 1820–1920.*
Providence: Museum of Art, Rhode Island School of Design, 1986.

Yarnall, James. "Tennyson Illustration in Boston, 1864–1872." *Imprint, Journal
of the American Historical Print Collectors.* 7 (Fall 1982): 10–16.

Yohannan, J. D. "Emerson's Translations of Persian Poetry from German
Sources." *American Literature* 14 (January 1943): 407–20.

WILLIAM MORRIS HUNT EXHIBITION CATALOGUES

Pastels and Drawings by William Morris Hunt. Location unknown. December 27,
1878.

Exhibition of the Works of William Morris Hunt. Introduction by John C. Dalton.
4th ed. Boston: Museum of Fine Arts, November 11, 1879–December
15, 1879; extended to January 31, 1880.

*Exhibition Catalogue of the Paintings and Charcoal Drawings of the Late William
Morris Hunt* at his Studio, 1 Park Square, Boston, Mass. Introduction by
Truman H. Bartlett. January 19–31, 1880.

Sale by Public Auction of these Paintings and Drawings [by William Morris Hunt].
Boston: Horticultural Hall, Tremont Street, February 3–4, 1880.

"Paintings by the Late William Morris Hunt." *Metropolitan Museum of Art Hand-
book* 6, Loan Collection of Paintings (April 1880).

Memorial Exhibition of the Works of William Morris Hunt. Boston: St. Botolph
Club, April, 1894.

*Exhibition and Public Sale of the Celebrated Paintings and Charcoal Drawings of the
Late William Morris Hunt.* Boston: Warren Chambers, 419 Boylston Street,
February 23–4, 1898.

Loan Exhibition of the Works of William Morris Hunt. Milton, Mass.: Town Hall,
November, 1905.

Memorial Exhibition of the works of William Morris Hunt. Boston: Museum of
Fine Arts, March 8–31, 1924.

Centennial Exhibition of Paintings by William Morris Hunt. Buffalo Fine Arts
Academy and Albright Art Gallery, April 20–June 30, 1924.

William Morris Hunt. Paintings and Drawings. Newport, R.I.: Cushing Memorial
Gallery, June 15–July 14, 1968.

The Late Landscapes of William Morris Hunt. College Park: University of Mary-
land Department of Art, January 15–February 22, 1976.

William Morris Hunt, a Memorial Exhibition. Boston: Museum of Fine Arts, 1979.

The Return of William Morris Hunt. Boston: Vose Galleries, September 30–
November 26, 1986.

Index

244